michel nuridsany

100

masterpieces of painting

Flammarion

michel nuridsany

100

masterpieces of painting

From Lascaux to Basquiat, from Florence to Shanghai

Flammarion

Preface

In his *Art of the Novel*, Milan Kundera offers a model of what is in his eyes the finest sentence in the French language: the opening lines of *Point de lendemain* ("No Tomorrow") by Vivant Denon. "I was passionately in love with the Countess of ——; I was twenty years old, and I was inexperienced; she betrayed me, I became angry, she left me. I was inexperienced, I missed her; I was twenty years old, she forgave me: and, as I was twenty years old, inexperienced, and still betrayed, but no longer abandoned, I thought myself the best loved of all lovers, and, by that token, the happiest of men."

Let's not quibble over the avalanche of commas or the colon before the "and." By common consent, punctuation has no rules: it is how the sentence breathes, here dazzlingly spirited and exuberant. But in this paragraph of a few lines, Vivant Denon contrives to use the word "inexperienced" three times, "betrayed" twice, and "I was twenty years old" three times, too. Now the French hunt down repetitions as being absolutely unacceptable. So how can this sentence possibly be a "model"? It's because here the repetitions never give one the impression of just saying the same thing; they are evidence of the impetuous youthfulness of the hero. The "perfection" of this style thumbs its nose at time-honored rules; exactitude of expression, truth, is superior.

Proust bewitches us with interminable, oppressive sentences, while Céline throws us hither and thither with short-winded phrases peppered with suspension points. Kleist's clipped "officer" style meanwhile makes the outpourings of passion all the more real.

An artist is far more himself in his defects than in his finer qualities. The latter make him a worthy journeyman, a workmanlike, wily technician. It is his defects that make him stand out; it is by dint of them that he is what he is—a species all to himself. "Perfect?" No! But brilliant, certainly.

But isn't a masterpiece just an example of perfection? No. Is the *Mona Lisa* perfect? Is Mozart's *Don Giovanni* perfect? And *Don Quixote*? A rather over-literal definition has it that a "masterpiece" is a "proof of excellence presented to a guild institution." But "guild institutions" do not exist today, any more than brotherhoods. It is presently supposed, in the words of Arthur C. Danto, professor at Columbia University, to be an "impoverished concept." Hmm. Wouldn't "a concept that has changed" be better? Changed just as taste, ideas, and lifestyles have all changed, evolving in the light of scientific discoveries, social developments, the ways people dress, eat—worship even? Yes, for the Church has changed, too, as religions and dogmas—and even ostensibly measurable scientific truths—change.

To convince oneself of the fact, one only has to flick through the chapter dealing with the Renaissance in a book on nineteenth-century art history. Forgotten or even unknown names are placed on a pedestal with an air of certainty that surprises today's art-lover, while the absences, such as Uccello and Piero della Francesca, are nonetheless astonishing, almost outrageous. And yet, what seems more unquestionably to deserve the accolade of "genius" than the art of the Renaissance? Well, even there....

I recall a discussion with Aurélie Nemours. For her, art stops at Cimabue, at the gates to the Renaissance, to begin once again with geometric abstraction. "All those muscles!" she said, crinkling her nose, thinking of Michelangelo. She only liked the *spiritual in art*, and loathed storytelling, even when restrained and signed Masaccio.

A choice, such as the one we propose here, is often based on one predominant idea from which the rest results. My starting point was a wish to see a history of painting in one hundred masterpieces which would not be confined to the lands of the Western world alone, but which would also embrace, for example, the grandeur of Chinese painting, including calligraphy, which is at once writing, poetry, and painting.

Yet I didn't want this broader scope to be a hurried affair with just a couple of Chinese pictures (which is what often happens these days), so I have included eight masterworks which give some idea of the evolution of Chinese painting, just as we habitually do for Italian, French, and Flemish art. This decision is accompanied by a widening of scope that takes in Persia (miniatures), Japan (prints), India (the paintings in the caves at Ajanta), Russia (icons), Ireland (illuminations), Mexico (early murals), and so on, but also including Byzantine painting and the West's own sublime Middle Ages. In short, this book presents painting as art that reflects the globalization governing our lives today.

That has meant that certain fields may seem slightly underrepresented (at least compared to the place generally accorded them), such as impressionism, neoclassicism, or nineteenth-century Western painting. Certain artists, selected in other anthologies of the same type, do not then appear. Choice implies arbitrariness and a particular viewpoint. Yet, precisely because of this, perhaps the qualities of those in our final selection shine all the more brightly.

For the most recent period, which goes up to 1987, my choice tries to take account of the switch from Europe to the American scene that occurred from the 1950s in the main trends in painting; similarly, I strive to show the revolutionary upheavals that took place in Russia at the beginning of the twentieth century.

So here, in the form of one hundred masterpieces, is this imaginary museum: painstakingly designed, all areas open, with room for the inevitable and the more recent arrivals alike; a place in which to rediscover our cultural heritage and open our eyes to the world.

I remember there was once a radio program where listeners were invited to request rare works, hitherto not broadcast. I thought it would be an idea to ask for Beethoven's Fifth Symphony, which, in the 1950s, seemed never to be off the airwaves, but which had scarcely been played for the last thirty years. In the same way, *Mona Lisa*, incessantly hyped by the Louvre, copied, mocked, appearing in ads and on T-shirts, has become, as it were, "invisible." It seemed as if this might be an urgent candidate for rediscovery. She needs to be "reread," just as we have to rediscover and reread Raphael's *Sistine Madonna* or Michelangelo's *Last Judgment*.

Open to so much, the following pages do however take care not to pass over our tradition, the tradition of today. Meanwhile, try not to forget the most crucial thing in all this is to enjoy.

Michel Nuridsany

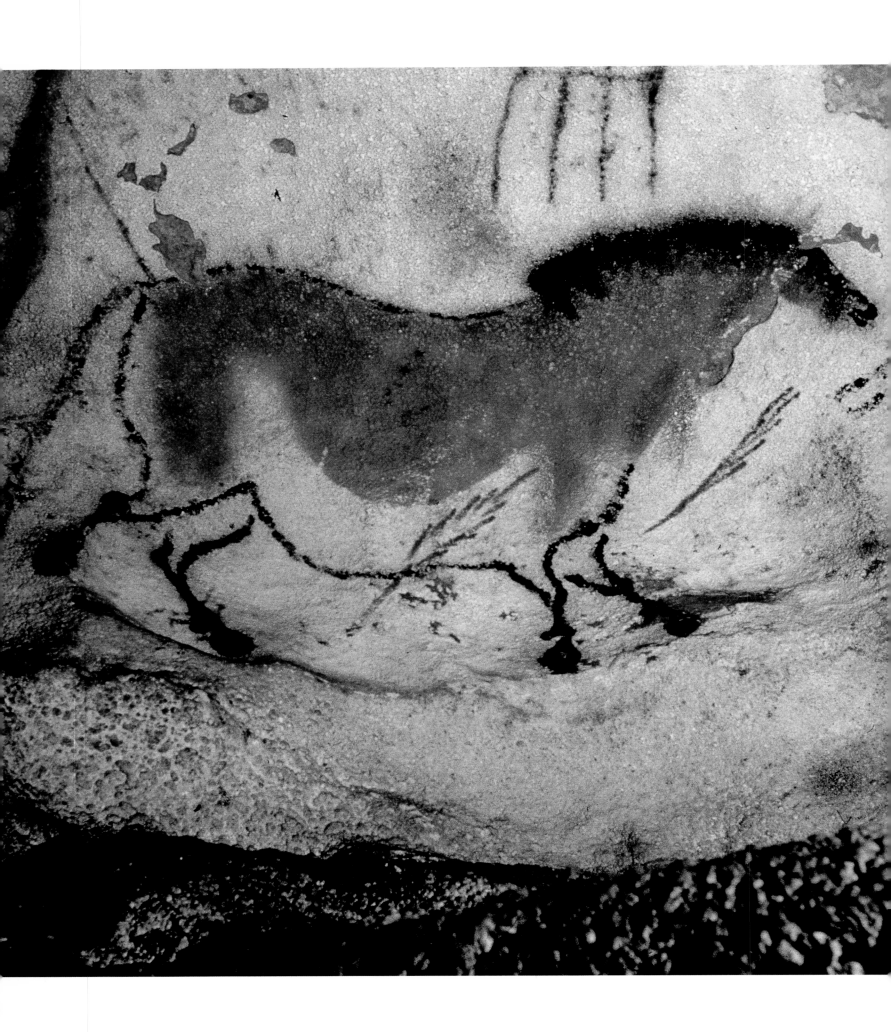

Lascaux
"Second Chinese Horse," 16,000 B.C.E.

What splendor! Bulls, horses, stags, ibexes, rhinoceros! On the walls of the gallery known as the "Hall of the Bulls" there's almost too much to take in; on the ceiling of the narrow, rather tortuous corridor leading to it one meets, yellow-coated and short-legged, the famous so-called "Chinese" horses.

"This is the Sistine Chapel of the Périgord!" exclaimed Abbé Breuil when he stumbled across these miraculously beautiful and fresh paintings in 1940. Shortly before, on a wooded hillock above the village of Lascaux (population one hundred and fifty) located on the left bank of the Vezère in southwest France, a fir tree had become dislodged, opening up a hole in the ground. Four teenage boys noticed it and inched their way in. What they saw stunned them and they rushed off to tell their teacher of the discovery. He in turn alerted the priest of the village, Henri Breuil, and, barely three months later, on December 27, the site was listed as a historic monument.

The cave opens halfway down the slope. The total extent of the cavern is no more than two hundred and fifty meters over a difference in altitude of thirty; comparatively little overall, perhaps, but it contains no less than one thousand five hundred figures and six hundred signs. The main gallery near the entrance features a group of bison, horses, and stags painted in carbon black and red ocher. Their coats are covered in dots and geometrical motifs whose meaning remains unknown.

After this room, known as the "Hall of the Bulls," the following axial "diverticule," or passage, is populated by stags, bovines, and horses, and is rightly considered as the zenith of Paleolithic cave painting.

Various tools, lamps, and pigments (158 little blocks of dye) have also been found on the site, together with scraps of food. These caves, however, somewhat uncomfortable, were never inhabited.

Since the discovery of Lascaux, many have wondered what the pictures might mean. Although other perfectly preserved caves, like the Chauvet Caves, have since added to our knowledge, the puzzle remains. Probably they formed part of some animist activity and testify to the makers' familiarity, complicity, or even identification with the animal kingdom and the natural world generally, but conclusive proof is lacking. Still, even if it is unclear what these paintings were used for, their sureness of line and formal invention are admirable, and as art they are dazzling and amazing. Picasso is supposed to have said: "We've done nothing better since."

Opening to the public after the Second World War, the cave had to close in 1963 as the carbon dioxide expelled by the daily tally of one thousand two hundred visitors was beginning to damage the paintings. So, two hundred meters from the originals, a full-size replica was constructed. As a copy, it is as faithful as it could possibly be. But it is a copy.

Millions of visitors have only seen that "cave of Lascaux," which is strange for a period that values the authentic so much.

Lascaux (France)
"Second Chinese Horse," 16,000 years B.C.E. Wall painting.

Ta-n-Zoumaitak
Clothed figures wearing adornments, c. 8000 B.C.E.

Prehistoric art exists everywhere in the world, in more varied forms than might be thought and in surprising quantities. In France, there are examples at Lascaux, Niaux, Pech-Merle, Rouffignac, Castanet, Font de Gaume, and the Chauvet Cave; it is found in Spain at Altamira, in Czechoslovakia, in Norway, in Siberia, in Brazil, in Paraguay to the west of Patagonia, down the cordillera of the Andes in a strikingly

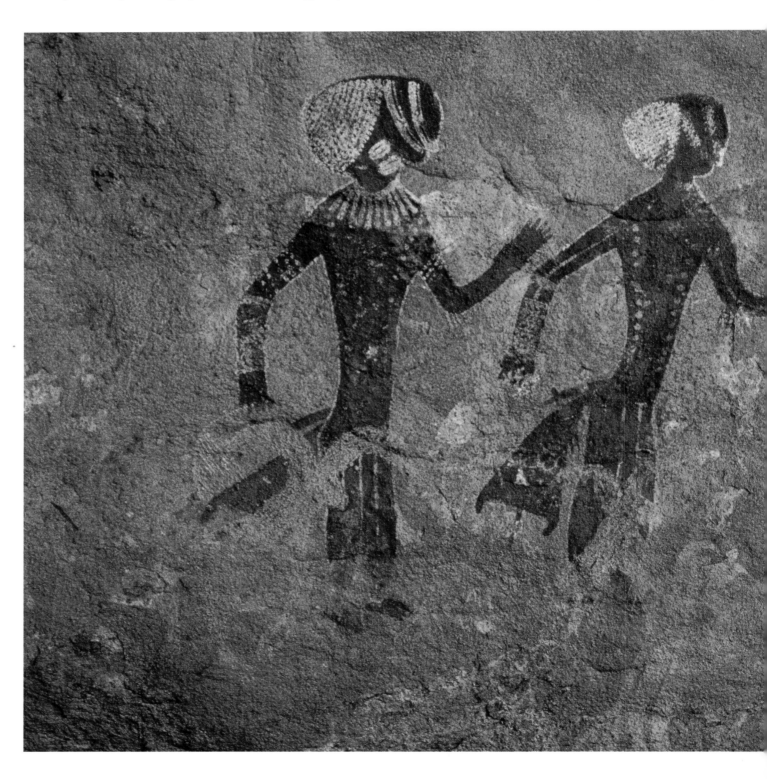

beautiful lunar landscape, on the walls of the famous caves of Los Manos with its hundreds of handprints, in the middle of India in the Bhopal region, where the figures possess geometrical bodies, in South Africa around the Cape, which has the highest concentration of cave art in the world, in Australia, where the traditional style (known as "X-ray") is like a door to the land of dreams.

In the south of Algeria, in a region located west of the nearby Libyan border, to the north of the Niger and northeast of the Hoggar, there is— in the sandy high plateaus of Tassili-n-Ajjer, close to the oasis of Djanet— an astonishing stone forest. It has been compared to a city, with streets, lanes, and columns, as well as to an "open-air museum." There, at Sefar, Jabbaren, at In Aouanrhet, and at Ta-n-Zoumaitak, one finds groups belonging to the Round Head style which look more beautiful still in photographic enlargements.

Ten thousand years before our time, the Sahara was still green. It was occupied by animal species that have since disappeared, and by hunter-herders who covered the rocks that jut out in the sand dunes with thousands of extraordinarily vivid carvings and paintings.

From before the Cattle or Pastoralist Period (6,000 B.C.E.), the Round Head style features figures with relatively schematic but highly diversified physiques. On their heads they sport a kind of cap or artistically dressed hair, and they wear, it would seem, a mask that does indeed make their heads appear round, or at least disk-like.

The two personages here belong to a small group of diagrammatic and manifestly Negroid figures, together with animals, in particular ibexes, with powerful and long, curved horns, though one is associated with an imaginary creature summarily represented by a brown line.

Located on an extensive stone shelter, the two—perhaps imaginary— characters that the people who discovered them thought of as "Martians," wear loincloths and are richly adorned. Ringed with a fine white line, the bodies are russet brown in color and awash with ornaments, including necklaces, earrings, long bracelets on the wrists and the legs, as well as painted designs—based on a range of lines, dots, and circles—over the arms, torso, and legs.

The most original and elegant group, its enigmatic character undoubtedly related to some kind of shamanistic activity, it is also the most fascinating. In Jebbaren, the silhouettes of these round heads sometimes reach impressive proportions, with the largest on top of an immense shelter measuring some six meters.

Ta-n-Zoumaitak (Algeria)
Clothed figures wearing adornments ("Round Head" group), c. 8,000 B.C.E. Wall painting.

Egypt
Group of young musicians, c. 1400 B.C.E.

First off, the viewer is attracted by the charm, freshness, and gentle, buoyant elegance of these youthful musicians, and to the tremulous, almost perfumed sensuality wafting up from this painting, which was discovered on the wall of a tomb, drawn to its almost life-enhancing radiance.

In the center, an almost completely naked brown-skinned girl plucks at a long-necked stringed instrument. She continues the movement of the right arm of the flute-player to the left, cutting diagonally across the composition and onto the strings of the harp played by another girl to the right. Beneath their white robes and elaborate neckwear, two of the girls keep their feet together. The one in the center, however, stands feet apart, flexing her right leg and twisting her bust to expose her breasts— a rare gesture in Egyptian painting of the Thirteenth Dynasty. Such disarming and unusual flexibility of line contributes greatly to this painting's delicate lightness and grace. It should be recalled that the reigns of Thutmosis and Amenophis III were a period of exceptional peace and prosperity in which the arts flourished.

This musical group used to adorn a tomb in Thebes that is famous for its many brightly colored and wonderfully preserved paintings. It belongs to Nakht, the name of a "priest of the hours" at the temple of Amon, who was responsible for overseeing ceremonies marking the course of the sun and the passing time.

The first thing seen on entering the tomb was an "offering to the day," featuring an impressive spread of provisions. Then come Nakht and his wife with a necklace and sistra, symbols of rebirth, followed by the priest inspecting his fields; there are various scenes of sowing, reaping, and grain-weighing.

Everywhere the same abundance of things to eat—ducks, slaughtered and butchered oxen, figs, grapes—together with scenes of fishing and hunting, a teeming mass of fish, ducks, butterflies, and dragonflies taking flight: episodes from daily life; symbols both of death and resurrection.

The pigments, finely crushed and dissolved in size, are used here with an economy of means that emphasizes the design and the rhythmical interplay between the various profiles and the alternation of straight and curved lines: sooty blacks, russets, a slightly paler brown, calcium carbonate. And that's all: almost a cameo. Truly amazing!

Egyptian art did not employ perspective. It had no call for it. It was not realistic. Built up in blocks of color, it preferred conceptual analysis, affording a powerful and trenchant synthesis whose subtlety and naturalness is delightful, awe-inspiring. Here stylization results in both concentration and radiance.

Egypt
Group of young musicians playing the flute, lute, and harp at a funerary feast (Tomb of Nakht), XVIII Dynasty (c. 1400 B.C.E.).
Painting on plaster.
Thebes.

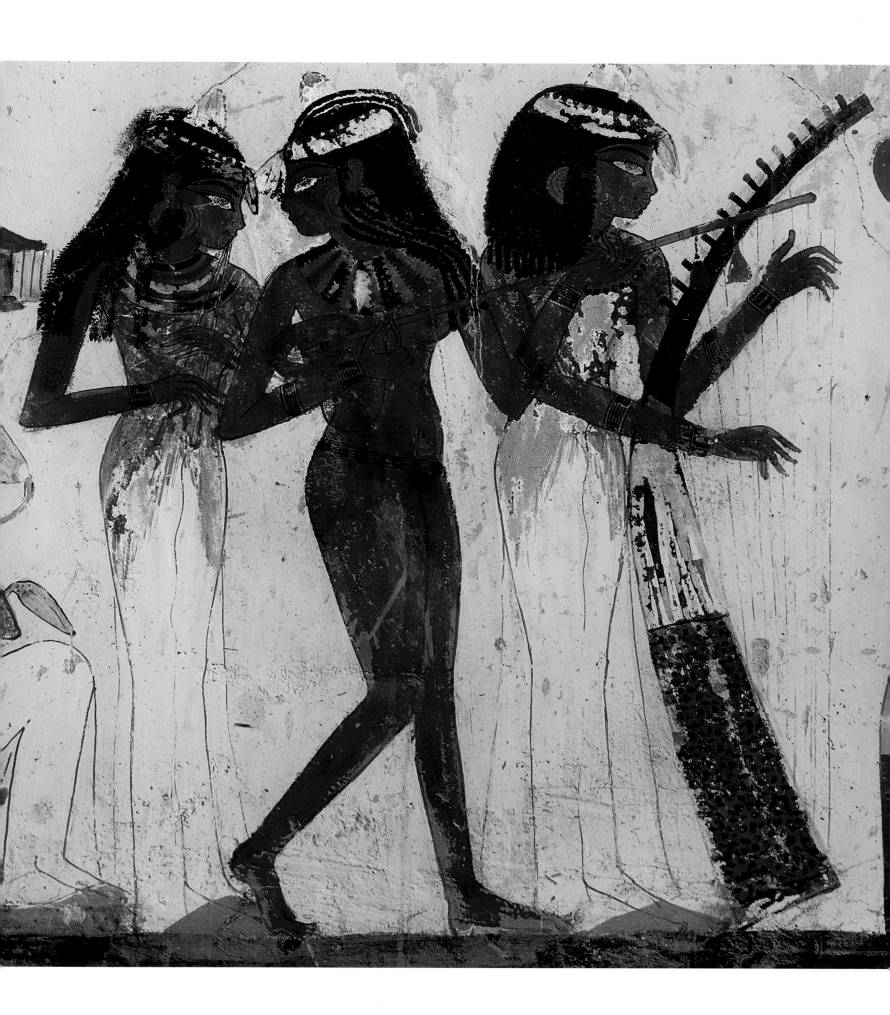

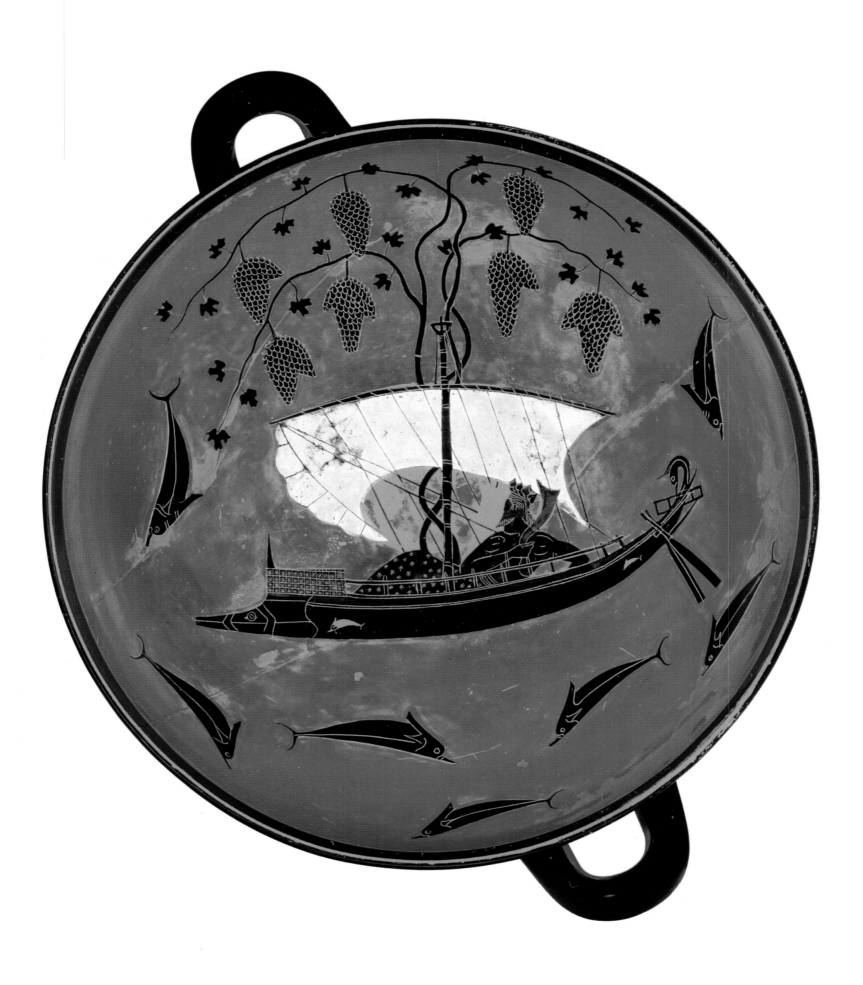

Exekias
Dionysos Crossing the Sea with Dolphins, 500 B.C.E.

Jean-Luc Godard, in his movie *Contempt*, shows Greek sculptures filmed in vibrant colors by Fritz Lang. For the Greek world was in fact awash with color, far more than the blanched marble statues in our museums and the impeccable ruins of the temples would have us suppose today. Polychrome paint covered the statues and the walls of buildings, religious and secular alike. That has long since disappeared, and all that is left is the paint decorating the ceramic vases that, decorated before firing, preserve their designs and colors intact.

In the sixth century B.C.E., potters and painters were specializing in a new form of vessel, with thin, graceful flanks and a base that terminated in the shape of a "trumpet." These cups were decorated in a miniaturist style and were artworks rather than objects for regular use, being signed. They are referred to as being by the "Group of the Minor Masters." At the same time, Attic ceramics were developing in a very different direction, characterized by monumentality and vigorous figures painted on vases of large size. The most eminent representative of that trend was named Exekias, a painter and potter who elevated his art to a degree of perfection that is unparalleled and who, naturally enough, would also sign his "works," often on the stem of the cup. Exekias, who produced masterful depictions of gods, heroes, and men, was also an innovator: he invented a slip that, after firing, turned coral red, as can be seen here (slip painting consists in covering a piece of ceramic with a coat of a clayey substance that masks the original hue of the paste). He devised a form of cup with a short and robust base, the outside being decorated with large eyes whose purpose was apotropaic (to deflect bad luck), as well as with more allusive features approximating to a nose and eyebrows. Fighting warriors figured on either side of the two handles (or "ears") and were invariably black in color. Nonetheless, though these ceramics are dubbed "eye cups," it is the interior decoration that makes the greatest impact, the base being entirely occupied by a black picture on a red ground that, at the same time powerful and refined in its detailing, testifies to an acute sense of composition. The décor inside represents Dionysos lying in a boat whose mast is entwined with a mass of vines and which carries a large white sail. Floating over a sea of a strange red—or wine-like—hue, it is accompanied by an escort of dolphins that weave and dive along the edges of the cup.

A masterpiece of Greek decorative painting, this drinking cup featured in banquets (*symposion*) where drinks were taken recumbent and the cup held by the base, the handles being used only when it was being passed from guest to guest.

Exekias (Greece)
Dionysos Crossing the Sea with Dolphins, 500 B.C.E. Attic eye cup, paint on ceramic, height 5¼ in. (13.6 cm), diameter 12 in. (30.5 cm).
Staatliche Antikensammlungen, Munich.

Pompeii
Dionysiac initiation (detail), c. 70 B.C.E.

Perhaps it derived from the kind of leader cult that shadowed the triumphs of Pompey and Caesar: in the Roman world, the first century B.C.E. witnessed the onset of an individualism that pushed some portraitists into exploring the resemblance and psychology of their models; while others, still more extreme, turned an unforgiving spotlight on their physical and moral shortcomings. However, this was followed by another, very different trend that was less concerned with self-publicity. It was an escapism—expressed in literature in the lyric and in painting in antirealism—primarily in interior decoration. Initially, it appeared on walls like those at Pompeii in the form of fake marble; then in illusionist paintings, complete with columns that seem to leap out at the viewer; next in doors and windows, and then finally over entire walls, which draw aside to reveal not just the other side of the domestic world, but a veritable parallel universe, in virtuoso, theatrical trompe-l'oeil pieces that transform what are small rooms into vast, imagined spaces.

Painted on the walls of the house known as the "Villa of the Mysteries," there is a gallery with make-believe pilasters, an elegant door in decorated wood, as well as faux marble, false hangings, and deceptively placed apertures through which one has the impression of seeing a sky that opens onto the "mystery."

The large fresco that gives its name to the villa is composed of twenty-nine figures. These appear on a trompe-l'oeil podium or dais, and their impact is further enhanced by their almost life-size dimensions. According to some authorities, this painting shows a young bride being initiated into the Dionysian rites; others see it as the education of Dionysos himself, while others again discern the wedding of Ariadne and the god, or even some Orphic initiation.

The painting is divided into the following episodes: first there's a child reading something written on a scroll flanked by two women. Then a priestess advances, carrying a tray bearing liturgical objects. The sacrificial scene that follows shows a priestess purifying a branch and a silenus playing a kithara. A wall at the back shows another silenus toying with a theatrical mask, while in the center appear Ariadne and Dionysos. On the right, a kneeling woman removes a veil from a basket. Again on the right, a winged female demon seems to be whipping the stripped back of a girl; she is burying her face in the lap of her seated friend, who lays a protective hand on her hair.

This admirably composed detail, painted on a red ground, shows, on the right, a maenad holding a thyrsus; another plays the cymbals and, with an elegant movement of the arm, makes the bolt of material that ostensibly veils her nudity swirl into a ring round her body.

Pompeii (Italy)
Dionysiac initiation (detail), c. 70 B.C.E. (Second style, second phase). Fresco.
Villa of the Mysteries, Pompeii.

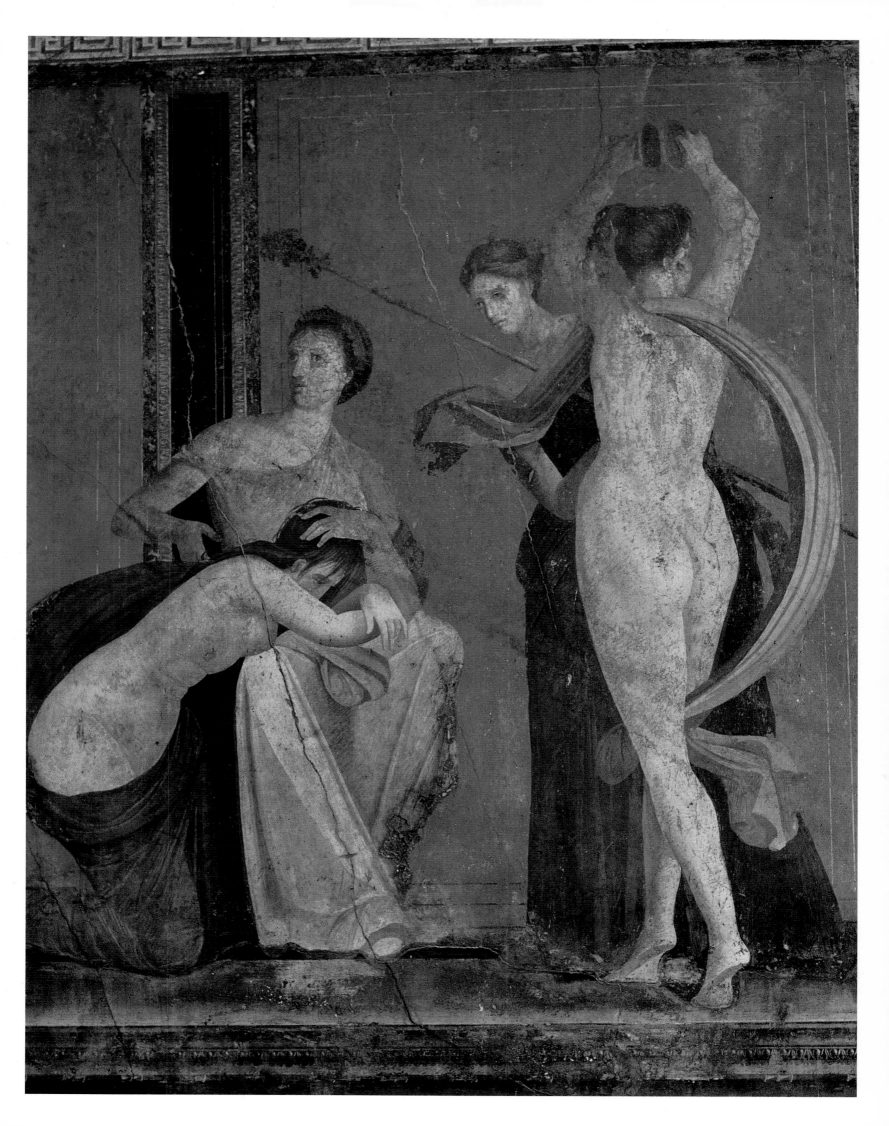

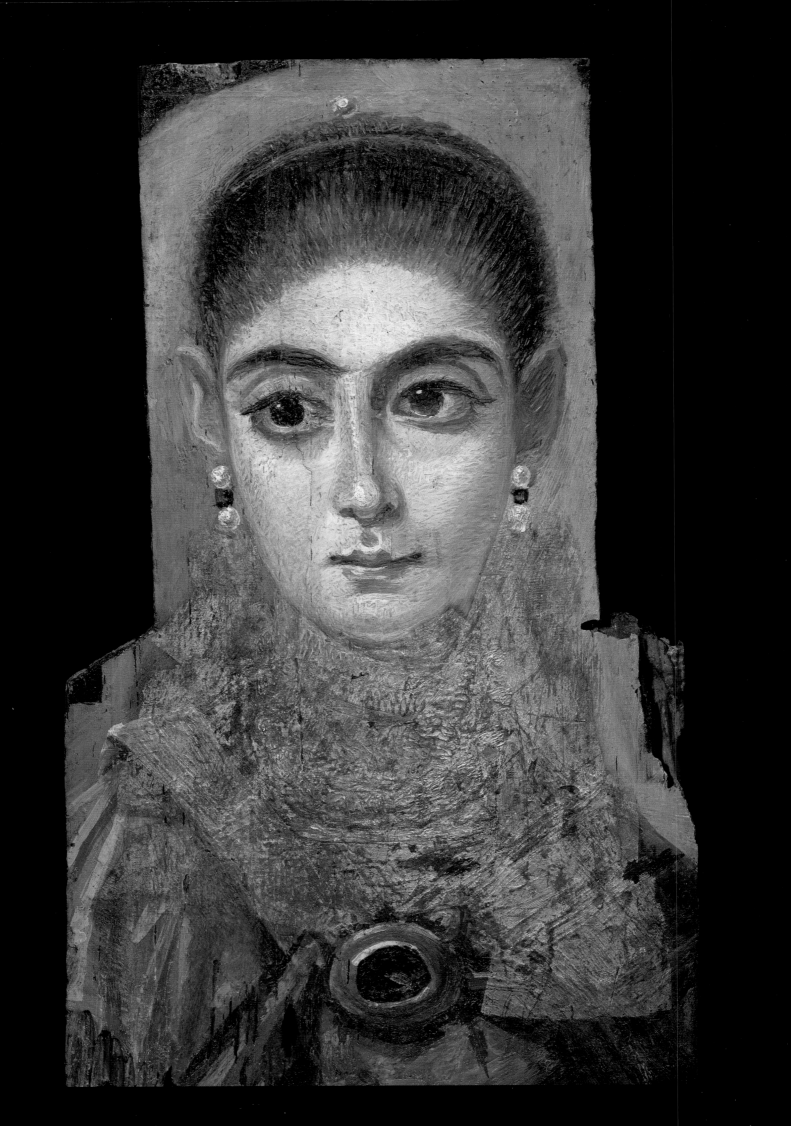

Fayum
"European Girl," c. 117–138 C.E.

These portraits that we now admire under sophisticated museum lighting were intended to be buried. The painters who created them would never have dreamed they would one day become visible again. This is something that should be borne in mind as we look at what are now known as "Fayum portraits." Fayum is a fertile region in Egypt, one of the most important wheat-growing areas in the ancient world, located not far from the Nile Delta and about one hundred and fifty feet below sea level.

For these likenesses, painters worked together with the future deceased, not to enhance the social standing of the sitter or to glorify their art: their collaboration was intended to give the patron a face suitable for the afterlife. The aim was to produce an identity for an individual before he or she entered the realm of death; to have one's portrait painted was to prepare to cross over into the other world.

The Greeks, Romans, Egyptians, Libyans, and Syrians who lived at Fayum during the Greco-Roman period all mummified their dead. Once finished, the "face" of the deceased, painted on linen or on a thin plank of wood—usually poplar—and slightly smaller than the actual face, was inserted in the strips just above the mummy's head.

Many different kinds of Fayum portraits exist. There are hundreds of them, all realized by untutored or local painters. The artists remain equally anonymous: some were second rank, but others were geniuses, such as the one who executed this fascinating face, which is now in the Louvre and known as the "European Girl."

Unlike nine-tenths of these portraits, in which the sitter appears in three-quarter profile, this one is painted face on. Well, *almost*: the cheek is ever so slightly pinker on the right, the corner of the mouth is a touch tauter to that side, too, while the eyes gaze down a line that slopes almost imperceptibly towards the left. These minute divergences contribute enormously to the strange and bewitching charm that emanates from this face beyond the grave that remains indubitably alive—as does the golden veil that conceals the neck, framing and enveloping the chin and cheeks, as if displaying them—though why or how, one cannot begin to guess.

Like almost all Fayum portraits, this one was painted in pigment bound with encaustic: yellow ocher, red earth, black, and white. Every illusory trick is brilliantly deployed: the light is very slightly brighter on the upper lip; contrast is reinforced around the eyes; the jewelry is emphasized, the piece in the center of the painting at the bottom having perhaps been executed in three dimensions.

But here, as in nearly every such portrait, the most conspicuous and haunting features are the eyes, which have an infinitely expressive look of caressing softness, totally cleansed by the imminence of death or its expectation.

The extraordinary humanity of this remarkable face is here allied to a feeling of abeyance, to a thoughtfulness that hovers on the brink of the eternal chasm.

Fayum (Egypt)
"European Girl," Antinoopolis excavations, Hadrian Period (c. 117–138 C.E.). Wax paint on wood.
Musée du Louvre, Paris.

Ajanta
"The Beautiful Bodhisattva," fifth century

"The Beautiful Bodhisattva" is to Indian painting what the *Beau Dieu* at Amiens is to early French sculpture: a masterpiece acclaimed by tradition, the epitome of the vigorous, harmonious spirituality of Indian mural painting.

Let us briefly recall that, to escape from the misfortune of living and the endless cycle of reincarnation and to attain Deliverance, Buddhism preaches an ascetic path: it is necessary to leave one's family, house, trade, and abandon all earthly pleasures; the food needed to subsist must come from begging, and sheltering in a hut is allowed only during the monsoon.

Little by little, though, these huts were replaced by more durable structures in which certain *bhiksu* (mendicant monks) decided to reside permanently, leaving others to pursue a wandering existence. The monasteries thus created were arranged into narrow cells that opened onto a central courtyard with a refectory, a kiosk, a well, and a stupa (a dome-shaped structure) containing ashes of the Buddha. In mountainous regions, monasteries were often dug into the rock, creating astonishing cave structures such as Ellora and Ajanta.

The caves of Ajanta are located 217 miles (350 kilometers) to the northeast of Bombay in an impressive site that arches in a gentle half-circle over 2,000 feet (600 meters), overhanging one of the meanders of the Waghora. Twenty-eight in number, they were carved and built from the second century B.C.E. to the fifth century C.E., a period that marked a highpoint of Indian art.

Cave 1, which contains the frescoes featuring the Beautiful Bodhisattva, comprises twenty grooved columns with capitals, abacuses decorated with floral or animal motifs, and admirable high reliefs. But the cavern is primarily known for its murals, which are executed not on wet plaster like true fresco, but on a dry coating composed of sand, earth, lime, and a glue, such as gum or resin. Illustrating mythical episodes in the life of the Buddha, they are fantastically busy, with cleverly calculated chromatic contrasts in autumnal colors that have been obtained from mineral and sometimes vegetal pigments. They present a brilliant, luxuriant mix of narrative and decoration—spiritual interiorization conjoined to expressive celebration of the human body.

The scenes represent the Buddha's erstwhile existences, highlighting his merit, courage, compassion, forgiveness, and determination, with all kinds of spells and ordeals on the way to Renouncement. In the midst of the agitation surrounding him, the Beautiful Bodhisattva, motionless and calm, radiates gentleness, clemency, and serene nobility. The grace and delicacy of the modeling (characteristic of Ajanta painting) and the pensive tenderness of his expression is wonderfully allied to a beauty marked by extreme reserve.

The frescoes, created during the reign of the Gupta, are a marvel from one of the most brilliant periods in the whole history of India.

Ajanta (India)
"The Beautiful Bodhisattva," Cave Number 1 (detail), fifth century. Buddhist frescoes.

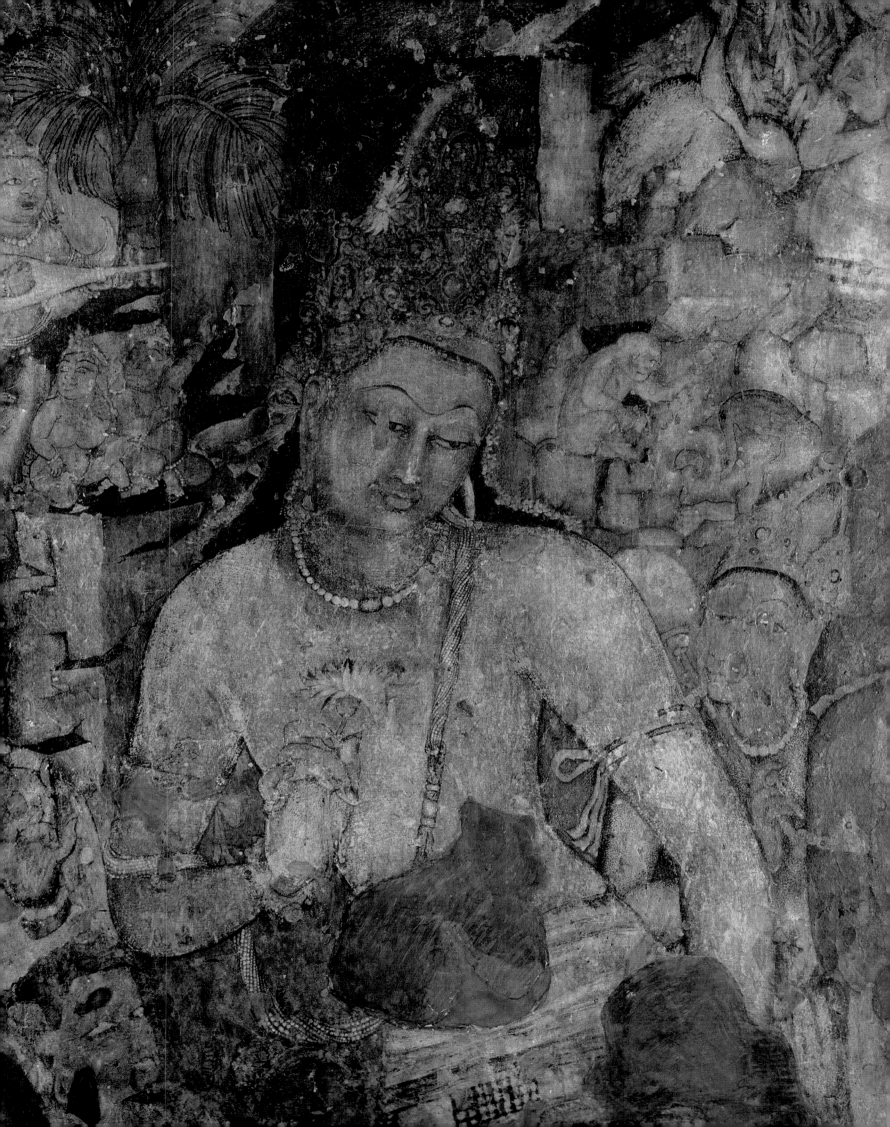

Ireland
Book of Kells, eighth century

The fact that Chinese calligraphy—which is at the same time poetry, painting, and many other things besides—still flourishes as a genuine art form should not blind one to the qualities of Irish penmanship above and beyond its decorative function. Especially when the work in question is the *Book of Kells*, unanimously hailed in historic and artistic circles as one of the key works of the European Middle Ages.

Simultaneously concealing and revealing, hiding and displaying, the extraordinarily luxuriant

ornamentation in the *XPI* Monogram for the Incarnation is not simply a masterpiece of interlace of patently Celtic origin. It is, like certain Ethiopian paintings of the present day, at once a work, an object, and a mysterious path, with its connotations of magic and revelation.

These visible forms are not just "something written" and then embellished; they show the Word, the divine Word, which must be hidden in order to remain Truth, as if in a tabernacle. This illumination is then the place of a metamorphosis and a transubstantiation, but also of a penetration.

In the thirteenth century, an erudite churchman of Scottish origin, Giraldus Cambrensis, said of the *Book of Kells*: "Look at it closely and you penetrate into the greatest secrets of art, you will find there ornaments of such complexity, such a wealth of interlace knots and lines that you would think it the work of an angel rather than that of a human being."

The book contains the four gospels of Matthew, Mark, Luke, and John, lists of Hebrew names, and the Eusebian canons. Most experts agree that its probable place of origin was the monastery founded on the island of Iona in the west of Scotland by an Irish saint, Saint Colomba. It is believed that several artists and copyists worked on it around 800 C.E. at Iona and then at Kells. Three different hands have been identified. According to legend, Saint Colomba himself is supposed to have contributed to the book, though this is highly improbable, as it would date the manuscript to the sixth century.

In the ninth century, to protect this valuable artifact from Viking raids and to seek shelter themselves, the community of Iona moved to the monastery at Kells, in the county of Meath, Ireland, where the book was to remain until 1007, when it was stolen. Its gold cover encrusted with precious stones was torn off and the rest thrown in a ditch. What could be recovered was returned to the monastery of Kells, remaining there until 1541 when the Roman Catholic Church took it under its protection. In 1661, it was repatriated to Ireland and donated to Trinity College, Dublin, where it is now conserved.

Book of Kells (Ireland)
XPI monogram for the Incarnation (folio 34r), eighth century. Illumination, 12¾ x 9½ in. (32.2 x 24.2 cm). Trinity College Library, Dublin.

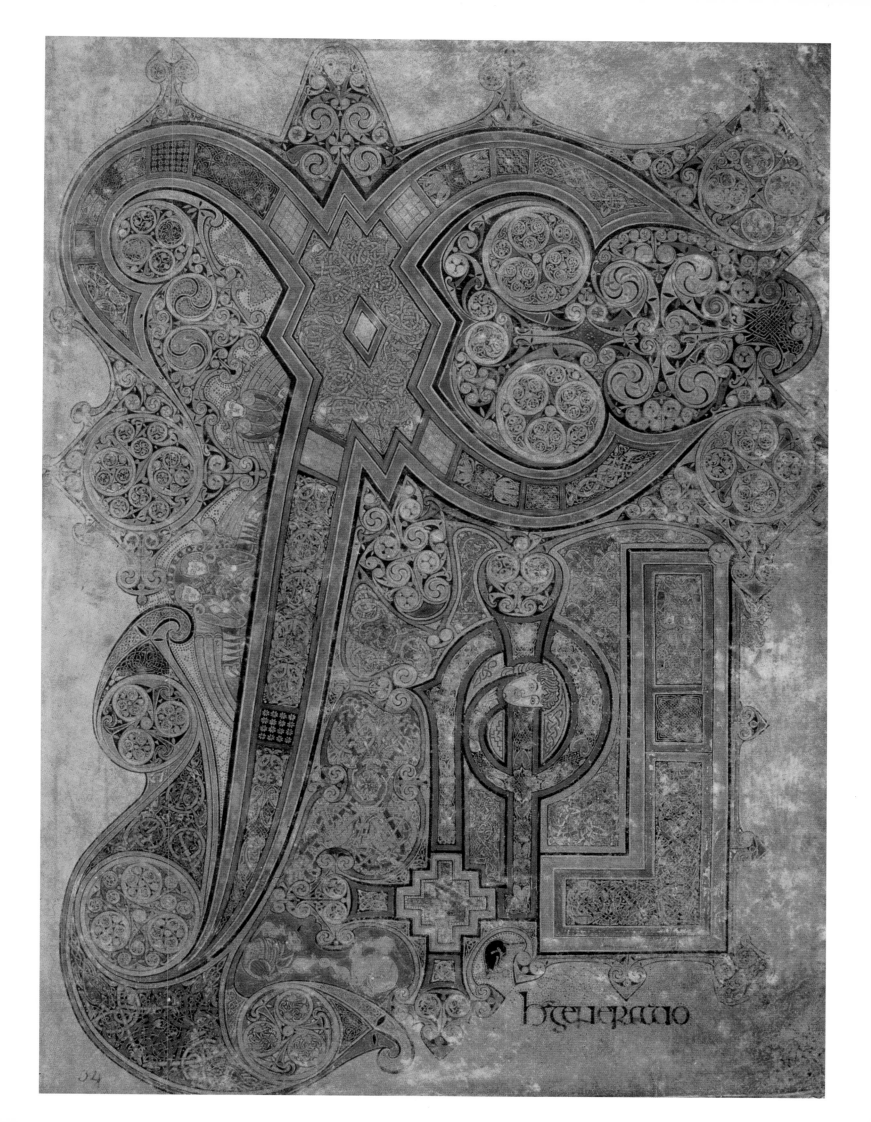

ħgeneracio

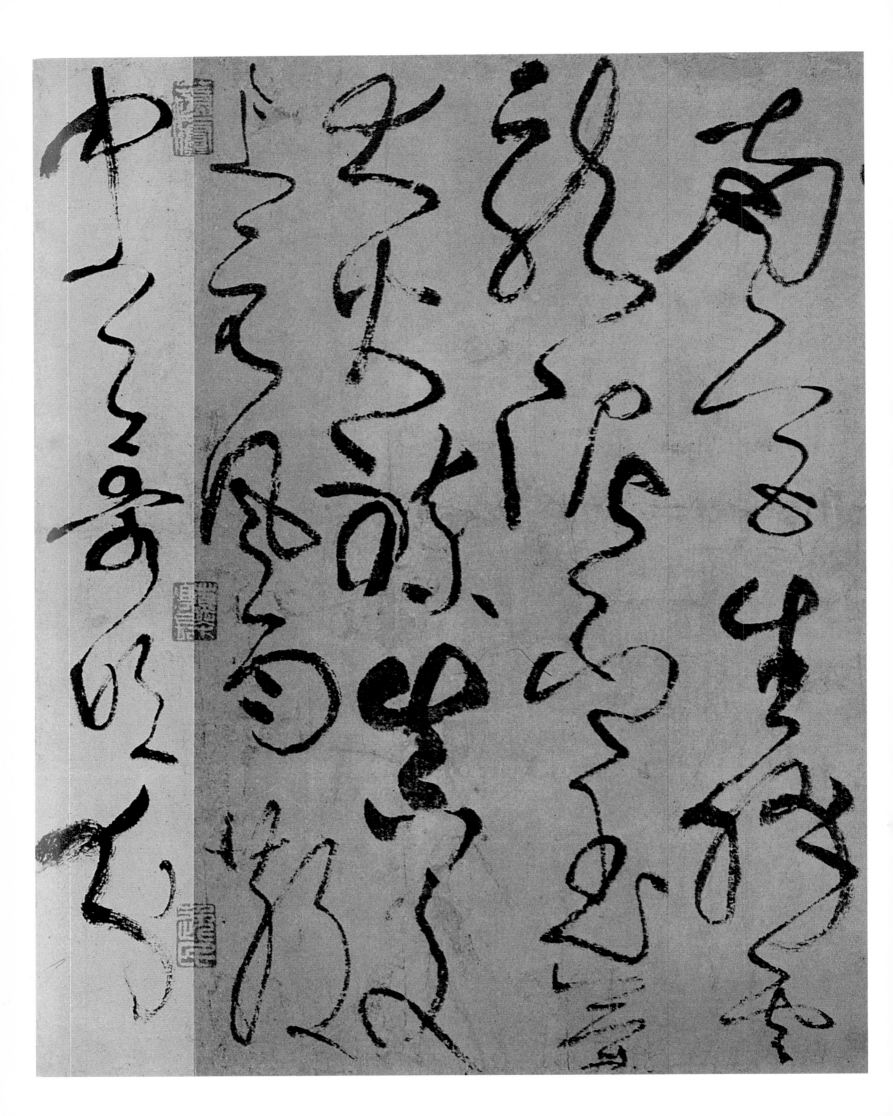

Zhang Xu
"Four poems in ancient style," c. 658–748

"A painting is a poem that can be looked at," said Mi Fu, one of the most famous painters and collectors of the Song Dynasty. How can one possibly define what is often improperly termed "calligraphy," or

Chinese writing, when, as here, it is at once poem and painting; when it requires such an effort of creative imagination, demanding that viewers read it "as artists," as explorers, in the same way that they plumb language, poetry, and painting to the deepest core of their being and discover the mental images locked up within what is surely one of the supreme expressions of the human mind?

But we still have to come to agreement about concepts such as "beauty," "quality," and "masterpiece." François Jullien is not wrong to remark that a linchpin in Chinese spirituality, music, poetry, and painting—to the limits of the perceptible—is the nondescript and the unassuming; a refusal to characterize, since it fosters inward detachment.

"Draft" or "grass" cursive script—in Chinese, *caoshu* (*ts-ao sho*)—falls into three styles: ancient, modern, and "crazy," the latter being characterized by connections between lines and characters amounting to an almost uninterrupted succession of arabesques, executed exceedingly rapidly using shorthand and impromptu flourishes.

In the T'ang Dynasty, Haisu and Zhang Xu adopted this latter style and elevated it to heights of exuberance, invention, freedom—brutality, even—that were daring in the extreme. Both were consumed with a passion for wine and produced their finest calligraphy when intoxicated. Originally from Suzhou, Zhang Xu took the nickname of the "mad drunk." When under the influence, he would howl and leap around uncontrollably, writing as if in the grip of a revelation, even painting using strands of his hair dipped in ink.

Zhang Xu tells how his genius was revealed to him: "It was when watching a princess and a porter quarreling for right of way on the road and hearing drums and wind instruments playing that I, the 'mad drunk,' understood the art of the brush. It was on watching Gongsun making his sword dance that I was struck by his marvelous power. Since then, every time I see cursive by Zhang Zhi of the Han, the wonder of his script once again sends me mad to write."

In penmanship as in dance, disputation, or music, the whole body is in motion. Even though the movement is expressed solely through the speeding brush, it is felt all the more keenly because it is contained. It enters into resonance with the world.

The "four poems in ancient style," one of the most famous manuscripts in "crazy" cursive, consists of four poems—two by Yu Xin and two by Xie Lingyun—on eight sheets in various colors assembled into a scroll.

Zhang Xu (or Chang Xu), c. 658–748
"Four poems in ancient style," T'ang Dynasty (618–907). Manuscript composed of eight leaves in different colors arranged as a scroll, height 11¼ in. (28.8 cm).

Zhou Fang
"Palace ladies wearing flowered headdresses,"
c. eighth century

Though to award honors to one side or another would be invidious, it might be observed that, while China was approaching its classic phase under the T'ang—with the country reunified, the State reorganized, and with unprecedented prosperity instilling vitality and creativity into every field of art (music, poetry, calligraphy, painting, dance)—the West was, artistically speaking, still at the beginning of the Middle Ages.

As with every classicism, it was a period of rulebooks, of ranks and norms; but variety was in demand, too. Three strands of thought emerged—Confucianism, Buddhism, and Taoism—expressed by three tendencies: realism, expressiveness, and impressionism.

Zhou Fang, a painter who exercised his talents from 780 to 804, belonged to the "realist" tendency and was famous for his genre pieces, including ladies of the court, a specialty of his.

Painted on silk, "Palace ladies wearing flowered headdresses" comes in the form of a long scroll and possesses one undoubted merit: the work is definitely in the master's hand or in that of one of his close disciples.

Exquisite is the word that springs to mind on opening these delectable, delicately colored paintings. The ladies have white-powdered faces, elegant, so-called "butterfly" eyebrows, towering coiffures artistically carved and bedecked in flowers, with a smattering of jewelry and opulent printed fabrics over

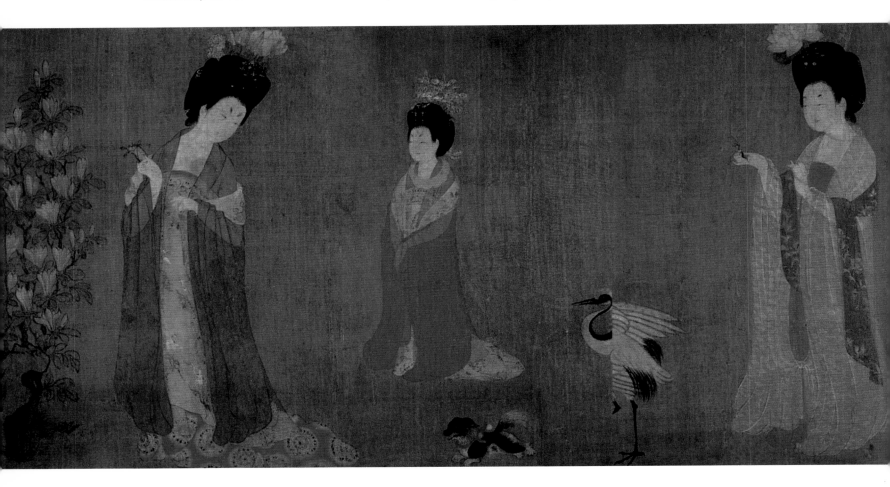

which they drape bolts of captivating, translucent gauze. The manners, attitudes, and hand gestures; the way the upper body twists and the head droops; the gap between the bodies and the few objects they carry, touch, or look at—all evince an art at the summit of its stylization. There is no narrative and no subject in this painting as it unfurls along the ribbon of the scroll—it shows noblewomen, ladies-in-waiting, and animals, as well as a few plants for the pleasure of the eyes, in warm, subtly graduated tones.

It will be noticed that, although side by side, the ladies do not look at one another. Their attention is drawn by other things: a magnolia, a pug, a crane, a butterfly, etc. The painter establishes a correspondence between two groups, human and non-human, seeking to convey perhaps the loneliness each recognizes in and partakes of with the other.

In the mid-ninth century, in his landmark "Record of the Famous Painters of all the Dynasties," theorist Zhang Yanyuan contrasts Zhou Fang with Zhang Xuan: "He attained stylistic perfection, devoting all his art to portraying rich and eminent people, avoiding all reference to village or rustic life. His depiction of costume is simple and powerful, his coloring gentle yet elaborate."

Even in the extraordinarily creative T'ang period, Zhou Fang was thought of as preeminent among painters.

Zhou (Chou) Fang, Active 780–804
"Palace ladies wearing flowered headdresses," c. eighth century. Handscroll, ink and color on silk, 18 x 71 in. (46 x 180 cm). Liaoning Provincial Museum.

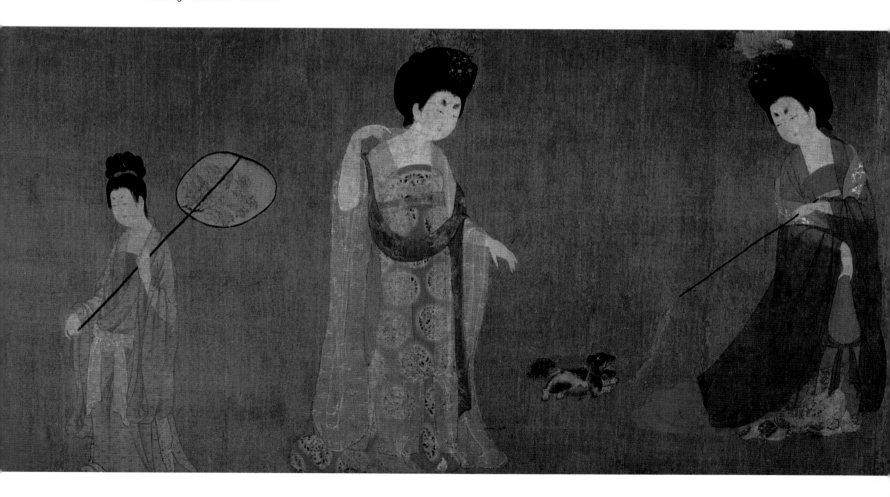

Cacaxtla
"Battle scene," c. 900

Discovered about thirty years ago not far from Tlaxcala, a little more than 60 miles (100 kilometers) from Mexico City and about the same distance from Teotihuacan, in whose orbit the city then was, the frescoes of Cacaxtla are, undoubtedly, the finest in central Mexico.

By 300 C.E. Teotihuacan was the ruling power over this region and the dominant influence. A sizable metropolis, it had an intricate water system, a road network, pitches for playing the sacred ballgame, but no fortifications: the period was one of peace. The arts flourished. Around 600, though, this era ended brutally. The reasons for its collapse are not clear, but it might have been the result of barbarian invasions from the north.

Prior to the so-called "postclassical" period, at which time a measure of stability was reestablished, a prolonged intermediate stage around 1000 testifies to contradictory influences against a backdrop of upheaval. It was this strange, transitory period that produced the splendid frescoes at Cacaxtla. Mayan influence is tangible, particularly in the evident *horror vacuo*, whereas ceramics found at the time the site was discovered betray the scarcely less obvious impact of Teotihuacan.

The main mural presents a lively and ferocious battle scene. Depicted life-size, or almost, the warriors, victorious and defeated, square up to one another and the blows rain down; men are run through, pushed over, and dispatched. On the ground, amid the rigorously depicted carnage, the wounded howl with pain among the corpses, as the chiefs look on unmoved. Warriors and chieftains alike sport headdresses with feathers, helmets, and fabric or vegetable fibers twisted and tied up. Their clothes are colorful, sumptuous: close-fitting tunics; short trousers with tassels, held up by belts knotted at intervals with long hanging braids. Bracelets of all kinds adorn their biceps and their legs below the knee, while their ears and noses are pierced with wooden tubes. The bodies tumble over each other, intertwined inextricably. Here, the warrior on the right towers over another whom he has beaten to the ground with his arm; the victim pulls his legs in, throws his head back, and awaits the death blow.

Overlapping irregularly, the colors of the frescoes—limited to green, brownish-red and yellow ocher, black, and white over a russet or green ground, and framed by friezes of untold fantasy and imagination—convey an impression of both utter confusion and extraordinary opulence. Completely unlike the pictures at Teotihuacan, with their misshapen physiques and elaborate abstraction, here the bodies are rendered with impressive naturalness and expressivity, from blocks of color that combine wonderfully with subtle modeling and embryonic yet engaging perspective.

An incomparable decorative genius is omnipresent—in the clothing, in the friezes, covering every last space.

Cacaxtla (Tlaxcala), Mexico
"Battle scene" (detail), c. 900. Mural.

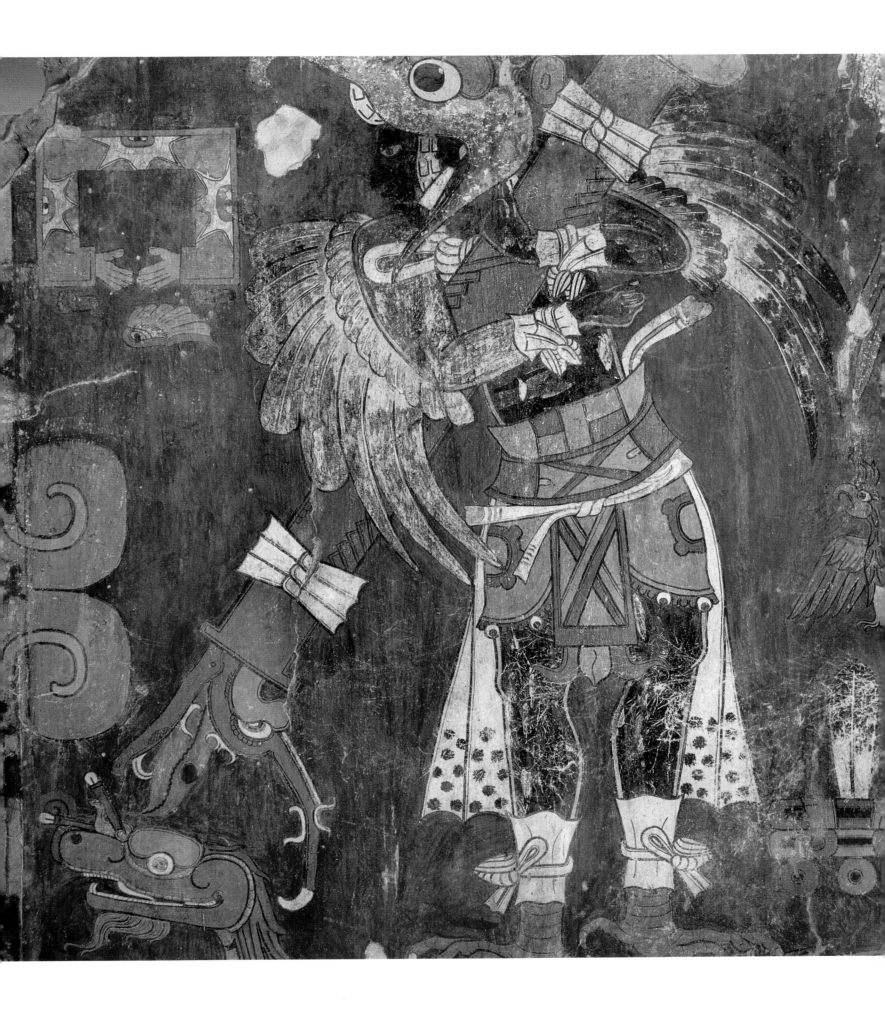

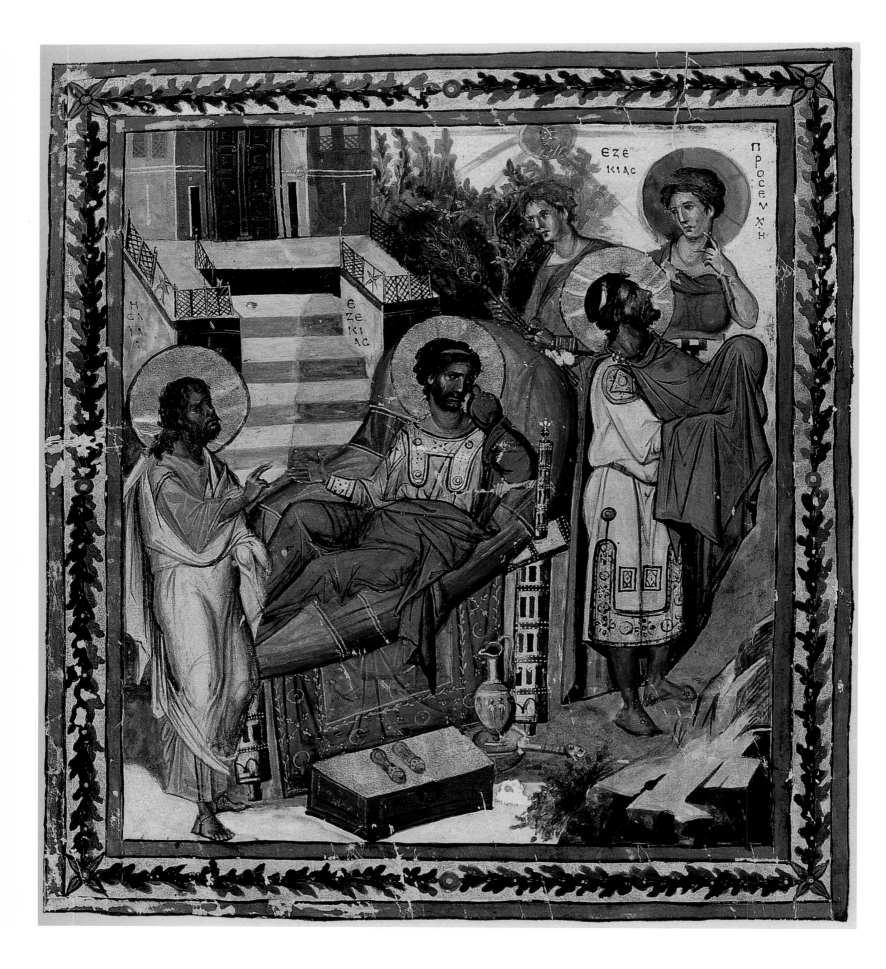

Byzantium
Paris Psalter (King Ezechias), early tenth century

The quarrel in Byzantium from 700 to 900 that saw the cult of images pushed to its extreme in clashes with its opposite, iconoclasm, should not be viewed as absurd. All the arguments and counter-arguments in fact concerned the nature of Christ—whether he was more Man than God or more God than Man, or else completely one or completely the other. The debate swung this way and that according to epoch or emperor.

Those hostile to images considered them as substance, concluding that to revere them is to adore matter. Others were of the opinion that the model of all images is the Incarnation, since God had made himself visible in the form of Christ, as Saint Paul proclaimed. To challenge the legitimacy of images would then amount to doubting the reality of the Incarnation and denying that Christ took genuine human shape. These discussions then were not futile debates over the sex of angels, as some have put it, stigmatizing the infinite subtlety of Byzantine thought. Byzantium, an empire that was to endure a thousand years (330–1453), and which was known until the bitter end as the "Roman" Empire, fundamentally revolved—as no power, no thought, no art since Plato has done—around the question of the image.

The so-called *Paris Psalter* was made on the order of Constantine VII Porphyrogenetes for his son Roman II. In it, one admirably composed miniature, where vigorous verticals collide with a less incisive diagonal, depicts Ezechias twice on the same image. Ezechias was a rich and powerful king of Judea who, put to the test by God, was reconciled to him through the good offices of Isaiah (represented here standing on the left), and died at peace.

In front of his palace, the king, standing on the right in an attitude of prayer, lifts up his eyes and his hands, covered by his cloak, to God. Behind him, his finger on his cheek, appears a personification of prayer. In the center, the same Ezechias, lying on a bed resembling a throne in which he will die without complaint, is being fanned by a fair-haired young man.

In front of the bed, beside a stool decorated with a Gorgon's head, a splendid ewer stands on a paten. These toiletry essentials, common in Roman Antiquity, bear witness to the receptiveness to ancient art felt in Byzantium during the reign of Constantine VII, which is called, rather inadequately, the "Byzantine Renaissance."

In Byzantium, the claim to be the heirs to the splendor of Rome was often underlined by references of this kind, signs of an explicit affiliation, as if the tangible presence of the Roman grandeur of yesteryear enhances the beauty of the present. In this field, too, as in so many others in Byzantium, caution is called for: paganism is at the empire's gates and to be suspected of it could be dangerous.

So this is Antiquity, but a Christian one, idealized, "depaganized." Hence this hybrid, halfway art, where Roman features dissolve into a distinctly Christian idiom.

Byzantium (now Turkey)
Paris Psalter (King Ezechias), early tenth century. Miniature on parchment, 14½ x 10½ in. (37 x 26.5 cm).
Ms. gr. 139, fol. 446v, Bibliothèque Nationale, Paris.

Beatus of Liebana
Vision of Saint John, early eleventh century

This astonishing and audaciously colorful illumination on parchment originates from one text by a single author: the Catalan monk Beatus. He died around 798 "in odor of sanctity" at the monastery of Val-Gabado in Asturias, of which he was abbot.

At one time a simple monk, at the monastery of Saint Martin in the mountains of Liebana he became a Benedictine theologian; there he played a prominent role in the debate against the Nestorian doctrine that threatened to undermine the whole foundation of the Church. This doctrine, defended by its

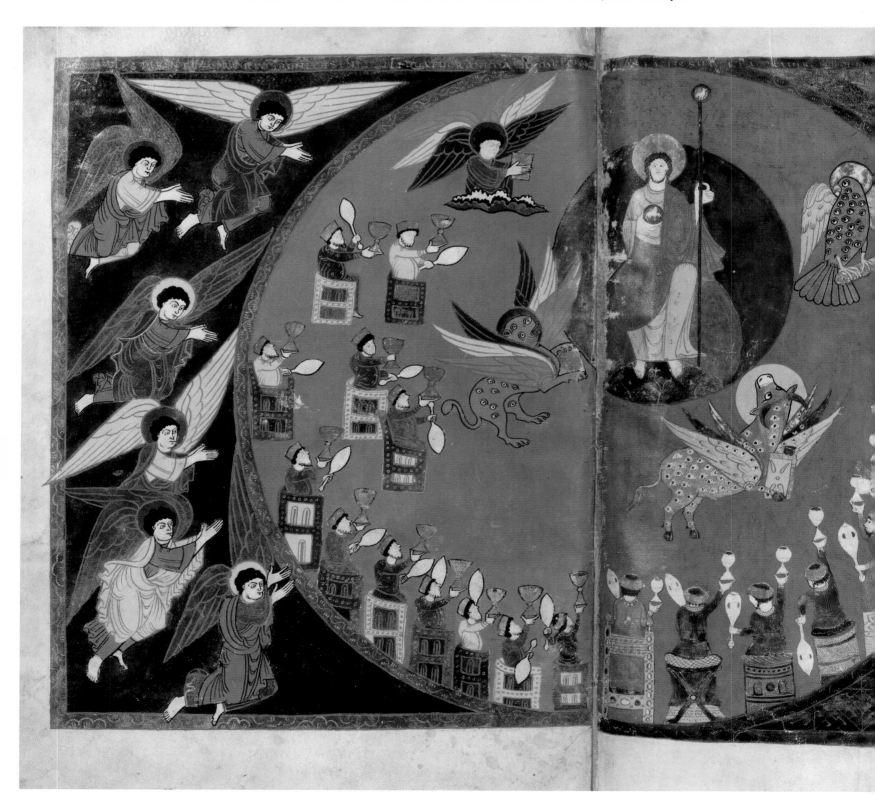

proposer, Nestorius, the patriarch of Constantinople, returned to the ideas of Antioch Christology that opposed the theses of the School of Alexandria. According to the former, the two natures of Christ (human and divine) are strictly separate, whereas the latter sees the divine in God absorb the human to compose an inseparable unity of two natures. Nestorius pursued the Antioch doctrine to its limit, leading him to reject Mary as the "Mother of God" and relegating her to that of "Mother of Christ." For him, Mary is the mother of a man in whom the Word was made incarnate. The pope commanded Nestorius to

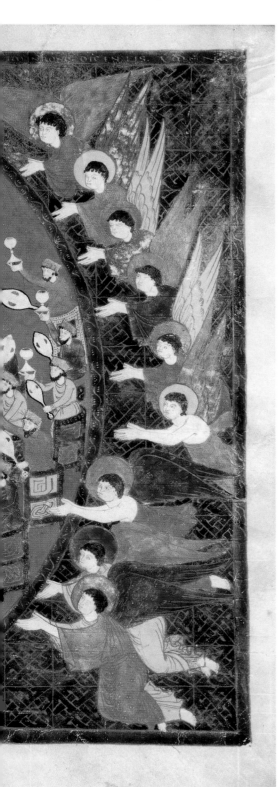

give up this position; otherwise he would be deposed. A council was convened and the polemic rumbled on for centuries.

It was at the request of Etherius, bishop of Osma, that Beatus penned his commentary on the Apocalypse, which perhaps transmits to our time a tradition of the primitive Church that helps in decoding this cry of anguish, this vision. Young Beatus's commentary very soon gained a formidable aura of authority and spawned countless glosses and copies.

The illustration here is drawn from the manuscript executed at Saint-Sever in southwestern France at the time of Abbot Grégoire de Montaner (1028–1072). It is believed that four painters worked on the rich iconography, which is inserted between the biblical text and the commentary and discloses its eschatological meaning. On folios 121–2, which show the illustration reproduced here, two painters collaborated in illustrating a vision that occurs in Chapter VII of Revelation. God is exalted by the four evangelists, the angels, and the circle of twenty-four elders holding up cups and rebecs (three-stringed musical instruments).

Bearing in mind the controversies on the nature of Christ, it can be seen that, amid this ocean of crimson, golden yellow, violet, and gold, God—represented in the middle of what is virtually a midnight-blue mandorla—bears, in his right hand, a medallion showing the Lamb—that is, Christ; while in his left hand he holds a sort of scepter terminating in an image of the dove, that is, the Holy Spirit. The composition in fact exemplified the anti-Nestorian theses that Beatus of Liebana most wished to promote.

Entering the Bibliothèque Nationale in 1790, the manuscript contains 290 parchment leaves and 81 paintings with color contents pages and decorated initials. The pebble calf binding dates from the seventeenth century and is emblazoned with the coat-of-arms of Charles d'Escoubleau de Sourdis.

Beatus of Liebana (Saint-Sever School)
Vision of Saint John: Christ in Majesty and the Twenty-Four Elders of the Apocalypse,
early eleventh century. Illumination on parchment, 14½ x 11 in. (36.5 x 28.6 cm).
Ms. Lat. 8878cc ff. 121v–122, Bibliothèque Nationale, Paris.

Saint-Savin-sur-Gartempe
Frescoes, eleventh and twelfth century

One will never be able to thank Prosper Mérimée enough for what he did here. Alerted to the exceptional quality of the painted decoration at Saint-Savin, in 1836 the young inspector-general of historic buildings put all his energies into halting its degradation and urgently pursuing its restoration. In 1840, he had this church in Poitou, which stands on the banks of the Gartempe, listed as a "historic building," thereby saving one of the finest examples of ninth-century fresco. In a letter to François Guizot, the government minister who had commissioned a thorough review of all the historic monuments in France, he wrote: "I do not hesitate to state, minister, that I have never seen any monument in any country which deserved more the interest of a government well disposed to the arts." In his travel notes, Mérimée added enthusiastically: "Whatever the date of the paintings at Saint-Savin, they are indisputably one of the most precious monuments of an art then in its infancy, an era from which so few works have come down to us."

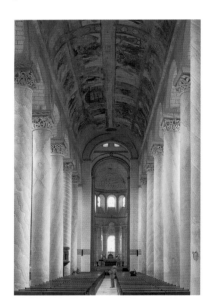

In 1984, this fragile masterpiece was classed as a World Heritage Site by UNESCO. Rebuilt in the eleventh century by the dukes of Aquitaine and the counts of Poitou, the abbey church itself is of unquestioned architectural beauty; but it is the quality and the freshness of its frescoes, so perfectly integrated into the structure, that make it such an exceptional piece. The nave, with its painted marbled colonnades, which halt at the semi-circular vault, does perhaps recall primitive architecture, but the breath, vitality, and freedom at work here are pure Romanesque. Romanesque art is a style, but first and foremost it is a spirit. And it is this spirit that wafts through the frescoes in the crypt, showing the martyrdom of Saint Savin and Christ in Majesty; in the apsidioles, with its saints and angels; in the tribune, with its New Testament scenes; in the porch, with episodes from the Apocalypse and another *Majestas Domini*.

But it is in the nave—over a vault measuring 138 feet (42 meters) long by 56 feet (17 meters) broad by 69 feet (21 meters) from the ground—that it comes over most clearly, on the four bands comprising scenes from Genesis and Exodus, the Creation, the Fall, Cain and Abel, and the Ark in guise of a *drakkar*. Discrepancies in execution, composition, and design of the frescoes have been underlined before: the painting is meticulous on the porch and in the crypt, elegant on the tribune, but "broad brushed" on the vault. In the church, it is obvious that the power, sobriety, and accentuation of each stroke were determined by the desire that the scenes should be readable from afar. Perhaps this is why stress is laid on the joints of the bodies, why the torsos are split into a series of arcs, and why panels of color are placed behind certain figures to emphasize them, as in Ottonian miniatures.

A sublime honey color imparts a sense of unity. But beyond all this is what Henri Focillon called their *fierté de jet*—their lofty impulsiveness—that most touches us here.

Saint-Savin-sur-Gartempe (France), eleventh and twelfth century.
Above: General view of the nave. Facing page: the building of the Tower of Babel,
workers carrying blocks of stone on their shoulders. Fresco painting.
Nave, Saint-Savin-sur-Gartempe Abbey Church.

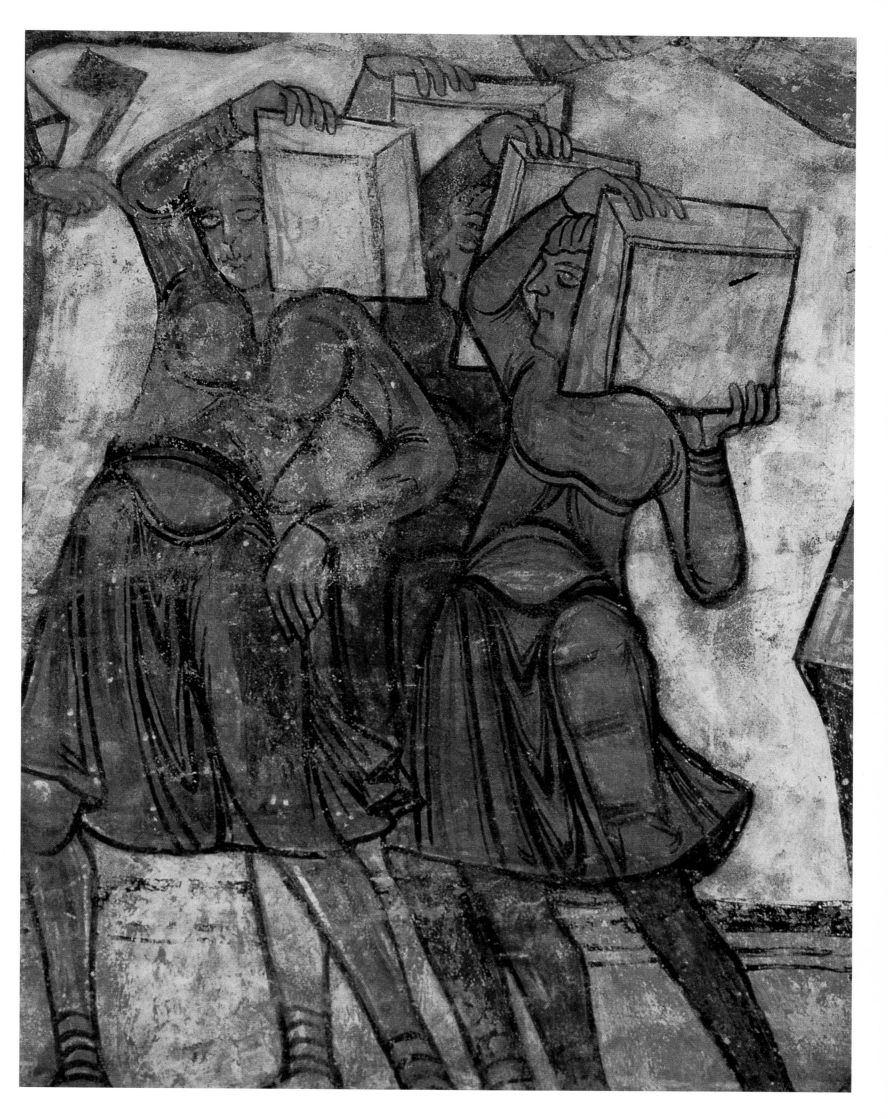

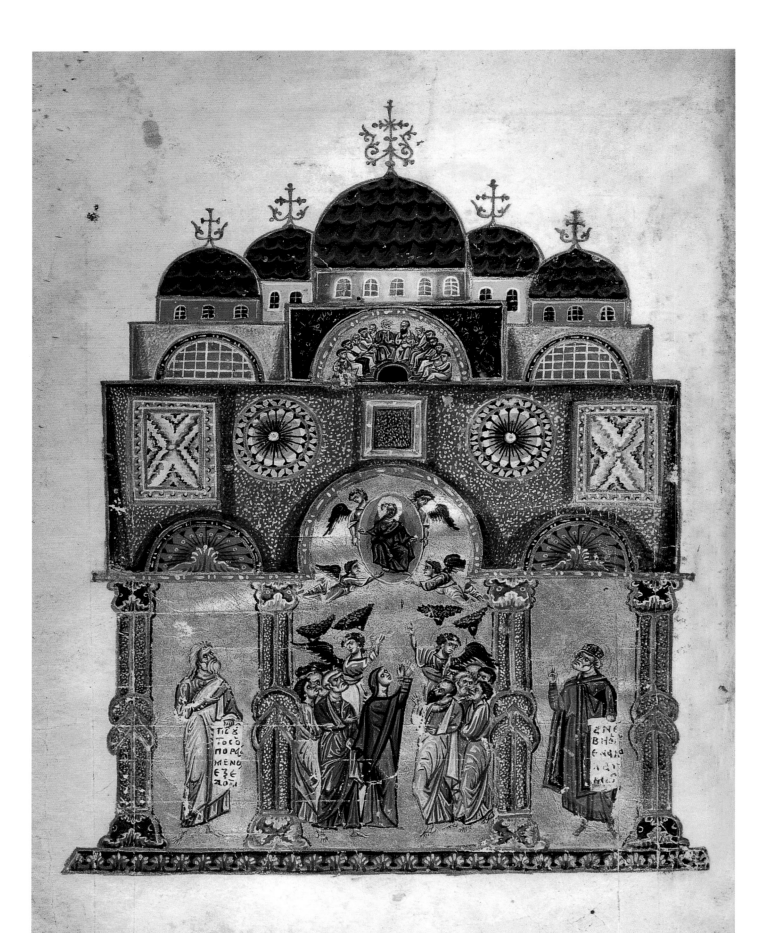

Jacobus of Kokkinobaphos
Frontispiece to the Homilies, mid-twelfth century

Saint Bernard, who worked tirelessly to encourage the Christian West into the Crusades in which the Templars played such a significant role, died in 1153. Elected king of Germany in 1152, Frederick Barbarossa became emperor of the western Holy Roman Empire in 1154, the same year Nur ad-Din seized Damascus. Under the Comemnians in the east, Byzantium intervened in Hungary and Dalmatia, allied itself with Venice against the Normans, seized back Corfu, occupied Ancona, turned its back on the Turkish Seljuk, clashed with the redoubtable Pechenegs, and entered into all sorts of unlikely alliances, in particular with the Polovtsians. Yet this period of instability and transition also witnessed the spread of a formidable spiritual revival, of which the *Homilies* to the Virgin by Jacobus of Kokkinobaphos is a shining example.

As the price of providing ships, men, and provisions for the Crusade, Venice had demanded that the crusaders retake the port of Zara (Zadar). But the Dalmatian port was an ally of the Crusade, and a furious Pope Innocent excommunicated both the Venetians and the crusaders. Meanwhile Alexius, son of the deposed Eastern emperor, promised further funds for the crusaders in return for his restoration to the throne of Constantinople; when these were not forthcoming, the crusaders besieged the city.

The twelfth-century spiritual rebirth in the western Empire was to eradicate all ancient (that is to say, as they saw it, pagan) character from religious art. If this manuscript is compared to the Paris Psalter (illustration p. 28), executed in the tenth century, it is obvious how the later artist has abandoned the old models and opted for a clearer and more thoroughly theological exposition. The art of this epoch is characterized by balance, measure, grandeur, and serenity.

This parchment miniature represents Christ's Ascension. It was at this time that the Ascensions that had earlier tended to decorate apses came to adorn entire domes. Through Christ, God watches over the world. This selfsame image is found on gold coinage, in tandem with the imperial likeness: a terrestrial sovereign corresponding to the celestial Lord. This exemplifies the interdependence between earthly and heavenly power that this art is designed to stress. Mary was also reproduced on coins stamped with effigies of the emperor; the Mother of God, she who intercedes, raises her arms and prays for his success.

Here, too, Mary adopts the pose of an orant, turning to Christ in a mandorla, presented and borne aloft by angels, who are also dotted among the apostles and Mary, thus reinforcing the bond that Mother and Son establish between heaven and the sublunary world.

More still than in another version in the Vatican, in the Bibliothèque Nationale *Ascension*, ornament runs riot, devouring all before it. Observe the dazzling polychrome of the church, with its knotted pillars, its pediments and cupolas; its blues, reds, greens, and golds; its rosettes and windows, and its improbable blue and pink capitals.

The decorative intoxication characteristic of Byzantine works of the period finds its most sumptuous and convincing expression in this frontispiece to the *Homilies* on the Mother of God by the monk Jacobus (or James) of Kokkinobaphos. The work is a proud assertion of wealth and power ... on the brink of the abyss.

Jacobus of Kokkinobaphos, active twelfth century
Ascension. Frontispiece to the *Homilies*, mid-twelfth century. Miniature on parchment, 9 x 6½ in. (23 x 16.5 cm). Ms. gr. 1208 fol. 3v, Bibliothèque Nationale, Paris.

Fan Kuan
Travelers among Mountains and Streams, c. 1000

From the tenth century onward, the art of landscape occupied the first rank in the hierarchy of the pictorial genres. An absolute masterpiece of landscape painting, and of Chinese painting generally, *Travelers among Mountains and Streams*—which is for us rather austere in appearance—is the one every Chinese person cites when asked to name a painting that encapsulates the art of the great classical masters.

So what is so admirable about this eminent work? In the foreground to the right, one can just make out

a tiny caravan of travelers accompanied by a train of donkeys advancing along the bank of a waterway. Towering over them, an impenetrable wall of mountain, complete with cascading waterfalls. It should be borne in mind that in Chinese, landscape painting is known as *shan shui*, i.e. "mountain and water," any landscape being necessarily a combination of these two elements. Beyond that, it is also a union of the full and the empty, the *yin* and the *yang*, the female principle and the male principle, the passive and active.

Here the juxtaposition between the virtually opaque mass of the mountain and human fragility reaches a zenith. In painting, as in Chinese thought, man forms part of the universe. There is no opposition, no distinction. There is a correspondence, a constant to-ing and fro-ing, from macrocosm to microcosm. Nature is neither a décor nor an arbor for some solitary walker, but a living entity, a work in progress, as yet incomplete.

Faced with this "organic being," the artist proposes neither a second reality nor an illustration of the title; instead he makes manifest the *idea* that the various elements of the painting are called upon to catalyze. The intention is to capture something of the "breath" of the universe, the swirling energy of the cosmos—here, of the majestic, serene nobility of the world. This is a world governed, one should perhaps add, by the sagacity of a powerful sovereign who leads his people (that is, all humanity) to happiness, thanks to his privileged relationship with heaven.

Under the Song Dynasty, the imperial son of heaven—who is represented by the mountain peak in the center and shown towering over his assessors, ministers, and counselors (the less elevated mountains and hills)—embodies the outward form of an ordered and mighty empire, almost infinite in extent, if here cordoned off by the formidable wall erected in front of us.

An enduring model for all Chinese artists, this work is the only one extant by the Tao master Fan Kuan. Little is known of its creator. He was born in Shaanxi (Shensi, right in the middle of China) and lived around 1000, an era when the prosperous economy of the Northern Song gave rise to inventions such as gunpowder and printing, and when Hangzhou numbered some 500,000 inhabitants. It was an era of renewed interest in Confucianism, and of the ideal of the universal man—a combination of scholar, poet, painter, and statesman—of the T'ang Dynasty.

Fan Kuan, active 1022–1031 under Emperor Renzong
Travelers among Mountains and Streams, c. 1000 (Northern Song dynasty, 960–1127). Ink and color on two silk panels joined in the middle into a wall scroll, 81¼ x 40¾ in. (206.3 x 103.3 cm).
National Museum of the Imperial Palace, Taipei.

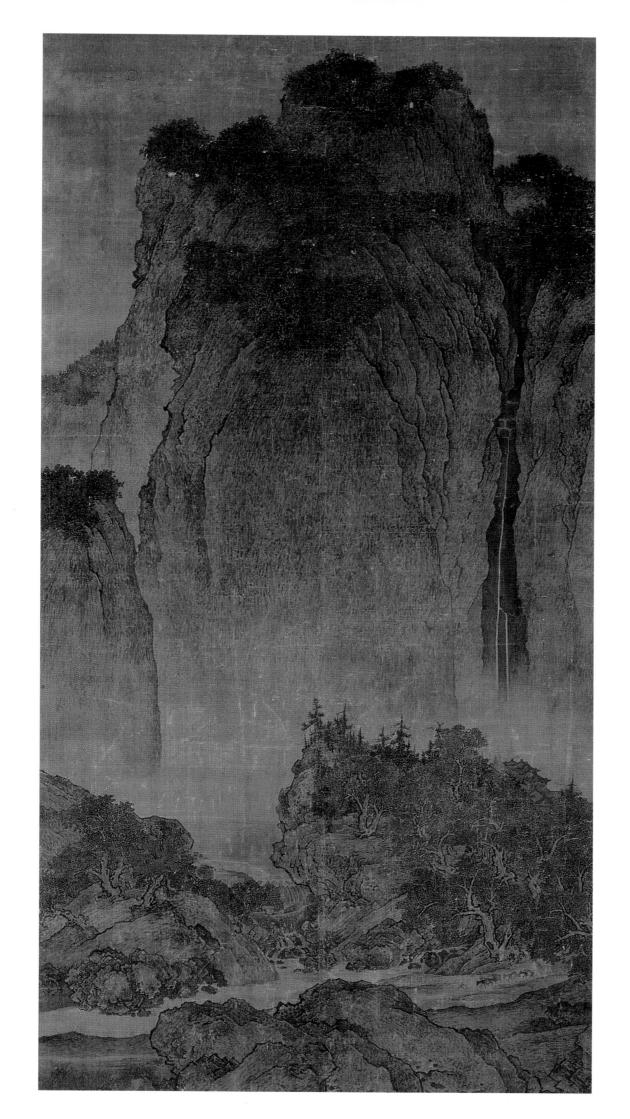

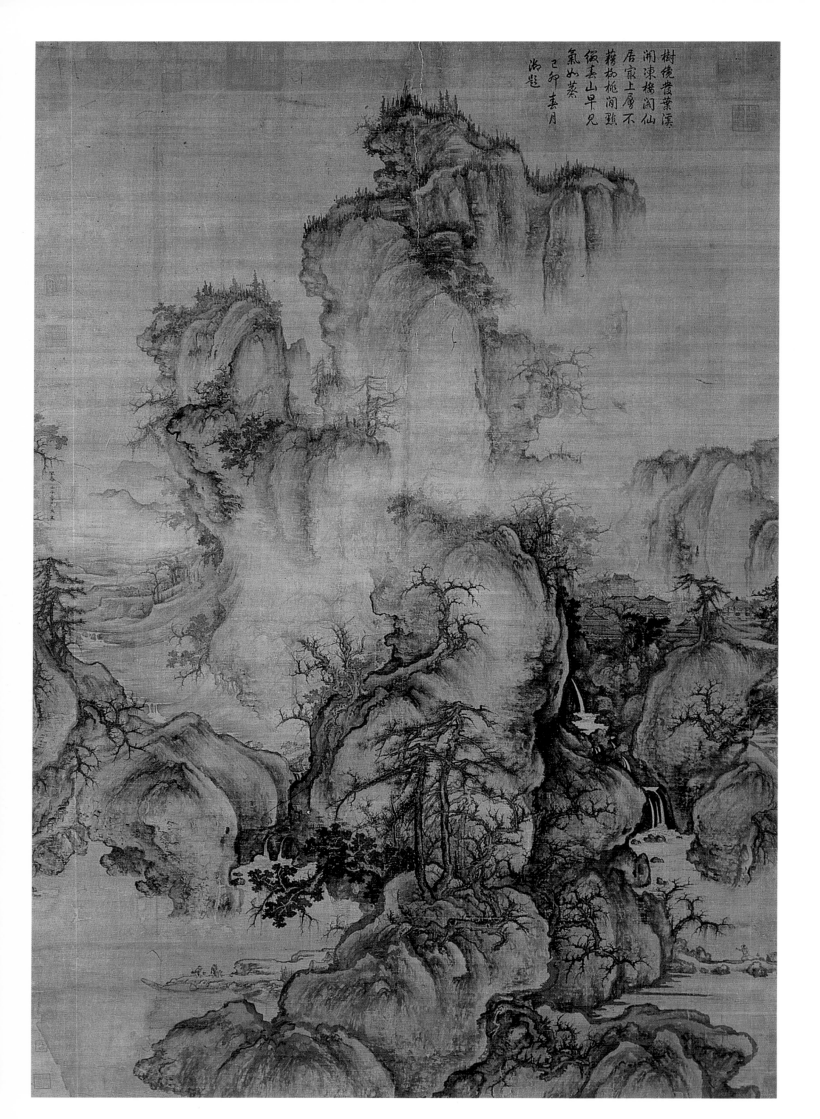

Guo Xi
Early Spring, 1072

As with the majority of Chinese landscape paintings, *Early Spring*, made in 1072 using ink on silk, does not depict a precise place. Instead, it was painstakingly composed in the studio and includes a certain number of evocative and familiar elements that emerge from intuitive communion with nature.

In Chinese painting of this period, reality had to be clearly represented, but artists avoided

overemphasizing individual characteristics that might jeopardize its essence. Painters such as Guo Xi would travel and take notes, afterwards assembling them into a landscape whose goal, according to the treatise compiled by his son, was to re-create the appearance of the real world and thus glorify the imperial throne, guarantor of the cosmic order.

The wall scroll illustrated is both powerful and balanced in its ebb and flow, an image of growth in total accord with the dream of the imperial protector. The viewer's eye is urged to follow it in all its twists and turns: from the minute figures at the bottom, up to the waterfalls, through the mist and clouds, off to the summit of the mountain, and finally up to the sky itself.

And yet, at the same time, one's attention glides over the paint surface, thanks to the energetic and intricate virtuosity of an artist who deploys every conceivable technique in drawing, inks, and wash to produce a meticulous study of the knotty trees, of the rocks at the base, so firmly anchored in the real, and of those at the top, lightly laid in with a brush soaked in water.

Guo Xi, like all scholar painters of the time, avoids bright colors. They were only good for "professional" painters, who were considered "vulgar." He employs calligraphy ink, thus associating landscape painting with the most refined tradition of all: in China, penmanship is regarded as the most elevated form of art.

At this time, the Song Dynasty found itself at a turning point in its destiny. Following the long decline of the T'ang, the central power had shattered, splitting into five states and ten kingdoms (907–960). Though the arts flourished, it was a period of great military upheaval, ending only with the victory of Zhao Kuangyin, who, in 960, inaugurated the dynasty of the Song and began to reunify an empire whose borders were being constantly harried. If this era (960–1279) has been compared to the Renaissance, it is because it was marked by a period of relative stability coinciding with the end of Buddhist hegemony, the development of an enlightened middle class, and a return to the classical tradition, with the intention of consolidating the heritage of earlier times and forging a synthesis of past knowledge.

Guo Xi, who was such a dominant figure in art that he became private painter to Emperor Shenzong, the model imperial patron, embodies this sense of completion and synthesis. He regarded landscape painting as a means of apprehending the meaning of the entire natural order of the world.

Guo Xi (Kuo Hsi), c. 1000–1090
Early Spring, 1072 (Northern Song Dynasty, 960–1127). Vertical scroll, ink and colors on silk,
62⅓ x 42½ in. (158.3 x 108.1 cm).
National Palace Museum, Taipei.

Wang Shen
Dense Fog over the River, c. 1100

This work, showing mountains in serried ranks above a fog-bound river, is one of the finest of all examples of painting on a hand scroll. This type of scroll is designed to be laid out on a narrow table with raised edges and slowly unfurled from right to left, to be read and admired in contemplative silence.

Opening this example by Wang Shen from the right-hand side, first of all one sees little, except for a kind of mist and one or two shadows of hardly visible, shapeless boats, a void that persists surprisingly for almost one-third of the work.

Gradually, as one unrolls, spits of land appear, jutting into the water, then long valleys, vegetation, hills, and mountains, painted in the blue-and-green style in which the young prodigy Wang Ximeng (1096–1119) excelled; they are deployed in the golden air, shimmering like a mirage. Thus he evokes the world of exile, far from the imperial court, where many artists and men-of-letters of the time found unparalleled inspiration.

Wang Shen, who was perhaps a disciple of Guo Xi—his influence is felt in another splendid hand scroll entitled *Fishermen's Village under Snow* (c. 1085)—had once occupied an eminent post in the

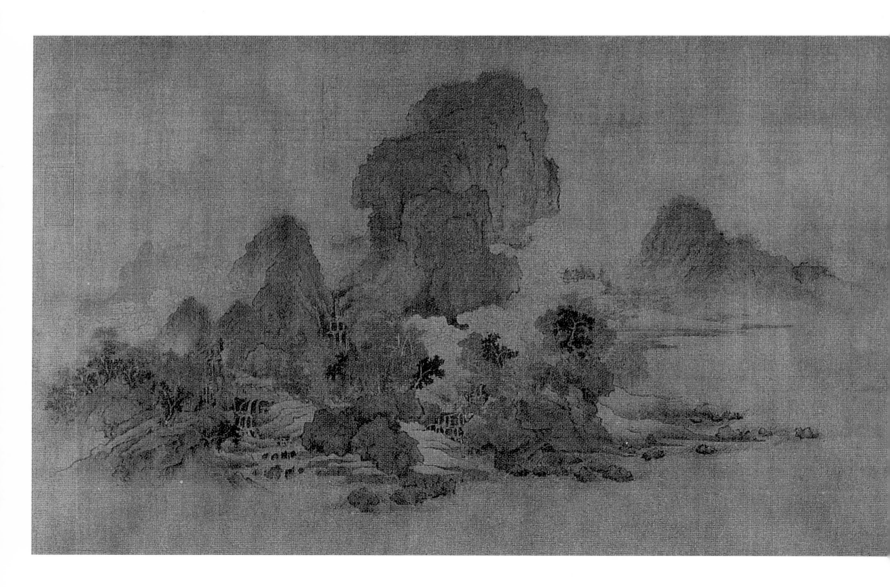

Imperial Palace. Well read, a poet and calligrapher, he was related to the powerful military men who had founded the dynasty, playing—as it were—the mandarin.

Enthralled by his talents, Emperor Shenzong (Ying-tsung), a generous and sensitive patron, chose him as his son-in-law, in addition to appointing to him art tutor to his son, Zhao Ji, who was to reign in the name Huizong. This emperor, more famous for his qualities as a painter than as a leader of men, laid the stress on three aspects of painting: realism, the study of old masters, and the attainment of a "poetic idea," thereby popularizing the alliance between painting, poetry, and calligraphy.

Though fortune had smiled on him, Wang Shen became enmeshed in the intrigues around the schemes of reformer Wang Anshi at the court of Emperor Shenzong. He was forced into retirement for many years.

Wang Shen was to idealize this world of exile—or, rather, he painted it as if in a dream, transforming a landscape whose depiction is determined by the emperor into an infinitely more personal event that verges, in its expressive subjectivity, on the romantic.

Wang Shen invented this very new, poetic style at a time when the power of the Northern Song was on the wane. The emperor had become more interested in painting, calligraphy, poetry, and music than in the business of State, and was being encouraged in that by advisers and ministers, who went about shamelessly plundering the country. Eventually he succumbed to the advancing Tartar armies of the Jins. Awaiting the dynasty of the Southern Song in 1127, China entered into an era of upheaval.

Wang Shen, 1048–1103
Dense Fog over the River, c. 1100 (Northern Song Dynasty, 960–1127). Hand scroll, ink and color on silk, 17¾ x 65¼ in. (45.2 x 166 cm). Museum of Shanghai.

Liang Kai
Immortal, 1172–1204

Exploding like a slow-motion bolt of lightning, the ink overflows onto the paper in deep blacks that seep beyond the stroke in which the brush tries to confine it. The brush is a feather-light tool guided by an ethereal hand, with gestures at once intoxicated and hypnotic.

The lines, decisive yet somehow strangely erratic, strive to convey a fleeting presence that the potent, pulsing, dark-hued liquid disturbs, questions, and badgers—in search, perhaps, of an answer. Traces of water; traces of ink. Weightless, the deposited ink burrows down into a blindingly white infinite. It's far from elegant. Beautiful, rough-hewn, unpolished; it is painting that snags on the grain of the paper before spouting out uncontrollably and careering to the surface to break into a profound, singularly disconcerting silence.

The point is worth laboring: the aim of this art is not aestheticism. On a quest for itself, it is reinvented in rapid gestures that carve open a space at the core of a vast expanse of white. This somnambulistic artillery thrusts daringly through the scurrying void: squirting, jetting out, and squirming. Twists and turns are born from tiny alterations in brushwork, from a lack of ink, or from an excess of water.

Chuang Tsu, the great Tao philosopher of the third century B.C.E., was wont to say: "My art consists in this: in showing the emptiness of the self." The author of some occasional remarks on painting, the late seventeenth-century monk-painter Shi Tao said: "the act of laying in the first line becomes the creative act par excellence, the one that separates the sky from the earth." These two observations seem to converge in this work, the second sheet of the album *Ming-hua lin lang*.

In painting, Liang Kai is one of the most inspired representatives of Chan Buddhism, from which Japanese Zen was to emerge. The figure he captures here in a dozen brushstrokes is both allusive and powerful. No face, just a way of carrying oneself. A self-contained spirituality. This Immortal (sometimes called a "hermit") is a real force.

Working at the time of the Southern Song Dynasty in the thirteenth century, Liang Kai studied under Chia Shih-ku, a master whom he was to outstrip rather quickly. Painting in a wide range of styles, in 1210 he was appointed painter-in-attendance to the Academy by the emperor.

He was weighed down by honors, esteemed, admired. He was even offered the coveted "golden girdle." But at this point he broke with everything, left the court, took the nickname "Madman Liang," and, glorying in non-conformism, gave himself up to drink.

It was under the influence of wine, like many other Chinese poets and painters—such as Zhang Xu, who also dubbed himself "mad"—that Liang Kai, as if suddenly liberated, attained the summit of inspiration, of creative imagination, simultaneously abolishing all external resistance and every inner obstacle.

Thus the style came into being. Unrestrained, it was without a will of its own: concise, uncomplicated, and trenchant. This was an awakening; a vibration at the heart of the Chan.

Liang Kai, active in the early thirteenth century
Immortal (or "Hermit"), 1172–1204, Period of the Southern Song (China). Album page, ink on paper, 19¼ x 11 in. (48.7 x 27.7 cm).
National Palace Museum, Taipei.

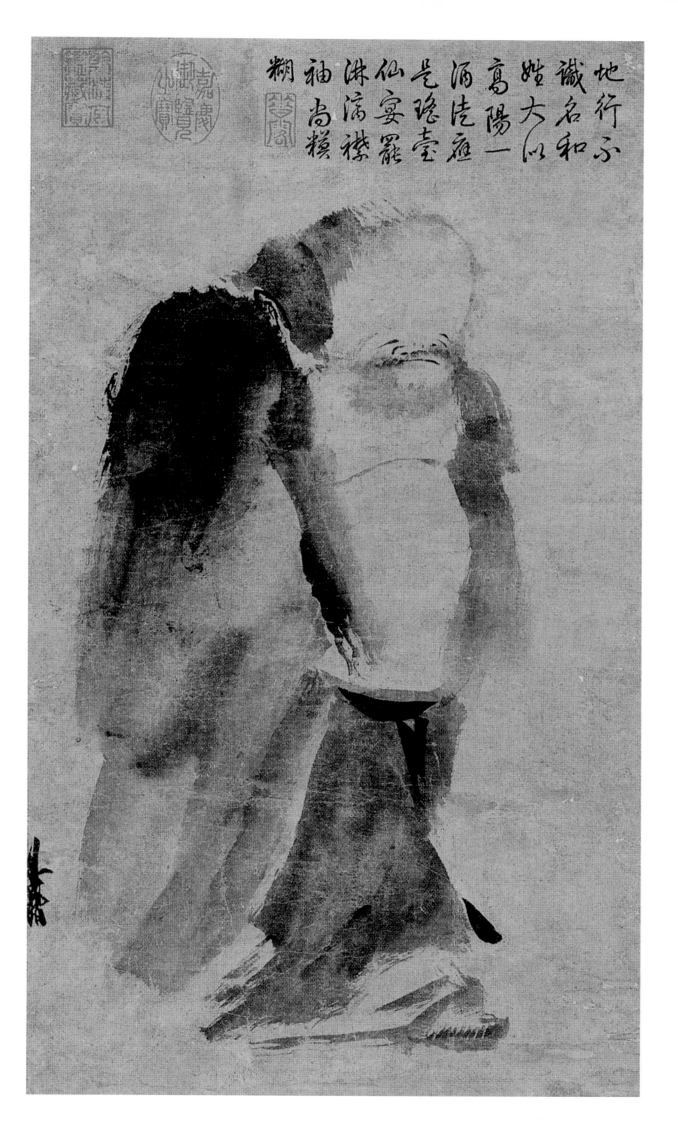

地行不
識名和
姓大以
高陽一
涸洗雁
毛瑤壺
仙宴罷
淋滴襟
袖尚糢
糊

Zhao Mengfu
Elegant Rocks and Scattered Trees, early fourteenth century

To situate Zhao Mengfu chronologically: in 1271, the Mongol Khanat named its state "Yuan," unified China in 1279, and created a centralized power that placed all the regions and ethnic communities in China under a single jurisdiction, just as it had been during the dynasties of the Han (206 B.C.E.–220 C.E.) and the T'ang (618–907).

A brilliant personality of many parts—calligrapher, poet, painter—Zhao Mengfu originally came from Zhejian (Chekiang, south of the Yang-tse Kiang delta). He was a member of the imperial clan of the Song, but switched allegiance to the Mongolian Yuan Dynasty (1271–1368) when it attained power. He occupied many official functions; he was promoted to the directorship of Han-lin College and was in charge of receiving edicts, and was eventually awarded the title of "duke" of Wei, becoming a high public official.

As a painter, he created many masterpieces in various fields: horses (the admirable *Tialiang tu*, in the "sketch" style, showing a rider and his mount in the wind), bamboo, flowers, birds, and landscapes.

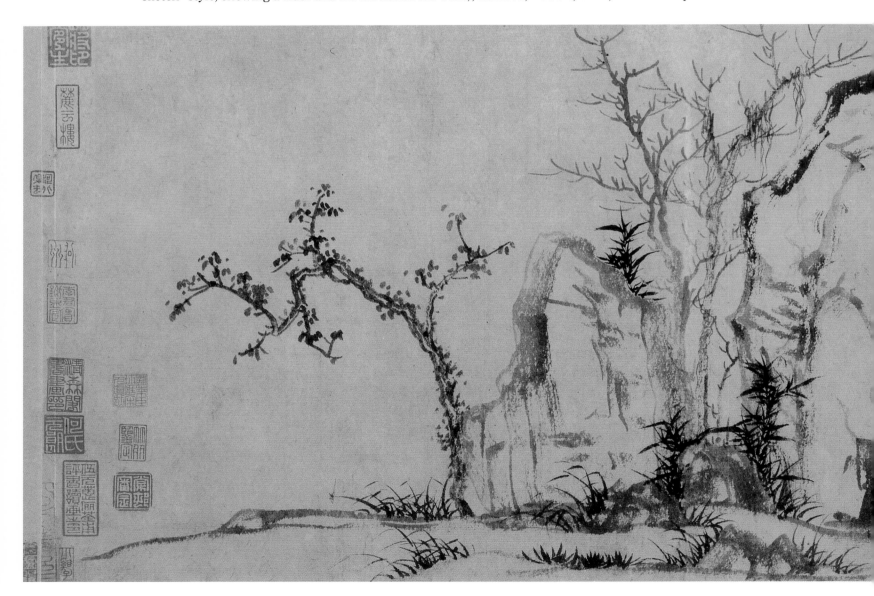

Much ink has been spilt on the quatrain accompanying this painting, also known as *Old Tree, Bamboo, Brambles, and Rock*: "Rocks in 'flying white,' trees in 'great seal' [character],/for the bamboos, follow the 'eight' method [of script];/those who understand all this/will learn that painting and calligraphy are one and the same thing." Of course, it is the last part of the poem that has attracted questions, amazement, and criticism in equal measure, as well as a phenomenal increase in the number of calligraphers who were persuaded that they were painters.

As for the technique of "flying white," also used in calligraphy and here associated with rocks, it consists in using a virtually dry brush to produce broken, almost threadbare strokes. Here, the ample, rough-hewn lines, streaked or pricked with white to conjure up the boulders, are incomparably expressive, admirably rendering the vast ruggedness of the rocks, while strokes of black ink capture the firmness of the branches, and conical lines of a more pronounced black (the eight-character style) convey the fluid foliage of bamboo, in which Zhao Mengfu was a distinguished specialist. The painters of the Yuan dynasty liked to translate personal experiences. Their landscape painting reflects inner life more readily than it depicts mountains and water.

Remembering that line remains the foundation of Chinese painting, Zhao Mengfu, with his idiosyncratic, smooth, undulating style, proves one of greatest calligraphers since the T'ang.

One must also constantly bear in mind a fundamental Yuan truth: skill and beauty were not the qualities most prized in China. As for virtuosity and charm, they were regarded as vulgar. Excellence demanded a certain dose of awkwardness and nonchalance.

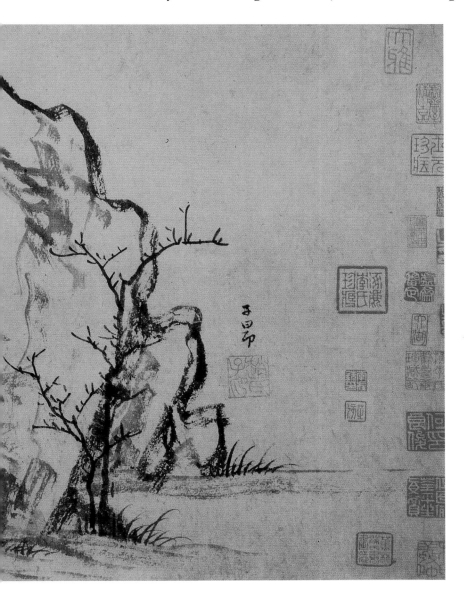

Zhao (Chao) Mengfu, 1254–1322
Elegant Rocks and Scattered Trees, early fourteenth century, Yuan Dynasty (Mongolian). Section of a hand scroll, ink on paper, 10¾ x 24¾ in. (27.5 x 62.8 cm). Museum of the Imperial Palace, Beijing.

Jean Pucelle
Belleville Breviary, 1323–26

These delicately humorous and deliciously fresh illuminations belong to one of the finest breviaries of the fourteenth century, which, before being conserved in the Bibliothèque Nationale, had been part of the treasury of the monastery at Poissy. Royalty, nobility, clergy, and even the general populace showered gifts on the abbey in honor of the Saint Roi (Saint Louis) who, following his death at the siege of Tunis and his canonization in 1297, had become an icon for an entire people.

This two-volume breviary, complete with a golden clasp emblazoned with the arms of France, is the work of the greatest Parisian illuminator of the era, Jean Pucelle, who was head of a significant workshop.

It was during this period that laymen were taking over from monks in illuminating even religious manuscripts. Like other craftsmen, they formed guilds and would live in a particular district. At this time, little distinction was made between a sculptor and a stonemason, and it was said that more than one illuminated manuscript painter had a second job as an innkeeper.

By the end of the twelfth century, Paris numbered some seventeen limners; but because they did not sign their works, their names have not come down to us. Two are known, however, though only by their first names: Nicolas and Honoré, both "heads of workshops." In their work, the colors are lighter, the decoration softer, the figures treated with suppleness and delicacy. The miniature is now more than "stained glass on parchment." Probably a pupil of Honoré's, Jean Pucelle was instrumental in this new departure.

The entire development of the miniature in the fourteenth century, a time of *Bibles moralisées* (illustrations with concordances between the Old and the New Testament), bears the imprint of his style. Private demand for breviaries intended for individual devotions and for Books of Hours (compilations of devotional texts, offices, and prayers corresponding to the time of the day—hence the name) swelled considerably. These books are enriched by illustrations, with ornaments whose quality and opulence depended essentially on the financial resources of the person commissioning the piece.

Compiled for Jean de Belleville, Jean Pucelle's breviary is remarkable for its elegant and involved style, its refined and tempered colors, for the delicacy of its tail- and head- pieces and its marginalia, and for a zoo-like bestiary, at once tongue-in-cheek and charming, wonderfully captured in a sinuous, whimsical line. A monkey and a butterfly, a dragonfly and some birds, blues and greens that match or clash in turn, the contours, the gentleness, charm, and joyful imagination of the whole—all these elements enchant.

With Jean Pucelle, who splendidly conveys the sensitivity of his time and who exemplified the prestige of the School of Paris, a new conception of the illuminated book is evident, in the way he surrounds the text with an interlace formed by stems sprouting into red, blue, or even gilt leaflets, weaving into veritable nets onto which the figures are grafted.

Narrative yet decorative, the illuminated book could now become a whole—and a culmination.

Jean Pucelle, active Paris, early decades of the fourteenth century–1334
Belleville Breviary, "Saul Throwing His Spear at David," 1323–26. Illumination.
Ms. lat. 10483 fol. 24v, Bibliothèque Nationale, Paris.

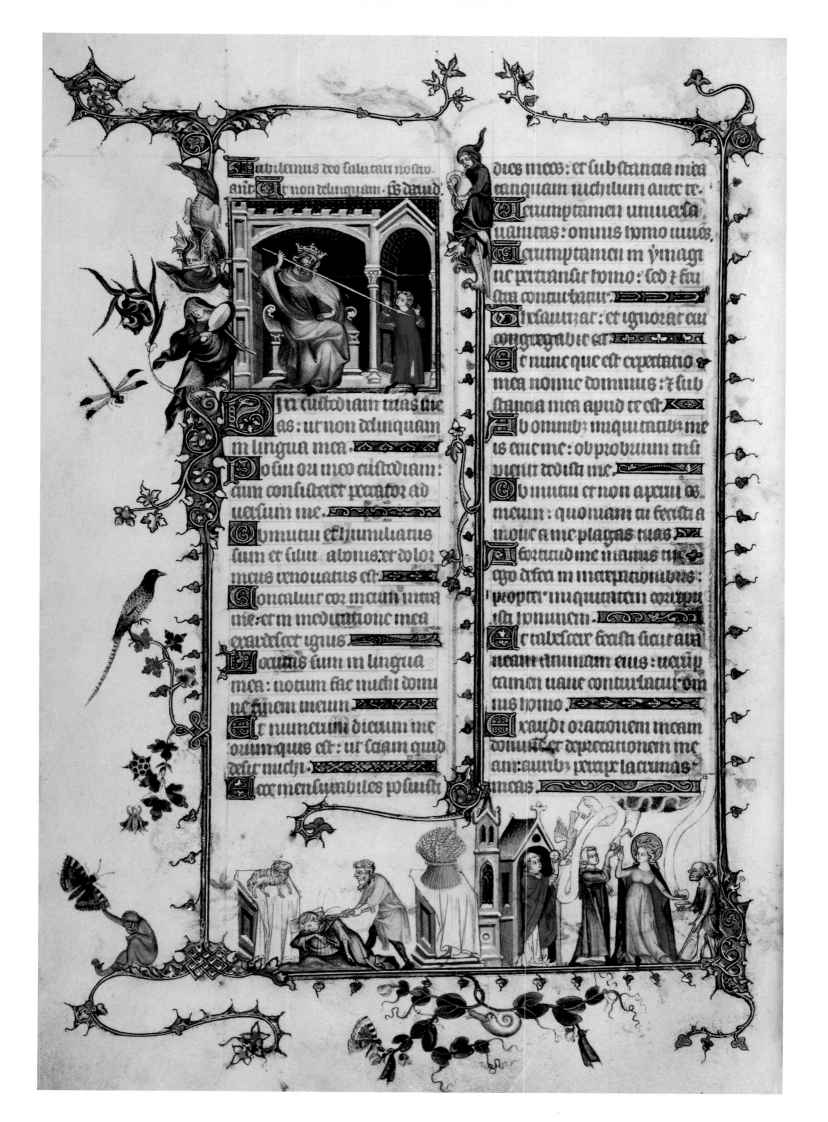

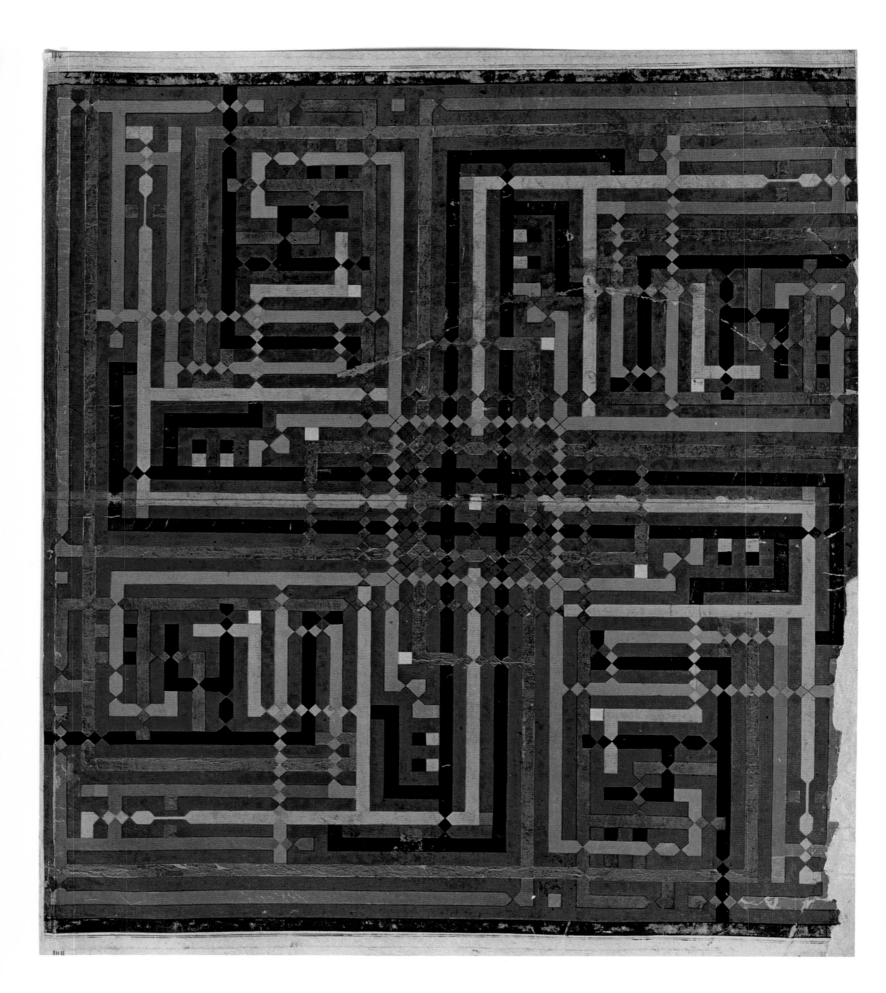

Central Asia (?)
Page with the name of Allah, fourteenth century

This is quite possibly the most fascinating work in this book. Yet, since it is impossible to locate geographically and historically, it is also the one that poses the most questions; the one that is the most difficult to "read." What is it exactly?

One can be sure that it belongs to the Topkapi Museum in Istanbul, where it is cataloged under call-mark "Hazine 2152, f. 9, verso." And that's about all. As the Topkapi contains a wealth of Qur'ans, paintings, and examples of calligraphy realized for dignitaries by eminent masters (brought back as booty by Selim I following his victory over the Persians at Caldiran in 1514), it may be presumed to be a princely commission. Conjecturing further, some believe this page, penned in a stylized, Kufic script, represents the repetition of the name of Allah four times, and that it was executed in Baghdad; but others are reminded of a type of square composition that was a particular favorite of Ahmed Qara-Hisari, a calligrapher famous for the elegance and clarity of his compositions at the time of Suleyman the Magnificent, though it might hark back to older prototypes.

Readily recognizable amid the tangle of lines, the swastika, however, tends to point to other territories under Mughal influence. With its marked Timurid leanings, the style would imply an origin near Samarkand in Central Asia, and it is this assumption that has been most frequently adopted.

This page, whose "abstract" beauty has been much discussed and praised, has also been described as a "graphic enigma," or even as a purely decorative piece. Its beauty is undeniable, but it can be neither "decorative" nor "abstract," for it embodies the sacred essence of that geometrically tinged calligraphy that haunts every Kufic script. The term "Kufic" designates a type of calligraphy originating in the city of Kufa in Iraq. It is a writing style characterized by elongated horizontal baselines on which sit low verticals, and by a pronounced taste for the square and for simplification. This baseline is a crucial factor, insofar as it governs the entire evolution of this calligraphy as an art. And what an art!

Here the red, the green, the yellow, and the black resonate, collide, jostle, clash, interlock, and combine with a virtuosity that rejoices in the simultaneously austere and dizzying geometrical games encouraged by this type of Arabic script; in the squared-up page, the overlaps, the leaps, the throbs, the impulses, the planes, the angles, and the extensions—in short, in a glorious simplicity wedded to consummate refinement.

For the Muslim, the world does not end up in a book; it *is* the book. Such penmanship should then be envisaged as the "cursive song of the divine," as the historians Sijelmassi and Khatibi so beautifully put it before going on to define Arab calligraphy as a "geometry of the heart as enunciated by the body."

Central Asia
Page with the name of Allah written in Kufic decorative script, fourteenth century. Illumination. Hazine 2152 fol. 9v, Library of the Topkapi Museum, Istanbul.

Mistra
Nativity, fourteenth century

At the bottom and in the center of the fresco, Mary Mother of God falls asleep within the intricate folds of her blue veils. The Christ Child lies in an oblong cradle at her side, watched over by an ox and an ass. Round about, cohorts of bustling angels attend, together with many other figures of various sizes, some on the backs of speeding horses, others on foot; all hurrying to witness the event: the Nativity. With its elegant and sinuous rocks in pink and yellow, cut out to reveal the miracle and leaning inward as if to protect it, this is a masterpiece of Byzantine painting in its late Greek phase, dating from shortly before the empire fell. This delicate fresco work, full of charm, decorates the walls of the Church of Peribleptos in Mistra, capital and administrative center of the despotat of Morea that included the Peloponnese, which had recently been recovered by Byzantine forces.

It is one of the truly great compositions featuring a Gospel cycle. The technical mastery of the painter, the refinement of the color scheme, and the art of the composition are all admirable. Nonetheless, as Byzantium tottered, the peculiar characteristics of her monumental painting seemed to lose their authority, if not their quality; they retreated before an aesthetic centered on the icon, a genre that was poised to flower in the great works of Duccio and Rublev.

In spite of the extraordinary upheavals surrounding the sack of Byzantium by the crusaders and the civil strife that followed, the epoch that saw the building and decoration of the Church of Peribleptos at Mistra was not one of artistic and spiritual impoverishment—even though, due to lack of funds, ceramic decoration was gradually abandoned in favor of fresco. Indeed, the arts shined so brightly that this strange period has even been dubbed the "Second Byzantine Renaissance." Artistic and even political life deserted an increasingly endangered Constantinople to take refuge in the Peloponnese, in particular at Mistra, where churches with towering domes, a wealth of windows, elaborate small columns, and splendidly decorated exteriors proliferated.

The period marked the triumph of *hesychasm*, a doctrine of contemplation whose aim was the simultaneous discipline of mind and body. Founded on a program of constant prayer, it was meant to enable the believer to flow into the divine essence or into energies radiating from it. Hesychasm was defended by Saint Gregory Palamas, an eminent monk at Mount Athos and archbishop of Thessaloniki. In July 1351, the belief was consecrated as the "official doctrine of the Orthodox Church" at a synod. Gregory Palamas died in 1359 and was canonized in 1368, thereby ratifying the triumph of monasticism and Oriental mysticism. The Paleologus era proved one of singular prosperity for Athonite monasteries.

Mistra (Greece)
Nativity, fourteenth century. Frescoes.
Church of Peribleptos, Mistra.

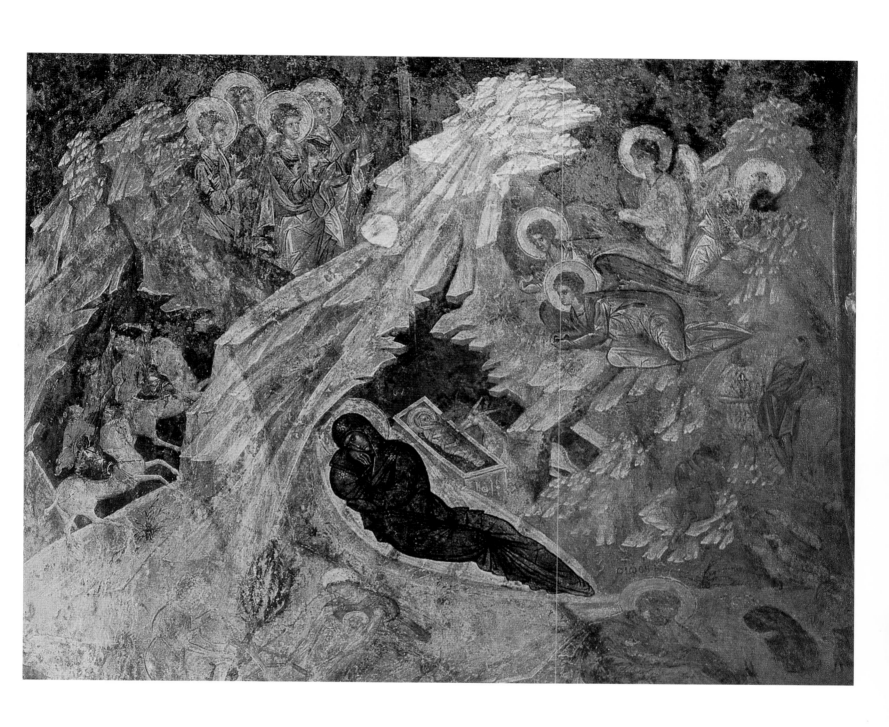

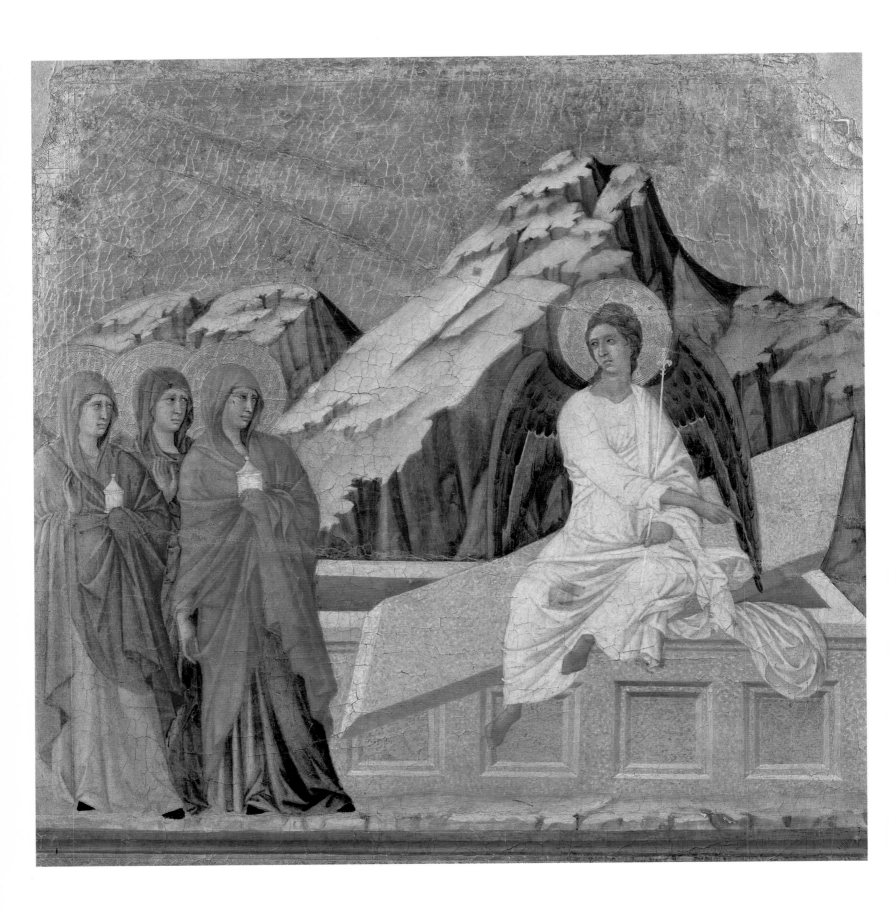

Duccio
Maestà: "The Marys at the Tomb," 1311

Independent, impulsive, insubordinate; an extravagant and not particularly hardworking rebel: this is the image of Duccio that emerges from the chronicles of the time.

One only has to examine the contract drawn up by the "Opera" of the cathedral at Siena for the *Maestà* (literally, "majesty," that is, a representation of the Virgin and Child surrounded by angels and saints). This was to be an altarpiece comprising a magnificent figure of Mary, together with seventy-eight other pictures of varying sizes, the whole commission constituting his most important work. The clauses are so exacting, so nitpicking, so downright suspicious, one might say, that, even if pettifogging of this kind was not rare at the time, they betray the authorities' concern to protect themselves from an artist who, though admired, seems to have possessed a fearsome character. The picture, it stipulated, was to be entirely in his own hand, and he was to put all the "talent he received from God" into the service of the work ordered, while the patrons would supply the necessary materials. Duccio was to work without stint until the completion of the retable, and not to accept other orders. To be extra safe, he was requested to swear on the gospel that he would respect the terms of the contract "without deceit."

It took him two years and eight months to bring this sizable commission to completion; in the end, the result exceeded expectations and the altarpiece was received enthusiastically.

On June 9, 1311, all shops having closed, the great work was borne in triumphal procession through Siena. The bishop was at its head, and all the municipal officials followed amid droves of priests, while bells rung out over the city. The entire day was spent in prayer and almsgiving, until finally the splendid *Maestà* could be erected in the cathedral itself.

In the center of one of the faces of the diptych, overwhelming the other figures by her pose and sheer size, sits a Virgin of extraordinary humanity, flanked by angels and saints. According to the historian Enzo Carli: "The theme of the Madonna as queen of heaven surrounded by angels and saints had literary antecedents; in the figurative arts, however, it is a Sienese invention, and the *Maestà* of Duccio is its prototype."

In the work of this founder of the Sienese school (with Cimabue, in whose workshop he most probably trained), the *Maestà* represents above all the ideal, unparalleled encounter between the Gothic spirit of the West and the Byzantine tradition of the East. This is superbly exemplified in one of the most beautiful *predellas*—the one known as the "Marys at the Tomb," which combines the two styles with a freedom in the choice of coloring, an elegance of design, a narrative confidence that one seldom meets in Cimabue, who was a more monumental, rather more backward-looking painter.

Duccio's manner already prefigures the naturalism of Giotto. No histrionics: instead, a reserve, a stillness, and a grace that are evidence of an authentic masterpiece.

Duccio di Buoninsegna, Siena c. 1255–1319 Siena
Maestà (back panel detail: "The Marys at the Tomb"), 1311.
Museo dell'Opera del Duomo, Siena.

Giotto
The Kiss of Judas, c. 1305

And then, at last, came Giotto: the immense, the legendary Giotto. He is characterized as making his entrance into the history of painting like a miracle, a magical aura gathering around him as it might around a saint. He was born into a peasant family. One day, while still a child, he was drawing a sheep when Cimabue happened to be passing by. The sketch was so true to life that Cimabue recognized his

genius and asked to take the boy along to work with him.

Boccaccio and Petrarch both speak of him with respect, while Dante quotes him in the *Divine Comedy*; as he himself affirms, it is thanks to him that painting is reborn. Later this extraordinarily powerful personality would be seen as the foundation stone of the Renaissance.

The opinion of his pupil Cennino Cennini, author of the *Treatise on Painting*, is worth heeding: "He translated the art of painting from Greek into Latin." It helps one appreciate how Giotto became a national hero: he was the promoter of a wholly new art, freed from Byzantium, from Hellenism, and harking back to the glorious past of Rome.

Around 1300, Giotto's reputation was at such a height and the modernity of his vision so patently in step with the tendencies of the time that Italian princes openly competed for his services. Enrico Scrovegni was the son of Reginaldo, whom Dante casts into hell as a usurer in his poem. Enrico must have been a considerable figure—or perhaps it was his remorse at being afflicted with the same "vice" as his father that was considerable—for Giotto to agree to provide the decoration for his chapel in Padua, which Enrico had built in the teeth of countless obstacles. His generous commission did not prevent Giotto from depicting his patron in the vast composition representing the Last Judgment on the rear of the façade. Enrico appears offering Mary Mother of God the model of his chapel and wearing a violet robe, a color symbolizing repentance.

It is naturalness rather than naturalism that is so admirable in these frescoes, equally celebrated for their realism, for the physical characterization of each and every figure—a thing that had scarcely existed before him—as well as the marvelous clarity, delicacy, variety, and limpidity of their color.

The dynamism and dramatic intensity of the famous *Kiss of Judas*—where good and evil clash in a meeting of lips—have been stressed many times, as have the beauty of the yellow robe of the betrayer positioned between others in gray-blue and faded red, and the power of the composition generally. But it is the vibrant understanding of humanity that overrides any other quality in this powerful masterpiece, from the center of which the figure of Christ radiates his luminous serenity.

Instead of relying on the sublime, Giotto softens the image of the sacred, making it feel closer, bringing it—as it were—down to earth. This new humanity is especially visible in gestures that have totally lost all liturgical quality. In spite of their dignity, solemnity, reserve, self-control, these are everyday gestures. In Assisi, a youthful personality was striving to express itself; in Padua, we are in the presence of total mastery and awesome power.

Giotto (Giotto di Bondone), Colle Vespignano 1267–1337 Florence
The Kiss of Judas, c. 1305. Fresco, 70¾ x 78¾ in. (180 x 200 cm). Scrovegni Chapel, Padua.

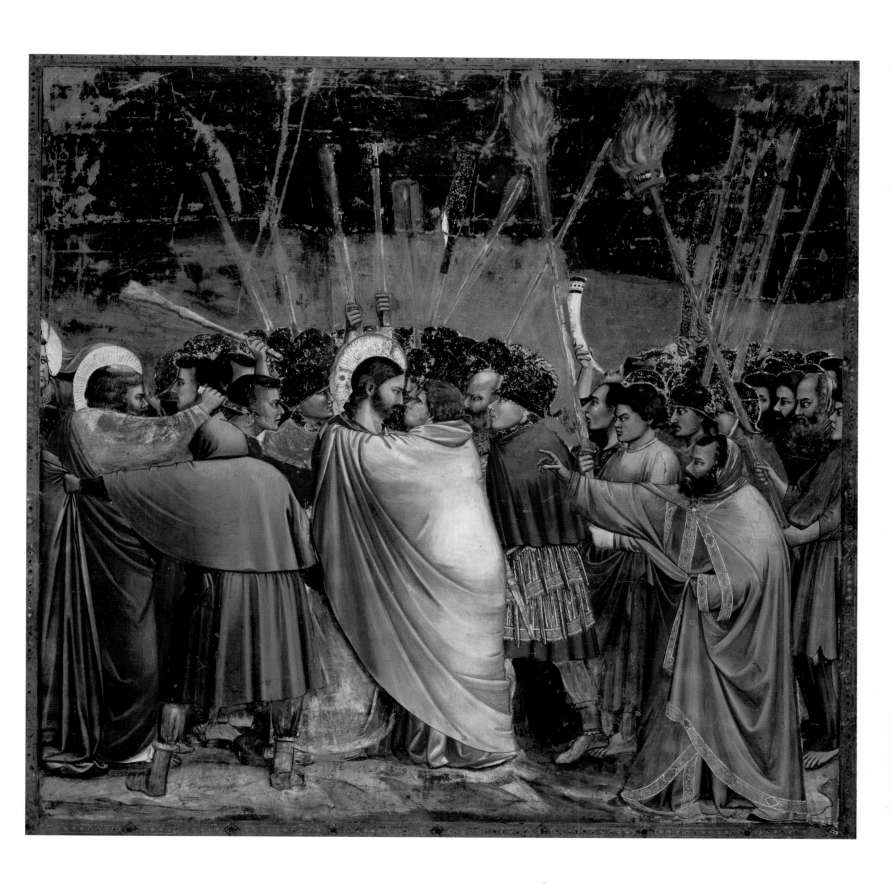

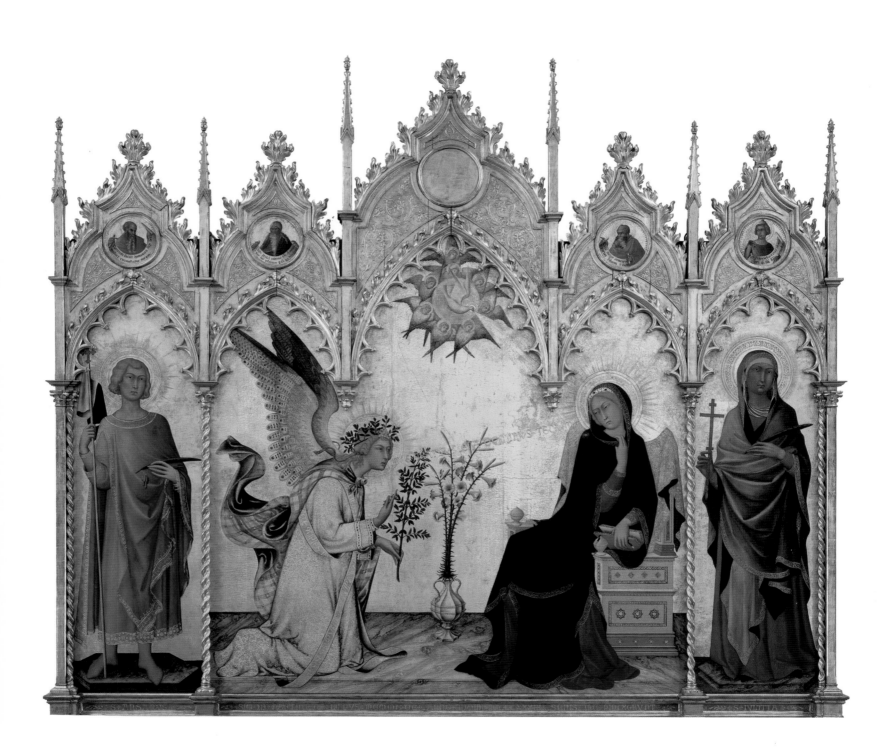

Simone Martini
Annunciation, 1333

Grace and gentleness; elegance combined with rare aesthetic perfection, and delicacy of emotion: this great triptych painted in Siena is a pure miracle.

The entire composition of the altarpiece's central panel is based on the subtle shift of the Virgin's body from foreground to mid-ground as she advances and recedes, her wooden, ivory-inlaid throne being located at the same time parallel to the picture plane and at a slant—as shown by the position of the armrests.

A dynamic, energetic intruder—the angelic messenger—peers over towards the woman who is to receive the Good News, and utters words that pour out of his mouth in gold lettering towards the face of the Virgin: *Ave Gratias Plena*.

Mary's slight withdrawal in response to the angel's announcement is canonical; but the pose, delicately aristocratic in its reserve, testifies to rare "psychological" sensitivity and to a refinement typical of court art and of International Gothic.

Swamping the picture, gold pervades and binds the entire composition; it also underlines the immaterial nature of the angel, thanks to the subtle gold on gold of his robe over a ground of the same hue.

Simone Martini's taste for gold-work, for rich decoration, as well as the influence of Byzantium (evident in the majority of Sienese works of the time) has rightly been stressed. The ground, however, no longer plays the same symbolic role as it did in the Middle Ages: rather, it is there to point up the opulent harmony of color in the angel's checkered mantle, the precious handling of the wings, and the fluting on the vase of lilies. In the center of the composition stand two symbols: the laurel brought by the angel, which signifies immortality, and the lilies in the vase, here a feature of the Virgin's household, denoting purity.

With the brothers Lorenzetti, Simone Martini is the most representative painter of the second generation of Sienese artists: the end of Duccio's life coincided approximately with the first known works of Simone Martini, while Simone died four years before the Lorenzettis fell victim to the plague that devastated the city and brought with it a noticeable slump in the creative arts.

The *Annunciation*, set up on the altar of San Ansano in the cathedral of Siena in November 1333, constituted the most significant commission offered to an artist since Duccio's *Maestà* painted some twenty-two years earlier. In 1799, on the orders from the Grand Duke of Tuscany, the retable was transferred to the Galleria degli Uffizi in Florence. The neo-Gothic frame was added around 1900.

Shortly after creating one of the most admired pictures in all Italian painting, Simone Martini left for Avignon, where the popes were to reside for nearly one hundred years from 1305 to 1403. Benedict XII was in the process of having a larger, better-protected palace constructed at the time Simone Martini arrived; there he painted a (since lost) portrait on parchment of Laura, Petrarch's mythical beloved.

Simone Martini, Siena 1284–1344 Avignon
Annunciation, 1333. Triptych, egg tempera on panel, 104⅓ x 120 in. (265 x 305 cm).
Galleria degli Uffizi, Florence.

Andrei Rublev
Icon of the Trinity, c. 1411

The Russian Orthodox Church, too, has its councils. In 1551, the Council of the Hundred Chapters pondered the icon question that, a few centuries previously, had so exercised the Byzantine world. In an effort to define its iconographical canons, it hailed that of the *Trinity* by Andrei Rublev (or Rublyov) as the paragon.

The pictorial and technical qualities of this work are certainly admirable and could scarcely be bettered as a model. So, for this reason at least, such an accolade is hardly surprising. Yet what won over the monks was something deeper and, moreover, more specifically Orthodox: the piece shows an ideal catechesis of God without God being represented. In the icon of the *Trinity*, we are in the presence of God, but we do not see him; we do not understand him.

Rublev based his work on an episode of the Bible that refers to the visit of three mysterious travelers who announce to the aging Abraham that he is to father a son. In fact, these three angels are hypostases of the One God. All three figures illustrated here possess identical features. This is not a mistake, a shortcoming, or artlessness: the three persons of the Trinity are identical and "consubstantial," each fulfilling its own particular role.

In Rublev's icon, the angel on the left represents the Father, the one in the middle the Son, and the one on the right the Holy Spirit, and while those in the center and right turn their heads in the direction of the one on the left, he remains still, since the Father is the originating principle from whence all derives.

Behind them, a house, a tree, and a rock are all eminently symbolic. The blue worn by the figures is that of the divine. In the center of the picture stands the chalice of salvation. The rectangle on the front of the table stands for the cosmos. The composition of the work is circular—that is, without beginning, without end, without hierarchy.

In an outburst of admiration, Florenski, the great Russian biologist, engineer, mathematician, priest, and theologian of the early twentieth century (called the "Russian Leonardo da Vinci"), exclaimed dramatically, if somewhat paradoxically: "Rublev's *Trinity* exists, consequently God exists!"

Moscow, which called herself the "Third Rome," had only really been Moscow for thirty years when, in 1380, Prince Donskoy vanquished the Khan Mamai, ending the leonine alliance with the Golden Horde and liberating the city from the Tartar yoke. Two years later, Moscow was set ablaze by Tokhtamysh Khan. In 1408, the city was once again devastated by Edige Khan, who set fire to the monastery of Trinity-Saint Sergius, where Rublev was to conceive his famous icon. And each time Moscow was reborn from her ashes.

It was in this context, from which national conscience emerged and which was also the "golden age of Russian holiness," that a monk "filled with joy and understanding" named Rublev painted this icon of uncommon spiritual elevation and incomparable harmony that earned him canonization as one of the Orthodox Church's artist saints.

Andrei Rublev, c. 1360–c. 1430 Moscow
Icon of the Trinity, c. 1411 (*Old Testament Trinity, Hospitality of Abraham*). Icon, painting on wood, 56 x 45 in. (142 x 114 cm). State Tretyakov Gallery, Moscow.

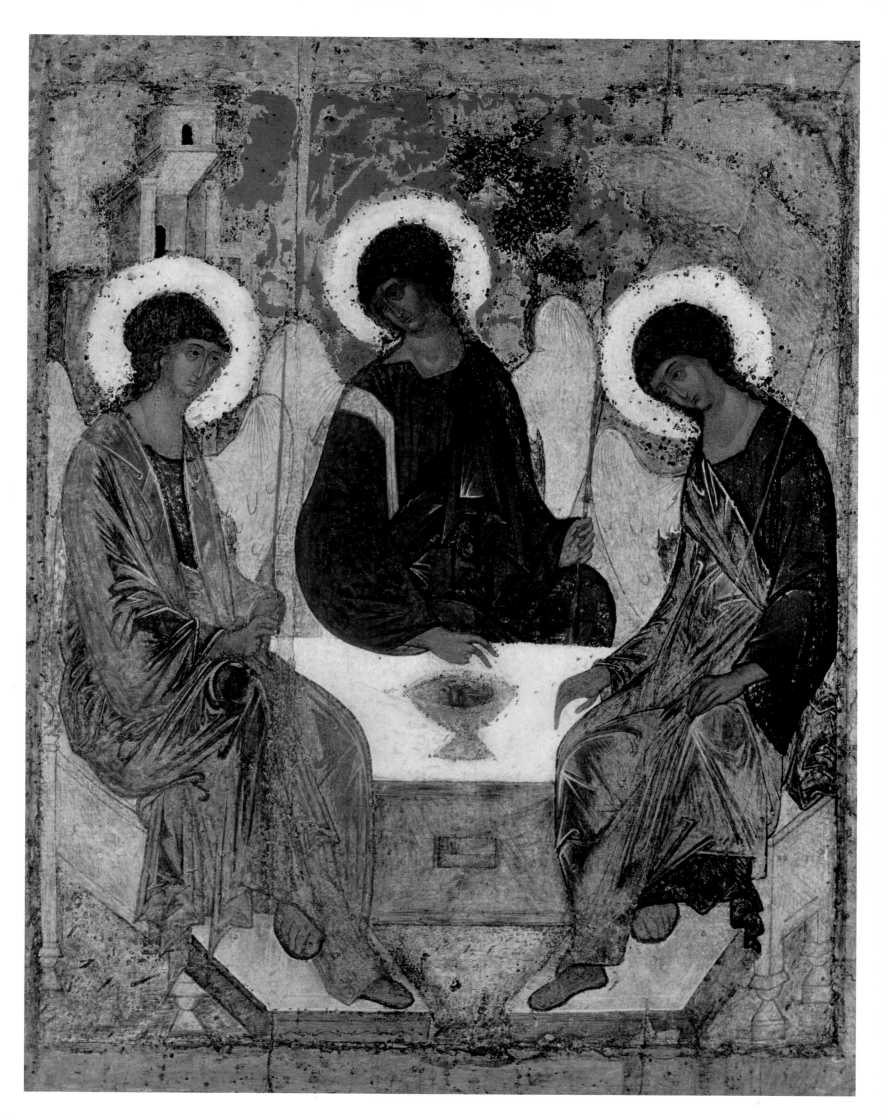

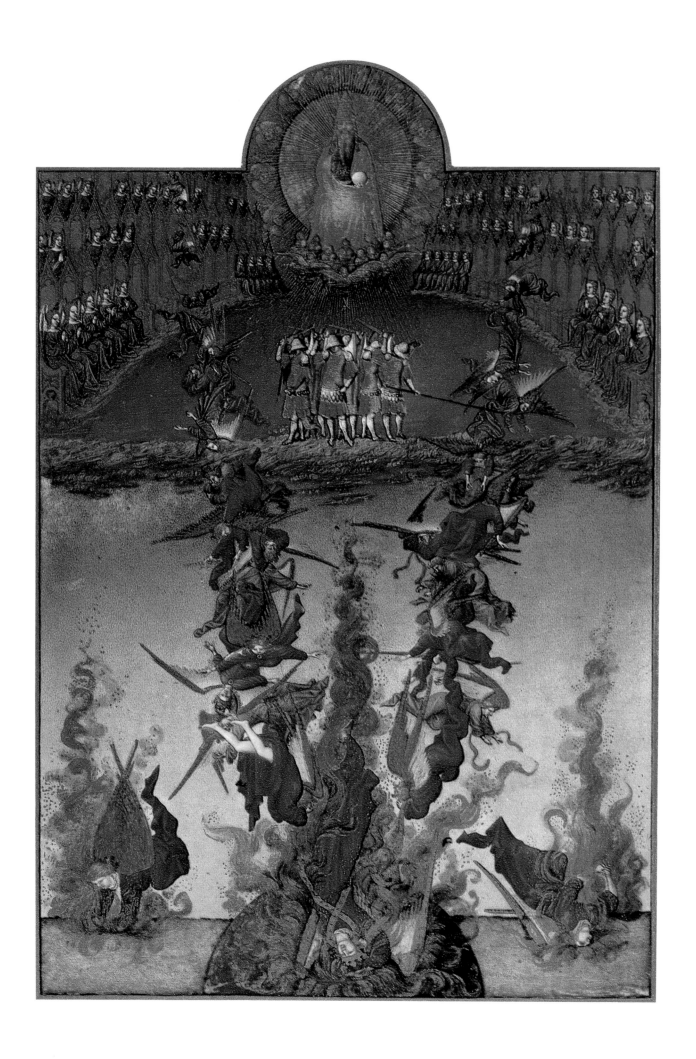

The Limbourg Brothers
The Fall of the Rebel Angels, 1416

The third son of King Jean le Bon, Jean, Duc de Berry, was wealthy and extraordinarily extravagant. He collected exotic animals, such as dromedaries and ostriches, as well as jewelry, illuminated manuscripts, and castles, owning no less than seventeen.

He purchased some of his books, others were given to him, and still others he commissioned, choosing the most competent and most famous artists, among them the Limbourg (or Limburg) brothers, to whom, in testimony of his esteem, he gave the title *valets de chambre*. They produced *Les Belles Heures* and *Les Très Riches Heures*, that "king of illuminated manuscripts," for the duke.

The brothers' names were actually Herman, Pol, and Jehanequin (Jan), and they had been born in the 1380s in Nijmegen, Flanders, though they were probably German, and they died young—all three in 1416, probably from plague.

"Very Rich Hours" are, according to medieval tradition, a collection of texts for each liturgical hour of the day, with additional prayers, psalms, masses, and even a calendar. With pictures of the twelve months of the year, the calendar in *Les Très Riches Heures* is justly celebrated, and its refinement in this field was never excelled. The manuscript of *Les Très Riches Heures*, which the duke was determined should be best of all those he possessed, comprises 206 leaves of a fine and relatively glossy vellum. The script is the same from the beginning to the end of the manuscript, as are the capitals. Left unfinished by the Limbourg brothers in 1416, some of the paintings in the manuscript (*The Ascension* and *The Christ of Pity*) are in the hand of Jean Colombe.

Several large-scale paintings are bound in with the manuscript like plates, some with subjects that are truly exceptional for a book of hours: the anatomical drawing of a man, a map of Rome, and two astonishing works—the arrest of Christ at night and the fall of the angels.

Seldom treated by artists, the theme of the rebel angels is one of the most personal, most original, and most daring of all the miniatures in *Les Très Riches Heures*, where lapis lazuli blue and dazzling gold predominate. It is also one of the most beautiful.

This plate, presumably because the revolt of the angels and Lucifer's lust for revenge were the wellsprings from which all sin flows, was placed at the beginning of the Penitential Psalms. At the top, God, his face aflame, is placed in a double circle. At his feet hover fiery cherubim. To either side, the celestial powers sit on pews of gold, flanked by the empty seats once occupied by the rebel angels that the Lord has driven out. At the entrance to paradise, the celestial army, silver-helmeted and in coat of mail, mounts guard. The actual fall of the angels is treated in a dizzying swirl of blue robes and golden wings that explodes into a conflagration as they plummet to the ground.

The Limbourg Brothers, active in the early fifteenth century
The Fall of the Rebel Angels, 1416. Manuscript paintings, 11½ x 8¼ in. (29 x 21 cm).
Musée Condé, Chantilly.

Masaccio
The Tribute Money, 1424–27

Like many words with the suffix "-accio" in Italian, the name Masaccio, from Tommaso, is disparaging. But why? Artists vied with one another to praise him. Vasari claimed that "painting owes him its second birth," and a distraught Brunelleschi, on learning of Tommaso's premature death, kept on repeating, "We have suffered a great loss." Some of Masaccio's compatriots were clearly more critical, though: they dubbed him an exaggeratedly insouciant character, who walked about poorly dressed and paid as little heed to himself as to others. The status of the decoration in the Brancacci Chapel in Florence is, however, plainly exceptional: at once a work of maturity and an early piece, Masaccio was twenty-three when he began it and twenty-six when he completed it. He died a year later at the age of twenty-seven.

Felice Brancacci, the patron, enjoyed a reputation in Florence for wealth and power. In 1424, on his

Masaccio (Tommaso di Giovanni Mone Cassai), Castello San Giovanni di Valdarno 1401–1428 Rome
The Tribute Money (left-hand wall in the Brancacci Chapel), 1424–27. Fresco, 100½ x 235½ in. (255 x 598 cm).
Brancacci Chapel, Santa Maria del Carmine, Florence.

return from Cairo where he had been the Florentine ambassador, he commissioned frescoes for the chapel from Masolino, who in turn engaged the services of Masaccio. Twenty years separated the two artists: the elegant, traditional, open-minded Masolino, and the strong-willed, daring Masaccio, fired with enthusiasm for the innovations of the time—and first and foremost for Brunelleschi's "artificial perspective."

As discoveries stemming from the recent restoration have revealed, *The Tribute Money* is now to be ascribed entirely to Masaccio's hand. It can be regarded as the most remarkable piece in the whole chapel, and as his most important work. After that, he hardly painted anything else—a notable exception being the famous *Holy Trinity* fresco in Santa Maria Novella, Florence.

The Tribute Money refers to the gospel of Saint Matthew. In the center, Christ turns to the tax

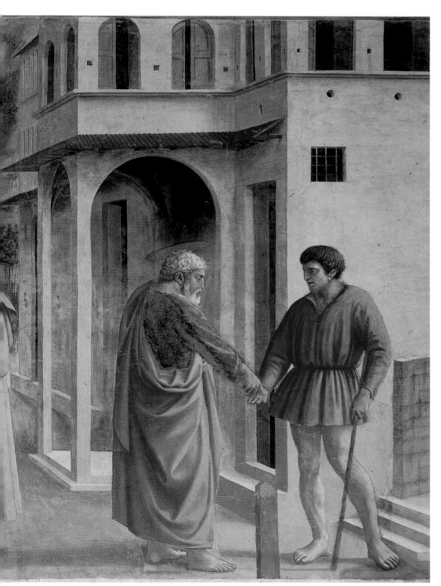

collector, claiming his due. With his right hand, Jesus indicates to Peter where the money is to be found; on the left, in the background, Peter, on the shores of a lake, removes the coin from the mouth of a fish. To the right, he hands the tribute over to the tax collector.

These three scenes, showing the action unfold, are set in one single space, as was usual at the time, but staged here over several planes.

Much has been made of the admirable realism of the features, expressions, and attitudes of the apostles as they await Christ's response to the tax demand, because it is clearly a trap: does the Son of God have to pay up as well? More striking still is the balance between an individualization derived from Giotto, whose quest for naturalness Masaccio pursued, and a quiet, unmoving, simple gravity imposed on the scene by a conception of reality that was to have an enduring and explosive impact on the history of painting.

In this fresco, light plays an essential, hitherto unparalleled role. It emanates from a specific source, and in a natural way shapes scenes and a landscape governed by the recently devised laws of perspective. The shadows (most notably those flitting between the legs of the tax collector) reinforce the sense of space.

Fra Angelico
The Annunciation, c. 1438

The purity, simplicity, luminosity, and transparency of Fra Angelico's work have induced many art historians to overstress certain aspects of this painter, either making him into a saint who never painted without praying first, or emphasizing his backward-looking relationship to the ongoing Renaissance.

It is perfectly possible to pray before painting (as Warhol did every morning) without being a starry-eyed innocent unaware of the theories and discoveries of one's time, just as it is possible to be possessed of a different viewpoint without necessarily being a painter of the Middle Ages who had wandered into the fifteenth century.

Guido di Pietro, known as Fra Angelico, was born about 1400 on the outskirts of Florence. He studied painting and miniature illumination, though it is unclear where and how, and he entered the monastery at Fiesole aged twenty. He studied theology at Cortona and Foligno, was ordained, and returned to Florence where, from 1439 to 1445, he painted the convent of San Marco; the Reformed Dominicans had recently acquired the site and a substantial rebuilding program was underway. Over the following ten years, two popes—Eugenius IV and Nicolas V—were to call him to the Vatican to execute various works. He became prior of the convent of San Marco and he died at Rome, famous and admired, in 1455.

The decoration of the monastery, which was to occupy Fra Angelico from 1438 to 1445, is in keeping with the place: austere and luminous in its spirituality. For the work, he was not only to produce paintings on panels, the large retable and the famous *predella*s of the Deposition of Saints Cosmas and Damian, but also a vast number of frescoes including *The Annunciation,* located in cell number three.

This simple and severe painting, from which all details not essential to the scene have been expunged, echoes the space of the cell. The place the angel chose to announce the "good news" is not depicted realistically, but ideally, geometrically, staged over a series of lines and planes, while the light, too, appears ideal, absolute.

This large painting was positioned facing the door, on a wall with a window that therefore incorporates two openings: one onto the physical world, the other onto the spiritual. It represents an aid to meditation.

Closer inspection proves that, in modeling and in perspective, Fra Angelico does not ignore any of the lessons of Masaccio. Both artists make their points discreetly and remain subjugated to a thought that sets itself against humanistic culture on two essential points: its conception of the space and its approach to history. For the Thomist Fra Angelico, space exists only as a construct of the intellect. God created the world and the light, which are both emanations of astral bodies. As for history, it may be useful in giving an account of facts in the past, but action is governed by Providence alone.

John Paul II authorized the Order of Preachers to celebrate rites in honor of Blessed Fra Angelico who, on February 18, 1984, was declared patron saint of artists.

Fra Angelico (Guido di Pietro, Fra Giovanni da Fiesole), Vicchio di Mugello c. 1400–1445 Rome
The Annunciation (cell number 3), c. 1438. 73½ x 61¼ in. (187 x 157 cm).
Convent of San Marco, Florence.

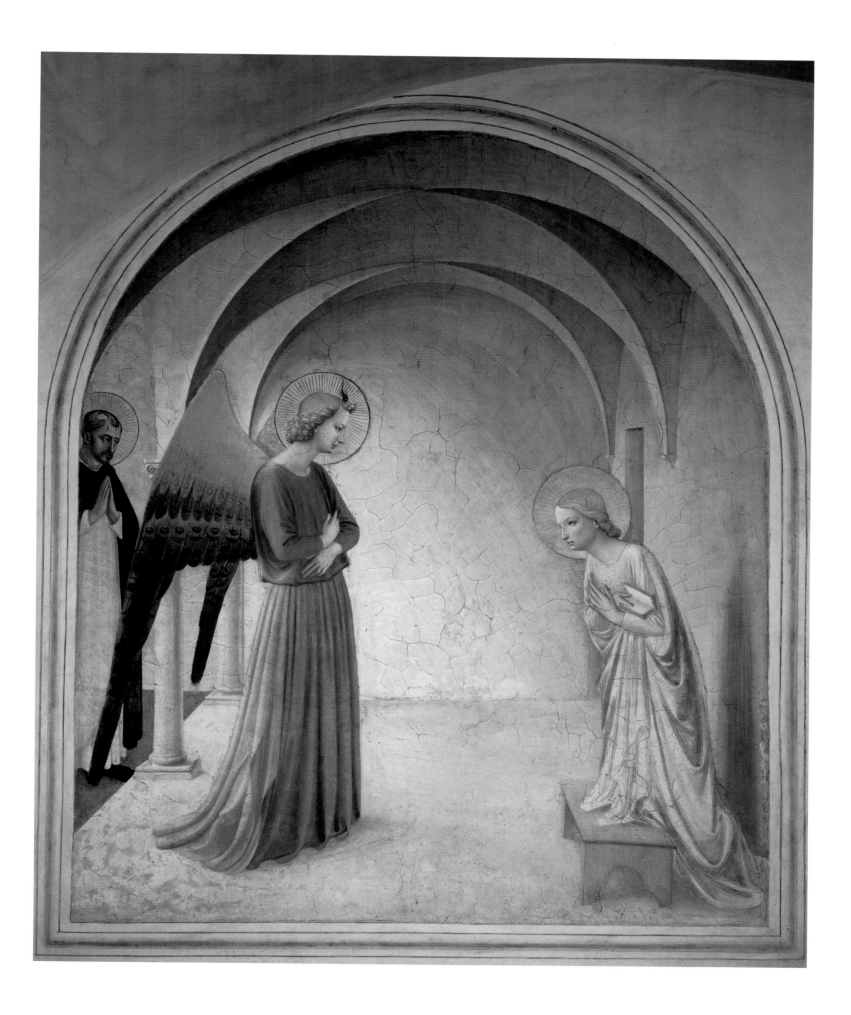

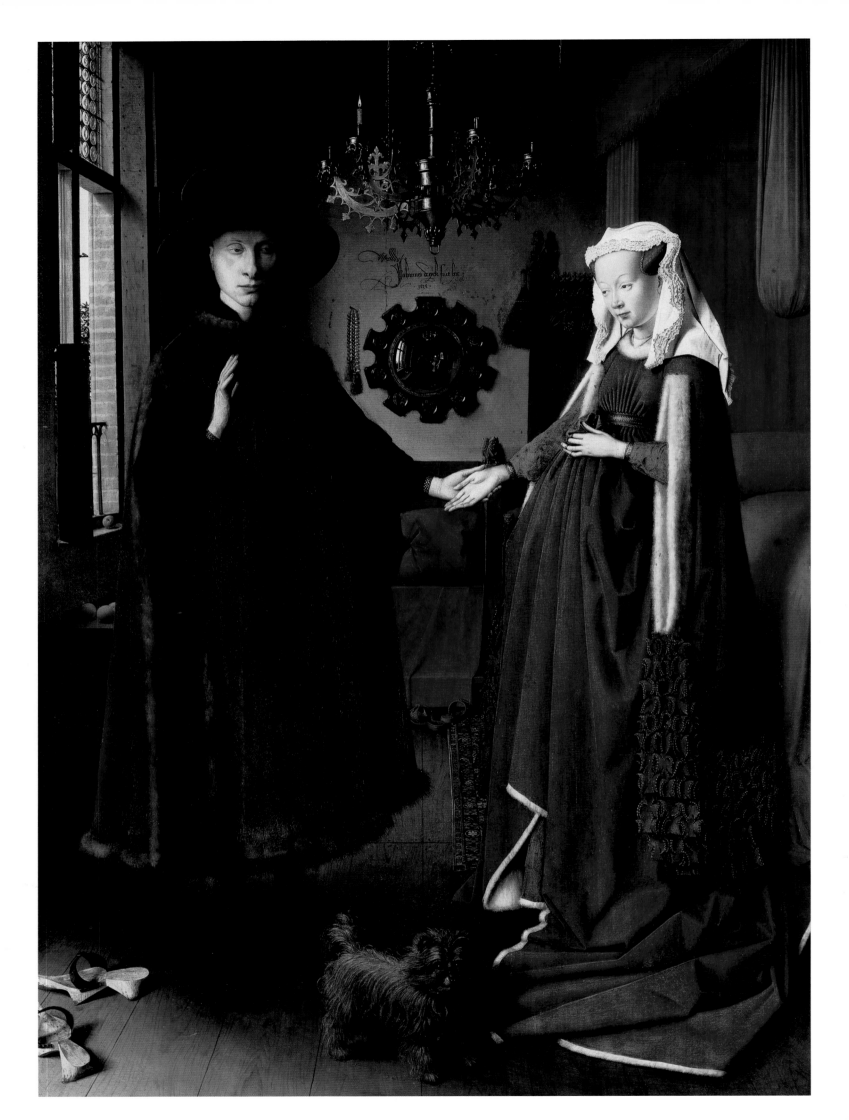

Jan Van Eyck
The Arnolfini Wedding, c. 1434

The revolution the Italians were staging at the beginning of the fifteenth century had echoes in Flanders in the persons of Jan Van Eyck and Rogier Van der Weyden who, at around the same time, were triggering another kind of Renaissance in northern Europe. Though equally preoccupied with realism,

theirs would be of a different stamp. Van Eyck in particular was exercised by a painstaking perfectionism that made him incomparable in the depiction of materials, flesh, and the light that pervades and circulates through his compositions.

Traditionally, he is credited with the invention of oil painting. In fact, it had existed before him, but he did so much to improve and popularize it that such a conflation is readily understandable.

Born around 1390, probably in Maeseyck, in about 1417 he surfaces as a miniaturist, working for Duke Wilhelm IV of Bavaria. From 1422 to 1424 he was in the service of John of Bavaria, prince-bishop of Liège and count of Holland, for whom he executed decorations in the palace at The Hague. In 1425, his patron having died, he joined the service of the duke of Burgundy, Philippe le Bon (Philip the Good), becoming not only his official painter, *valet de chambre*, entitled to wear ducal robes and to parade with other dignitaries, but also a kind of ambassador, responsible for more-or-less secret missions that led him to travel to Italy, Spain, Portugal, and England. By 1430, Van Eyck established himself in Bruges (which since 1419 had been capital of the duchy), where his relationship with his protector was on such a good footing that in 1434 the duke acted as godfather to one of his children.

Van Eyck was a painter of genius who can be regarded as the founder of Western portraiture. Many notable dignitaries—such as Chancellor Rollin and foreigners such as Arnolfini, a councilor at the duke's court—all vied to be painted by the master's hand in an effort to further embellish their prestige.

Combining precision in detail with a flair for conveying the profound character of the sitter, who—in what is a remarkable innovation—establishes eye contact with the viewer, in 1434 Van Eyck painted a disconcerting double portrait masterpiece, *The Arnolfini Wedding*. Bathed in a soft light, this full-length portrait, interior, and genre scene combined represents the banker standing tall in a sumptuous fur coat and broad-brimmed hat, and Jeanne Cenani, viewed side-on, wearing a full green robe. Above them is a chandelier lit with only one candle, a symbol of Christ witnessing a scene; the painting has been seen as depicting the couple's engagement, rather than merely a joint portrait. Such a thesis seems to be supported by the presence of the dog at their feet, a symbol of fidelity, as well as by other details, such as the fruit on the window ledge that recalls Paradise.

But it is the convex mirror showing the scene at the back that introduces another dizzying dimension into the picture. It reveals two other figures—witnesses at the betrothal, perhaps?—facing the couple, who are now being viewed from the rear. Some have thought one of these two figures might be the painter himself. An inscription on the wall—"Jan van Eyck was here"—may well attest to this.

Jan Van Eyck, Maeseyck c. 1390–1441 Bruges
The Arnolfini Wedding, 1434. Oil on panel, 32⅓ x 23½ in. (82 x 60 cm).
National Gallery, London.

Rogier Van der Weyden
Deposition, c. 1435

Born in 1400 in the free city of Tournai, then a dependency of the kingdom of France, Rogier de la Pasture settled in Brussels in 1435, translating his name into Flemish to become Rogier Van der Weyden. In his new home, he was made "painter of the city," an essentially honorary post that enabled him to work for patrician families such as Chancellor Rollin and Philip the Good, without needing to be attached to Philip's court.

He studied painting at Tournai with Robert Campin, whom modern scholarship identifies with the "Master of Flémalle," a painter with a strong personality influenced by French and Flemish miniaturists, whose highly charged art and realistic approach to depicting religious symbols would have also exerted an influence on Jan Van Eyck. Rogier Van der Weyden borrowed from this new manner of representing reality and from the discreet use of shadow.

Having gained a prominent place under Robert Campin—he seems to have become something like "head of studio"—he obtained an order for a *Deposition* from the ancient and powerful brotherhood of the foremost crossbow-makers of the city of Leuwen (Louvain), known as the *Grand serment des arbalétriers*. The wealthy guild possessed its own chapel, Our Lady without the Walls, which contained a

statue of the *Mater Dolorosa*. Painted as an altarpiece for this chapel, Van der Weyden's work was later acquired by Maria of Hungary; in turn, she gave it to the king of Spain, Philip II, which is why it is today held by the Prado Museum after long hanging in the Escorial.

Rogier Van der Weyden's *Deposition* is inspired by a version by Robert Campin that we know only from a copy. While the general composition is indeed similar, one quickly notices the distinction between the two artists: while Campin opposes groups of raw, dramatic substance, Rogier Van der Weyden fuses his ten figures into a harmonious unity that expresses pain, certainly, but places the stress on compassion. This emotion is most wonderfully expressed by the brilliant idea of folding the body of the fainting Virgin so she is parallel to that of her dead Son. For Mary is not only the person who intercedes: she also participates viscerally in the Passion of Christ and in the Redemption.

Compacted into a tight space, the figures, ten in number, are shown life-size and as if frozen, or even "coagulated," in time. Christ's body is held under the armpits by Nicodemus, and by the feet by a luxuriantly dressed Joseph of Arimathea. The latter, who has been identified as a member of the brotherhood of crossbowmen, looks beyond Christ to the skull of Adam at the feet of Saint John, who also leans forward to support Mary. Behind him on the left are the two sisters of the Virgin.

On the right, the Magdalen wrings her hands and arms with extraordinary expressiveness. "Expressiveness" is the keyword for an art that is, here, at its apogee.

Rogier Van der Weyden, Tournai 1400–1464 Brussels
Deposition, c. 1435. Oil on wood, 86½ × 103 in. (220 × 280 cm).
Museo del Prado, Madrid.

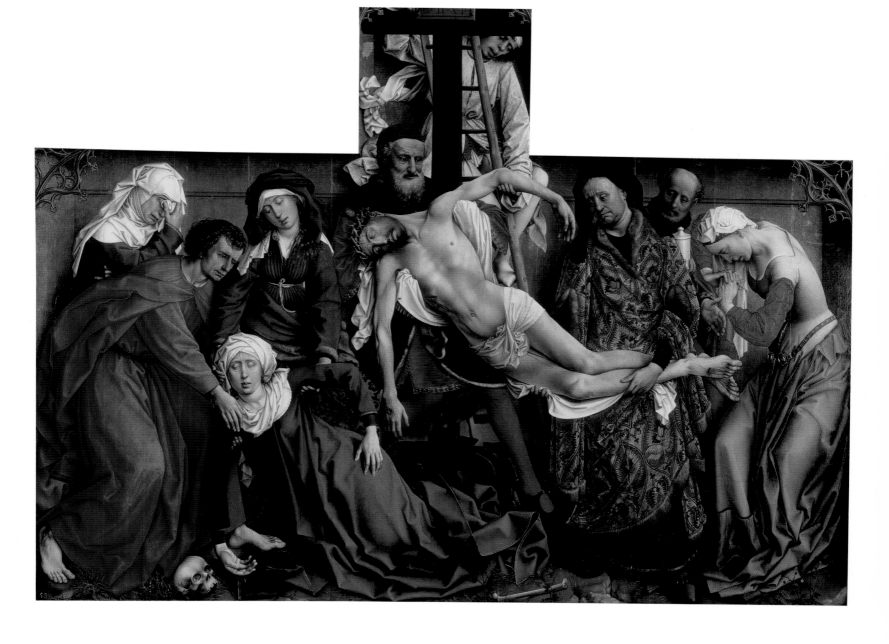

Enguerrand Quarton
Pietà at Villeneuve-lès-Avignon, 1450–57

The *Pietà*, this masterpiece of the Provence School, long anonymous or vaguely ascribed to a "Master of the Pietà at Villeneuve-lès-Avignon," is now credited to Enguerrand Quarton. Quarton also created another work that is nearly as famous: *Coronation of the Virgin*, painted in 1453–54 for the altar of the Holy Trinity in the church of the Carthusians at Villeneuve-lès-Avignon.

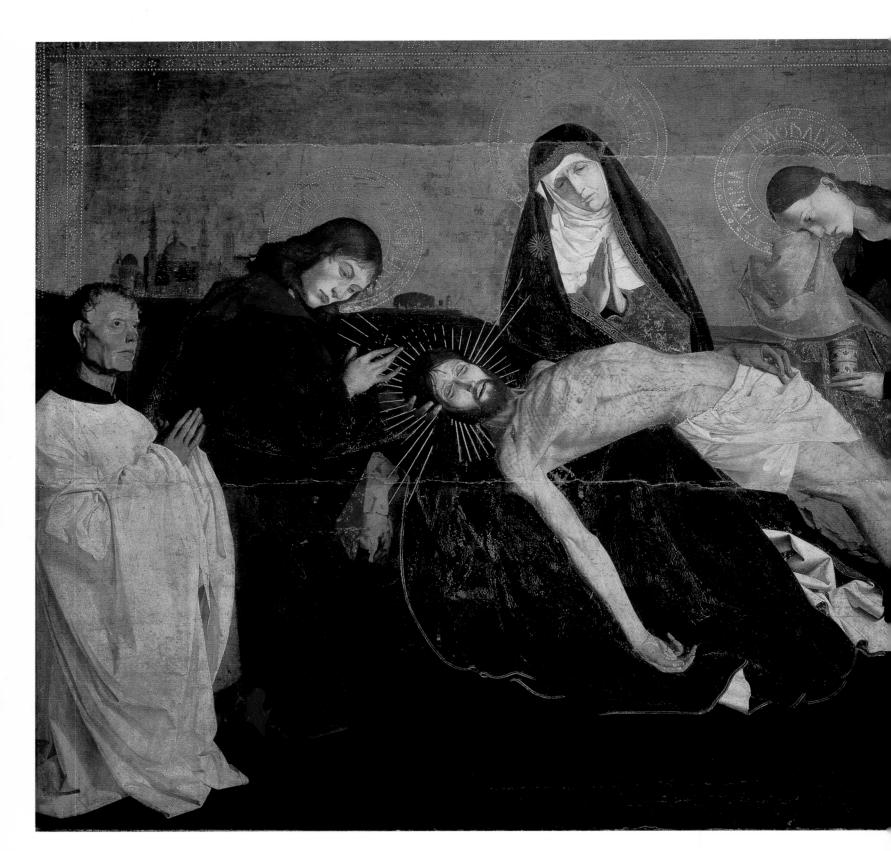

Over recent years, a relatively precise outline of the painter's biography has emerged. He left his native north some time between 1435 and 1440 and moved to the south of France, where he eventually settled. In 1444, he is referred to as dwelling in Aix-en-Provence. He rented a house in Avignon in 1447. From that time he was recorded, year after year, as "living in Avignon" or as a "painter from Avignon."

On April 24, 1453, a "fixed price" was arrived at for the *Coronation of the Virgin*, which was destined for the church of the Carthusians at Villeneuve-lès-Avignon. There is no mention of the *Pietà*. This work was shown at the Louvre in 1904 on the occasion of an exhibition of "primitive French masters," where it was "discovered." And before that ? It seems that until the Revolution it had been in the church of the Carthusians at Villeneuve-lès-Avignon.

The work is—in the sculptural roughness of its forms, and in the intense expression of the faces—both one of the most characteristic and one of the most striking examples of the art of fifteenth-century Provence. It is a work out of time, beyond style, transcending everything, managing to transform its realistic elements into symbols of austere grandeur. Simultaneously rustic and erudite, sober and monumental, it has preserved much of its mystery. Who is the donor kneeling on the left, with gnarled hands and jutting-out veins? What is that city in the distance, whose slim minarets stand out against the gold-colored ground? A Jerusalem that is at once earthly and heavenly? The spare harshness of the painting is nonetheless overpowering. At its heart the artist has placed the simple yet sublime mystery of the death of the Son of Man and the Lamentation as never before. Perhaps he can only be compared to the Christ in Grünewald's Isenheim Altarpiece, who is endowed with the same roughness, though the vehement emphasis is quite different.

Extremely sober, the composition with its penetrating, abrasive angles, is organized around the tortured, broken body of Christ, which lies horizontally over the knees of his Mother. There are four figures (plus one other: the donor) in this theater of pain that celebrates misfortune as a promise of redemption— four characters in a mystery play of death and resurrection: the blanched cadaver drawing in Saint John on the left and Mary Magdalen on the right, who both lean in towards him, and the upright figure of the deathly pale Virgin, hands raised in prayer, who bisects the composition with a contrary momentum that thrusts it upwards.

This incomparable work appears more primitive than it truly is. Incomparable in its terrible expressiveness which, rooted in commonplace reality, attains the most elevated spirituality.

Enguerrand Quarton (or Maître Enguerrand Charreton), Laon 1410–1466 Avignon
Pietà at Villeneuve-lès-Avignon, 1450–57. Painting on panel, 63¾ x 85¾ in. (162 x 218 cm).
Musée du Louvre, Paris.

Petrus Christus
Portrait of a Girl, c. 1446

Was Petrus a minor master, an epigone, a late imitator of Jan Van Eyck, or a more original artist than is commonly thought, a painter worth rediscovering?

Among his works, one picture stands out, and has propelled his name to the forefront of the history of painting: the famous *Portrait of a Girl*, a tiny oil on panel, a fragile, enigmatic work of unparalleled delightfulness. Might it be dubbed the *Mona Lisa* of the North? Around it, legends, obsessions of a similar type, have coalesced. Certainly the unflinching stare—half come-hither, half standoffish—is equally troubling. It is charming, without doubt, but with a charm that is hard to pin down.

Still, is she even a "girl" exactly? Tradition has it that she might be the wife of an English lord named Talbot who was staying in Bruges in 1446, the picture's generally accepted date of execution. More recent research, however, suggests it is of his niece, named Anne or Margaret. This is based on the statement by Gustav Waagen, who was able to make out, on a frame that disappeared in 1825, the name of Petrus Christus. He also claimed to have read the words: "a niece of the famous Talbot." But a new theory has been advanced: that Waagen might have translated *nepos* incorrectly as "niece" instead of "little girl." And as the only record of what was inscribed derives from Waagen, whence the word *nepos*—is it a back-translation? In short, many hypotheses have been advanced and they will probably continue to run for a long time to come. Still, in the end, the identity of the sitter is of little importance: it's the light, the almost childlike beauty of the portrait that makes this unique piece a work apart, a rare miracle, an enchanted masterwork.

There's the perfect oval of the face, underscored by the cap ribbon beneath the chin and rubbing against the cheek; the eyebrows plucked—in keeping with the fashion of the time—almost into nothingness and enhancing, if that were possible, the ideal purity of the forehead's swelling dome; the hair under the headdress drawn back tight; the almond-shaped, gazelle-like eyes; and then the simultaneously sidelong and piercing gaze that one is unsure whether to call cold (almost implacable), or anxious, or even frightened, and the halfway smile, slightly sulky, vaguely scornful—or perhaps both at the same time.

The delicate shading and diffuse light which, instead of picking out the uneven texture of the gracious head, flits over the contours of a face that still harbors telltale signs of childhood in the midst of her beauty, so that one is more sensitive, perhaps, to the fragility of the portrait than to its perfection.

In an atmosphere of what is relatively homely luxury, and with remarkable unpretentiousness, the artist, even if he takes pains to delineate the model's necklace, gown, and coif, eschews pointless detail to set up a relationship between viewer and portrait that forfeits none of its intensity, of its overwhelming, opalescent enchantment.

At length one sees nothing but the glance and a pearly complexion that casts a spell over not just the picture, but the air that surrounds it as well.

Petrus Christus, Baerle c. 1410–1473 Bruges
Portrait of a Girl, c. 1446. Oil on wood, 11 x 8¼ in. (28 x 21 cm).
Staatliche Museen, Berlin.

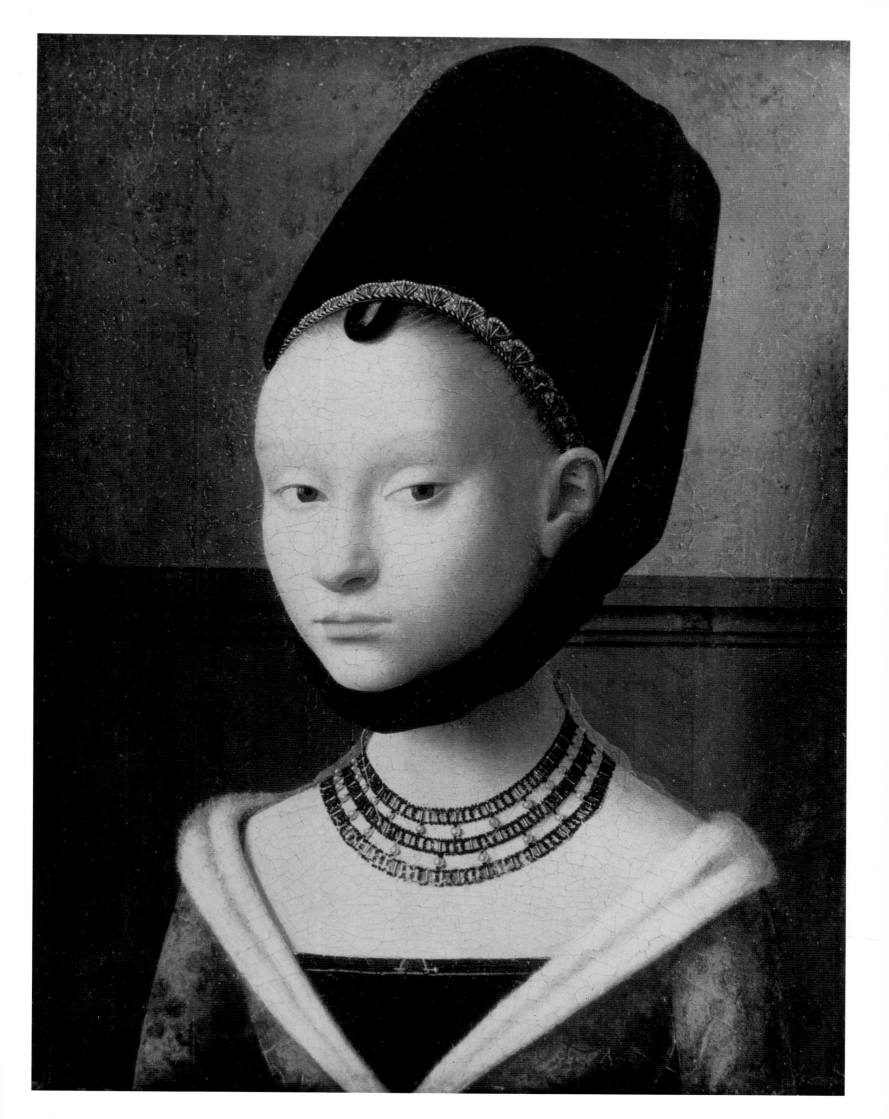

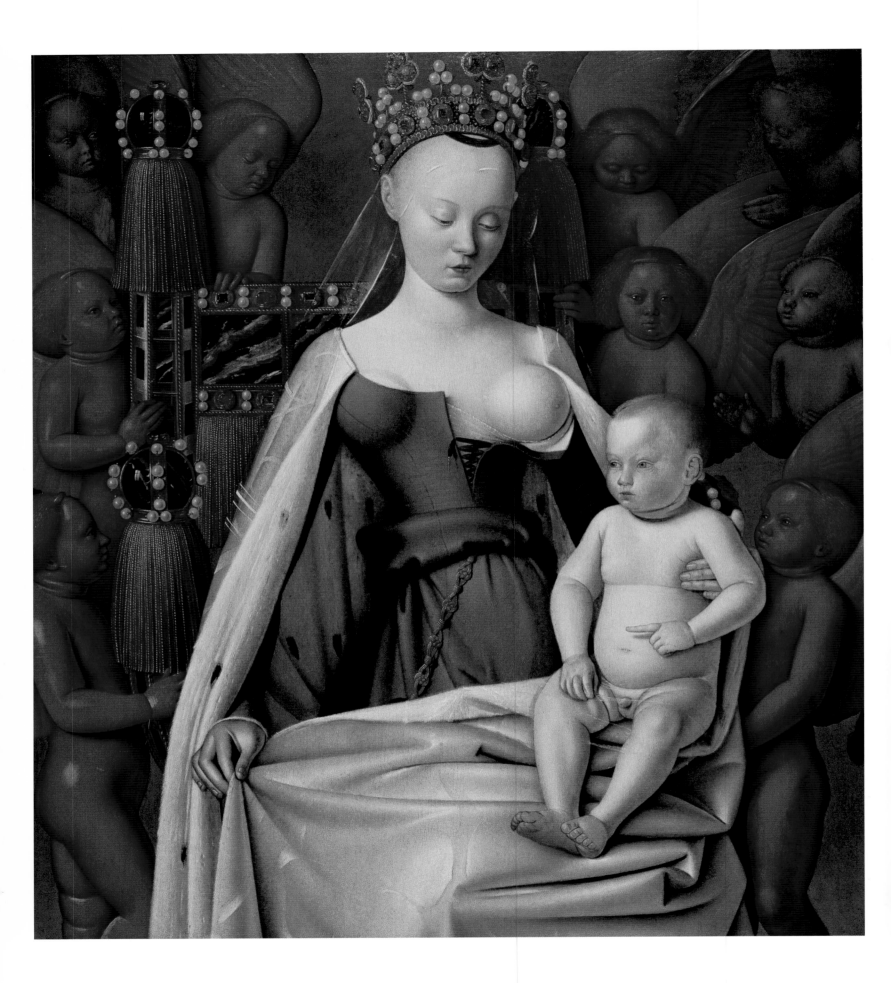

Jean Fouquet
Virgin and Child Surrounded by Angels, c. 1450

This is an incredible picture. No matter how it is approached, it proves endlessly astonishing, fascinating, disturbing. The daring stroke of depicting the Virgin bare-breasted, the torrid clash of colors, the frozen purity it exudes, the eroticism of almost every element.

That said, however, one should not forget that the panel initially belonged to a painting known by the name of *The Melun Diptych*, whose two parts could scarcely be more unlike; they are linked solely by the gaze of the Christ Child, who turns toward the panel on the left. This panel shows Etienne Chevalier, who is being presented by Saint Stephen. Etienne (Stephen) Chevalier was executor for Agnès Sorel, the official favorite (this was an innovation) of Charles VII; she died in 1450. Fouquet shows her as the Virgin, with a broad, bulbous forehead, pleasantly shaped if slightly protruding eyes, a straight nose, and a dimple on the chin. As for the bosom, one should recall that Agnès Sorel, "the most beautiful woman in the kingdom," had launched the plunging, "off-the-shoulder" neckline that amounted to "debauchery and dissolution" according to chroniclers of the time.

When one compares the two panels in the mind's eye or in reproduction, one is forcibly struck by the discrepancies in style: the one on the left deploys the geometrical perspective discovered by Fouquet during a journey to Italy, while the right-hand panel belongs to the world of the Gothic and of manuscript illumination.

Jean Fouquet was first and foremost a miniaturist of genius, as testified by an important version of *The Jewish Antiquities*, consisting of twenty paintings, where the great fifteenth-century French painter brings two innovations to the miniature: the treatment of the crowd and a virtuosity never before seen in the handling of the various planes.

Fouquet had traveled to Rome in around 1447, initially to seek a papal dispensation: he was the son of a priest, and born out of wedlock, so he petitioned Nicolas V to absolve him from this "stain of birth" that made it problematic for the Church to advance his payments. This apparent stumbling block had not prevented the preceding pope, Eugenius IV, from inviting Fouquet to paint his portrait, however, which soon became renowned for its truth to life.

The *Virgin and Child Surrounded by Angels* is a very different matter, obviously: rather than Mary, Virgin Queen of Heaven being the true subject, it is the dazzlingly beautiful Sorel, who is portrayed head-on and at the center of the panel, sporting a royal crown, in the midst of blood-red cherubim.

The "collage" of the triangular-shaped central group, underscored on the left by the diagonal formed by the mantle, together with the interpenetration of the milky white and iridescent red, have both been analyzed as the encounter between the female and male principles. Perhaps that is going a bit far. In any event, it is clearly the most impassioned pean to eroticism ever placed in an allegedly religious painting. And a ravishing picture to boot.

Jean Fouquet, Tours 1420–1481 Tours
Virgin and Child Surrounded by Angels (*The Melun Diptych*, right-hand panel), c. 1450.
Paint on panel, 37 x 33½ in. (94 x 85 cm).
Koninklijk Museum voor Schone Kunsten, Antwerp.

Andrea Mantegna
Dead Christ, 1500

Some are of the opinion that Mantegna's Camera degli Sposi is "the most beautiful room in the world," a masterpiece of decorative art painted for Ludovico Gonzaga and his wife between 1472 and 1474. It is a unique ensemble of frescoes that cover the vault, the four walls, and the embrasures of the two windows on the *piano nobile* in the northeast tower of the Ducal Palace at Mantua. However, the overpowering force of expression in his *Dead Christ*, in its destitute, vulnerable nudity, has made this work more famous still.

Dead Christ is an unflinching representation of a corpse, or that of a Christ more human than divine, whom death has taken as it will take us all. The representation of the cadaver reminds us of those by Enguerrand Quarton or Matthias Grünewald, in their very different styles. This impressive painting is also a work of consummate virtuosity, deriving straight from the teachings of Alberti, who raised the cult of the Antique to a new level and promoted the imitation of nature by means of perspective.

The author of this intense, uncompromising piece was an irascible individual who quarreled unceasingly with his collaborators and neighbors; an authoritarian personality, with a fierce, overbearingly proud character. He was also a passionate collector of old objects, the splendor of which was much admired by Lorenzo de' Medici on a visit to him in 1466.

Protected from 1460 by Marquis Ludovico Gonzaga, Mantegna's toughness did not stop him creating many portraits and engravings, stage designs, cartoons for tapestries, and even sets of table linen for him, as well as participating actively in refurbishing the palace. In Padua, he became Gonzaga's familiar rather than a mere employee, working up from craftsman to courtier, earning a stipend for his talent, independently of any commissions he might garner.

Regarded as the foremost painter of the northern Italian Renaissance, Mantegna created a synthesis of the Tuscan contribution in a region that was still impregnated with Gothic culture, even if Venice had played host to Uccello, Ferrara to Piero della Francesca, and Padua to Filippino Lippi, all of whom had left their imprint.

He trained in Mantua, and it was there that he died. At the time it was a brilliant city, with a university that attracted a rich vein of humanism. Francesco Squarcione took him on as a pupil in his workshop and adopted him: it was thus that Mantegna discovered Antiquity in the sculptures his master had brought back from travels through Greece. This kindled a taste for the classical that marked his painting and reinforced his passion for collecting.

Mantegna was a precocious artist who absorbed Florentine innovations with enthusiasm, fervor even, employing them in his own vigorous and concentrated manner, as is clear from this work.

Andrea Mantegna, Vicenza 1431–1506 Mantua
Dead Christ, 1500. Oil on canvas, 32 x 26¾ in. (81 x 68 cm).
Pinacoteca di Brera, Milan.

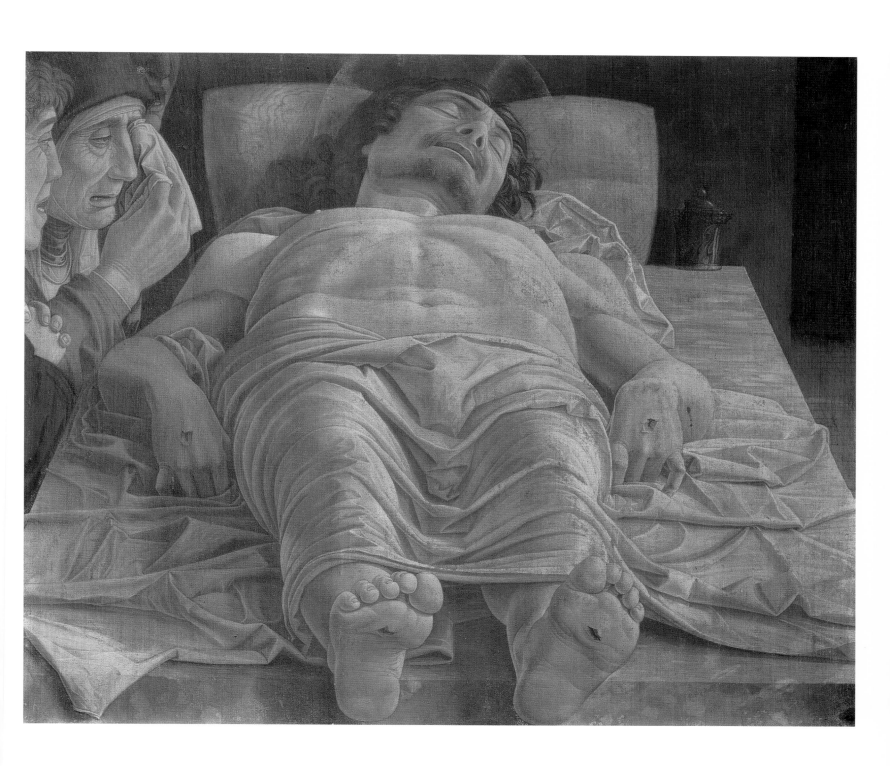

Paolo Uccello
The Battle of San Romano, c. 1438–40

In Uccello's work, everything seems to happen as if in a dream, sometimes as if in a fairyland; it is awash with gold, draped in night, where improbable events occur. This is surely why the surrealists adored his *Profanation of the Host*, his weird *Hunt*, his marvelous *Saint George and the Dragon*, as well as his trio of *Battles*. These three scenes were painted between 1435 and 1460 to celebrate the 1432 Battle of San Romano, which saw the Florentines—under the command of Niccolo da Tolentino—beat the Sienese, who were allied to the Visconti family of Milan. They comprise three large panels designed for a room in the Medici palace on Via Larga. Today, one is in the Louvre, Paris, one in the Uffizi, Florence, and one in

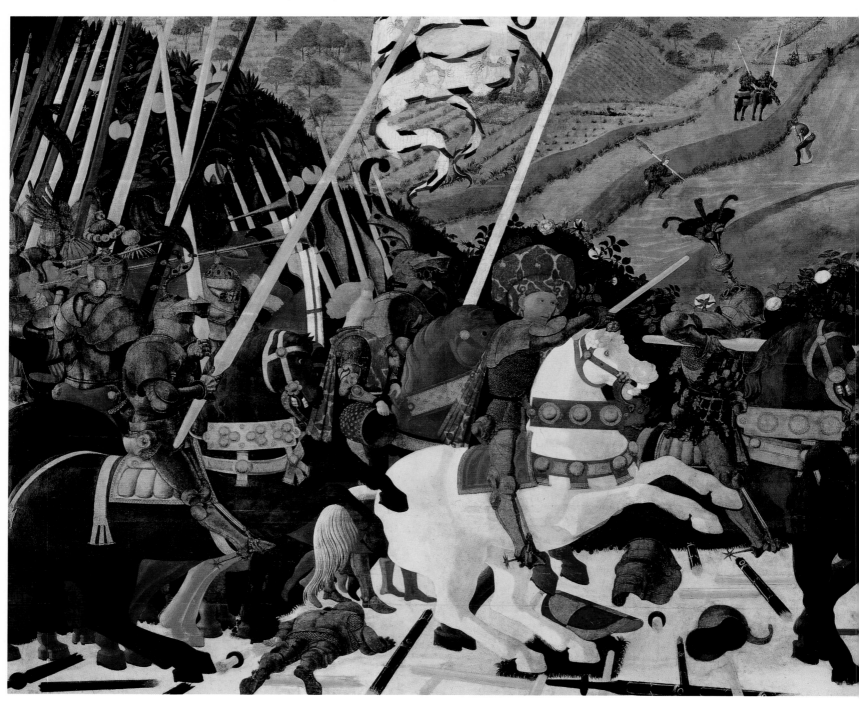

the National Gallery, London. These dizzying works, with their perfectly unrealistic colors, distort, in a spellbinding manner, the "rational" character of perspective to become a product of the purest, most admirable fantasy.

In these battles, perspective serves to immobilize the action, gelling it into a solidified, idealized narrative. The "bizarre and sophisticated" spirit of Uccello, as stigmatized by Vasari, here relegates the space to little more than a theoretical surface (since perspective enables any geometrical form to be represented on a plane), where everything is compacted down to profiles, to a complex of colored zones crisply delineated by an outline.

In the best of the three "battles," the one in the National Gallery, the most striking thing initially is the unreal luminosity of the white horse being ridden by the victorious captain in the center; the whole theatricality of the event, with the clashes between geometric horsemen on the forestage to the right and in the landscape in the background. Other, subordinate sequences are cordoned off by a hedge of roses, and by orange and pomegranate trees: a soldier fleeing, another stringing his crossbow, two other riders who are heading off. These are the emissaries dispatched to Micheletto Attendolo da Cotignola, whom Tolentino had brought back to the Florentine camp.

The interminable horizontal lance that bisects the composition contributes as much to the sense of perspective as the lances on the ground, which are lined up rather expressively and oriented towards a vanishing point located just below Niccolo da Tolentino's baton. The lances parallel to the picture plane intersect with the first, forming a kind of "perspectival network," rather like a pavement: every painter knew that this was the best way to accentuate such an effect. But how does the perspective work exactly? In this battle, as in the two others, Uccello did not use one vanishing point, but several. The dead soldier lying prone on the ground at the bottom left is depicted in exaggerated foreshortening, appearing to fan out towards the background, as if pictured in perspective, but reversed. An error? No: as an artist, Paolo Uccello knew better than anybody that theories are made to bend to the less rationalist demands of art.

Paolo Uccello (Paolo di Dono), Florence 1397–1475 Florence
The Battle of San Romano, c. 1438–40.
Painting on panel, 71½ x 125 in. (182 x 317 cm).
National Gallery, London.

Piero della Francesca
The Dream of Constantine, c. 1460

The Dream of Constantine is not necessarily the most famous fresco by Piero della Francesca in Arezzo, but, situated in the bottom register, right at the back of the choir, it is one of the most poetic. There, more than elsewhere, the theorist and author of several treatises on painting and perspective takes a back seat before the brilliant artist, who here creates not only the first "nocturne" in all Italian painting—as Caravaggio will one day recall and which Vasari cites with admiration—but also a peerless meditation reflecting the high point of his explorations of light and color.

It was in 1452 that Piero della Francesca began painting his most substantial work, the great cycle of frescoes covering three walls of the choir in the church of San Francesco at Arezzo. These were devoted to the legend of the True Cross as recounted by Jacobus de Voragine in the *Golden Legend*. Finished in 1459, it is divided into ten main episodes, which the painter organized not according to narrative logic, but according to formal echoes, with a contrasting juxtaposition between the full faces and the profiles, and so as to satisfy the passion for symmetry and for the emphatic frontality that typify his work.

Vasari alludes to Piero's "new and gentle manner," but he says nothing of his quest for the essential structure of form and for geometrical simplification (in which he follows in the footsteps of Uccello, whose art was a great influence on him), nor about the static equilibrium and the exemplary, almost magical luminosity of the air that washes over the figures, nor again about their impassive detachment and gloriously ample—yet graceful and solemn—gestures. But Piero della Francesca's interest in the perspectival construction of space never waylaid him into making his compositions artificial or schematic.

The scene showing Constantine's dream recalls the time when the Roman Empire was being torn apart by the rivalry between him and Maxentius. The night preceding the battle at the Milvian Bridge (October 28, 312 C.E.), Constantine was sleeping in his tent when an angel appeared, foretelling of his victory under the sign of the Cross. And so, brandishing the Christian emblem, as Piero shows in the following episode, Constantine earned a great victory over the "pagans."

Della Francesca here translates the concerns of his patron Bacci and of the Church of his time, for whom the fall of Byzantium (in 1453) and more especially the encroachment of the Ottoman Empire was a cause for concern. Constantine the Great, as painted by Piero, thus symbolizes the victory of the Church over the unbeliever and voices an appeal, perhaps, to the spirit of the Crusades.

The intense and exceptional light flowing from the celestial messenger (whose shape could be described, at the very least, as bizarre) bathes the scene in a light at once supernatural and dreamlike, with contrasting reflections and chiaroscuro effects that plunge some areas into darkness and illuminate others. Any theatricality is tempered, however, by an overall stability in composition and by the faint glow emanating from the slumped figure who stares out as if in a waking dream.

Piero della Francesca, Borgo San Sepolcro 1410–1492 Borgo San Sepolcro
The Dream of Constantine, detail of the "Legend of the True Cross" cycle, c. 1460. Fresco, 129½ x 75 in. (329 x 190 cm).
Bacci Chapel, Church of San Francesco, Arezzo.

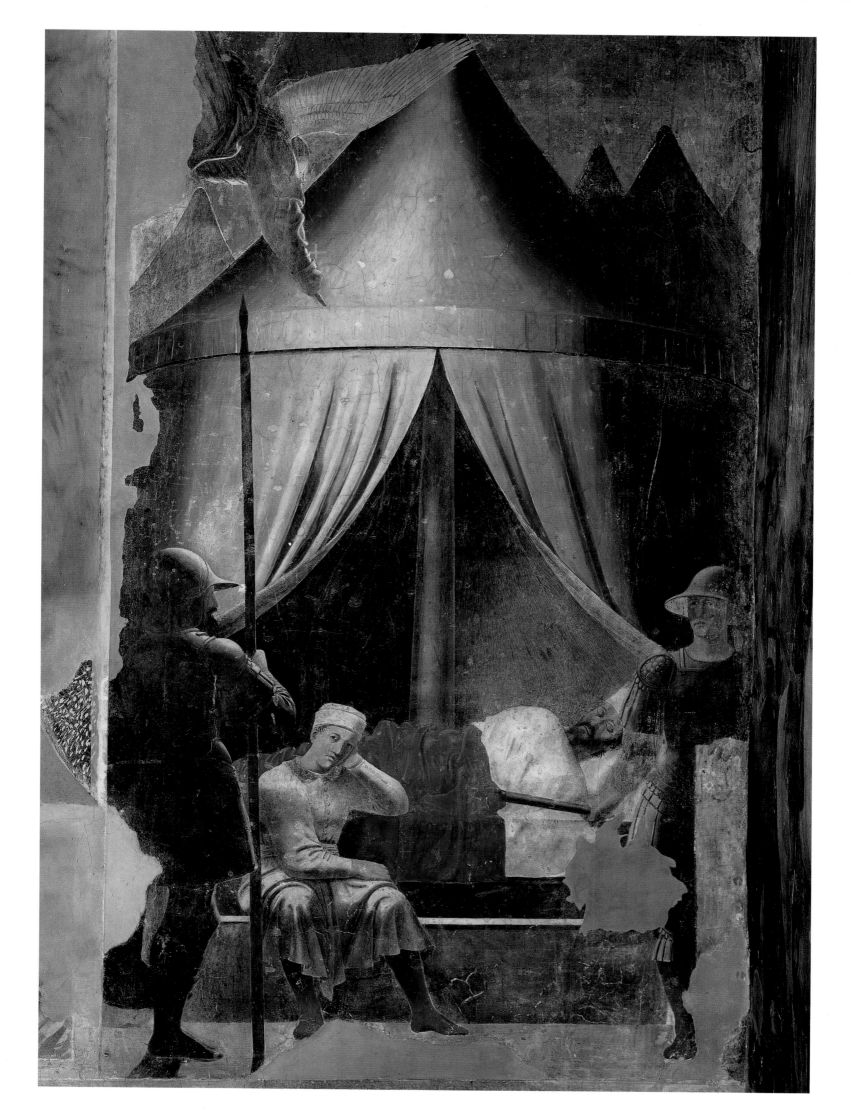

Sandro Botticelli
Primavera, c. 1478

Botticelli, the nickname of Alessandro Filipepi, means "little barrel." As a youth this virtuoso artist entered the workshop of Filippo Lippi, whose influence was to endure in his work, and who belonged to the intellectual coterie that had coalesced around Lorenzo de' Medici.

Greatly esteemed while alive, Botticelli fell into oblivion after his death, being rediscovered only in the nineteenth century by the Pre-Raphaelites. It is clear that the history of art is not a fountainhead of immutable truths, but a sequence of contradictory statements, under constant revision, especially by contemporary painters. Wasn't it the cubists and the surrealists who were the first to blow the dust off

Paolo Uccello, just as Rossetti and Swinburne had done for Botticelli?

If Piero della Francesca represents the apogee of the serenely equitable art of the fifteenth century, in which the beautiful identified itself with the good, the art of Botticelli, an artist from the second half of the century, unfolds against a backdrop of uncertainty and crisis all over Italy, but especially in Florence, with the assassination of Giuliano de' Medici, the execution of the Dominican friar Girolamo Savonarola, whose fiery sermons had awakened many a conscience (notably that of Botticelli himself), the fall of the republic, and the expulsion of the Medicis in 1494.

Before, at the end of his life, he gradually succumbed to melancholy, despair, loneliness, and religion, Botticelli, whose art Vasari described as "virile," had been a celebrated painter, protected by Lorenzo who, after the foiling of the Pazzi conspiracy in 1478, appointed him official painter. So this refined, more or less esoteric painter was able to give form to the Neoplatonic dreams of Cosimo de' Medici and the philosopher Ficino.

Neoplatonism was a movement which, taking its cue from Plotinus, attempted to fuse the thought of Plato, Aristotle, and the Stoics. For Neoplatonists, love is an emotion completely detached from passion: contemplative and transcendent, a path to absolute truth, to the secrets of the universe, of God and his perfection. This is more or less what one finds in the famed yet enigmatic *Primavera* ("Spring"), where Venus disports herself within an orange grove with her companions. The Three Graces dance a graceful roundelay about her, while her blindfolded son flitters about above. To the right, one sees the metamorphosis of the nymph Chloris as she flees the unwelcome attentions of Zephyr. Regretting his violent passion, the wind transforms her into Flora, goddess of spring flowers. As for Mercury, messenger of the gods, on the extreme left, he gestures with his right hand raised, banning the clouds from entering this Neoplatonic garden where, according to the Medici court poet, Angelo Poliziano, eternal spring and peace will reign.

The slightly melancholic grace of this picture (the expression of an ideal that was being increasingly threatened in the years it was painted), is decidedly Florentine in its impassioned line, which is precise yet fluid, and frames the marmoreal modeling of the bodies wonderfully.

Sandro Botticelli (Alessandro Filipepi), Florence 1445–1510 Florence
Primavera, c. 1478. Tempera on wood, 80 x 123½ in. (203 x 314 cm).
Galleria degli Uffizi, Florence.

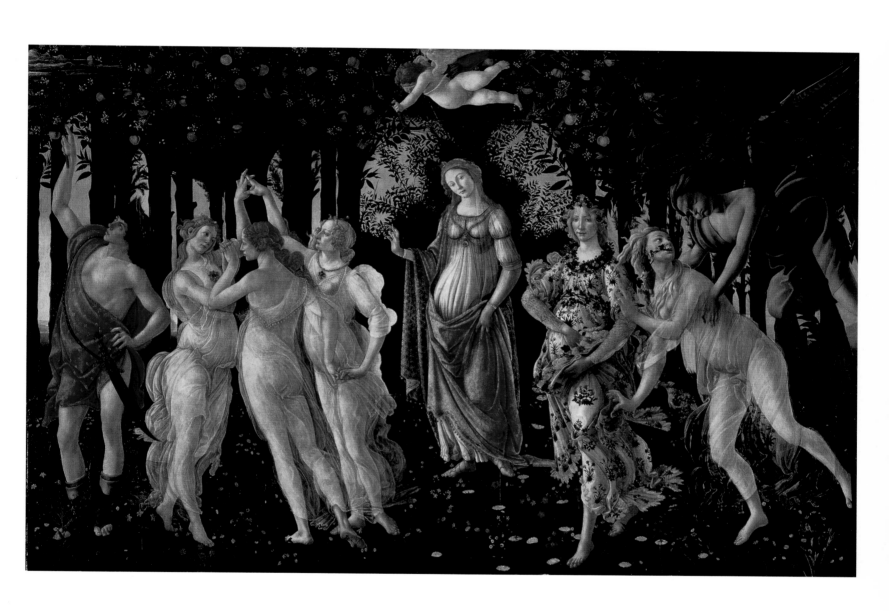

Giovanni Bellini
Sacred Allegory, 1490

In Venice, painting, at least in modern terms, starts with the Bellini family: father Jacopo, sons Gentile and Giovanni, as well as a daughter, Nikolosia, who married Mantegna.

In Venice, there is a "before" and "after": the Bellinis. From the Ducal Palace, restored by Giovanni, to the portraits of Sultan Mehmet II which Gentile executed in Constantinople (where he'd been sent by the Serenissima Republic), quite apart from altar paintings, the Bellinis seemed such an incarnation of the destiny of Venetian painting that the *paterfamilias* was nicknamed "Jacopo Veneto."

Astride two worlds, that of the fifteenth and sixteenth centuries, Giovanni Bellini belongs by his spirituality to the first, but prepares the way for the second, especially in his discovery that space can

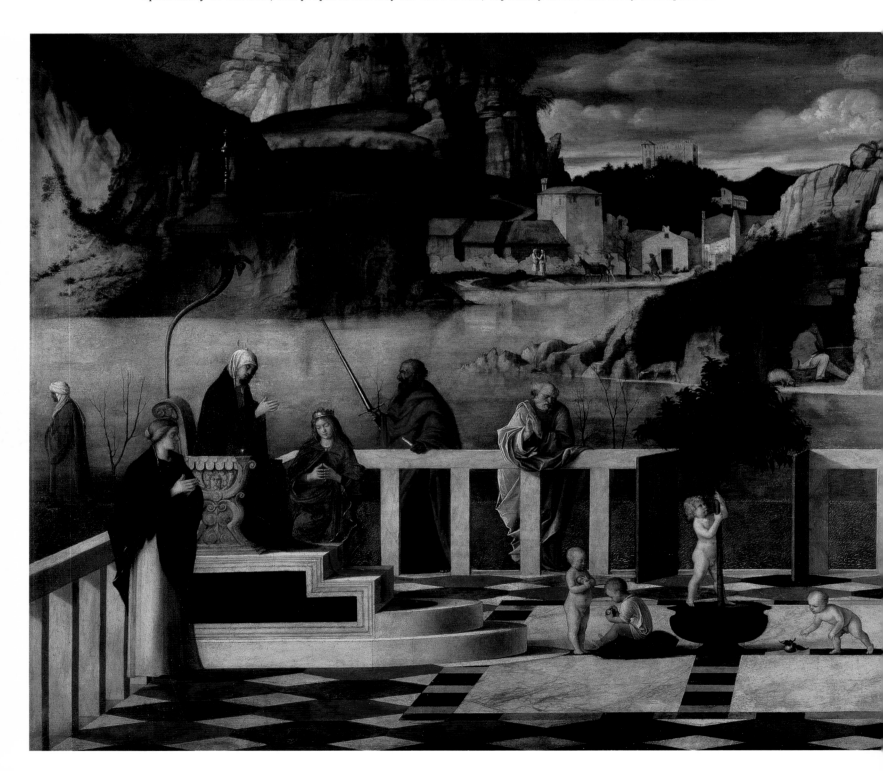

be rendered by tonal relationships, a technique that exerted a profound influence on the many artists who, after him, give Venetian painting its enviable reputation.

This allegorical scene is one of the most mysterious paintings in the history of art. In 1858, while he was staying in Florence, Degas felt its fascination and even copied it. Luciano Berti, conservator at the museum of the Uffizi describes it as follows: "The Virgin sits on a throne in a rich, marble-paved enclosure and flanked by two angels. On the other side of the balustrade stand Paul and Joseph, while the Christ Child plays on the floor. Three *amoretti* gather oranges to offer him. On the right stand Job and Saint Sebastian. The background features a marvelous view of a village and a lake boxed in between some hills."

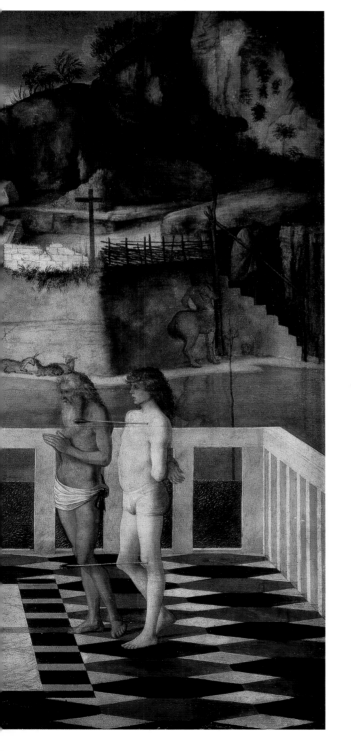

This description omits the tree in the center, undoubtedly a "tree of life," behind which the space cropped by the balustrade opens out. If one can see the young man standing on the right with two arrows in his body as Saint Sebastian, what is he doing next to the swarthy old man, and why is the latter necessarily Job? Why not Saint John the Baptist, whom others have made out in the *putto* plucking an orange? Are the women surrounding the Virgin actually angels? The one sporting a crown could be Justice and the other Truth—or Faith and Hope. The figure wearing a turban on the left who is shown leaving the scene is also passed over in silence, though some have thought he must stand for heresy, being driven out by Saint Paul who brandishes a sword in his direction. Nothing is said either concerning the shepherd or penitent in the distance in his cave, who is perhaps Saint Anthony.

This magical picture has also been thought of as a transposition of a fourteenth-century poem, "The Pilgrimage of the Soul," as a *sacra conversazione*, as a meditation on the Incarnation, as an allegory of Redemption, as a "crib" ordered by Isabella d'Este, or even as a vision of Paradise. The meaning of the work has then been lost.

Its calm and meditative spirit remain, together with this unalterable fact: the art of Giovanni Bellini is primarily contemplative.

Giovanni Bellini, Venice 1430–1516 Venice
Sacred Allegory, 1490. Oil on wood, 28¾ x 46¾ in. (73 x 119 cm).
Galleria degli Uffizi, Florence.

Joachim Patinir
Charon Crossing the Styx, c. 1500

Never mind "Klein blue," Patinir blue is at least as penetrating and powerful and varied and deep and alluring and seductive. Once you've seen the blue in a picture by this Flemish master born in Dinant, there's no forgetting it.

In *Charon Crossing the Styx*, one of his most bewitching pictures, it is made more luminous still by the presence of a bright reddish-brown body standing in a small boat of much the same color, right in the middle of the picture, offsetting and awakening the blue.

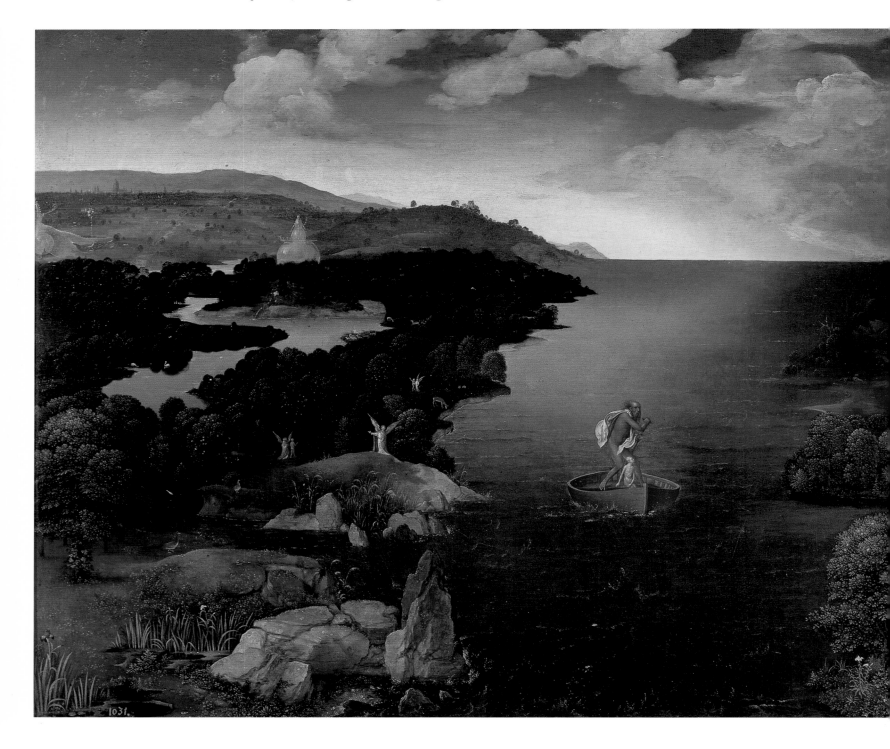

Initially, it is the charm, the magic that one admires in a painter whose work remains subject to archaisms; it is a price worth paying, perhaps, to reach the heart of a mystery where the crystalline rocks are as blue as a stormy sky, where the blue of the rivers, lakes, glaciers, and seas merges with that in the far background.

Joachim Patinir, who died rather young, had only a brief career. Modern historians ascribe some eighteen or nineteen pictures to his hand. That's not many. Dürer, to whom compliments did not come

easily, called him an "excellent painter of landscape." He is meant to have been the first Flemish painter to accord a preeminent role to nature, which now did not just serve a function or act as a backdrop.

His *Charon Crossing the Styx* is one of those meticulously painted pictures that needs to be looked at through a magnifying glass; it is peppered with details and clever little observations scattered among the leafy trees, in the smoke rising from the fires or in the distant prospect.

In the Prado in Madrid, where, when I saw it, it was hanging in a small room devoted to Flemish painting, it was hard to take one's eyes off it, and its fascinating light turned it into a rare jewel. It was like soft, radiant music after the great fanfares of Velázquez and Goya and Bosch.

Did Patinir take the subject from the medieval world? It is true that the painter seems to be reinforcing this idea or convention, showing paradise on the left, with its angels peacefully walking next to those chosen by God, and, farther on, the domes of iridescent glass and agreeably undulating fields. On the right, meanwhile, looms hell and its steep, storm-prone slopes and a tower whose entrance is guarded by three-headed Cerberus, with its fires, abominable creatures, and menacing fears. But this would be to ignore the Styx and the boat, piloted by Charon, who transports the souls of the dead. Patinir, at the junction between the medieval world and the Renaissance, was trying to depict— like Bellini in his allegorical scenes—the harmonious union between the Christian and pagan worlds.

Just as admirable as the crispness and dreamlike precision of his painting is Patinir's propensity for bird's-eye views, pictured as if through a wide-angle lens, with the horizon hovering high up in the composition, as was the tradition in the Middle Ages, the image widening out into scenes of astonishing depth.

Belonging to Philip II's collection, the panel was saved from a fire in the Alcazar in 1734.

Joachim Patinir, Dinant 1485–1525 Antwerp
Charon Crossing the Styx, c. 1500. Painting on wood, 25 x 40½ in. (64 x 103 cm).
Museo del Prado, Madrid.

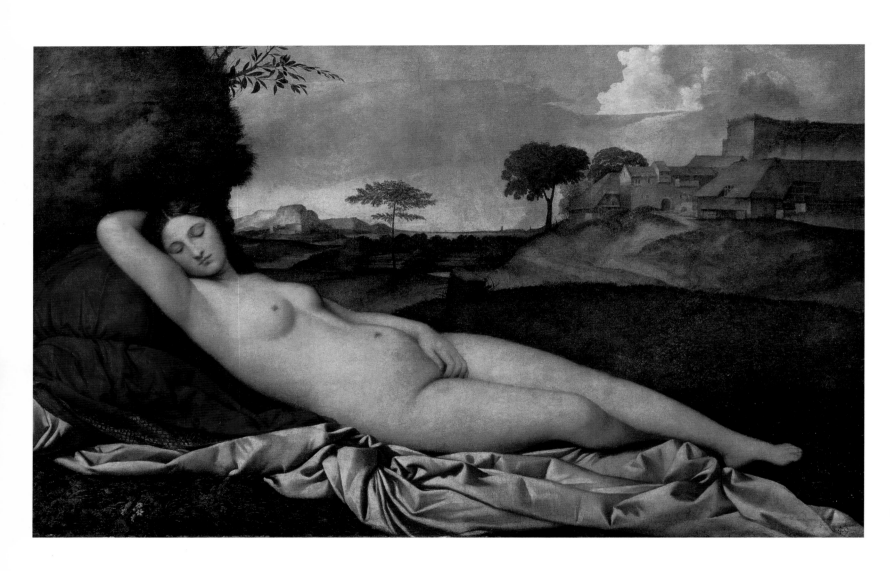

Giorgione
Sleeping Venus, c. 1500

He was good looking, he sang and played the lute divinely, he painted—for an elite circle of refined amateurs—works whose meaning for the layman is problematic, even impenetrable. He was the young master of Titian, who was about the same age and who quickly became his rival, and his life ended when he was just thirty-three. Rich pickings then for myth and legend.

He tore through Venetian painting like a meteor. These were the Bellini years and he was Giovanni Bellini's pupil; he influenced Bellini and Bellini influenced him. They talked and talked, and Giorgione was to come to the fore as one of the first to abandon "colored drawing," and to transpose "living and natural things" directly into painting "without drawing."

He was an innovator and was nicknamed "great George" (Giorgione, in other words); it was through him that the "modern manner" arrived and triumphed. In about 1550, Vasari was to name him—together with Leonardo da Vinci, Michelangelo, and Raphael—as one of the heroes of the new painting based on the notion of tonal color. Throughout his career, Giorgione was to adopt a fluid style, all subtlety and nuance, which, to express his infinitely delicate sensibility, often made use of raking light. And all this was couched in an atmosphere where the extreme gentleness of light and shade allows the landscape and figures to harmonize in a restful, almost deliquescent air.

This limpid art exudes a lyricism, a magic that resonates with the Arcadian poetry of the time and is attuned to the quivering sensibility of the artist. The lyrical purity it expresses is unique, ideal.

Many historians of today turn their nose up when they hear that this *Sleeping Venus* is Giorgione's finest picture. "But it's not exactly a Giorgione," they'll tell you, "it's only partly by him. Look at the cloth under the nude that disrupts the whole composition; that's by Titian, as is the landscape." And when we turn to the commentators of the past: "The canvas of a nude Venus sleeping in a landscape with Cupid," writes Marcantonio Michiel in his *Notes* of 1525, "is in the hand of Zorzo da Castelfranco, but the landscape and the Cupid were completed by Titian." (because there was once a Cupid that has since been expunged by one of the legion of slapdash restorers).

All this is true; but the nude, which is indeed by Giorgione, and conjured up by his hand alone, is—there is no doubt—the most beautiful nude in the world. Locked away in her dreams, blossoming, radiant, yet modest, she is at the same time pure and sensual. Even beleaguered by Titian's extraneous décor (the cloth undoubtedly, and the cushion) that sit so uncomfortably with the serene, pantheist poetry of the composition, the nude still shines brightly, weaving her spell. One has eyes only for her as she lies in line with the hills, eyes closed, in harmony with the world, beneath the dusting from a benevolent sun, as luminous as an epiphany.

Giorgione (Giorgio [Zorzo or Zorzi] Barbarelli; Zorzo da Castelfranco), Castelfranco 1477–1510 Venice
Sleeping Venus, c. 1500. Oil on canvas, 42½ x 68½ in. (108 x 174 cm).
Gemäldegalerie, Dresden.

Leonardo da Vinci
Mona Lisa (La Gioconda), 1503

Much has been made of the declining "aura" of art. Well, *Mona Lisa*'s at least seems to have life in it yet. Even if she is better known in the form of reproductions, T-shirts, ads, posters, and bags of all kinds than in the original, in 2005 from twenty thousand to forty thousand visitors a day hurried to the Louvre to catch a glimpse of her. Her cachet is such that, when she was stolen, people came to gaze forlornly at the

nail from which she once hung; Duchamp iconoclastically painted her with a moustache, and Daniel Arasse had to confess that "in the end" the *Mona Lisa* was his favorite picture because there was still so much to say about it. Does too much admiration kill admiration?

One can now dispense with the myths, fantasies, and "mysteries": today the conditions of the commission are well known. In 1503, the unemployed Leonardo da Vinci responded favorably to a proposition from Francesco del Giocondo, a Florentine dignitary. He wanted a portrait of his wife, Lisa Gherardini, who had given him two male heirs, to decorate the interior of a new residence. As always, Leonardo dithered, carrying off the piece and working on it (in particular on the position of the hands) for a further twenty years. And, as he did so, the picture moved away from being a more or less realistic portrait to attain universal significance.

If one peers closely at this masterpiece, which has been looked at so often, one can just make out two small columns, whose presence is more obvious in the two bulges at the base of the picture. A detail? No: these columns rest on a parapet placed unusually *behind* the sitter, who is thus placed in the same space as the viewer, while her direct gaze also sets up a relationship of equally uncommon proximity.

The setting—all water, earth, and rock—is also out of the ordinary, with not a tree, not a house in sight. There is no agreeable backdrop of the type contemporary painters were in the habit of placing behind their figures, but a primeval landscape: incomplete, transient, fluid. Rather like the halfway smile. As beauty, too, is transitory. So says Ovid and it is what Leonardo is trying to show in this superficially serene picture, where everything is shifting, uncertain, unstable, luminous, and anxious.

Recently, swelling visitor numbers have meant that this mythical picture—a centerpiece of French cultural heritage, used, on occasion, as a diplomatic bargaining token—has had to be moved. Now one shuffles through a sort of funnel closed off by barriers, hoping to glimpse the icon for an instant among the arms of tourists waving digital cameras aloft, or between the heads of those who turn to have a snapshot taken of themselves standing in front of the masterpiece, or who check to see if she is as good as in the reproductions. In her temperature-controlled security cabinet, behind the nonreflective glass that keeps you at a respectful distance (not to mention the curved wooden barrier and a console bristling with electronics), she is completely invisible. Head for the bookshop: you can see her more clearly on a postcard.

Leonardo da Vinci, Vinci 1452–1519 Amboise
Mona Lisa (La Gioconda), 1503. Painting on poplar panel, 30¼ x 21 in. (77 x 53 cm).
Musée du Louvre, Paris.

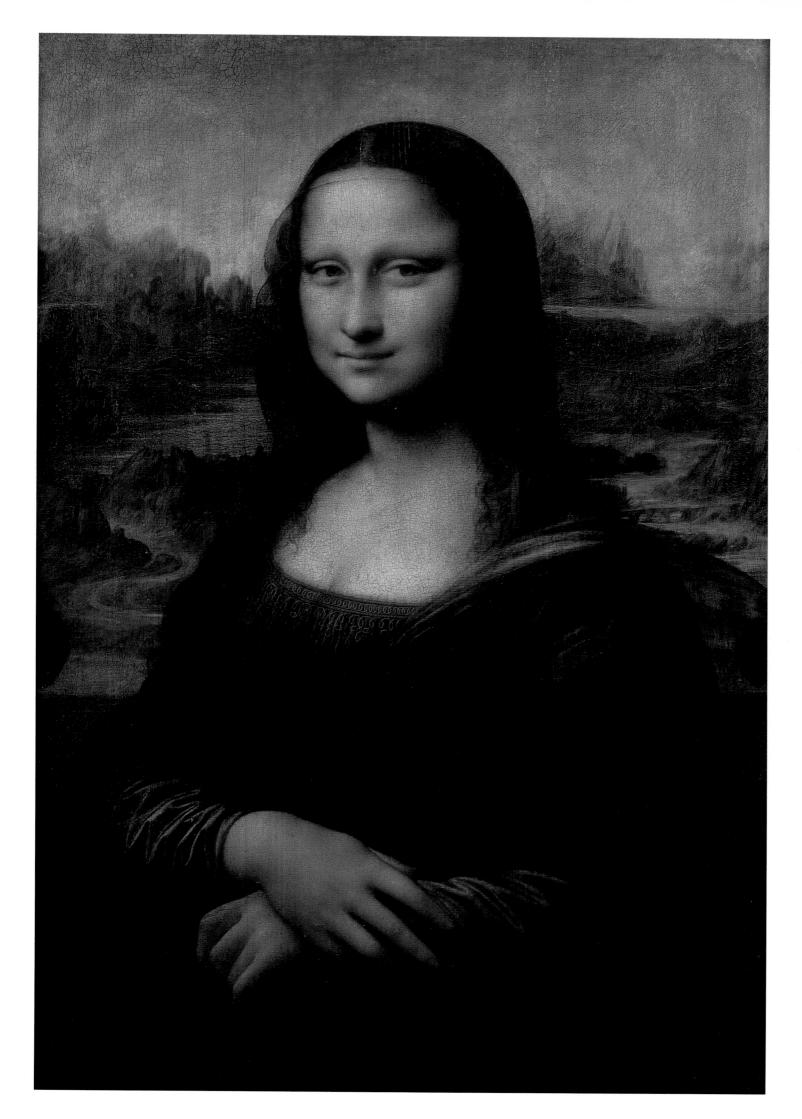

Albrecht Dürer
The Large Turf, 1503

Throughout his life, Dürer loved to learn new things. He traveled, went out into the world, met artists and people from all walks of life, taking in and absorbing a great deal. He was inquisitive about everything, erudite, not averse to scribbling, one who liked to observe, reflect, discuss, theorize, write; he was a painstaking and patient worker, hugely gifted, who sought not so much "the gold of time," like André Breton, but a definition of absolute beauty.

An engraver of the first caliber, a peerless draughtsman, he was so meticulous, so precise, such a virtuoso that he can only be compared to his contemporary, Leonardo da Vinci, as this staggering "tuft of grass" proves.

Dürer was an artist at once more conscious than any other of his own worth, and yet also aware of his own limits in terms of his desire for perfection, which was immense, almost boundless.

He exchanged drawings with Raphael and Grünewald, knew Bellini, Giorgione, and Leonardo da Vinci personally, had studied Mantegna, and influenced Pontormo. He garnered great fame in Venice. In the eyes of his admirer, Vasari, he had but a single defect: he was German.

When Dürer left for Italy for the first time in 1494, he was twenty-three. He explored the Tyrol and the Trentino, painted watercolors of the landscapes, villages, and castles in the manner of the views he had produced at Nuremberg some time before. These are delightful, deliciously spontaneous works, where his flair for observation is served by a sense of color that one would search for in vain in paintings of the same period.

Setting up his studio so that it could operate in his absence, he returned to Italy in 1505. His objective was now to perfect his knowledge of the "secrets of perspective"; for Dürer still belonged to the Gothic world and, with characteristic obstinacy, he understood it was time to escape.

Like the famous *Hare*, *The Large Turf* stands midway between these two trips. For Dürer, this was a difficult period, during which he lost his father, fell seriously ill, and realized he was afflicted by "melancholy."

The watercolors of this time were not exact descriptions: Dürer approaches things on their own terms. These leaves of great plantain standing tall, this Boraginaceae opening its plume of foliage, these tufts of dandelion and the pennate leaves of an umbellifer, this yarrow, all these grasses, such as the meadow grass, the white bent grass, are not symbolic, do not mean anything. Like Angelus Silesius's rose, they are *ohn' Warum*—"without a why."

His patent fascination with nature is conjoined to a mastery that is incomparable: since everything is green and thus has equal value, Dürer has to exploit the finest nuances, being careful not to attach more importance to one element over another, but placing all before us in a single unclouded and self-evident unity. It is a tour de force that conveys all the rapturous intensity felt by the artist.

Albrecht Dürer, Nuremberg 1471–1528 Nuremberg
The Large Turf (*The Large Piece of Turf*), 1503. Watercolor and gouache on paper, 16 x 12½ in. (41 x 31.5 cm).
Graphische Sammlung, Albertina, Vienna.

Hieronymus Bosch
The Garden of Delights, 1503–04

Bosch was an isolated figure among the artists of his time. Rather improbably, he is the contemporary of Leonardo da Vinci and Dürer, but his pictures show no awareness of perspective and seem oblivious to the artistic issues of his era. Conversely his work echoes medieval ideas such as Hell, Paradise, the Devil; evil, vice, suffering; death, the end of the world, damnation, and the Last Judgment. Even his bestiary seems to have escaped from the universe of the Middle Ages. His monstrous figures, his landscapes, his

haunting visions—which some say originated in sermons in which insects and animals were used to represent human shortcomings and sins—stem from a world unaware of, or hostile to, humanism.

Bosch worked at a time when heresy coexisted with mysticism, and when the wave of Lutheranism was clashing with the ideas of Erasmus, whose *In Praise of Folly* was printed in 1511. Lutherans believed that if Man can be saved, it is by the faith he places in God and by the grace that God grants him; Erasmus's followers believed that free will exists and is associated with faith.

Perhaps Bosch's intention was to place before his audience a symbolic moral system in which each might recognize himself and thus find a path to salvation. Satire lurks behind this morality, however; amid a world bristling with legs, beaks, and claws, full of venomous flowers, sexual symbols, and birds with moustaches, of monsters with horrendous teeth, with terrifying tentacles, with their ears cut off, wielding knives, it should not be forgotten that another contemporary of Bosch's was Sir Thomas More, author of *Utopia* (1516).

The Garden of Delights, his masterpiece, painted in 1503–04, appears to illustrate the relatively commonplace notion that pleasure is only transitory and its consequences too awful to contemplate. In the triptych, the panel on the left depicts a curious earthly paradise where animals devour each other; it is idyllic in its ethereal coloring, its transparency and clarity, but already no longer wholly without stain. In the panel to the right, beneath a vast conflagration, lies a terribly terrestrial hell, full of scenes of destruction that also seek to demonstrate the passing nature of all things, with a catalog of abuse, nightmares, and lunacy, encapsulated in the bizarre blue creature with the bird's head and hooked beak who, crowned with a cauldron and seated on a throne, tears apart a human being in its talons.

In the center, *The Garden of Delights* is itself arranged in several "circles," as if in a *Divine Comedy* of a wholly new complexion, with innumerable figures, drunk with pleasure, reveling, intoxicated with abundance, with giddiness, amid the light blues and soft pinks, among hybrids of every species—huge fish, gigantic fruit, fairy-tale cottages. Here, in the midst of references to alchemy, symbolism, esotericism, and magic, the game of life is played out.

Hieronymus Bosch (Hieronymus [or Jeroen] van Haken), S'Hertogen-Bosch (Bois-le-Duc) 1453–1516 S'Hertogen-Bosch
The Garden of Delights (central panel), 1503–04. Oil on wood, 87 x 76¾ in. (220 x 195 cm).
Museo del Prado, Madrid.

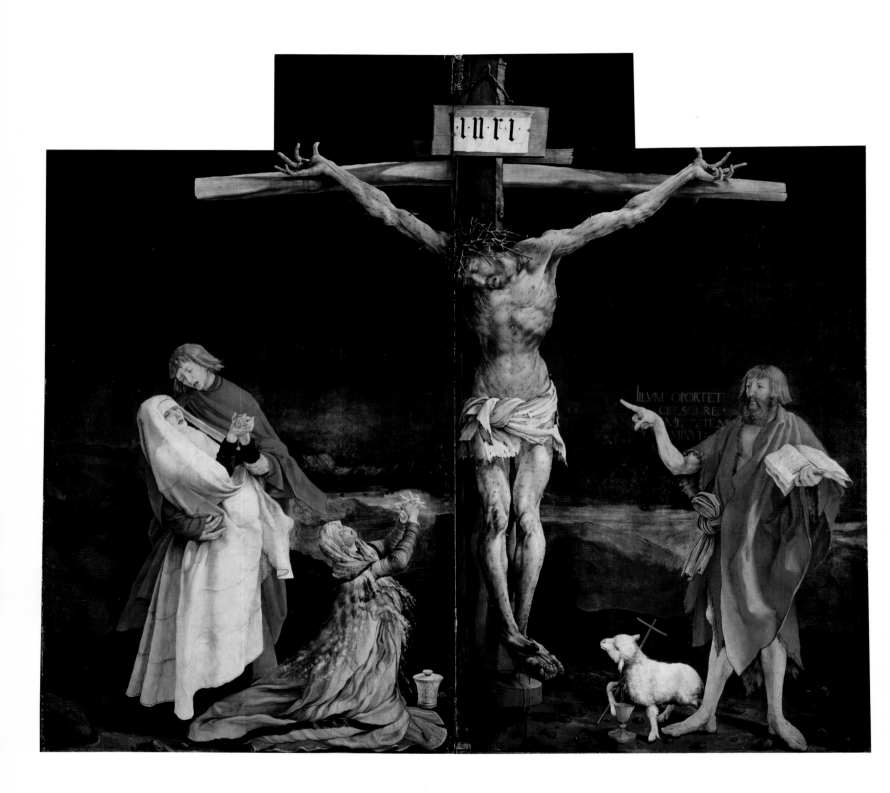

Matthias Grünewald
Crucifixion, 1513–15

This is surely one of the most awesome pictures ever painted: an appalling nightmare, a torture chamber. Nobody had ever painted the crucified Christ in this manner, as a livid and green corpse, fingers grasping convulsively, flesh bruised, sullied, blood-spattered, and raked with splinters. His face is not leaning but sagging, mouth agape as if dumbstruck by his own suffering. This Christ is but a single wound, a body suspended, struck with nails.

Can it be called realistic? No—more like savage. There is too much rage in the expression mixed with too much compassion. It's too rough, too jagged. It's rather coarse, haphazardly composed: the only thing that counts here is emotion.

Just look at the enormous Christ. If you were to place him erect next to the other figures at the foot of the Cross, he would tower like a giant. Lay his arms flat along his body and they'd reach down below the knees. Nothing could be "falser" than such a figure, but nothing is more extraordinary: sheer size and lack of proportion give this tortured body who so suffered for Man a formidable, undeniable presence. Its impact is unforgettable.

To the left, a group formed of Saint John, Mary, and the Magdalen. In a relatively conventional attitude, Saint John, dressed in red, steadies the Virgin. But Mary herself is an astonishing figure, in a nun's white veils that frame a youthful, very beautiful and hauntingly impassive face on a body thrown back, juddering, arms stiff, hands clasped one within the other, almost insensible with grief. As for the Magdalen, far too small in relation to the oversized Christ, she kneels, an uncoordinated child submerged in despair.

On the other side of the Cross, the figure of Saint John the Baptist stands tall and sturdy, holding an open book in his left hand and pointing to Christ with his right, while the Latin inscription in red letters running down the side records: "He must increase, but I must decrease." For, of course, the Baptist announces the Resurrection—hence his calm, his assurance, a foil to all the pain, the horror, the fainting fits. All this is so powerful, so expressive, that one might overlook the rather busy but dramatic landscape against which the tragedy unfolds.

Extraordinary in every way, this painting is in fact the central scene on the outside of the closed retable. The other pictures and *predella*s depict a miraculously luminous Resurrection, an Annunciation, an Entombment, an angelic concert, and various scenes from the life of Saint Anthony, because the polyptych was dedicated to him. It decorated the high altar of the church of the commandery of the Antonines in Isenheim. The members of this order took in the sick, and all those pilgrims who flocked to pray to Saint Anthony for protection from—or cure for—the toxic condition, ergotism.

Staring at this sorry Christ, the sick could at least comfort themselves with the thought that the God they came to beseech had also endured suffering, distress, and pain, just like them, and in this way surely they felt less bereft, less alone.

Mathias Grünewald (Mathis Neithardt Gothardt), Würzburg 1475 (?)–1528 Halle
Crucifixion (from the Isenheim Altarpiece), 1513–15. Panel, 106 × 121 in. (269.2 × 307.3 cm).
Musée d'Unterlinden, Colmar.

Albrecht Altdorfer
The Battle of Alexander, 1529

When the Italian artists Raphael and Michelangelo—contemporaries of Altdorfer, Grünewald, and Dürer—came to paint their masterpieces, they had a century of humanism and the study of ancient models and mathematical perspective behind them. They thus imposed on their work a quasi-scientific conception of art that did away with any connotation of "handicraft."

Not so the Germans. As Dürer wrote: "Until now, many talented young painters have been trained in Germany without any theory at all, with daily practice as their only guide." But theory isn't everything, and the—admittedly revolutionary—Italian conception was not alone either, as testified by Van der Weyden, Van Eyck, and other Flemish masters.

To understand the revival in Germanic art, one needs to recall the social upheaval and tumultuous impact of the teachings of Martin Luther in 1517 and the resultant adoption of Protestantism in several regions. What Luther said chimed in with the stirrings of the populace and their revolt against injustice. Likewise, it touched artists, compelling them to completely revise their vision of the world and pay heed once again to the words of Meister Eckhart and Nicolas de Cusa, whose concept of omnipresent God bears traces of the cosmology of the ancient world: every object, they taught, shines like an image of the exemplar.

Perhaps it was ideas like these that triggered Dürer's urgent quest for knowledge of the natural world, which he pursued in his drawings and watercolors. It fits in with the "feeling for nature" one finds in Altdorfer, a painter with a strong personality, who was greatly esteemed in his hometown of Regensburg where he was city architect and a member of the inner council.

Most impressive are the tremulous effects in the night scene of *Saint Florian Taking Leave of the Monastery*; still more, the already preromantic flavor of the vibrant if diminutive *Danube Landscape* in the Alte Pinakothek, Munich, in which Altdorfer is one of the first painters to tackle landscape in painting without including figures.

In his masterpiece, *The Battle of Alexander*, showing the victory of the young Greek sovereign over Darius (which might also have been conceived as a triumph of light over shade), the landscape sucks in every human action—even the most illustrious, the most heroic. The landscape absorbs all the tragedy of the situation in a mix of somber and violently luminous colors: tempestuous, whirling, even cataclysmic. The sky howls, exalts, suffers, strains, and remonstrates. In the end, what the action abandons on the individual level is amply repaid on the cosmic. And it is extraordinary.

It should not be forgotten that it was in 1543 that Copernicus in his *De Revolutionibus Orbium Coelestium* (completed in 1530, but only published by a Lutheran printer in Nuremberg thirteen years later) depicted for the first time a cosmos in which the earth is not fixed any more at the center, but instead rotates around the sun.

Albrecht Altdorfer, Regensburg 1480–1538 Regensburg
The Battle of Alexander, 1529. Painting on wood, 62¼ x 47¼ in. (158 x 120 cm).
Alte Pinakothek, Munich.

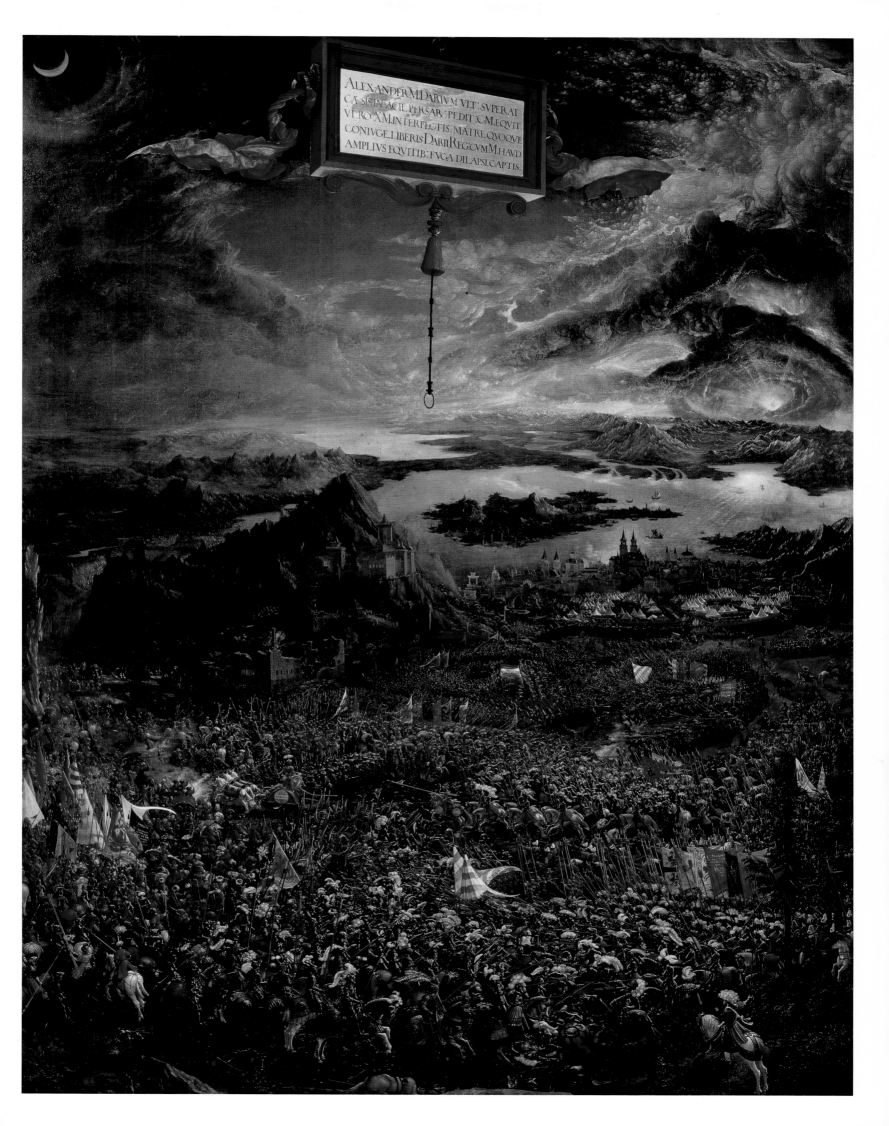

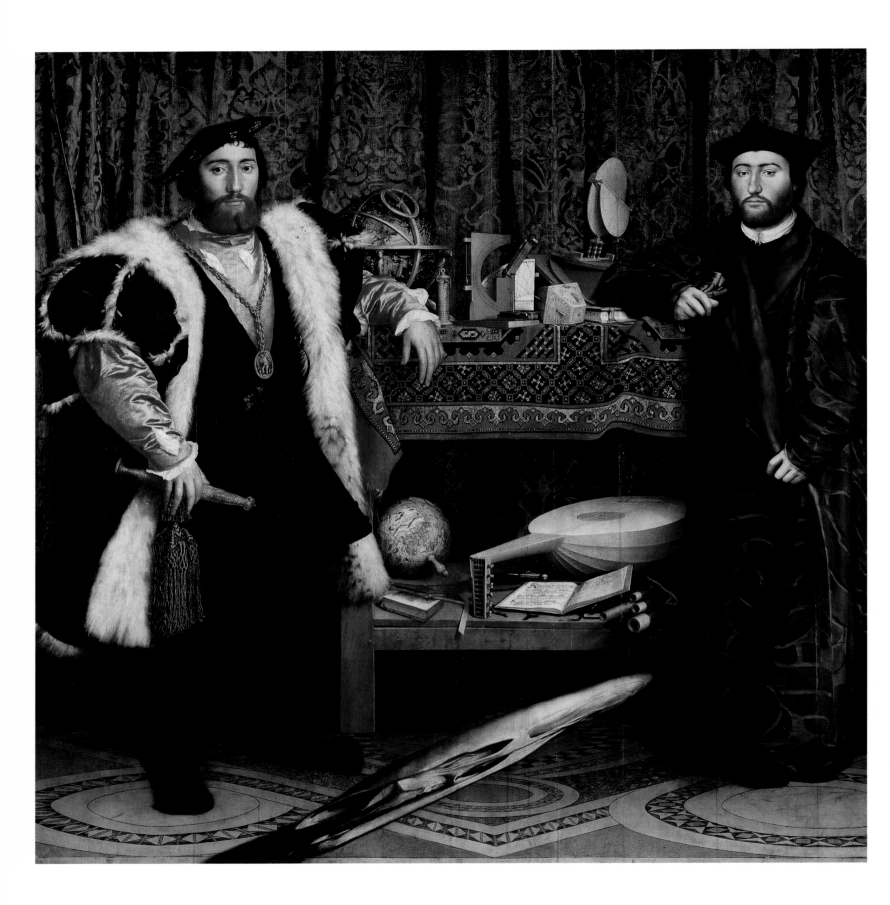

Hans Holbein
The Ambassadors, 1533

Holbein was the greatest German portraitist, and perhaps the greatest portraitist in the whole history of art. He died of the plague in London in 1543, aged forty-six.

Born in Augsburg in 1497, he had come to Basel in 1515. In 1517, he turned up in Lucerne, the following year in Milan, and the next back in Basel where he was granted the freedom of the city in 1520. In France in 1524, from there he left for London, returning again to Basel in 1528, setting out four years later back to London where he became official painter to the court of Henry VIII. So arguably Holbein could be called an English painter, rather as George Friedrich Handel became an "English" composer two hundred years later.

Holbein had moved to London due to a scarcity of commissions and the excessive austerity of Lutheran lands. In Basel, he had painted a likeness of Erasmus in his usual acute, calm, and objective style, which miraculously captures the intelligence and acumen of the great thinker. Erasmus duly recommended him to his friend Sir Thomas More, who put him up in London. Holbein also created a portrait of More that—needless to say—is marvelously analytical and subtle. "Earnest, chilly, his solidity is frightening. Everything is square in his work," was how the French poet and critic André Suarès saw him. He was the most impassive of painters, a man of facts and material, who reveals nothing, neither his moods nor his feelings.

Yes, except that it was the same painter who produced the disconcerting portrait of his wife when ill, accompanied by her two children, looking old at thirty, riven by disappointment and tragedy, humiliated, embittered, the "epitome of marital misfortune." And he also painted this bizarre piece, *The Ambassadors*, a seemingly effortless, confident, faultless work. On the left stands Francis I's ambassador to the court of Henry VIII, Jean de Dinteville, who ordered the picture as a souvenir of the London visit of a friend of his, Bishop Georges de Selves, himself the future French envoy to Venice.

The work is a double portrait in which two wealthy young Frenchmen, scholarly looking and oozing power, are shown almost life-size, leaning with their elbows on a piece of furniture with two shelves laden with scientific instruments (globe, torquetum or turquet, sundial, magnetic compass, quadrant, compass, set-square), as well as a lute and some books—all symbols of humanism and intellectual curiosity.

Dinteville sports an ermine-lined mantle with puffed sleeves; he wears around his neck one of the supreme distinctions of the time, the chain and insignia of Saint Michael. Selves, in keeping with his station, is wrapped in an austere coat of brown brocade.

The picture reaches heights even beyond Holbein's usual brilliance because of the indistinct object that occupies its lower half. Apparently spoiling the splendor of the arrangement, it is an anamorphosis, a sort of puzzle that, at odds with the composition, looks like a stain, something undesirable. Yet in fact, when viewed from the right of the painting, it is clear that this object is a skull, there to recall the brevity of life and the vanity of all things.

The impassive Holbein was perhaps not as "square" as all that.

Hans Holbein (the Younger), Augsburg 1497–1543 London
The Ambassadors, 1533. Oil on panel, 82 x 82¼ in. (208 x 209 cm).
National Gallery, London.

Xu Wei
Song of the Azure Sky, sixteenth century

While the Italians, Flemings, and Germans were developing drawing, coloring, perspective, and so inventing the Renaissance, in China the nationalist insurrection of the Red Turbans was driving out the grandson of Genghis Khan, Kubla Khan, who had founded the dynasty of the Yuan.

Chu Yuan-chang then proclaimed himself emperor, setting up the dynasty of the Ming, which is said to have marked the onset of a cultural revival after the long Mongolian domination, though this rebirth has more in common with mannerism or a flamboyant decadence than with anything we might identify as a Renaissance.

Xu Wei was a painter, poet, playwright, theorist, and, in particular, great calligrapher. Author of the famous scroll called *Song of the Azure Sky*, he lived under the eleventh emperor of the dynasty, Jiajing, who squandered his energies womanizing and searching for the elixir of life rather than in ruling his country. Xu Wei himself seems, due to his intelligence, literary talents, and knowledge of the art of warfare, to have been an oft-heeded adviser. In 1560, he served Hu Zongxian, the commander dispatched to defend the Chinese coast against incursions by Japanese pirates.

In 1565, however, when his by now disgraced patron was assassinated, Xu Wei found himself thrown into prison. Fearing for his life, he feigned insanity and attempted to commit suicide, but was his madness really fake? He became increasingly unstable, killed his third wife, emasculated himself, and, after seven years in prison, embarked on an itinerant existence completely given over to the contemplation of nature. It was at this time that he formulated his revolutionary ideas on calligraphy and produced his finest work, acquiring a name as an inspired innovator.

Song of the Azure Sky demonstrates his predilection for the Caoshu style, his dynamism, and his customary freedom, and testifies to an exuberance, a dizzying audacity, a brutality even that is virtually unparalleled. In the extract reproduced here, his instability jumps out at the viewer, because he alternates not only characters of various, often clashing sizes, but different styles. At the bottom of the right-hand column, for instance, appears an amorphous, soft *shen* ("spirit"), succeeded by, all alone at the top of the following column, a *fu* ("to assist") that is rough, decisive, almost "classical." Immediately afterwards, Xu Wei launches into a *ru* ("to enter") so out of proportion that it has to be pinned back to the *di* ("earth"), which then staggers into a *shang* ("to climb"), only to grind to a halt at the bottom of the sheet in the great sprawl of a *tian* ("sky"). Out of kilter, perhaps, but madly expressive, too.

Elsewhere, fired by anger or euphoria, Xu Wei crushes the brush, squirts the ink, spatters it over the paper. Unheeding of aesthetic judgments, he abandons himself to the torrid delights of the divine metamorphoses afforded by such tormented calligraphy.

Jean-François Billeter wrote that "his script is like a wounded bird flying over the edge of a chasm." Nothing could be more true.

Xu Wei, 1521–1593 China
Song of the Azure Sky (extract), Ming Dynasty, sixteenth century.
Horizontal scroll, 12¼ x 80 in. (31 x 203 cm).
Shanghai Museum, China.

102

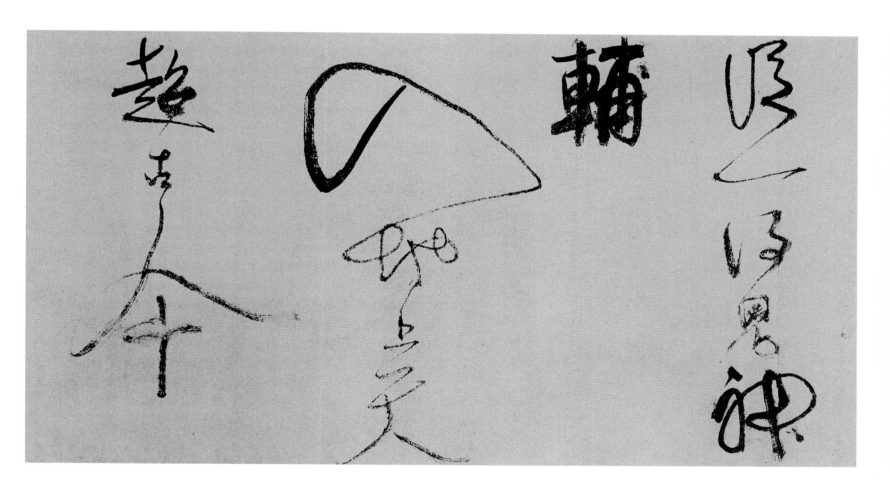

Sultan Mohammed Tabrizi
Divan Hafiz, c. 1533

Shah Ismail, of Azerbaijani origin, was the founder of the Sefavid dynasty (1501–1732). Having entered Tabriz victoriously in 1501, in 1510 he drove the Uzbeks out of the Khorasan. He was at once the cruelest conqueror (he used the skull of one of his enemies as a goblet) and a delicate poet. He was, it was said, as "delightful as a girl." He was to reign over a vast empire covering Azerbaijan, the Khorasan, Iraq, and Persia, on which he was to impose Alevism as the official religion. This branch of Islam, close to Shi'ism, originated in Central Asia before spreading throughout the empire.

He was succeeded by a son, Thamasp I, a less brilliant figure than both his father and his own successor, Ismail II. The latter reigned from 1524 to 1576; he not only fought against the Ottomans in the West and the Uzbeks in the East, but also against his own brothers, Sam Mirza and Alkass Mirza, who both wanted to surrender Azerbaijan to the Ottoman and whom he imprisoned.

The undisputed masterpiece of the Persian miniature in the Safavid era is the *Divan Hafiz*, painted for Sam Mirza, who had been, prior to his incarceration in 1561, one of the foremost patrons of his time. The work itself is probably in the hand of Sultan Mohammed, who is sometimes designated as "Tabrizi," to distinguish him from the four or five other figures likewise named Sultan Mohammed. He is meant to have been head of the Aq Qoyyunlu court workshop, and it is more or less certain that he taught painting to Thamasp when he attained power as shah, thereby considerably increasing the personnel of the *kitab khaneh* or school, while Behzad from Herat became principal counselor and tutor.

The miniature here shows a prince wearing a turban (it has been seen as a portrait of the dedicatee), seated on a splendid rug with a girl at his side. Both are well dressed and appear to entertain tender feelings for one another.

A kneeling page pours them a cup of wine. An exceedingly elegant platform shelters them from the heat. Like a carpet, grass lies all around, studded with neatly drawn flowers, a few trees, and delicately twisting shrubs, serving as a dark background against which the protagonists of this vaguely pastoral scene stand out.

To the left and right, at the bottom of the miniature, two groups of musicians accompany a pair of supple dancing girls playing the castanets. Above, some wonderfully conventional, "crimped" clouds on an ultramarine ground close off what is a composition of admirably restrained lyricism.

For the first few years after the Sefavids gained power, the school's style underwent no modification. Towards 1515, however, changes began to be made, and, by about 1530, the new style was fully fledged, with a softer, understated range of colors and less contrast. As one can see here, the scene is painted with a talent for arranging figures that is quite marvelous, virtually musical. The word harmony readily comes to mind: a joyous harmony.

Sultan Mohammed Tabrizi, sixteenth century
"Lovers Being Entertained by Music and Dancing," Divan Hafiz, c. 1533. 11½ x 7¼ in. (29 x 18.5 cm).
Private collection, Cambridge, Massachusetts. (Formerly: Cartier Collection)

Raphael
Sistine Madonna, 1513–15

Since the Renaissance and in all succeeding centuries (apart from our own), there is scarcely a superlative epithet that has not been applied to Raphael. "Divine" appeared almost too feeble to express the emotions inspired by the peerless art of this genius of balance.

But which Raphael exactly did people have mind? The one that bathes his figures in the precise if remote clarity of a Perugino? The classical creator of the "beautiful form" of the Roman School, the painter of *The School of Athens*, which dates to 1510? Or else the quasi-mannerist of *The Fire in the Borgo* of 1515? It was one year after this that he painted the *Sistine Madonna*, one of the most famous pictures in the world before the *Mona Lisa* made this coveted crown her own, and it is a work that is no way mannerist. Yet it is not really classical either. Ideal, we might say.

The Madonna is in the center, her feet resting on clouds, levitating. She is not on a throne as was the custom in the previous century. To her left is Saint Barbara, and on her right Saint Sixtus. Lower down are two quizzical-looking cherubs—seemingly starstruck since they started decorating sweet tins, CD covers, and greetings cards. One has two fingers on his mouth, the other gazes nowhere in particular, arms crossed over the balustrade or lintel that acts as a forestage.

This angelic twosome has been and still is a source of endless interpretation, from the most commonplace to the most erudite. Tradition has it that they are portraits of the children Raphael is supposed to have fathered with La Fornarina ("the little baker").

According to Daniel Arasse, they are meant as "the Christian figuration of the cherubim who keep the veil of the Temple in the Jewish religion. What they now bear witness to," however, "is the fact they are no longer guardians of the secret or a Lord invisible." Perhaps, because God is indeed here, in the arms of the Virgin, all the more visible as he appears high up at the center of the canvas. He stands between two curtains fixed on a slender rod, which bends under the weight of the green drapes that open to reveal him.

Truth (or the godhead) was once veiled: now it is displayed, it *reveals* itself. That is where the whole import and beauty of this picture reside. If dusted down and cleansed of all commentary (such as that by Dostoyevsky among others), one can simply contemplate the extraordinary humanity of the God Child as he gazes straight out with a serious expression. It is a far cry from the rather saccharine sweetness of *Saint Cecilia*, *Saint Catherine of Alexandria*, *The Transfiguration*, and other pictures in the same genre; here we are in the natural, the deeply moving simplicity of the moment when the Virgin lifts up the Living God so that we might see him.

Raphael (Sanzio Raffaelo Santi), Urbino 1483–1520 Rome
Sistine Madonna, 1513–15. Oil on canvas, 104⅓ x 77 in. (265 x 196 cm).
Gemäldegalerie Alte Meister, Dresden.

Michelangelo
The Last Judgment, 1537–41

A giant. A genius. A superman. An ogre, why not? In all his guises, Michelangelo overwhelms, exceeding all measure. Rodin called him "the last Gothic," and Romain Rolland, "the first of the romantics." He was both one and the other, embracing everything, devouring everything, starting out Gothic, moving to mannerism, overleaping it and, in the meantime, with Leonardo da Vinci, encapsulating the entire Renaissance. A relentless creator, at once sculptor, painter, architect, and poet, he was a demiurge. He believed that man is master over his destiny, and this he was to proclaim throughout his life, in a style that was sometimes overwrought, but with an awe-inspiring power that overwhelms and subjugates.

"Although rich, I always lived poor," he said. This robust, desiccated, squat individual, driven on by a savage energy, was indeed frugal, sleeping rarely, often fully dressed on the very spot where he had been painting or carving. He was tetchy and guarded his independence jealously.

When Julius II commissioned him to decorate the ceiling of the Sistine Chapel in 1508, he began by demolishing Bramante's scaffolding, erecting another to his own design, and sacking all the assistants. He started working alone, grinding his own colors as, flat on his back, he painted the entire vault as well as sections of the side walls. All in all, he produced one thousand square meters of painting.

The first part of the work was unveiled triumphantly to the public on November 1, 1509. After a lengthy gap, during which Michelangelo awaited further funding and tried to get his fees paid, the fresco was finally finished in 1512. More sublime still, more innovative in any case, is the imposing and troubling scene of the *Last Judgment*, which covers the entire wall to the rear of the Sistine Chapel. This was only started in 1537 and completed in 1541, under Pope Clement VII, who had been a friend from his youth at the court of Lorenzo de' Medici.

Traditionally, a *Last Judgment* shows the elect at the top, rising up to heaven, utterly divorced from the damned below. To say Michelangelo paid this tradition scant respect is indeed an understatement. With the body of a divine athlete, the Savior, his right arm raised in a gesture of righteous vengeance, but also (something often overlooked) with the left crooked as if beckoning in the elect, creates around him a dramatic and visionary swirling motion, in which the plummeting damned counterbalance the elevation of the elect—the latter looking like giants determined to take heaven by storm, while the former are bereft, frightened little figures floating in an indefinite space.

One has the impression of being present as the immutable order of the universe is upended, as a world collapses. It should not be forgotten that Michelangelo was as much shaken up by the plague of 1527 as by dire prognostications of the religious reformer, Savonarola. On the vault of the Sistine Chapel, he painted the creation of the world and its re-creation by the Son of Man. Here, it is wrenched apart, explodes, blazes.

Of extraordinary dramatic vitality, the composition frees itself from the frame, disgorging into boundless space, without landmarks. Terrifying.

Michelangelo (Michelangelo di Lodovico Buonarotti Simoni), Caprese 1475–1564 Rome
The Last Judgment, 1537–41. Fresco, 49 x 42½ ft. (15 x 13 m).
Sistine Chapel, Saint Peter's, Rome.

Titian
The Flaying of Marsyas, 1570–76

Which Titian do people speak of when they recall this extraordinary colorist—who lived for almost a hundred years, who started painting with Giorgione and who ceased with El Greco? (When Titian died, El Greco deserted Venice and moved to Madrid.) What common factor is there between the honeyed, luminous portrait of the beautiful *Flora*, and this acid, somber, almost muddy *Flaying of Marsyas*? Sixty years separate the two works; they were not painted by the same man.

At the end of his life, Titian tried to stem the tide of orders (any collection worthy of the name had to possess a Titian) to concentrate on a handful of pictures. This friend of Aretino, this hardnosed and consummately organized artist, who managed his studio like a factory (imposing the idea that a picture leaving his workshop was by him, even if it was mainly executed by studio hands), for the first time in his life started painting for himself, alone.

He could now focus, and at the same time let himself go. He'd try anything. The Vienna *Tarquin and Lucretia*, the *Pietà* in the gallery of the Accademia in Venice, the *Crowning with Thorns* in the Alte Pinakotek, Munich: all are masterpieces of death-defying audacity, where form is laid waste—or almost—by color; distended, diluted by neighboring colors in a manner that disconcerted (that's a euphemism) his contemporaries. It was alleged, of course, that such canvases were painted by a purblind dodderer, or that he'd left them unfinished.

The Flaying of Marsyas is meant to be an allegory of human existence and of the vanity of all things. Marsyas was a Phrygian satyr, and such a past master in the art of playing the flute that the country people voiced the opinion that Apollo could hardly twang his lyre more tunefully. Since Marsyas did not demur, Apollo took umbrage and challenged Marsyas to a contest. The Muses and Midas, King of Phrygia, were to be judges and jury, with the winner earning the right to inflict the punishment of his choice on the loser.

Midas declared in favor of Marsyas (which was why Apollo stuck ass's ears on him), while the Muses opted for Apollo. Since a final decision proved impossible, Apollo squared up to Marsyas: "I bet you can't do on your instrument what I can on mine: turn it over, and play and sing at the same time." This was obviously impossible, so Apollo had Marsyas skinned alive, nailing his skin to a pine tree.

The striking thing about this picture—which seems haunted, as if gnawed at by shadows and by strange, sinister shafts of light—is how calm the gestures are. The flayers seem like professionals who have work to do. Apollo (is it even him?) plays on the violin. Midas is lost in thought.

Only the paint howls—tortured, twisted—with demented brutality, in the grip of chaos.

This incomparable master of color, who graced the splendor of Venice's golden age, here crushes, kneads, and pulverizes materials that crumble and gush, spiraling, oozing, ground to dust into the air. When brushes no longer seemed up to the job, Titian used his fingers. No more lines. No more contours. Just color. In this work, we are on the brink of impressionism, even expressionism—a prodigious achievement.

Titian (Tiziano Vecellio), Pieve di Cadore 1485–1576 Venice
The Flaying of Marsyas, 1570–76. Oil on canvas, 83½ x 81½ in. (212 x 207 cm).
Archbishop's Palace, Kromeriz, Czech Republic.

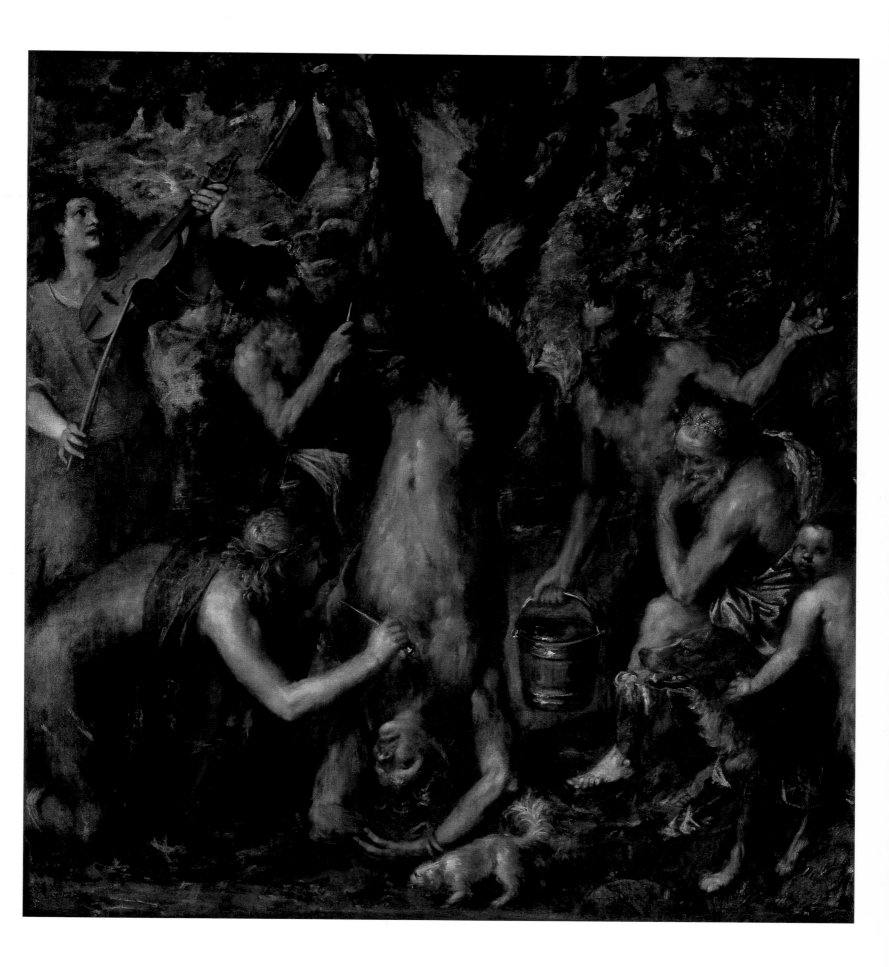

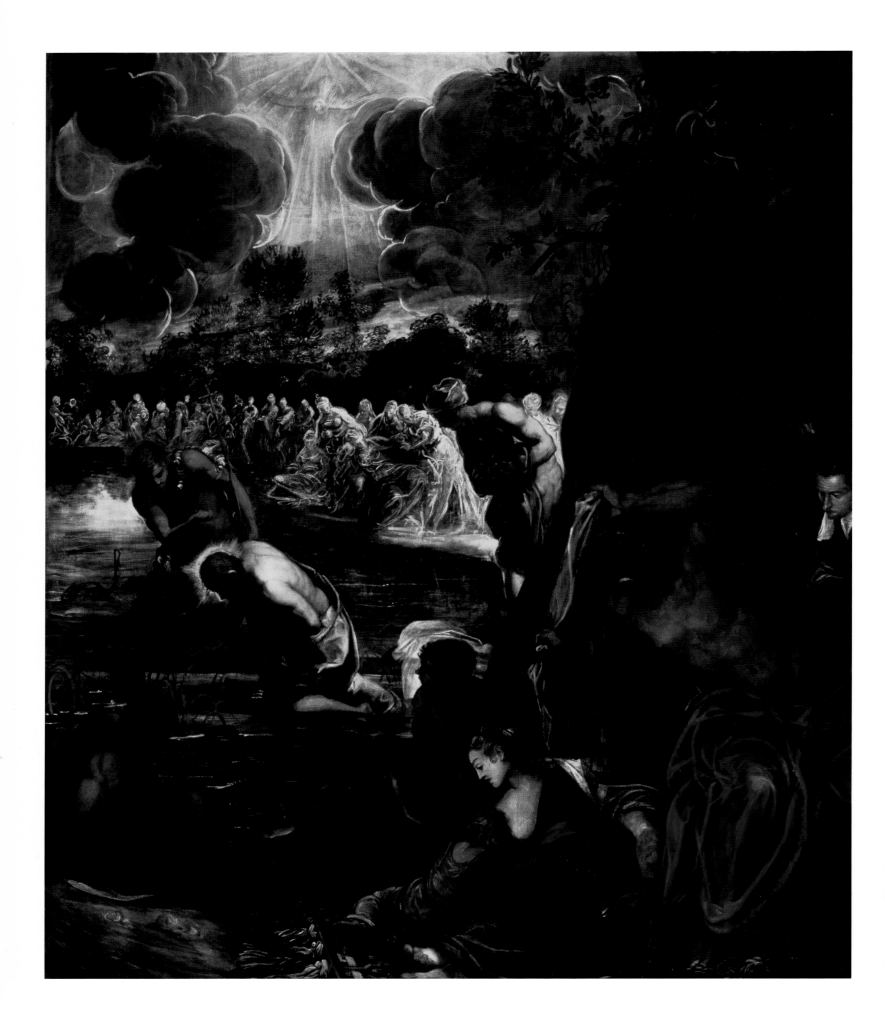

Tintoretto
The Baptism of Christ, 1578–81

Tintoretto worked at extraordinary speed. "People thought he'd just started and he'd already be finished," Vasari declared, calling his rapidity "frightening." One example was in the way he managed to get his first major work, *The Baptism of Christ*, accepted at the Scuola di San Rocco. The members of the brotherhood had ordained that their ceiling would be painted by the artist producing the finest design. Giuseppe Salviatti, Federico Zuccari, Andrea Schiavone, Veronese, and Tintoretto were all summoned. While the others carefully composed sketches, Tintoretto, the son of a dyer (*tintore*, hence his nickname), took the measurements of the site of the work and, with customary dispatch, painted the whole thing, even installing it in the proper place.

When the brotherhood convened to examine the various projects and to make a decision, it could hardly fail to notice Tintoretto's complete work already *in situ*. Extremely annoyed, they pointed out that they had only asked for a drawing, not a complete piece. Tintoretto retorted that this was the only way he made designs, that he could not do otherwise, and that designs should be presented in this manner to avoid misleading patrons. Furthermore, if they did not want to pay him for his work, he would offer it to them as a gift. Thus, in the teeth of considerable opposition, Tintoretto's plan worked.

Having decorated the entire ceiling, he went on to tackle the rest of the Scuola, becoming its official painter in 1564 and producing one of the most astonishing ensembles to be seen in Venice today. The interior of the Scuola is divided into two great halls: one on the ground floor, and the other on the second that opens onto a smaller space, the Albergo, in which the meetings of the brotherhood took place and for which Tintoretto painted a forty-three-foot (thirteen-meter) long *Crucifixion* of incredible complexity.

The Baptism of Christ does not offer the same virtuosity, nor a landscape as beautiful as the one in *The Flight to Egypt* on the ground floor; nor is its composition as original as *The Nativity* to its left on the second floor, or *The Last Supper*, with its diagonal table, which is on the same wall a little further back. However, in this painting it is the inner stress, in both emotion and form, that has the upper hand: the dramatic power of the light that serves as a catalyst to the colors and the brushstrokes alike. The light is extraordinarily mobile and the vitality so imperious; it is incomparably broad, yet taut. And all this fits marvelously with a scene whose subject is nothing less than humanity's emergence from darkness into light.

The picture splits into two unequal sections down a bold diagonal formed by a rock sheltering a woman disrobing. On the left, Jesus is being baptized. All around, in a conflagration of chiaroscuro, vertiginous and dynamic spaces gape, setting up an electricity that neither spoils the delicacy nor defuses the nervousness of the notations. This is a consummate demonstration of Tintoretto's creative vigor and visionary genius.

Tintoretto (Jacopo Robusti), Venice 1518–1594 Venice
The Baptism of Christ, 1578–81. Oil on canvas, 211¾ x 183 in. (538 x 465 cm).
Scuola Grande di San Rocco, Venice.

Paolo Veronese
The Wedding at Cana, 1562–63

He was thirty-five years old when he completed the masterpiece, *The Wedding at Cana*, a tour de force measuring some seven hundred and fifty square feet (seventy square meters) and including one hundred and thirty highly individualized figures, and created in fifteen months. Fresh controversy has broken out surrounding this impressively arrayed crowd: following a restoration that revitalized the

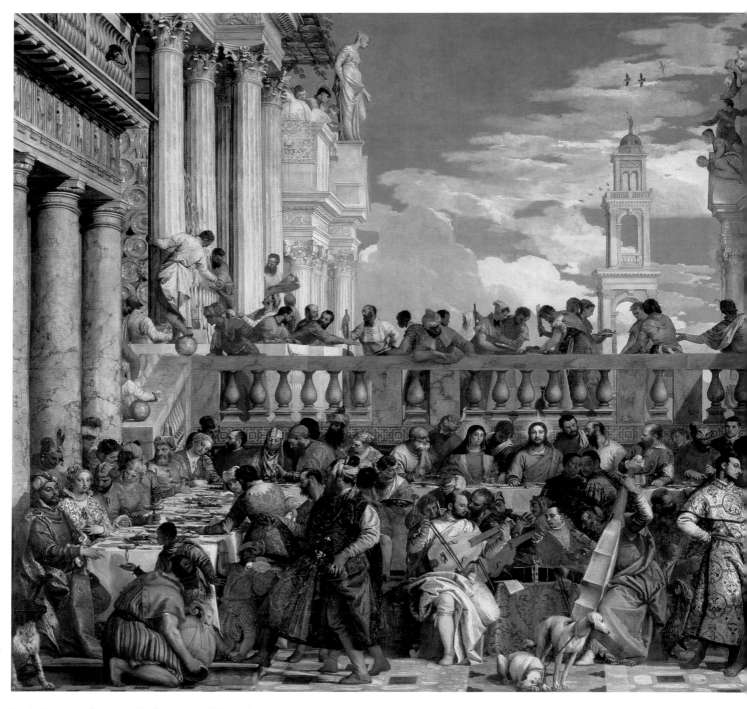

Paolo Veronese (Paolo Caliari), Verona 1528–1588 Venice
The Wedding at Cana, 1562–63. Oil on canvas, 266½ x 391¼ in. (666 x 990 cm). Musée du Louvre, Paris.

harmony of the picture, has the red coat worn by the character standing on the left turned—or has it simply reverted—to green?

In 1560, the Benedictines of San Giorgio charged Palladio with refurbishing their conventual buildings. The first to be built was the refectory. Veronese's modern approach to color associated with his

strong lines and contours had already attracted attention in the many commissions he had received; he was summoned to paint what was to be the only work in the hall.

The contract stipulated that the piece be *monumentale*, so as to occupy the entire wall at the back of the refectory, and that it must also appear to extend the space. Hence the role granted to the sky, painted in a lapis lazuli imported from the Orient by Venetian merchants, which sparks an orgy of blue. Against a theatrical décor, Veronese organizes a truly extraordinary scene, with the upper part of the canvas empty except for the azure sky, while the lower section teems with guests decked out in the Venetian style. Everything seems at the same time everyday and yet hallowed: the meat carved by a servant in the center of the scene symbolizes the mystic body of Christ, while the bone gnawed at by a dog at the bottom of the composition alludes to his impending death. In the foreground is a splendid group of musicians made up of the four great painters of Venice: Veronese himself in white, Tintoretto, Bassano, and Titian in red, playing the bass viol.

Changing water into wine was Jesus' first miracle, but more importantly it was a prefiguration of the Eucharist. The Virgin cups her hands in the shape of a glass that will contain the new wine, the Blood of Christ. This explains her unexpected gravity and that of Jesus amid the light-heartedness of the other guests. Elsewhere, though, the picture radiates joy: in the manner in which the light colors are set off, in its dazzling richness, in its harmony, and in the sheer size of the composition. It was no coincidence that Rubens, no mean colorist himself, kept a score of canvases by Veronese in his studio.

Perfect from the outset, the entire work breathes youthful vitality and ease. This Veronese is a classic, but a luminous one. The immense success of *The Wedding at Cana* led many religious communities to commission similar episodes from him. He executed a large number. In 1573, the tribunal of the Inquisition thought they detected impropriety in certain attitudes and figures in a *Last Supper*. Veronese was ordered to change them, but, having none of it, simply retitled the piece, *The Feast at the House of Levi*, claiming for himself and his art the "freedom of poets and the mad."

He was plainly a man of courage as well as wit.

Nicolas Poussin
Landscape with the Ashes of Phocion, 1648

Poussin was an intimidating genius. He died renowned, admired, not to say venerated by all in his lifetime: his life and work were accepted as exemplary. Yet he died an isolated figure.

He is indeed a paragon, but a remote one. Might one talk about mystery? But nothing could be further from smoke and mirrors than the clarity of his painting, the smoothness of his idiom.

And yet his art, held up as an acme of classicism, is more complex than is generally believed; and the same goes for the individual.

Aged thirty, Poussin left for Rome, staying there—except for a brief and puzzling twenty-two month stay in Paris from 1640 to 1642—until his death some forty years later. Jacques Thuillier is thus

objectively correct in wondering what the "true" nationality of the "French painter" Poussin might have been. But there are so many reasons to contradict him: Poussin was French through and through. He was fascinated by Raphael, by Rome and Antiquity. Yet can he be enrolled by hook or by crook into the ranks of Italian painting? Michelangelo, Pontormo, Caravaggio seem to stand shoulder to shoulder. But Poussin? He's an exception: like those that exist in French grammar, in spite of its reputation for logic.

Was he really so "at ease in this Italy where Antiquity is a constant presence"? Certainly, but that would be to pass over the evident sensuality of a painting scorched by fiery reds. It would also be to ignore what Delacroix justly pointed out when he called Poussin one of the "boldest innovators in

painting," adding that he "arrived in the midst of mannered schools for whom skill was placed higher than the intellectual aspect of art." "Intellectual": now we're getting to the nub of the question. It has been suggested that "if Le Sueur is the painter of feeling, then Poussin is the artist of thought."

That's easy to say. But Poussin is not so readily pigeonholed: in fact, he had two tendencies that fall into two distinct periods. Before his trip to Paris he was fluent, brilliant, theatrical, sometimes vehement; after his return, his approach was "philosophical and poetic, with the idea predominating."

Writing of the *Funeral of Phocion*, the counterpart of *Landscape with the Ashes of Phocion*, Fénelon dubs Poussin a "conscientious artist," whose composition, "although it lacks freedom, and should by rights be termed an 'arrangement,' is of unquestionable beauty in its rigor, and endowed with that symmetry he so admired in Domenichino." Fénelon goes on to say that it should not be forgotten that he "was the true creator of the laws of landscape."

This work exudes a sublime feeling of calm, of majestic impassiveness in the face of the pointless actions of humankind. What is the subject? Phocion, an Athenian general famous for his extreme forthrightness, had been condemned to death on a charge of treason. Even his corpse was banished, being purloined by his widow, who cremated it and collected the ashes.

The landscape is organized as a stoic meditation around a vertical axis in the exact middle of the picture; in an ideal light, exactly at the heart of the world.

Nicolas Poussin, Les Andelys 1594–1665 Rome
Landscape with the Ashes of Phocion, 1648. Oil on canvas, 45½ x 69¼ in. (116 x 176 cm).
The Walker Art Gallery, Liverpool.

117

Peter Bruegel
The Conversion of Saint Paul, 1567

In many respects, Bruegel the Elder seems to be in the tradition of Bosch, following up on a body of work that he is meant "to continue," as apparently demonstrated by his impressive *Triumph of Death* and *Fall of the Rebel Angels* or, better still, by *Dulle Griet* (*Mad Meg*). But let us examine the dates: fifty years separate their careers. The affiliation then can only run skin deep; it is less substantial than is generally believed. The realism of the scenes painted by Bruegel in his ebullient *danses macabres* is quite unlike Bosch's dreamlike "fantastic." As for the coloring of the *Fall of the Rebel Angels*, for example, it provides a vista onto quite another space.

From this point, starting with works teeming with mischief and horror, more carnivalesque than metaphysical, it took a further ten years for Bruegel to come into his own, following such marvelous open-air paintings such as *Haymaking* (or *July*) (1565) and *The Harvest*, where a down-to-earth zest, a truculence or skittishness, combines with a feeling for nature which from now on will form part and parcel of all his works.

He attained genius with pictures based on a process of burying the subject in an indifferent world, in midst of a crowd unaware of what is happening or unable to gauge the significance of the event. For instance, *The Fall of Icarus* (which we know only by what are in all probability copies), *The Way to Calvary*, and *The Conversion of Saint Paul*.

Painted two years before he died, *The Conversion of Saint Paul* shows a mountain landscape like those he must have seen during a journey in Italy, but magnified into a grandiose vision. Slowly, laboriously, a troop of men under arms trundles up a narrow rock gorge through which, in the far distance, one can just glimpse a plain. More or less in the center of the picture, there is a bend in the path, and from there the soldiers disappear towards another distant prospect.

All the horsemen, including the "Italian-looking" one clad in yellow in the foreground on the right, as well as the infantrymen, turn their backs to us, save for a rider wearing armor who stretches out an arm in the direction of the scene that gives the picture its title.

In the distance, one can just see Saint Paul, who for the moment is still only Saul, who has been thrown off his mount in the midst of some soldiers who hardly notice the accident. Bruegel tempers the dramatic quality of the scene, sending a single naturalistic sunbeam to stand for the divine words: "Saul, Saul, why are you persecuting me?"

Because of the way Bruegel depicts the pathway (it seems to peter out into a dead-end), and the black cloud that obscures the bottom of the picture, the scene has been interpreted symbolically. The military expedition to Damascus where Saul was to persecute the Christians is not only halted by his providential fall, it is reassessed, for Saul and his contingent have taken the wrong path. Henceforth they will have to take a different road, to undergo a profound *conversion*.

Peter Bruegel (called the Elder), Limbourg (or Breda) 1525–1569 Brussels
The Conversion of Saint Paul, 1567. Oil on panel, 42½ x 61½ in. (108 x 156 cm).
Kunsthistorisches Museum, Vienna.

El Greco
The Agony of Christ in the Garden of Gethsemane, 1608

If mannerism is exaggeration, what can one say about art of El Greco: squirting, blazing, twisting; all swaying walks, curves, waves, and convulsions? Here the flesh is prey to metaphysical pleasure, to exaltation and paroxysm. Take, for example, *The Opening of the Fifth Seal of the Apocalypse*, one of El Greco's strangest works, with the apostle Saint John, huge, amorphous, arms aloft, staggering as from a hallucination.

This native of Crete came to Venice at the age of twenty-five—where he might have been a pupil of Titian's, but who took more of a lead from Tintoretto—and, in 1577, left for Toledo, where Cervantes, Lope de Vega, Góngora, and Saint Juan de la Cruz lived. He might well be a mannerist, but above that he is an ecstatic, poetic artist haunted by the specter of transfiguration. The work of this troubled, proud, and paradoxical genius, greatly admired in his time, is so chaotic that El Greco, more than any other, questions the very notion of "masterpiece."

It is *The Burial of Count Orgaz* that is, probably, El Greco's "masterpiece," in the way it partitions off a realist lower section, where his exceptional talent as a portraitist is evident, from the more spiritual top part that indulges the consumptive deformations and elongations in which he excelled. Yet El Greco's genius does not reside in what is here a rare feeling of balance. Nor is it in the extravagant instability of his ungainly, harrowed *Laocoon*.

The Agony of Christ in the Garden of Gethsemane is surely the work in which El Greco proceeds farthest down his own peculiar path, where formal daring coincides with the most acute intellectual and spiritual expressiveness. All arrhythmia and dislocation, this painting—played out at night like the majority of his subsequent works—churns up the earth, throws up rocks, bodies, and the sky itself, just as it convulses the soul.

Clad in red, Christ kneels in front of a boulder. Framed by its dark mass, he gazes appealingly at the angel in a yellow cloak who hands him the chalice of the Passion, as if to burst out: *If possible, let this cup pass by me; nevertheless, not as I will, but as thou wilt—not my will, but thine be done.*

Beneath the angel, the apostles doze in a deep crack in a cloud, which, like a gaping maw, recalls that of the whale in *The Dream of Philip II*. The way the clouds, rocks, and drapery all mysteriously morph into mucus, flayed muscles, and peritoneum drew from Arthur Koestler's pen an inspired meditation on the organic viscosity that seems to haunt El Greco's painting. Further on, turning to the Madrid *Resurrection*, Koestler speaks of "resurrection in a digestive tract."

The cloud below left, in the center of which the apostles are sleeping, is echoed top right by a tortured maelstrom of fog, from which emerges, far in the distance, the figure of Judas. A bright light spouts out from the sky above the angel's head, like a dazzling shaft of lightning striking Christ's crimson tunic. There is no more to be said.

El Greco (Domenikos Theotokopoulos), Candia (now Heraklion) 1541–1614 Toledo
The Agony of Christ in the Garden of Gethsemane, 1608. Oil on canvas, 40 x 45 in. (102 x 114 cm).
Toledo Museum of Art, Ohio.

Jacopo da Pontormo
The Deposition, c. 1525

With Pontormo, everything is astonishing, not least his journal, of which its editor Cecchi said: "It is hard to imagine a more sinister document."

For example, this is one entry: "*Tuesday* I started to do the torso whose head faces downwards thus [drawing] I supped on salad and a fish, egg, 10 ounces of bread. *Wednesday* the coating I've done is so awkward I don't think it can come off, there are bulges everywhere where one can make out the joins and I supped on eggs and 10 ounces of bread. *Thursday* I did an arm. *Friday* the other arm. *Saturday* the thigh of the figure thus [drawing]. *Sunday* I dined and had supper with Bronzino and in the morning I planted the peach trees."

What could be more self-effacing, drier, more "sinister" indeed? Nothing could be more unlike the image we have of a painter who appears so theatrical, so contorted, so refined.

While scarcely more than a boy, his masters had been Leonardo da Vinci, then Andrea del Sarto. Raphael foresaw a glorious future for him. Michelangelo, impressed by the youthful painter's intelligence, kept in contact with him until Pontormo died.

It is crucial to grasp the fact that Pontormo was one of the leading lights of Florentine painting. Long discredited and considered as a "decadent," on the contrary he was at the time one of the inventors of a painting style opposed to the classicism and academism of Raphael's followers. It was called "mannerism" in reference to the "new manner" brilliantly promoted by artists like Pontormo. Its detractors, though, were to accuse mannerism of being merely "mannered."

Michelangelo had opened the way and Pontormo leapt into the breach, producing his masterpiece: *The Deposition*.

In 1525, Ludovico Capponi bought the chapel that would bear his name to house his tomb. Initially placed under the auspices of the Annunciation, it was subsequently refurbished and rededicated to the Mater Dolorosa. The principal purpose of the decoration ordered from Pontormo was to underline the patron's desire for the resurrection of his soul. Considering it is a *Deposition*, the first thing that strikes one in this strange, distressing picture, with its elongated, deformed bodies twisted into complicated movements, is the absence of the Cross. Hence the question: perhaps it is actually a *Pietà* instead?

Equally, perhaps even more striking is the crystalline, quasi-lunar clarity of the tender but acidulous coloring, impalpable yet crisply delineated, despite the jostling bodies around the Christ-figure, who is placed well in front of his Mother in a swirl of motion and counter-motion. It is admirable the way the delicate grayish-blues rub up against the bright reds, the gentle pinks become ensnared in the saffron yellow folds, and the blue pale contrasts with the raw green.

What extremism amid the refinement, what nervous sensibility: the artist's ego is driven to the edge in an undying assertion of the self.

Jacopo da Pontormo (Jacopo Carrucci), Pontormo 1494–1557 Florence
The Deposition, c. 1525. Oil on wood, 123¼ x 75½ in. (313 x 192 cm).
Capponi Chapel, Santa Felicità, Florence.

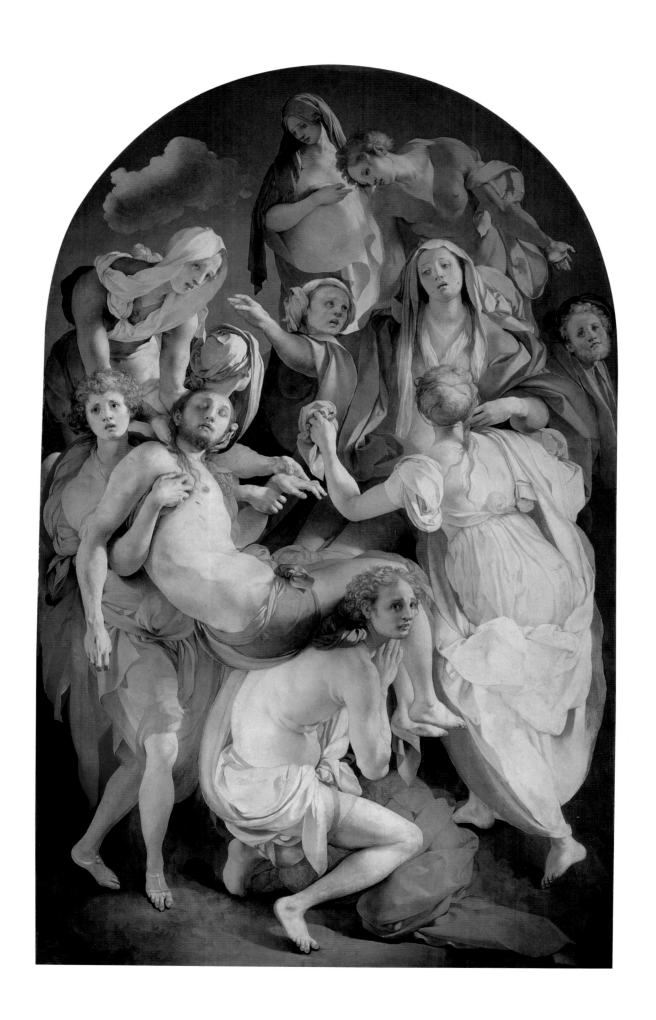

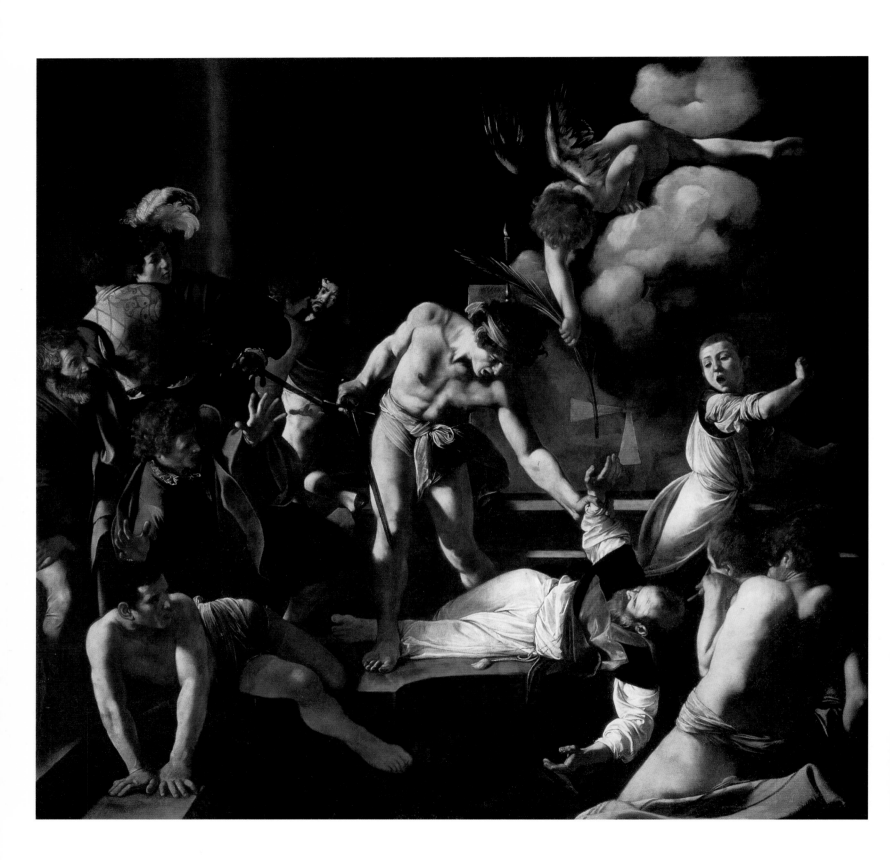

Caravaggio
The Martyrdom of Saint Matthew, 1599–1600

Benjamin Fondane famously characterized the rebellious poet Rimbaud as a *voyou*, meaning "hooligan" or "thug," and the word applies equally well to Caravaggio. Murderer, tumultuous genius: he created a raw violence that crashed through the bloodless sky of mannerism. Life—ordinary, coarse, brutal, real life—spurts straight onto the canvas: splashing, stinking, howling, and tearing off the veil. The paintings show rags, itchy scabs, dirty feet, calloused hands, bloated faces; they are full of never-before-seen obscurities, vehemence, stridency, dizziness, gloom; they show an acquaintance with the depths that no one had ever experienced or transcribed before.

Caravaggio lived in a time of unease that saw Shakespeare write *Hamlet* and Gesualdo produce madrigals of unhinged chromaticism. He knew what a corpse was, how a dagger, a sword, a blade penetrating into flesh actually feels. He did the rounds of the taverns, quarreling, dazed with noise and fury, prey to obscure passions, and fascinated by the inextricable links between pleasure and pain—as one can see in his gory *Judith and Holophernes* and the *Beheading of Saint John the Baptist*—and by the brutal realism that the light and shadow exacerbate. Just as revealing, perhaps more so, is the disturbing *David with the Head of Goliath*, where the disembodied face spewing blood is supposed to be a likeness of the artist.

But the life of Caravaggio, who often spent time in prison and died aged thirty-nine, had another side, made up of sincere and enduring friendships, and support from ecclesiastical protectors in high places in the Catholic Church.

It should not be forgotten that he painted Maffeo Barberini, a future pope, that his brother and uncle were priests, that in Rome he lived in the household of Cardinal Francesco Maria Bourbon Del Monte. Del Monte was a musicologist who was keen on the new sciences and on chemistry, a refined, freethinking gentleman who had gathered around him a coterie of attractive young men—indeed it was thanks to him that Caravaggio obtained the order for canvases for the Contarelli Chapel. Since Contarelli's first name was the Italian version of Matthew, the choice of the subjects represented—the vocation and martyrdom of the saint—is easily explained. Yet, as always, Caravaggio twisted the subject, reinventing it as nobody had done before him.

A riptide of fear, it is uncompromising, murky, and weird; yet the young torturer in the light looks so beautiful. Caravaggio creates a wholly new manner, organized to make the scene appear more real, but emphasizing its spiritual meaning. Look at the movement of Matthew's arms and those of the angel in the midst of this terrifyingly authentic ocean of blackness: the sign of the saint's acceptance of the will of God and of the Imitation of Christ.

It is with *The Martyrdom of Saint Matthew* that darkness seizes Caravaggio's palette. Comparatively Giorgionesque up to that point, it is in this piece that the painter employs a raking, scouring light that eats into the details and illuminates the most dramatic episodes of the story.

The canvas was unveiled to public view in about 1600. Overnight, Caravaggio became a household name. It marked the brilliant beginnings of an obscure light.

Caravaggio (Michelangelo Merisi da Caravaggio), Caravaggio 1571–1610 Porto Ercole
The Martyrdom of Saint Matthew, 1599–1600. Oil on canvas, 127 × 135 in. (323 × 343 cm).
Contarelli Chapel, San Luigi dei Francesi, Rome.

Peter Paul Rubens
Portrait of Suzanne Fourment, 1622–25

A caressing, perhaps loving look; unrestrained genius, glorious sensuality of light, a joy in color that sings, dances, and blazes: that is *The Straw Hat*, a massively popular picture that heralds Renoir.

The traditional title is surprising in that the hat, studded with feathers, is patently not made of straw. The canvas has been duly renamed *Portrait of Suzanne Fourment*. Many have wondered what the relationship between painter and model might have been: had Suzanne been a mistress? There is no cast-iron proof, though everything in this deliriously happy picture and in the three others he painted of her trumpets the fact.

It's all rather a muddle, though. Suzanne Fourment was the third daughter of a silk merchant, and sister-in-law to Isabella Brant, whom Rubens had married in 1609 and who died in 1626. Suzanne, who had married in 1612, was herself a widow by 1621. The following year, she remarried a friend of Rubens, Arnaud Lunden, and died in 1628. Two years later, Rubens married her younger sister Hélène: she was sixteen and he was fifty-three.

With her arms crossed modestly beneath a low neckline, from which peeks out an open chemise, Suzanne gathers round her a gray shawl, which is thrown over a black gown with bright red sleeves. Under a gray, gold-flecked sky, the gentle light, cut off by the broad-brimmed hat, delicately and delightfully shapes her cheeks, chin, neck, and cleavage.

Technically, what the painter has done here is to use a wood panel primed in white, which facilitates the effects of the glaze and the tonal transparency.

This small picture was made while Rubens was toiling on his celebrated cycle of the lives of Marie de Médicis and Henri IV—or else shortly afterwards. No doubt he was happy to be just painting, enjoying a release from the intrigues of the French court.

Rubens dominated his era both in intimate portraits, as here, as well as in the grand lyrical compositions. Painters of all periods delight in his art, from Watteau, who was overwhelmed by it, to Delacroix, who writes in his *Journal*: "He crushes you with all this freedom and audacity."

A man of the Renaissance in the seventeenth century, one of the baroque for whom Italy in 1601 was to change everything (he was influenced both by Caravaggio and Titian), some allege that in his own time Rubens was known primarily as a diplomat. He certainly played an eminent ambassadorial role in the conflict between England and Spain, to the point that General Spinola quipped: "One of his less considerable talents was painting."

Rubens worked on an immense scale, was forever traveling, and was endowed with an extraordinary facility for work. He was head of one of the most active workshops in all Europe, which employed— among others—Van Dyck, Jordaens, and Snyders. Rubens was a man weighed down by gifts: he was multilingual, a collector of antiques, and it was said that he could paint while simultaneously dictating a letter, listening to a reading of Tacitus, and engaging in conversation. His appetite for life must have been awe-inspiring. Rubens was a genius without limits.

Peter Paul Rubens, Siegen 1577–1640 Antwerp
Portrait of Suzanne Fourment ("Le Chapeau de Paille"), 1622–25. Oil on wood, 31 x 21¼ in. (79 x 55 cm).
National Gallery, London.

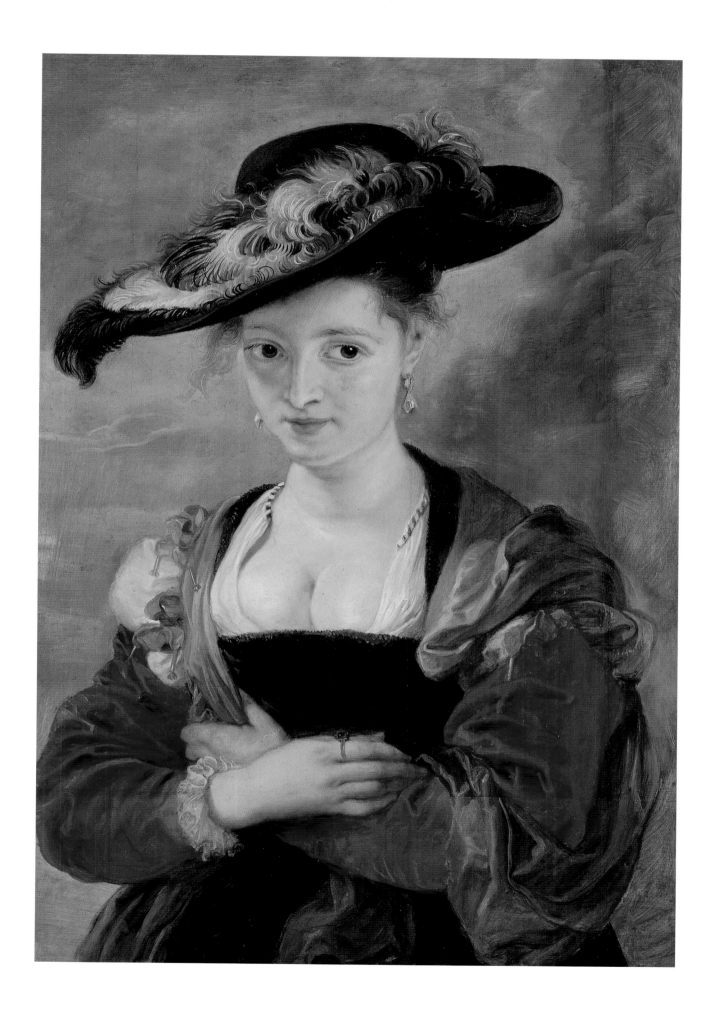

Diego Velázquez
Las Meninas, 1656

Velázquez is the artist whose brush, falling to the ground, was picked up by the king of Spain. "The painters' painter," Manet called him, and every other artist seems to agree. Is *Las Meninas*, then, the "masterpiece of masterpieces"? Does it have a greater claim to the title than the *Mona Lisa*, than *The Last Judgment* in the Sistine Chapel, or than Fan Kuan's *Travelers*?

It is a fascinatingly modern painting, a mixture of realism and non-realism, as masterly as it is

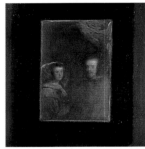

complex. Seemingly the epitome of balance, in fact it makes the head spin. What does it show? A tranquil court scene in the apartments of the Royal Palace. Balthasar Carlos, the crown prince, had occupied them; after his early death in 1646, Velázquez took up lodgings there. In the center stands the Infanta Margarita, surrounded by young ladies in waiting (the *meninas*). One, kneeling, holds up a tray with something in a jug for her mistress to drink.

On the extreme right, in front of two other servants, stands the female dwarf Mari-Barbola with her battered face. Another dwarf, Nicolas de Pertusato, teasingly kicks a dog lolling on the floor. At the rear, the marshal of the queen's palace, pictured climbing up some stairs giving into the hall, draws aside a curtain through which light enters, gently adding to—and competing with—that from another source, an unseen window on the right.

Whether one looks at the scene as a whole—almost homely in spite of an indefinable air of majesty—or in detail, it seems painted, thrown off even, in a way that is almost impressionist, with that foaming light, warm and measured, emphasizing the main subject, the infanta, in muted harmonies of gray and old rose.

But what then is Velázquez painting? Brush in hand, he turns towards the viewer, in front of a canvas approximately the same size as the picture we are looking at, but which we see only from the back? It is surely not the infanta: he scarcely casts a glance at her, any more than he does at the maids of honor or the dwarves. At what or at who is his glance directed, and what are the

infanta, the attendant, and the tiny woman gazing at? They all look to the front, towards something beyond, or rather at something outside the image field, which can be identified if we pay heed to the mirror at the center of the picture; it reflects the royal couple.

That's where everything begins to shift. Because one might recall that the *Arnolfini Wedding*, which was part of the royal collection at this time, also employed a mirror to reveal something lying outside the image field. The same device is used quite differently here, however. The object represented in the mirror is in fact the real subject of the picture. The canvas hides it and the mirror barely reveals it, showing it more as a virtual image than as a representation. The royal couple, the cynosure of the court's attention, is absent from the depiction, yet this lack sets up a tottering space that, paradoxically, is entirely filled by the monarchs.

Diego Velázquez, Seville 1599–1660 Madrid
Las Meninas ("The Maids of Honor"), 1656. Oil on canvas, 127 x 108½ in. (318 x 276 cm).
Museo del Prado, Madrid.

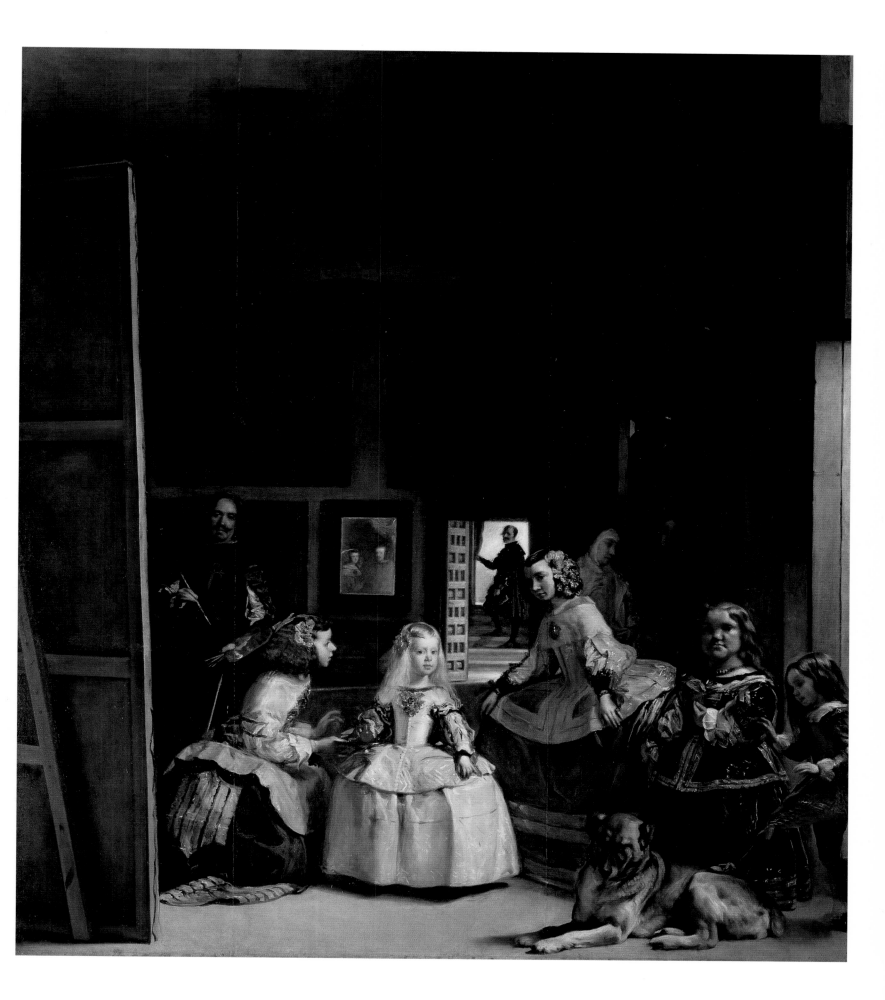

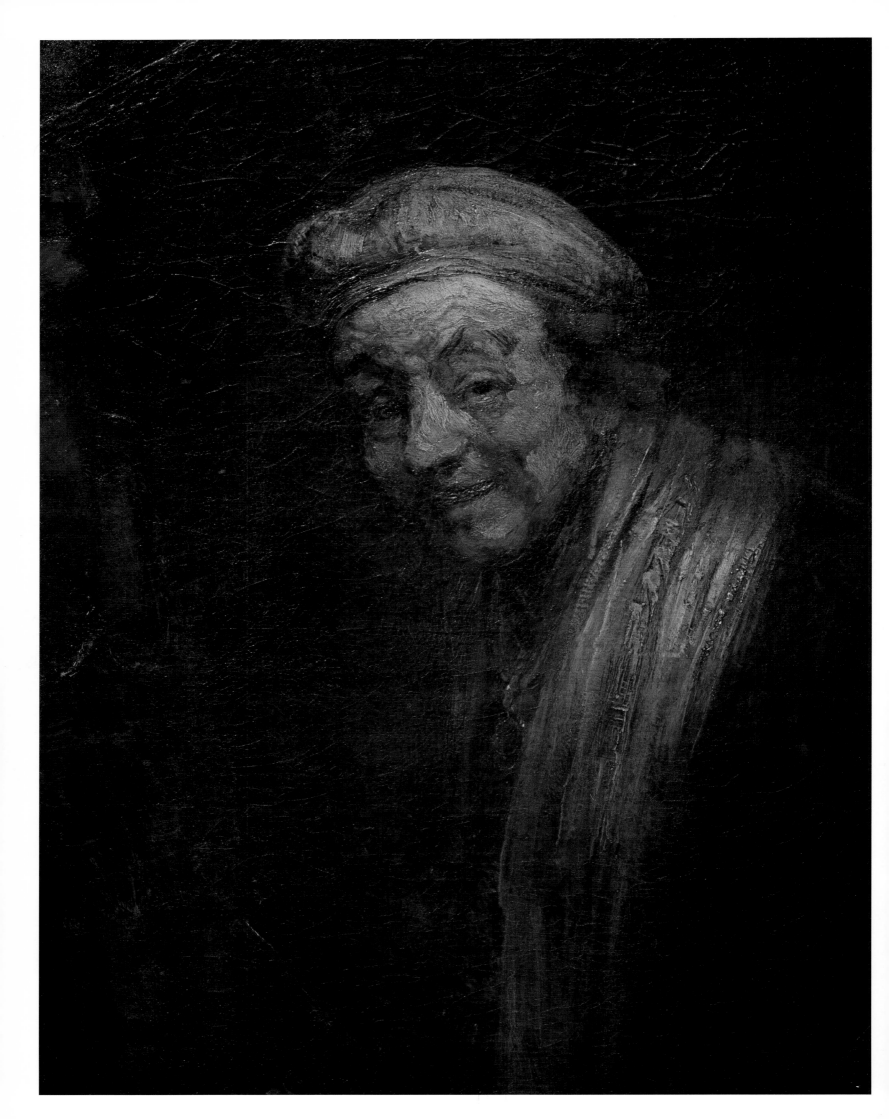

Rembrandt
Self-portrait, 1665

In this, his ultimate self-portrait, is Rembrandt truly prey to a fit of "lunatic laughter," as Malraux claimed? I'd prefer to say he'd turned into paint, totally and utterly. That, finally, he had let himself go and become paint. A thick, reddish-gold paste.

As Jean Genet pointed out in connection with this drunken picture, the riskiest Rembrandt ever painted: "He comes forth as a dauber possessed, color-crazed, jettisoning the feigned superiority and hypocrisy of fakers. In his last pictures, this becomes tangible. But first Rembrandt had to acknowledge and accept himself as a creature of flesh—what am I saying, 'flesh'? Of meat, of scrag, of blood, tears, sweat, shit, intelligence, and tenderness." And he adds, "The face and the background are so red that the whole picture makes one think of a placenta in the sun."

One is not, here, weighing up the triumphs and disillusionments, the scars of a whole life, as in the painter's "great" pictures, the ones that made him world famous, which are so dense, so deep; plunged into a darkness into which, in spite of everything, light still penetrates. Here Rembrandt is cracking up, like some old, slightly mad witch. As for the paint, it simply bellows. With joy? With terror? No: with unaccountable freedom. It lets rip, as in Picasso's last phase. It is a little like innocence on the brink of the abyss. A practical joke, one might say, played by some young whippersnapper. That's what painting is: no great shakes, but wonderful, indubitable.

There exist close to one hundred self-portraits by Rembrandt. He looked at himself in the mirror, aged twenty, with a self-assured and domineering air, gazing out impertinently, a delicate shade of a moustache beneath the nose, a bonnet from a bespoke hatter rakishly cocked on his head and decorated with a pretty feather, all painted in pink and pearl gray.

Ten years later, he tries out the bourgeois-made-good look, a placid face caught between a broad black hat and the impeccable ruff. A little later still, here he is with a self-important air, displaying an earring, his headwear the height of fashion, his plumes worth a fortune, in a coat lined with valuable fur. Ten years on and the substance begins to give at the sides—the face is wrinkled, with a worried, interrogatory look.

He has, meanwhile, been trying out various roles in drawings and engravings: mouth open, wild-eyed, pouting, laughing, or looking none too pleased, or else pot-bellied and complete with saber and an aigrette, with three mustachios, a scarf about his neck, in round hat and embroidered cloak, or else with his hair standing on end.

Rubens and Velázquez depicted kings, emperors, and the great and the good of this world. As for Rembrandt, he painted himself. He observed how time hacked into his face. He saw that it was chiseling him out, and his painting with him. But by the time the end was at hand, when he'd lost everything, when he was something of a has-been, he ceased caring about his appearance, about analyzing his features, perhaps even about fathoming his soul. He let painting and the painting alone do the work.

Rembrandt (Rembrandt Harmensz van Rijn), Leiden 1606–1669 Amsterdam
Self-portrait, 1665. Oil on canvas, 32½ x 25½ in. (82.5 x 65 cm).
Wallraf-Richartz Museum, Cologne.

Georges de La Tour
Job and His Wife, 1650

What a contrast! On the right sits a wretched creature, as old as the hills, drained of strength, laid low by some untold, overpowering misery, almost naked, the torso emaciated and wrinkly, the muscles sagging, beard unkempt, hands clenched, twisted together though it's hard to see exactly how. On the left, in profile, is a huge female, so huge that she has been bent round to fit into the frame, her two feet firmly planted, dressed in flame red, wearing an immaculate apron with perfectly ironed pleats, an ear adorned with a pearl.

Between them a prolonged, intense glance is being exchanged in which the woman's incomprehension is as clear as the man's unadulterated pain. What is happening between them, across the warm light of a candle flame in the heart of darkness? Is it some unspoken reproach, an interrogation, a near-maternal relationship? The man is Job, while she is his wife who, if she is not "mocking" him exactly (as an alternative title has it), betrays her refusal to accept his submission to a God who destroys the innocent and the guilty alike and "treats him as he would do one of his enemies." "Then his wife said to him, 'Do you still hold fast to your integrity? Curse God, and die.' But he said unto her, 'You speak as one of the foolish women would speak. Shall we receive good at the hand of God, and shall we not receive evil?'"

In a color scheme and using a technique so unusual that the work has been the subject of much speculation (being dated, by way of a comparison with the *Woman with the Flea*, to around the 1630s, or, with regard to its maturity, to the 1650s), Georges de la Tour has painted a scene of extraordinary humanity whose subject is this scandal: the silence of God in the face of the existence of evil and the misery of man.

Georges de la Tour represents the mystery of Job's stubbornness with jaw-dropping economy of means. When he was in the Resistance, the poet René Char hung a reproduction of the picture in his command post.

This awesome "nocturne" takes place in a surprisingly motionless silence, scripted by the interplay between glance and hand gesture and unified by an extreme stylization verging on the abstract. Georges de la Tour here dispenses with anecdote and delves into the essential. Caravaggesque in his "night scenes," and yet of a realism close to the brothers Le Nain, here (more still than in his famous "Magdalens") he outflanks such influences and categories to produce a picture that leading French art historian Jacques Thuilier regards as the artist's most daring: his masterwork.

Today, Georges de la Tour is seen as one of the figureheads of seventeenth-century painting; but this is a miraculous comeback. Following his death, he fell into complete oblivion, and it was only in 1863 that a scholar in Nancy tracked him down. It was a further fifty years before a German scholar ascribed two canvases in the museum at Nantes to him. It was not until 1934 that a number of his works were presented at the exhibition *The Painters of Reality* at the Orangerie in Paris, and again not until 1972 that a show devoted to him could at last do justice to his genius.

Georges de la Tour, Vic-sur-la-Seille 1593–1652 Lunéville
Job and His Wife, (*Job Mocked by his Wife*) 1650. Oil on canvas, 57 x 38 in. (145 x 97 cm).
Musée Départemental des Vosges, Epinal.

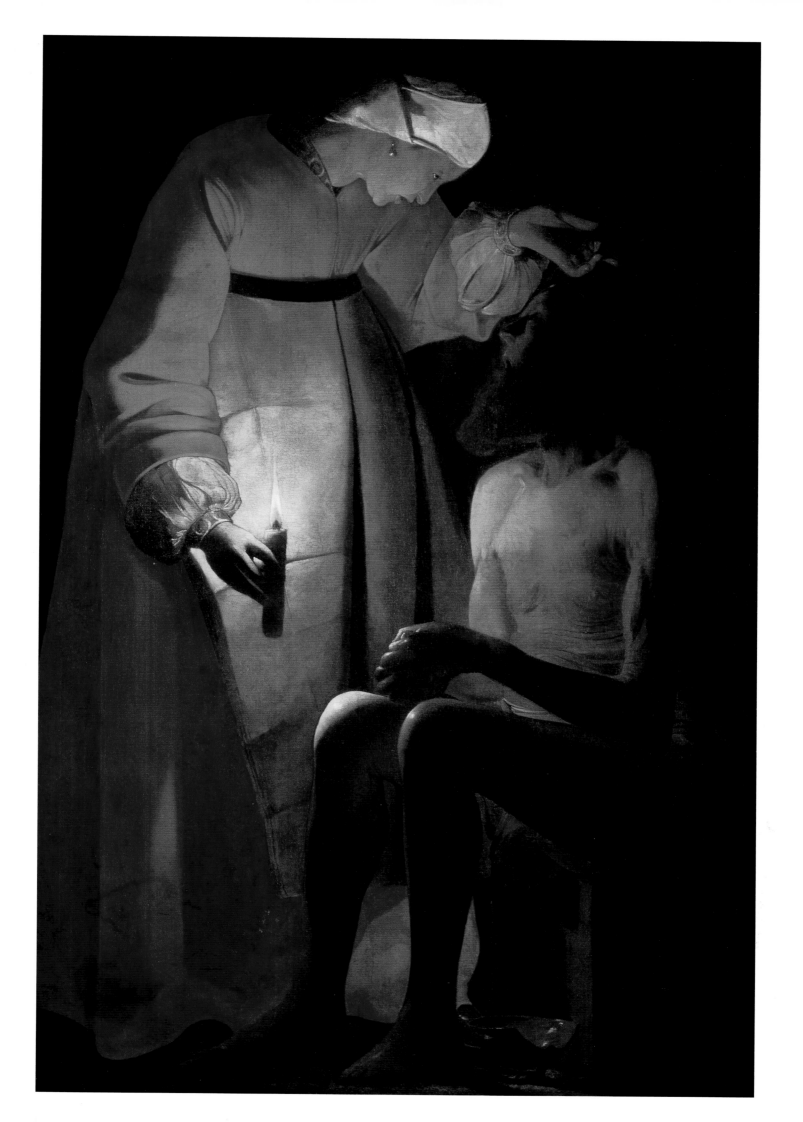

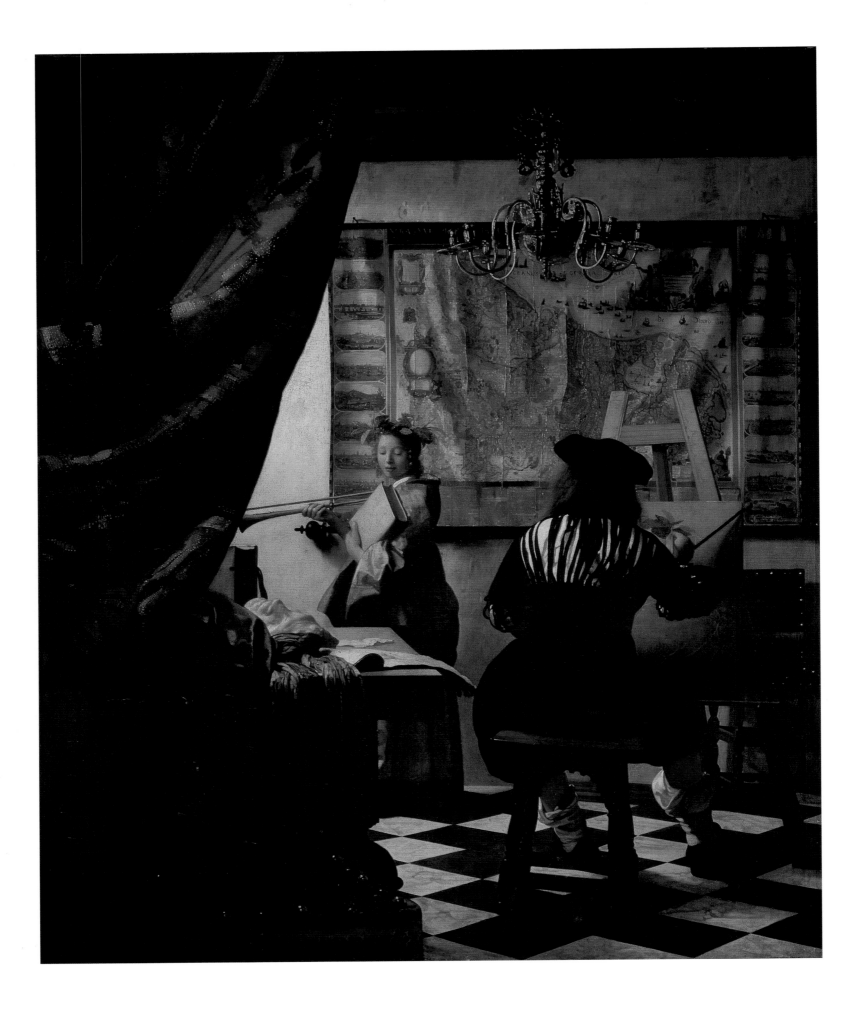

Jan Vermeer
Painting, 1665

Entitled by Vermeer himself *The Art of Painting*, for a long time known as *The Painter's Studio*, and now called simply *Painting*, this picture represents, at the fulcrum of Vermeer's art, an allegory, but a singularly realistic one, bewitched by light and silence.

The painter has set the episode in a studio, surely his own. On the left, a heavy curtain is drawn back so as to reveal the scene and some furniture: a chandelier without candles as it is daytime, the window dispensing a soft but adequate light, a chair in the foreground that provides depth to the representation and, more prosaically, holds the curtain in place, tiles that accentuate the virtuoso and complex perspective, and a stool, the painter's easel, and a large map on the wall.

The map shows the Netherlands. The borders, however, are not as they appeared in Vermeer's time, but as they had been in 1581, when Holland, through the princes of Burgundy, was part of the Habsburg Empire. Vermeer's map refers then not to a political unity, but to a pictorial one: that of Dutch painting. It is well known that Amsterdam was a great center for publishing engraved charts and maps. Walls were decorated with these maps, which corresponded to a striving for knowledge as well as to a pride in the youthful nation's identity. And in effect, its commercial and maritime reach far outstripped its size.

There are two singular elements in this tranquil composition, whose interior atmosphere is particularly calm: the allegory and the painter himself. Vermeer portrayed himself—but from the back (so no one was ever to know what Vermeer looked like), and in sixteenth-century dress, even though we are in the seventeenth century. It has been said that this supports Da Vinci's assertion that, unlike the sculptor, who cuts stone amid noise and dust, the painter works magnificently attired in a spotless studio.

As for the allegory, it seems so commonplace, so present in the flesh, even down to the laurel crown, that one hardly thinks to ask oneself what this model with half-closed eyes is meant to represent. The general consensus is she is Clio, Muse of History, holding the "trump of fame," since history painting is primarily the representation of glorious deeds.

Why then the title *Painting*? It is because allegory, latent in this not especially allegorical model, cannot *rise*, cannot come to life, except through that art. The subject of the canvas is the act of painting, its magic. And what painting!

No other picture by Vermeer demonstrates such a happy union of naturalistic detailing (such as the cracks on the map or the artist's doublet), stylization cleansed of all anecdote, and of sensual serenity—and no other presents us with such a marvelous marriage of yellow and ultramarine blue that the light is set aquiver and mixes into a warm harmony.

Jan Vermeer, Delft 1632–1675 Delft
Painting, 1665. Oil on canvas, 51¼ x 43¼ in. (130 x 110 cm).
Kunsthistorisches Museum, Vienna.

Jean-Siméon Chardin
The Girl with the Shuttlecock, 1737

No eighteenth-century painter of still life, it is said, can compete with or even be compared to him—and it's true. So why not choose, as Chardin's offering, the marvelous *Tabagie* (also known as "Pipes and Drinking Vessel"), with its porcelain blue and almost crumbly consistency, or the fascinating *Silver Goblet*, with its admirably restrained orangey reflections and almost "tactile" handling, or else the impressive and renowned *Ray*, which was exhibited in the open air on Place Dauphine in Paris for the feast of Corpus Christi, an occasion on which people were allowed to show their works and try to make a name for themselves? The fact is that *The Girl with the Shuttlecock* is an even greater miracle: here Chardin's consistent, creamy white is at least as sublime as his delicate blue or heartwarming brown.

But this "painter of animals, kitchen utensils, and diverse vegetables"—as the definition of the "talent" for which Chardin was enrolled into the French Academy of Painting in 1738 put it—should not be remembered for his still life alone. Chardin was also an inspired "genre painter," as signified not only by the famous *Benedicite*, showing youngsters saying grace before a meal, but also the delightful *Good Education*, and the no less enchanting *Governess*. Neither should one forget the fearless late pastels, likenesses of himself and others, laid in with green and blue hatching.

Through all this runs, like a stream of fresh water, a whole series of "child scenes," to which *The Girl with the Shuttlecock*, *The House of Cards*, and *The Child with a Top* (or *Teetotum*) all belong: genre scenes concentrated into the form of a portrait.

Does this portrayal of a girl absorbed in her world of games and dreams have, as has been proposed, something to do with the interest in childhood newly aroused by Jean-Jacques Rousseau? Perhaps. Yet here Chardin is more than an observer: he is a poet who knows how to capture the miracle as it happens, in a light that, entering from the left, establishes an unstable equilibrium.

Diderot, whose earlier philosophical preconceptions concerning painting Chardin did much to clarify, describes his technique as follows: "He lays in colors one after the other, virtually without mixing them, so that his work rather resembles a mosaic of separate pieces, like the needlepoint tapestry-work named *box stitch*." By means of such brushstrokes, neatly itemized rather than merging, Chardin obtains a mottled effect, thanks to which the light pervades everything, rendering the shadows transparent, and bringing out the sheen on the powdery face of the little girl, her milky-white apron, the blue cord from which hang a pair of scissors and a pincushion, the feathers stuck in the shuttlecock, the chair, the flowers on the bonnet, the russet-red battledore frame.

Is Chardin, like Corot, "a gently commanding simplifier"? He is certainly a poet who succeeds in illuminating objects and beings from within—a luminous painter.

Jean-Siméon Chardin, Paris 1699–1779 Paris
The Girl with the Shuttlecock, 1737. Oil on canvas, 31¾ x 25½ in. (81 x 65 cm).
Private collection, Paris.

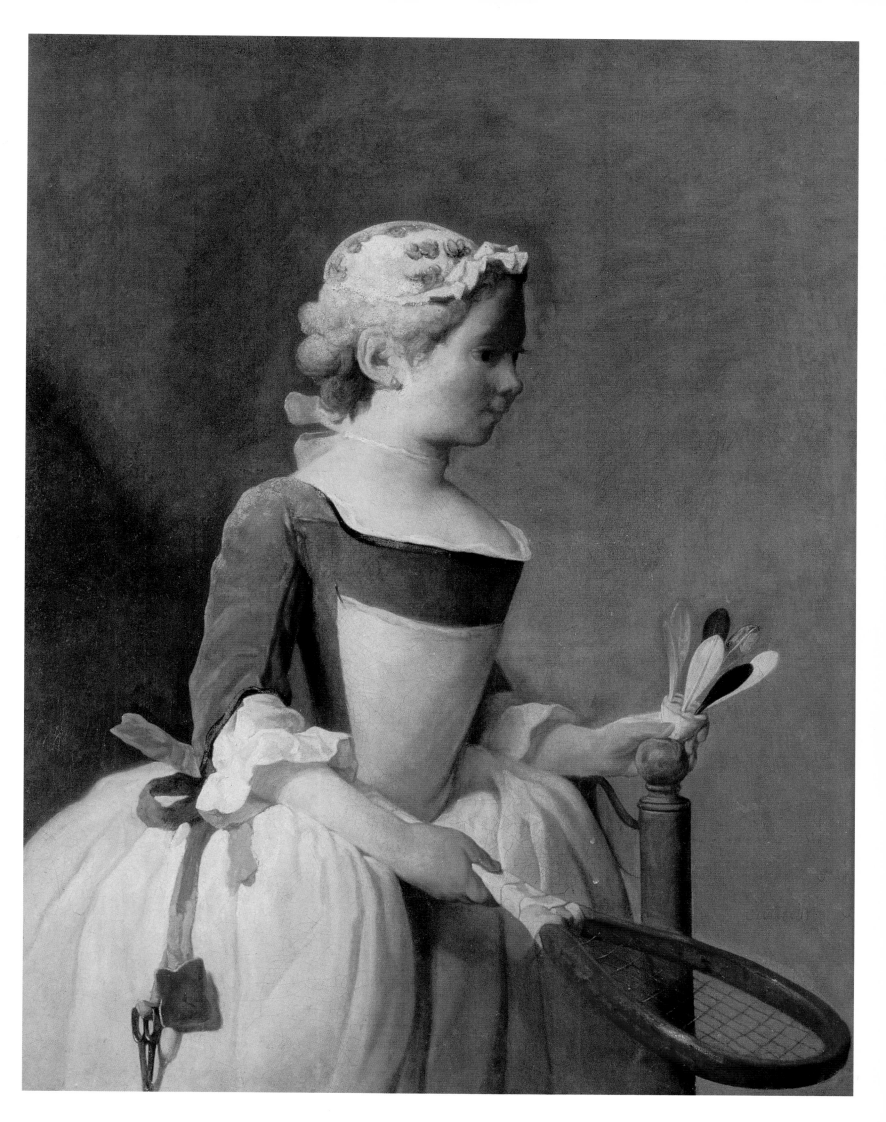

Antoine Watteau
The Two Cousins, c. 1716

Walking or lounging on the radiant earth, Watteau's youthful beauties are generally viewed from the rear, their hair put up with a deft, delicate gesture. It is there that Watteau's brush tarries, quivering, enflamed. Nabokov spoke eloquently of girls' necks, of the skin, almost transparently fair, transcendentally soft, dusted with hairs that trickle down the nape like a caress, a tender breath, a halting murmur.

In *The Two Cousins*, the park, the pond, and the statues are impregnated by an unhurried, fairy-like aura. A languor strums the air. The world is enchanted. Just look at this girl, her barely nubile body, her slender waist in a billowing pale yellow dress, her childish neck, tapering and fragile, so long; at the way she holds her head; at her delightful hairstyle with little red bows and a white plume.

By painting the girl from the back and by hiding her face, Watteau refuses to convey her feelings; he just leaves hints, letting us guess from tiny clues—a way of looking without seeing, from afar. A repressed loneliness suddenly engulfs her, detaching her from the group she formed just moments before with two companions who now have eyes only for one another. It is the transitory nature of the events that is so touching; everything appears to float, as in a dream. It all stems from the suspended, askance composition, with great wells of silence able to swallow up elements of the landscape—a little emptiness and a little sky.

See how it's done. See who looks where. The artist attains the same light vivacity as Marivaux does in his plays—like in a fencing exercise, where the foils swish harmlessly, whipping up the air, ricocheting, creating a climate of uncertainty in those walled gardens where beauty casts no shadows. This is a sensual theater that is delicate, but far from mannered; without complications, but with subtleties.

Can one speak of the erotic? There are shudders, certainly, in the skin, and even the dresses and their moiré. The trees. The sky. The paint trembles. Convulses.

Watteau's coruscating genius preempts the spirit of Louis XV and of Mozart, who was born in 1756, that is to say thirty-five years after the painter's death at the age of only thirty-seven. One should not forget that Watteau arrived in Paris in 1702, aged eighteen, at the end of the reign of Louis XIV, under whom he was to live for thirteen years, with a further six under the Regency.

The by now sinister Versailles was being deserted in favor of less enormous residences hung with smaller pictures. The *grand goût*, the grandest taste, was no longer fashionable. Watteau mixed in the most advanced social circles. No more a "Rubens for the thin" than a charming minor master, Watteau was a true innovator. He was a painter of youth.

Antiquity was dead. Watteau's Mount Olympus was a country estate or the Luxembourg Gardens. His Italy was that of the *Comédie Italienne*. His kingdom was that of the present. More precisely, his was a timeless land of grace and dreams whose beauty sears the heart.

Antoine Watteau, Valenciennes 1684–1721 Nogent-sur-Marne
The Two Cousins, c. 1716. Oil on canvas, 11¾ x 14¼ in. (30 x 36 cm).
Musée du Louvre, Paris.

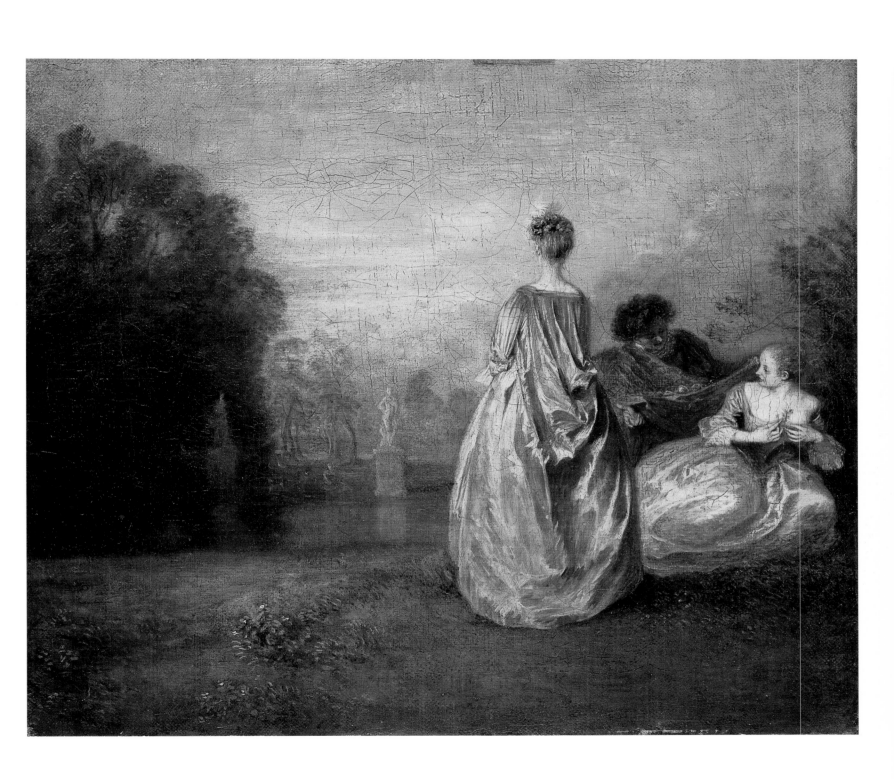

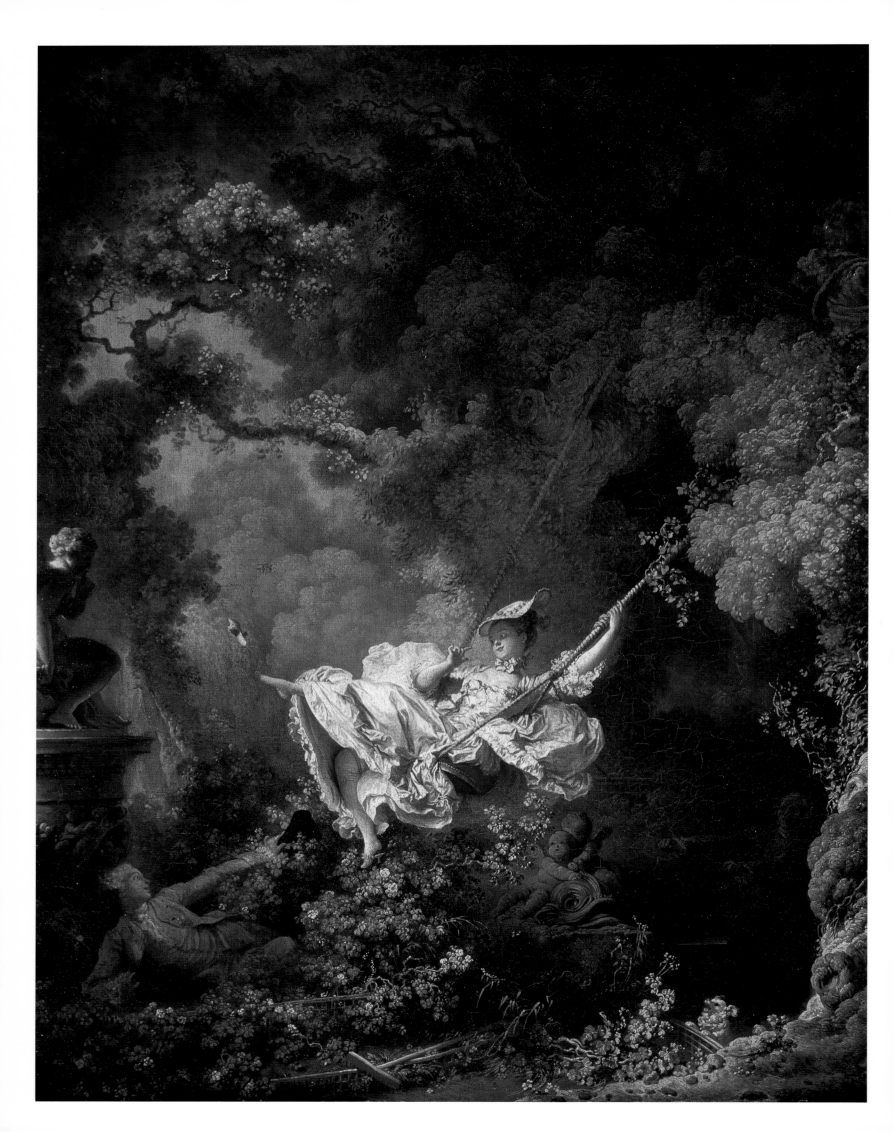

Jean-Honoré Fragonard
The Swing, 1766–67

Fluency and spirit, plus a lively, lighthearted briskness that carries all before it; peals of laughter joining forces with charm and imagination: this is what makes Fragonard special, and this is what strikes us here, in this spirited, rather rascally picture, where the painter has caught a suspended moment, a tipping point that is both fleeting and unstable—a snapshot, in fact.

"Monsieur Fragonard is all afire," reported Abbé Saint-Non, who was not much of an abbot but who was a bountiful patron and a friend. He took the painter along to Rome, where they gazed in wonder at the Tiepolos. He hits the nail on the head with this remark. Commissioning the painting, also entitled *Les hasards heureux de l'escarpolette* ("Lucky happenstances on the swing"), the Baron de Saint Julien, revenue collector for the French clergy, had originally asked Gabriel-François Doyen to paint a mistress on a swing being pushed by a bishop, and to show her revealing what should normally be concealed. His modesty offended, Doyen turned him down, instead suggesting that the baron might see if it might interest Fragonard, who had already gained a reputation for gallant and unbuttoned scenes. Fragonard discharged the commission with panache, arranging around the beautiful woman, the bishop, and the baron a luxuriant flurry of trees that becomes something resembling a voluptuous and magical foam. Delightful, brilliant, and something more: the erotic charge seems compounded by the thrill of the vegetation.

In the era of Louis XV, of mistresses, and of farmer-generals, everyone wanted a work by Fragonard to decorate some folly or private residence. But then the fashion moved on. His style was criticized: the pretty ornamental panels painted for Marie Jean Du Barry—today a jewel in the Frick Collection in New York—had hardly been installed before they were promptly mothballed. The taste turned to neoclassicism. Fragonard was a contemporary of David as well as of Boucher.

He was also a portraitist of the first rank, though. Not only because of the witty manner in which he mimicked Diderot, who resembled him, but who placed Greuze higher; but because, in his *Figures de Fantaisie*, the imperious vigor of the brushstrokes, the boldness of the colors are so wonderfully buoyed up by the freedom, the energy of the handling. And does it really matter that Fragonard cannot resist inscribing on the back of one of them, "executed in less than an hour"? Even Fragonard's bluster is attractive because it is tongue-in-cheek, with a wink to the viewer.

And that was not all, as some, keen to "excuse" him, have demonstrated. He also painted landscapes in the style of Hubert Robert, very "correct" genre scenes, as realistic as those of any other "minor master" of his time; but in the area of titillation, of eroticism, when the wind is in his sails, he is simply incomparable. The paint blazes and fizzes, the restless, energetic brush slides and squirts. There is nothing quite as dynamic as this paint that pirouettes, *allegro vivace*, melting with pleasure, the artist keeping faith with the sketch, with the wellspring from which his works bubble up.

Fragonard encapsulates the joy of pure painting. By 1792, in the midst of the Terror, he was conservator at the Louvre Museum, which was a strange end for such a charming man.

Jean-Honoré Fragonard, Grasse 1732–1806 Paris
The Swing, 1766–67. Oil on canvas, 32 x 25¼ in. (81 x 64.2 cm).
The Wallace Collection, London.

Giambattista Tiepolo
Treppenhaus of Würzburg, 1750

Fortunately no one today would dream of presenting Tiepolo, the genius of eighteenth-century decorative painting, as a minor master. His beginnings, however, might have afforded precisely such an impression: he was a delightful, adaptable jack-of-all-trades who was capable of fulfilling any order. Yet he soon abandoned the somber hues of that period and developed what was to become his specialty: low-angle perspectives, piling up elegant and luminous depictions that tip over into remarkably imaginative movements. This was in 1730, in the age of the rococo. Tiepolo's personality was forged.

A few years later, in 1740, on the threshold of full maturity (in spite of the onerous conditions, inadequate lighting, challenging space, and incorrectly taken measurements), he brilliantly carried off the decoration of the ceiling of the ceremonial gallery of Milan's Palazzo Clerici. Thanks to the complete freedom he was granted to conjure up an Apollo and the Continents, or the course of the chariot of the sun, his imagination ran riot: all one can see are dashing, vertiginous perspectives and quivering, impulsive flights of celestial figures amid blond, brown, gray-blue, pearl-gray clouds, that whip up the exotic and fabulous figures into gyrating spirals.

It was an overnight success. The Scuola Grande dei Carmini, a great rival to San Rocco where Tintoretto had executed his masterpiece, then ordered a decoration from him, a prestigious commission that he completed in 1749. Very soon, Tiepolo was drowning in orders. He accepted them all—several at once—even if that meant stalling and delays.

Now, though, his triumph was no longer limited to Venice, not even to Italy. In 1750, he took up an offer from the prince-bishop of Würzburg, Karl Philipp von Greiffenklau, to supply frescoes for his residence—two on the wall and one on the ceiling—in memory of Frederick Barbarossa who, among his many other achievements, had promoted the bishopric into a principality. The prince-bishop was so pleased with his work that Tiepolo, who had planned to be there for a matter of months, ended up staying three years and decorating the imperial staircase measuring some 6,458 square feet (six hundred square meters), his largest commission and a majestic masterpiece.

This time, there were no obstacles. Everything suited him: the gently swelling surface; the diffuse lighting; even the subject—the selfsame as in the Palazzo Clerici. Tiepolo was by now ten years older. Yet he still exudes that spontaneous freshness, and he gets even more carried away, because he senses that here he will create his supreme work. In effect, his mastery as a storyteller is without equal, unfettered; his imagination produces a composition of exceptional liveliness, lightness, and elegance, wonderfully at ease among luminous colors borne aloft by a momentum that scatters gods, allegories, and mere bedazzled mortals, whips up the clouds, and rips open the sky. The frescoes are a fabulous, eye-popping display whose fireworks bring down the curtain on Venice's Golden Age.

Giambattista Tiepolo (Giovanni Battista Tiepolo), Venice 1696–1770 Madrid
Apollo and the Continents, 1750. Frescoes. Facing page: General view of the Treppenhaus (stairwell) frescoes.
Above, top: Medallion portrait of the prince-bishop. Above, bottom: Mercury.
The Residenz, Würzburg.

142

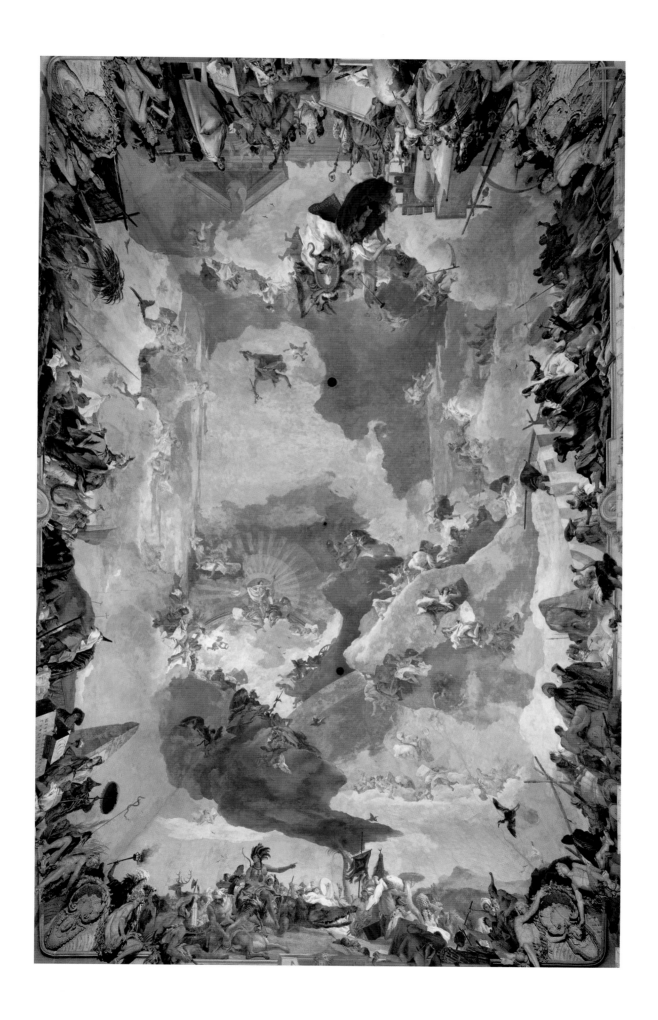

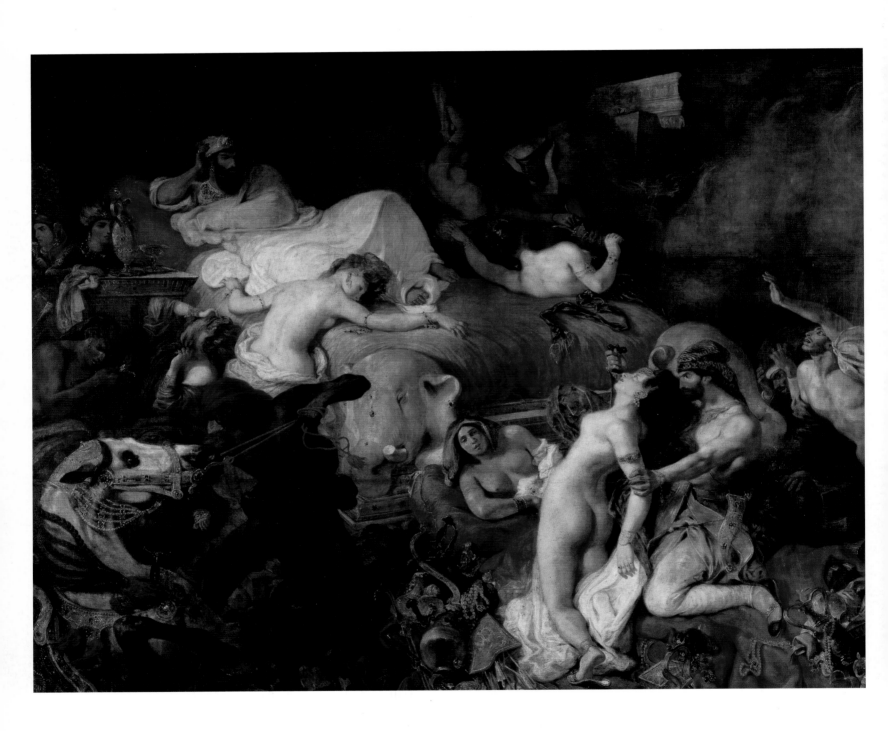

Eugène Delacroix
The Death of Sardanapalus, 1828

"To paint, one must have the fever," Delacroix confessed in his *Journal*. With him, in Breton's words, "beauty will be convulsive or will not be."

He is a "romantic," carried away by instincts and subjectivity, color-crazed, possessed by contrast, a violent opponent of "drawing," keen on Titian and Rubens, against Michelangelo, Poussin (he preferred Lesueur), and, his bugbear, Ingres.

His credo was overflowing line, and—beyond that—every overflow going: imagination, energy, zest, theatricality, and effect. In Delacroix's work, color is movement, vitality, urgency: a burning substance that plugs directly into expressiveness, driving on in an impetuous, poetical *furia*. "Pictures should not be over-finished," he proclaimed.

Delacroix was thirty years old when he presented *The Death of Sardanapalus* at the Salon. It was an early masterwork, the foundation on which all the rest was built. The picture takes as its starting point a dramatic poem by Byron, published in 1821, which sees Sardanapalus not as a tyrant, but as a hedonistic Oriental prince, as a "liberal" whose sole wish is the happiness of his people. Around him others spin intrigues and foment disorder, pushing him to fight. This he does, and he is caught like a rat in a trap. His palace besieged, he secures his wife's safety, and then, together with his favorite, throws himself onto a pyre erected round his throne.

What with Gothic novels (*à la* Horace Walpole, Lewis's *The Monk*, *The Vampire* by Byron, and Polidori) being all the rage, French taste at the time was perfectly attuned to this type of drama. People readily believed—or at least pretended to—in a story in *Le Courrier Français* that claimed that Byron was drinking blood from the skull of a murdered mistress!

Delacroix shows Sardanapalus lounging on a sumptuous bed amid a riot of wealth and pleasure. On the right, one can just glimpse the dark smoke of the pyre that is about to blaze. Sardanapalus, his glance as razor-sharp as the dagger, orders his eunuchs and soldiers to slash the throats of his concubines and horses. Then, as the colors ignite, there's a brief, staccato shudder, and ecstasy merges into death.

After David's balanced and motionless set-ups, the orgy of color, the way the composition scatters into all directions, the sheer anarchy of the picture all perplexed commentators. It is hard to imagine today just how outraged the response to this painting was: "The great majority of the public finds this picture ridiculous," *Le Moniteur universel* gloated. As for M. Vitet, state councilor, he protested against the tumble of isolated hues, the clashing brushwork: "M. Delacroix should recall," he moaned, "that French taste is noble and pure and cultivates Racine in preference to Shakespeare." He continued: "Eugène Delacroix has become a surefire scandal at every exhibition." As for the critic Delécluze, his condemnation was absolute: "The eye cannot extricate itself from this farrago of line and color. Sardanapalus is a painter's error."

But it was a glorious error indeed. As for the scandal, it was, before that of *Olympia*, the first of modern times.

Eugène Delacroix, Charenton-Saint-Maurice 1798–1863 Paris
The Death of Sardanapalus, 1828. Oil on canvas, 154¼ x 195¼ in. (392 x 496 cm).
Musée du Louvre, Paris.

Caspar David Friedrich
The Sea of Ice, 1823–24

No *Sehnsucht nach dem Süden* (nostalgia for the South) in Caspar David Friedrich; but, unlike so many of his contemporaries, a nostalgia for the Great North, a yearning for frozen wastes and clear and biting air. This fascination for the polar and its trenchant light runs through his secretive and meditative oeuvre, but is at its most palpable in *The Sea of Ice*. This is the decisive canvas of his mature phase, painted just before, in 1826, Friedrich became sick and fell into an increasingly dark and depressed mood, which culminated in the stroke that left him paralyzed in 1835.

Friedrich was born a Swedish subject, but studied chiefly in Denmark, afterwards settling in Dresden in Saxony, where, in 1810, Goethe paid him a visit. In one of his earliest canvases, the *Tetschen Altarpiece* (1808), he presents a crucifix among some fir trees, which are planted at the top of a steep mountainside against a reddening sky about to be engulfed by the landscape. This allegorical and mystic manner of treating landscape sparked a violent polemic. In this early piece, Friedrich had already affirmed his vision of the world: he was obsessed by death and the recurrent idea of man dwarfed by the awe-inspiring power of nature as a manifestation of God. It was when he saw *The Sea of Ice* while visiting Friedrich's studio in Dresden in 1834 that the sculptor David d'Angers came up with what is surely the best characterization of this painter's art, calling him "someone who has created a new genre: the tragedy of landscape."

The Sea of Ice depicts a landscape "without quality," a huge tangle of ice sheets in which, on the right, scarcely visible, a wreck has been trapped, crushed by the inexorable pressure of the frozen ocean. With transcendental technique, Caspar David Friedrich lays in this chaos with dry and precise, yet strangely lyrical lines, lit in a manner at once masterfully observed and studiedly unreal, where each dot of light reverberates over a corresponding particle of blanched frost. There are crevices, compressions and correspondences, formations and transformations—and yet, in the midst of this congested world, a curious sensation of emptiness.

Those who knew him well said that Friedrich communed with nature as if with an intimate friend. However, among all the hurly-burly, at the same time destructive and creative, man is absent. This is one of the original aspects of this brilliant landscapist, who managed to paint nature on her own terms in what was a unique alliance between description and allegory.

Explaining his manner of painting and his approach to art, he said: "Close your physical eye so as to see the image in your mind's eye…. Then, bring into the daylight what you saw at night so that it goes on to act on others, from exterior to interior." His recommendation reminds one of Chateaubriand's famous "eye of the soul." We are right in the middle of romanticism, but at a far remove from *Sturm und Drang*.

Caspar David Friedrich, Greifswald 1774–1840 Dresden
The Sea of Ice, 1823–24. Oil on canvas, 38 x 50 in. (96.7 x 126.9 cm).
Kunsthalle, Hamburg.

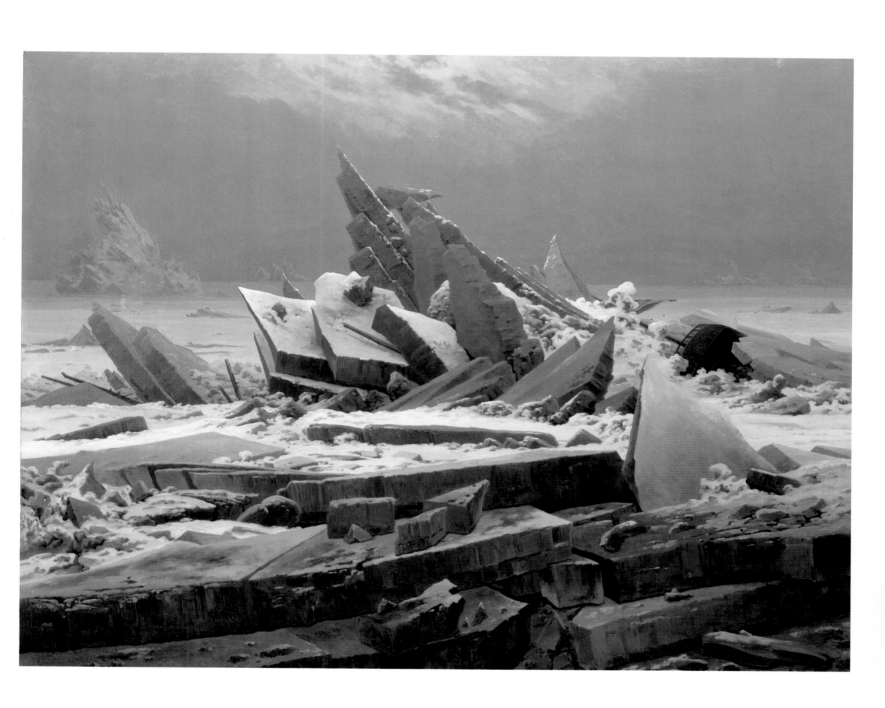

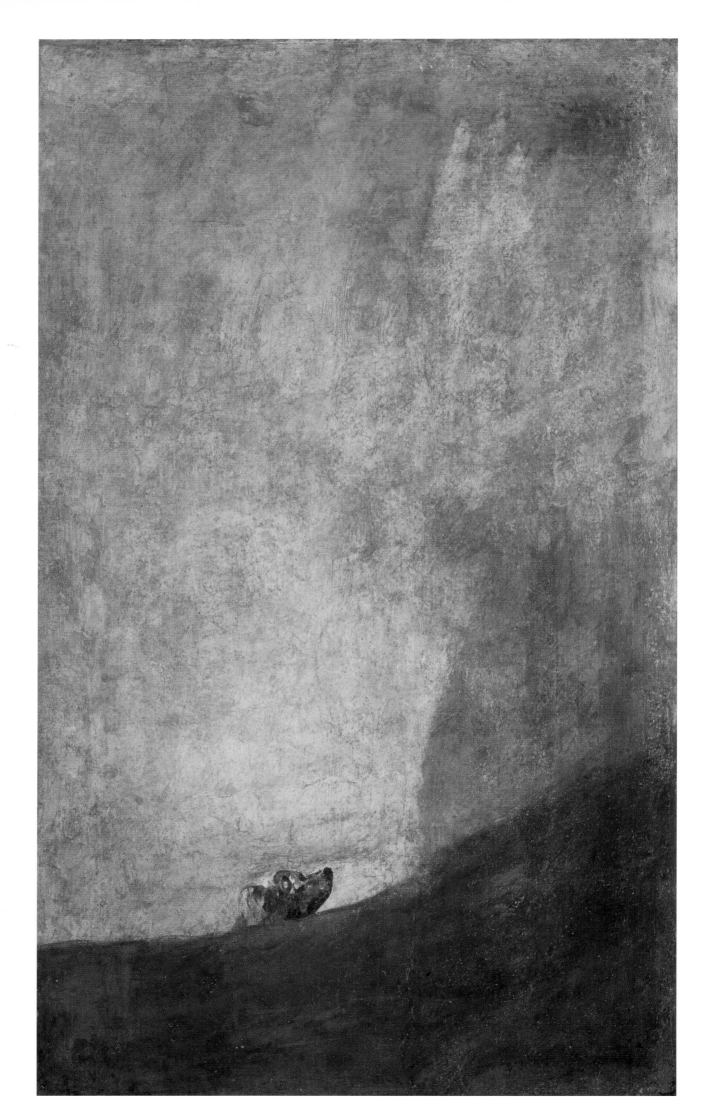

Francisco Goya
The Dog, 1820–23

A dog's dream? "The work of a medium," as Malraux alleges in his monograph? The picture—which shows, at the bottom, behind a sketchy hillock, the head of a small dog poking up towards an immeasurable sky in ocher and gray-blue above him—is more than minimal. It is uncertain whether it is a kind of call, a representation of Goya's mood or animalistic thoughts, or that void one finds in Chinese painting, which allows a being to adhere to the cosmos and to situate itself within it.

In 1819, Goya bought the Quinta del Sordo ("House of the Deaf Man") outside Madrid and decorated the interior with fourteen paintings: he is just as astounding in this painting as in the other paintings, but in a different way. In this empathic and dreamlike work located on the first floor, beside the blanched Fates, two absurd-looking men, half-buried, fighting with clubs, there are no monsters, plagues, witches' sabbaths, blackness, grating ironies; instead, the expression of a difference.

Is it the difference Goya himself felt? Or is the point to make the isolation, the silence of the deaf visible, tangible?

In 1792, aged forty-six, laid low by disease, everything changed. Goya even feared he might be going blind. So he locked himself away, irremediably, breaking with what he had been, with everything he had painted. It proved the death of a talent, birth of a genius. He had produced brilliant *espagnolades*, cartoons for tapestries—and all of a sudden, cooping himself up, playing to the gallery no longer, he plunged into an untold darkness, engraving the twenty-four *Caprichos* and dared to be *disagreeable*.

Substituting expression for the observation of reality, he empathized with the romantic idiom of crisis as it corresponded to what he was discovering within himself, to those shadowy realms he glimpsed behind the seemingly deceptive lights of Reason, to those fears and dangers that swim in the abyss of the self.

This crisis was, of course, one that all of Europe was undergoing at the end of the eighteenth century: questioning everything, up to and including man, who was becoming an "individual." Everywhere in Europe, painting, and also literature, was going back beyond the Renaissance and its references to Antiquity, reviving the Middle Ages, rediscovering unreason and its monsters, prizing open the safety-valves of the unconscious, burrowing, fathoming the nooks and crannies of being; putting the ego on a pedestal, or else dragging it through the mud. Delacroix, Füssli, Friedrich, Géricault, and Turner all champion subjectivity.

But, unlike others who sharpened their quills or manned the barricades, who hogged the limelight and wore their artistic dissent on their sleeve, Goya worked away in secret.

The Disparates or *Proverbios* were never put on sale in his lifetime, while only those close to him saw the paintings in the House of the Deaf Man. His work was too acerbically private, too instinctual, too corrosive to be viewed by people who were shocked by *The Death of Sardanapalus*.

A picture *a minima* that breaks fresh ground in painting.

Francisco Goya (Francisco José de Goya y Lucientes), Fuendetodos 1746–1828 Bordeaux
The Dog, 1820–23. Oil on plaster, painted on a wall of the "House of the Deaf Man," transferred to canvas,
53¾ x 31½ in. (134 x 80 cm).
Museo del Prado, Madrid.

Jean-Dominique Ingres
The Grand Odalisque, 1814

The French call a hobby a *violon d'Ingres*, and it's true that the painter received such a paltry allowance from his family as a student in Paris that he had to make ends meet as a fiddler in a band playing for light comedies. His father, who was also a painter and musician, initially intended him to be a musician, though he gave him drawing lessons as well. Ingres was so gifted in this field that it was decided to send him to study in Toulouse.

From there, in 1796, he traveled up to Paris to David's studio. In 1801, he won the Prix de Rome and his life was little more than a gently flowing river of academic success: he received the légion d'honneur in 1824, became a member of the Institut in 1825, director of the Villa Medici in 1834, and gained a seat in the Imperial Senate in 1862, where he toed the government line until his death.

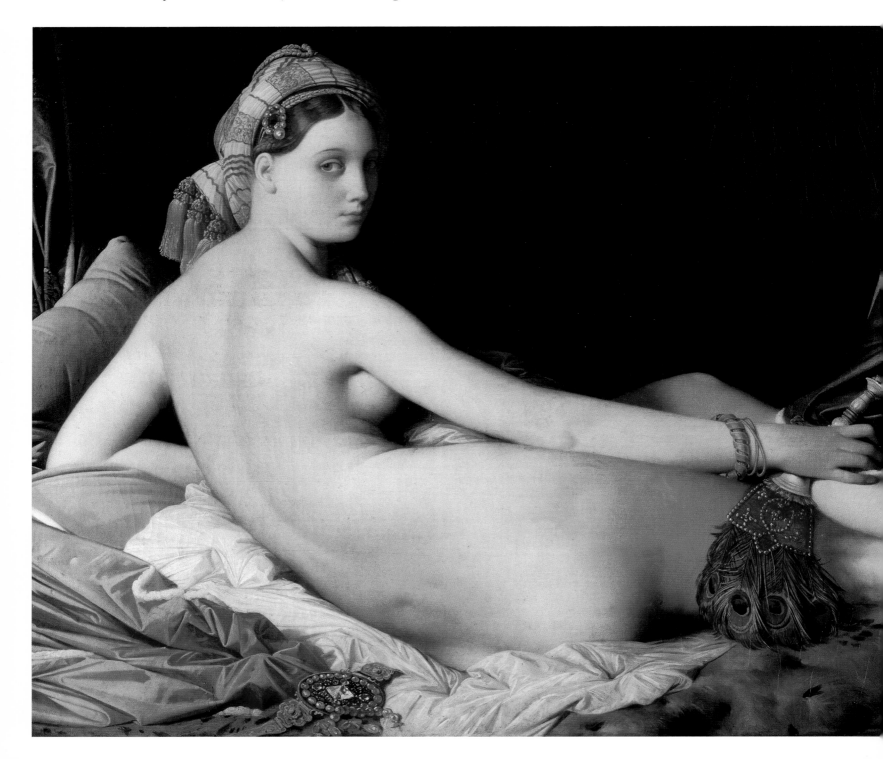

But Ingres is not just the hero of neoclassical academism against romanticism, the champion of drawing against paint, the official artist of *The Apotheosis of Napoleon I* for the ceiling of a room in the Paris City Hall, a perfect and chilly artist who dreamed of painting like Raphael, but a few centuries late (to the point that he was dubbed "Raphael II"), all the while posing as a bourgeois who might indulge in suspect comforts, an establishment conservative. One only has to look at *Jupiter and Thetis*, at the extraordinary, frightening mass; the twisted head uncertainly screwed onto the body; an arm one could scarcely call academic, hyperbolically, inevitably too long, interminable, elastic. These superb disproportions, these "defects" can be readily justified by the overall economy of the composition. *The Grand Odalisque* possessed, it appears, three supplementary vertebrae; but the whole charm of this pearl-white painting, where desire is not absent but simply suspended, arises precisely from such elongation.

"Stress the model's most prominent features," he recommended, "express them strongly, push them, if need be, to the level of caricature, and I mean caricature, the better to convey the pertinence of this indubitable principle," and: "As regards truth, I think it's better to go a little beyond it, whatever the risk."

Ingres's world is a "redrawn" world (Proust's expression), not one of "bookkeeping minutiae." In *The Golden Age* (the inspiration behind the title of Dalí and Buñuel's film, *L'Âge d'Or*), with its agglomerates of nudes, or *The Turkish Bath*, a will and testament of a picture that was long in the making (Ingres was a slowcoach), one sees its circular space gathering, joining together, a dreamland comprised of curves, ellipses, circles, voluptuous graces that stretch and arch, amassed into multifarious attitudes.

Here Ingres indulges not the crisp pointedness of his portraits, but the silky grace of the majority of his nudes. There is a timeless enchantment that runs through his work, as well as a "flatness" unknown in Delacroix—who has a reputation for being more "modern"—and which comes to the fore in Manet, whose *Déjeuner sur l'herbe* is an exact contemporary of *The Turkish Bath*.

Jean-Dominique Ingres, Montauban 1780–1867 Paris
The Grand Odalisque, 1814.
Oil on canvas, 35¾ x 63¾ in. (91 x 162 cm).
Musée du Louvre, Paris.

151

Utagawa Hiroshige
The Waterfall at Yoro, 1853

Japanese prints are often associated either with eroticism or with the influence that Hiroshige and Hokusai exerted on the impressionists, Toulouse-Lautrec, and Van Gogh, in the way their compositions are framed and limited to surprising, flat blocks of color. In fact, the Japanese print is closely related to the history of the country as it emerged in the seventeenth century, by which time it had regained a

measure of peace and stability. No fewer than five hundred thousand samurai were under arms, while the system that obliged feudal lords to reside part of the year in Edo (the former name of Tokyo), and the remainder on their estates, was saddling them with crippling debts, owed to a merchant class that expanded and prospered in the new urban centers.

In Japanese feudal society at the time, merchants occupied the lowest level, beneath warriors, farmers, and craftsmen. This merchant class, forbidden from flaunting its wealth under penalty of seeing its goods confiscated, was now reaching the corridors of power through financial dealings and loans. Having no tradition of refined entertainments, its members created a new demand for pastimes and recreations, such as picnics, festivities, and visits to pleasure-houses that swamped entire districts. Meanwhile their novels and paintings, eschewing the lofty speculations of court art, took their cue from everyday life with a line in genre scenes depicting landscapes, parties, street scenes, actors, and pretty women.

Ukiyo-e, the image of the "Floating World," is the art of a society wholly devoted to transitory pleasures. The mass production permitted by woodblock printing made it possible to reach a vast audience that wanted diverting, undemanding, and inexpensive forms of art.

The greatest names in this genre, which is anything but "minor," are Utamaro, the brilliant late eighteenth-century portrayer of life in the red-light districts, the exuberant Hokusai, who worked at the end of the nineteenth century, painter of the thirty-six views of Mount Fuji, including the famous *Wave*, and Hiroshige, a landscapist of incomparable lyricism.

The print representing the waterfall at Yoro in the district of Gifu close to Nagoya (also painted by Hokusai) is not as well known as *The Sudden Shower at the Ohashi and Atake Bridge*, or *The Plum Orchard at Kameido*, both copied by Van Gogh who possessed twelve prints by Hiroshige. It does not form part of the artist's most celebrated series: the *Hundred Views of Edo* and *Fifty-three Stations on the Tokaido Road*. There are no close-ups, though this was Hiroshige's specialty. The interest of the print lies instead in its gripping vertical layout.

In a rarefied yet confident work executed around the end of Hiroshige's life, the violent simplification of the treatment of the waterfall, combined with the subtleties of an impression that employs fine gradations of indigo—darker in the center of the cascade and almost white on the sides—set up tensions that are impressively modern.

Hiroshige Utagawa (Ando), Tokyo 1797–1858 Tokyo
Famous Views of the Sixty-odd Provinces of Japan: The Waterfall at Yoro, Province of Mino, 1853.
(Engraver, Ukogawa Takejiro. Published by Koshimuraya Heisuke.) Print.

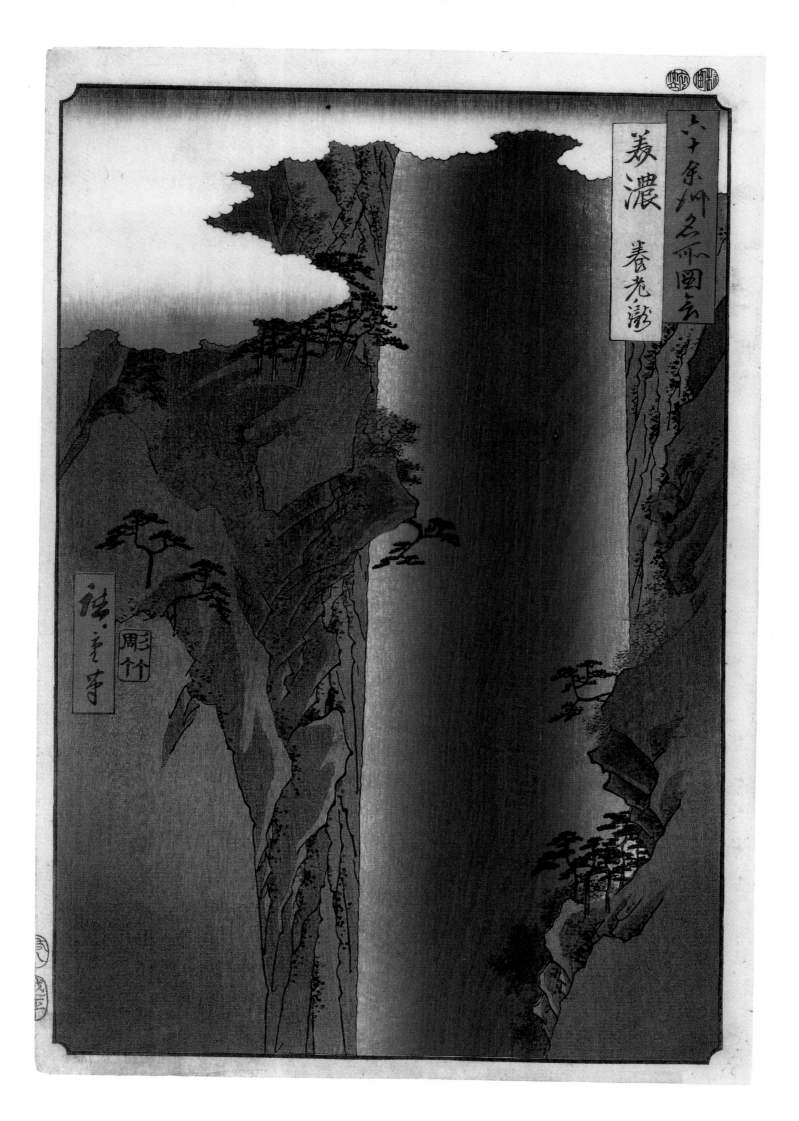

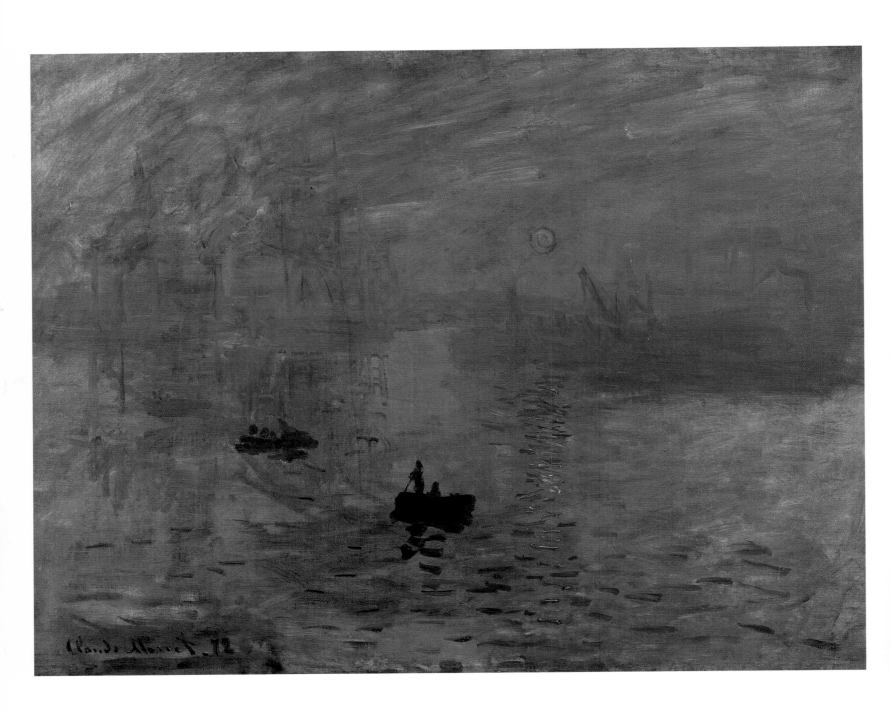

Claude Monet
Impression, Sunrise, 1872

One might prefer Monet's sumptuous *Waterlilies*, nonchalantly abstract in their variegated transparency and mauvish reflections of stagnant water, or the smoke of his rail stations, or else the series of hayricks and cathedrals, much in vogue today. In my eyes, though, none of Monet's works outdoes the madly audacious early piece entitled *Impression, Sunrise*, painted when Monet was thirty-three. One can hardly imagine a work more free, more off-hand even, utterly heedless of pleasing, its flair like that of a sketch.

It was unveiled at the first joint exhibition of the Société Anonyme des Artistes Peintres, Sculpteurs, et Graveurs, held on April 15, 1874, in Nadar's studio at 55 Boulevard des Capucines, and featuring one hundred and seventy-five pictures signed Cézanne, Boudin, Degas, Pissarro, Sisley, Berthe Morisot, and Renoir. Edmond Renoir, Auguste's brother, had asked Monet to give his work (a seascape painted at Le Havre) a title for the catalog; Monet is supposed to have blurted out, "Put 'Impression'."

If the public flocked to gawp at the works and poke fun, there were also those who were more favorable who could raise the show's profile. No one was to do more, however, than the critic of *Le Charivari*, Louis Leroy—though it was unintentional, as he loathed this type of art. Directing his bile at Monet's *Impression, Sunrise*, he entitled his article "Exhibition by the Impressionists." The squib was meant to be offensive, but it was taken up and became the term for a style of painting that stressed feeling, light, and fleeting realism.

The virulence of the critical attacks seems surprising now. But one has to place the dates of the artworks and political events side by side: the piece was not only contemporary with Rimbaud's arrival in Paris, but also with the Commune riots. The middle classes and its newspapers feared for their newly reestablished security. Anything and everything that might call into question the establishment or undermine the aesthetic and moral order must be quashed.

In this work, apparently dashed off in a matter of hours, where the form of the boats and men is not dissolved "artistically" but dabbed in hastily around an embryonic reflected sun painted in parallel lines of unblended orange, it would be an understatement to say that the brushwork is visible: it is provocative in its autonomy. Monet's treatment of water has often been stressed: "I would always like to be either in front or on top of it, and when I die I want to be buried in a buoy."

Zola was to declare that Monet adored water as he would a mistress, and that for him: "water is alive, deep, true above all." Yes. But what is also visible here is something that will later vaporize into a haze of a more aesthetic nature: a rapid way of rendering the ephemeral. Here, in its very impermanence, we are at the heart of this style and manner.

Claude Monet, Paris 1840–1926 Giverny
Impression, Sunrise, 1872. Oil on canvas, 19 x 25 in. (48 x 63 cm).
Musée Marmottan, Paris.

Édouard Manet
Olympia, 1863

It's true that she's no beauty, and that she has a vulgar, rather "cut-down" air. Yes, the hand she lays on her genitals resembles a spider. And yes, her flesh tone is dirty and the modeling clueless, as the French writer Théophile Gautier opined. But this picture, which, displayed at the 1865 Salon caused one of the most resounding scandals in the entire history of art, is also one of those by which modernity came into being, took flight, and broke with perspective to affirm the planar nature of painting. It is perhaps the "birth certificate" of flatness in painting; a springboard, then, for Malevich, Jasper Johns, and all the rest.

This scarcely alluring but fecund masterpiece has also been termed an icon of realism. And it's true that Manet made no effort to idealize his model, to make her into something other than what she is: a prostitute. Victorine, who acted as the artist's model for three years, sports the telltale accessories: a silken flower in her hair, earrings, a slender black choker around her neck, a gilt bracelet, and Louis XV slippers. The scandal is more that Manet makes no effort to conceal the fact.

It is moreover well known that he based the composition on Titian's *Venus of Urbino*, itself inspired by Giorgione's *Venus*. It's almost all there: the general position of the young woman, the pillow propping her up, the drapery that creeps under her right hand, her left hand covering and at the same time flagging the pudenda. But, if both nudes look at the viewer, then they do so in different ways. Titian's goddess is seductive and beckons one into the picture's world. In contrast, Manet's Olympia, whose head is raised in an attitude of challenge and neutrality that verges on provocation, fends one off.

Manet has also replaced the dog with a cat, while the two maids in the background are reduced to just one, who is black, and infinitely more present and conspicuous in her gaudy get-up, weighed down by a bouquet that competes for attention with Olympia's naked display. Unambiguously, Manet is saying that the flowers and the cat are as interesting as the nude. As for the trenchant vertical that in the Titian version bisects the backdrop to the picture and forms a line that falls plumb on the sitter's sex, Manet has shifted it a touch to the right and, crucially, it no longer provides the least perspective.

This is in fact why Manet took Titian's masterwork as his starting point. When one notices the vast, almost black block that devours half of the background of the *Venus*, one can hardly take one's eyes off it. Manet, as an artist, and a modern artist at that, simply drew the most radical conclusion and extrapolated the lesson of the Old Master, pushing it to its limits. The same year, at practically the same time, Manet, one of the most vigorous and active figures in the reaction against academism, also took part in the Salon des Refusés, presenting the *Déjeuner sur l'herbe*. It heralded another scandal, and another masterpiece.

Édouard Manet, Paris 1832–1883 Paris
Olympia, 1863. Oil on canvas, 51¼ x 74¾ in. (130.5 x 190 cm).
Musée d'Orsay, Paris.

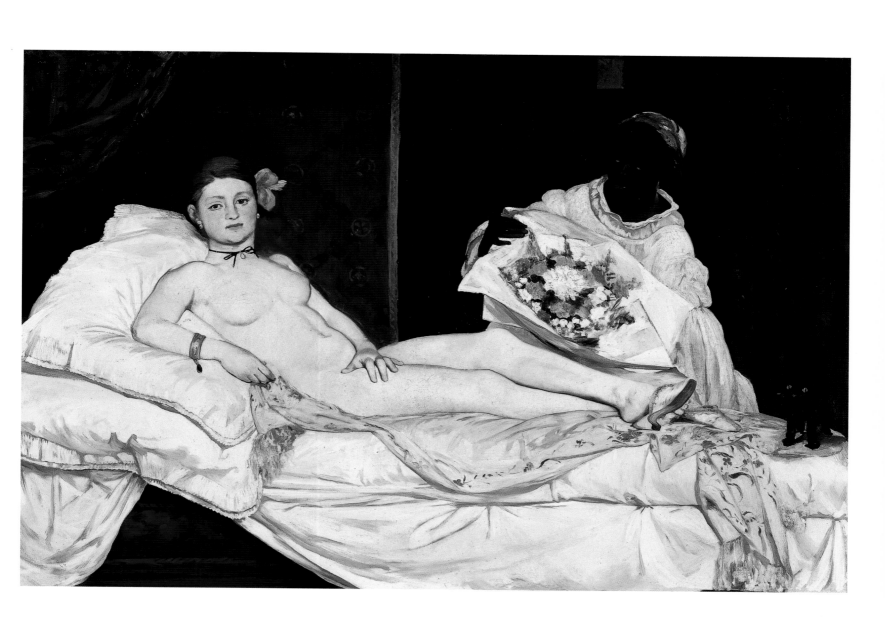

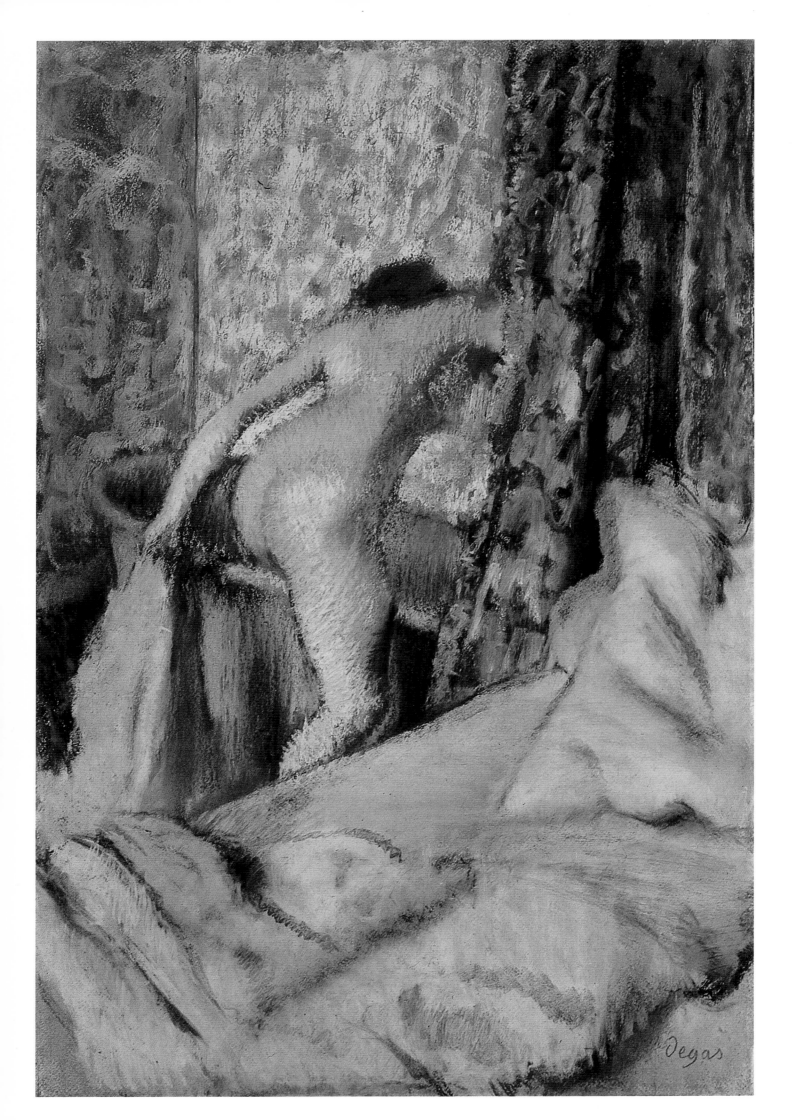

Edgar Degas
The Morning Bath, 1895

His father was a successful banker originally from Naples, while his mother hailed from New Orleans. He was called de Gas, paraded anti-Dreyfusard opinions, and clearly preferred Paris to the *guinguettes* and country lanes where Monet and the rest liked to set their easels. Yet this was not the only reason he considered himself different from the other impressionists: more importantly, while his colleagues voted for color and Delacroix, he had studied with Ingres and would be a worthy heir to classicism and the primacy of drawing. This perhaps also explains his manner of advancing by irascible surges, dashing one moment to the cutting edge of experimentation, then back to the "thirst for order" he mentions in a letter to Henri Rouart, only once again to heed the call of what was a ceaseless, irrepressible drive for innovation.

His "bourgeois" manner is of no consequence. In art, Degas was a subversive innovator. Like Baudelaire, he understood that modernity is urban and artificial: he always went for the floodlights of some down-at-heel music hall, or the rehearsal rooms at the Paris Opera where he painted his famous dancers, rather than to natural light, whose nuances and subtleties he left to others to capture.

As well as being hugely interested in the fledgling technique of photography, he also tried his hand at monotype, coating the glossy surface of the metal plate with a layer of oily ink, engraving, scratching, and then scoring it, using the handle of the brush, knives, even his fingers, drawing in the substance itself and finally adding pastel on top. Few artists had employed pastel since the days of Chardin. Degas, apparently so cerebral, reticent, undemonstrative, found it a release. Always on the search for a "modern" subject, he shows women ironing, laundresses. The ever-changing manner in which he frames his subjects derives from photography and Japanese prints: they are viewed from high above or from down below, like a low-angled shot, or with the foreground sliced in two.

The use of pastel, as in the admirable series of *Baths*, and in particular this one—with a slight overhang and somewhat askew, and with a foreground that sets back the principal subject—enables him to arrive at the synthesis between line and color for which he strived at the end of his life. Thanks to pastel, Degas could draw with color. As he observed in a notebook: "Nothing is as beautiful as two varieties of the same color side by side."

Beyond the chromatic splendor, here of exceptional originality, there is a way of depicting women, not in gracious or titillating poses but, as Degas himself put it, "without coquettishness, like animals grooming."

He will be accused of misogyny, of insulting feminine beauty. Yet he sought only a change in gear from realism to objectivity. His nudes, viewed as if through the keyhole, remotely, uncompromisingly, are not so different from the new realism (as against verism) advocated in 1979 in *For a New Novel* by Alain Robbe-Grillet, who was also the author—it should not be forgotten—of a book entitled *Voyeur*.

Edgar Degas (Hilaire Germain Edgar de Gas), Paris 1834–1917 Paris
The Morning Bath, 1895. Pastel on off-white laid paper mounted onto panel, 26¼ x 17¾ in. (66.8 x 45 cm).
Art Institute of Chicago, Ohio.

Georges Seurat
Sunday Afternoon on the Island of La Grande Jatte, 1884–86

Dead at thirty-one, having painted little but pondered much, Georges Seurat was the curious scion of a curious family. His father, who had the mellifluous first name of Chrysostome, lived off investments in his summer residence at Raincy, visiting his wife and son only once a week. He was a guarded, unspeaking recluse, just like his son, who was to lock himself away in the theories he found so fascinating. He became convinced that, like music, color could be taught, and endeavored to devise hard and fast rules concerning matters such as color harmony and linear composition.

He had been first stirred into action by the theories of Chevreul on the laws of simultaneous color contrast, having left the Ecole des Beaux-Arts where he had studied under a pupil of Ingres's. The following year, he was overwhelmed by Ogden Nicolas Rood's *Modern Chromatics*; all kinds of notions followed. In 1883, by then twenty-four, he painted *Bathing at Asnières*, composed with an eye to the great symbolist frescoes of Puvis de Chavannes, whom he had met the previous year and much admired, and showing a scorching summer's day with bathers on the banks of the Seine against a backdrop of factory chimneys. Expressions like "democratic Arcadia" have been used to describe that superb, calm, and dreamy canvas, which possesses a poetic freedom that *Sunday Afternoon on the Island of La Grande Jatte* does not. Seurat had not yet, however, become Seurat the champion of pointillism and divisionism.

He had already met the impressionists in 1879 on the occasion of their fourth group show. He very quickly decided to replace their intuitive approach to painting with something altogether more scientific: thus was neoimpressionism born. The new vision was expressed by a novel process—the decomposition of the basic tone into its components—and received support from a figure of the reputation of Pissarro. Renoir and Monet, on the other hand, signaled their disapproval by withdrawing from the eighth Impressionist Exhibition in 1886. In their view, through their canvases, theories, and declarations, Seurat and Signac were calling into question the translation of transitory reality and reverting to the fundamental tenets of composition.

An iconic piece that encapsulates neoimpressionism, alongside the thirty-four *croquetons* (small sketches) and twenty-four drawings, *Sunday Afternoon on the Island of La Grande Jatte* demanded lengthy gestation and took just as long to execute. There are no wonders of pretty brushwork here: nothing is left to chance. Everything relies on an unwavering "scientific" synthesis. Octave Mirbeau used the words "Egyptian imagination" in connection with this motionless and monumental painting that is studded with priestly figures, all either seen from the front or in profile—just like, in point of fact, Egyptian painting. It is a glorious affirmation of Seurat's credo: harmony, analogy between contraries, and synthesis. Referring to the few people who admired this canvas, Seurat simply said: "They see poetry in what I do. Wrong, I apply my method and that's it."

Georges Seurat, Paris 1859–1891 Paris
Sunday Afternoon on the Island of La Grande Jatte, 1884–86. Oil on canvas, 81¾ x 121¼ in. (207.5 x 308.1 cm).
Art Institute of Chicago, Ohio.

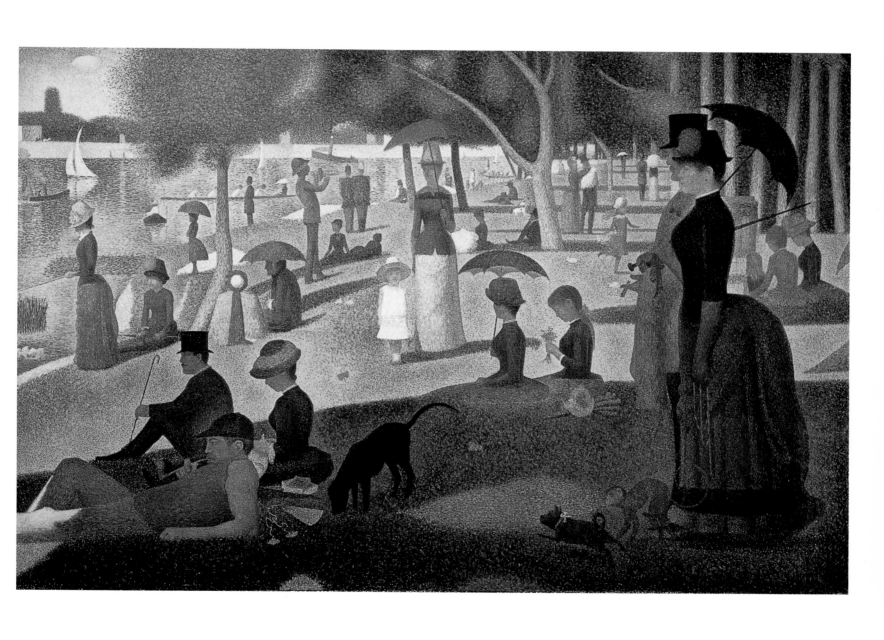

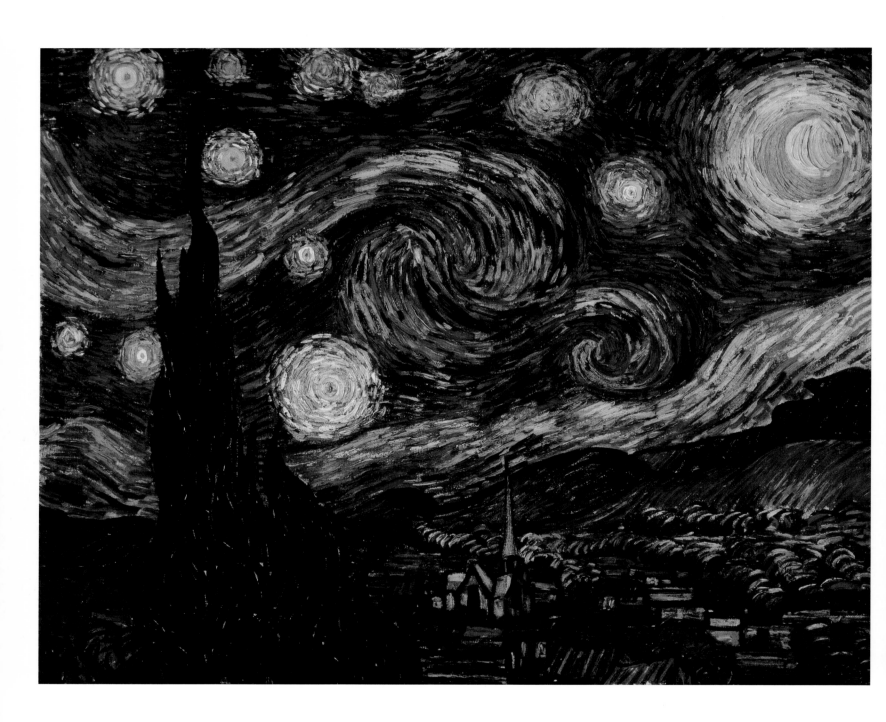

Vincent Van Gogh
Starry Night, 1889

A passion. A destiny. A devastating, meteoric trajectory. A light-giving fire. Nothing could slake his thirst for the absolute, his obsession for self-sacrifice: not the Bible, not even the evangelization of the destitute during a sudden embrace of poverty—like some frenetic pastor—at an early stage in his life in London and in the collieries. It haunted him, wore him down, and finally pushed him to live in a wooden hut in Holland, sleeping on a straw pallet, and cutting puttees for himself out of coal sacks. He wanted to share in the suffering of the miners, to show them he was one of them.

Van Gogh was like that: excessive, tormented, quarrelsome, frenzied; enraged, exalted, consumed by a "fire of love." The system frowned and rejected him. What could this outburst of brotherly love be for?

Dying at thirty-seven, Van Gogh had seen it all—hopes, failures, new starts, exaltations—living as if in a permanent state of emergency. His father was a vicar and his uncles were art dealers, so he slalomed between the Bible and painting. Yet, from the somber *Potato Eaters*, painted in Holland, to "the burning of a thousand suns" in Provence, via Paris where his palette was brightened by the discovery of impressionism, little by little he found his own path—or, rather, he found out how to resonate with the world and listen to the harmonics.

On February 21, 1888, Van Gogh arrived in Arles. He had no more than three years to live. His painting changed again: "I paint the infinite," he wrote. His pictures coruscate, releasing a surge of energy. The masterpieces come thick and fast. "Yellow is so beautiful!" he exclaims. "But when will I paint the starry sky, a picture that has always preoccupied me?" He'll paint it one night by the light of a hat pricked with candles. "Why," he wondered, "aren't these dazzling dots in the sky as easy to reach as the black dots on maps of France? As one takes the train to Rouen or to Tarascon—one takes death to get to a star."

Is this why, at the bottom of the *Starry Night* of 1889 (not to be confused with that of 1888), which has on the left a stereotypical, nondescript village slumbering in the peace of the calm evening against the backdrop of the Alpine foothills, he painted the cemetery tree—a cypress that connects earth to sky, in flux, twisting, seizing, convulsing into dark green or brown sparks? And above, there is a great rummaging, where color seems to have bothered him less than rhythm or movement. To every side, the sky cracks and the night breeze tumbles round the stars like the hair of a lunatic. Eddies of ultramarine around iridescent constellations that emit an orange or lemon-yellow light into the turbulent infinite. "I saw farther than was permissible," wrote Nietzsche. Perhaps this is what Van Gogh, the *voyant*, the seer, was trying to do in paint.

Vincent Van Gogh, Groot-Zundert 1853–1890 Auvers-sur-Oise
Starry Night, 1889. Oil on canvas, 29 x 36¼ in. (73.7 x 92.1 cm).
Museum of Modern Art, New York.

Paul Gauguin
Where Do We Come From? What Are We? Where Are We Going?, 1897

Descending on his mother's side from the viceroy of Peru and Flora Tristan, the muse of fledgling socialism, Paul Gauguin was born on June 7, 1848. Fifteen days later, Paris was bristling with barricades. Louis Napoleon Bonaparte's *coup d'état* quelled the revolt and Gauguin's father, who wrote for *Le National*, was forced to flee to Peru; he died on the sea crossing. The young Gauguin, along with his mother and his sister, was taken in by a great uncle. After his uncle's death, Gauguin returned to Paris, and at seventeen became a sailor, embarking for Brazil. He sailed the Pacific, discovered India, and Polynesia. Nothing could be more romantic than this vagabond existence plying the seven seas.

Back in France, on advice from his tutor Arosa, Paul entered the Bourse as a stockbroker. Strangely enough, it was there—again thanks to Arosa, who knew Pissarro—that he discovered painting. He bought pictures by Cézanne, Manet, and Monet, and learnt, as an amateur, to paint in bright colors.

Having caught the painting bug, he exhibited at the Salon of 1875 and joined the impressionist group. Aged thirty-five, he abandoned the Stock Exchange and threw himself body and soul into painting. Cézanne, Degas, and Puvis de Chavannes encouraged him to evolve a more personal style.

His stay at Pont-Aven in 1886 was essential to his art: it was there that he met Emile Bernard, who freed him from impressionism and neoimpressionism alike. He discovered Japanese prints and primitive art, rejected perspective, and instead began painting in broad areas of flat, saturated color encircled with

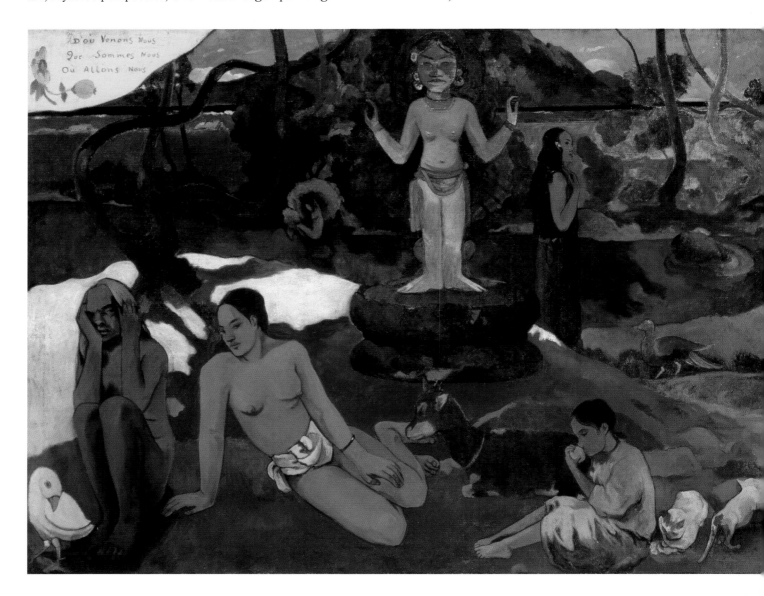

thick dark contours. This approach had a lasting influence on the fauves and on Picasso.

After this, he traveled to Arles and met Van Gogh, before returning to Paris. In 1891, he decided to quit "Europe's old parapets" to settle on Tahiti, as if in some primeval paradise, before once again heading back to Paris, where Bonnard, Vuillard, and Maurice Denis were vocal in their admiration. In 1895, he departed once more for Tahiti, settling in the Marquesas Islands, where he built his famous Maison du Jouir and became as innovative in sculpture as in paint.

It was in 1897—during his second stay on Tahiti and in a bleak period of utter discouragement, penury, disease, and suicidal impulses—that, toiling day and night in a feverish state, Gauguin painted the large picture that he considered his last will and testament. At the top of the canvas, the title is given in an inscription: *D'où venons-nous? Que sommes-nous? Où allons-nous?* It is a passingly esoteric *summa* whose rough and ready appearance Gauguin was keen to bring out. He painted it, he declared, "on burlap, uneven and full of knots"—an uncouth, sacred wood. The composition, made up of groups relatively independent of one another, unfolds from right to left, from birth to death with, in the center, a "noble savage" with an androgynous, luminous, statue-like body gathering some of the abundant fruit.

It is a preeminently symbolist theme, but wild, arcane, left in the rough, archaic, and musical. The poet Mallarmé found it extraordinary that "so much mystery could go with such brightness."

Paul Gauguin, Paris 1848–1903 Atuona, Hiva Oa, Marquesas Islands
Where Do We Come From? What Are We? Where Are We Going?, 1897. Oil on canvas, 54¾ x 147½ in. (139.1 x 374.6 cm).
Museum of Fine Arts, Boston, Massachusetts.

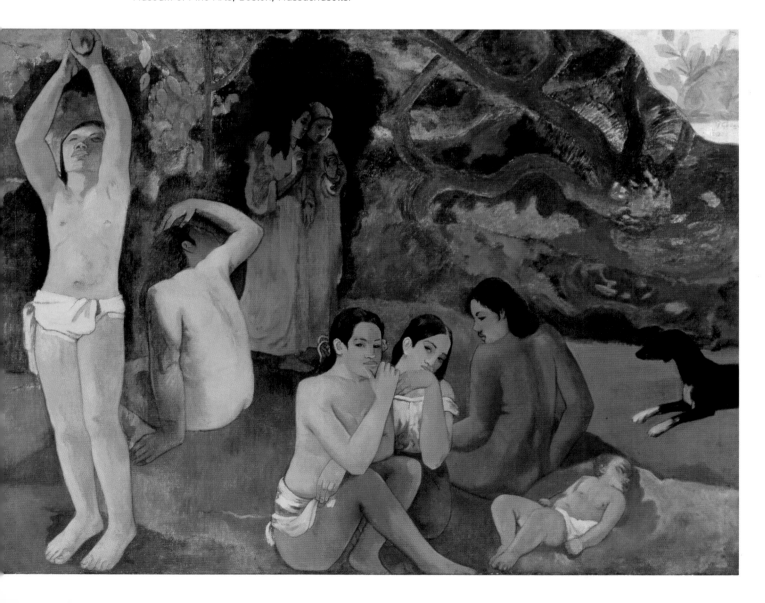

Edvard Munch
The Scream, 1893

On February 12, 1994, Edvard Munch's *The Scream* was stolen from the National Gallery in Oslo. Suspicion fell on anti-abortion groups, extremely active at the time in Norway. Three months later, "someone" offered to restitute the picture to the Norwegian government in exchange for one million dollars, but the offer was turned down. On May 7, a raid was prepared in collaboration with the Getty Museum and the British police and the painting was recovered.

On August 22, 2004, another *Scream* was seized, but this time during an armed robbery complete with balaclavas. According to the Swedish newspaper *Svenska Dagbladet*, the picture, which was not insured against theft, was burnt.

The Scream then shares with the *Mona Lisa* the dubious privilege of arousing this sort of covetousness, be it reaction or infatuation. For it is more than a work of the first rank, it is an icon—an icon of modern angst.

Four versions of *The Scream* exist, the most famous being the one in oil mixed with tempera and pastel illustrated here. The one stolen in 2004 was tempera on cardboard, and was on show in the Munch Museum, Oslo. A third version belongs to the same museum, while the last is in a private collection.

Can it be said to be an "expressionist" picture, or does it actually "announce" expressionism? It certainly holds nothing back, and is strongly influenced by Gauguin, another painter who replaced impression with expressiveness; it is a violently haunted piece, urgently painted, an outpouring of magma giving rise to a palpable anguish that overwhelms the entire piece, rocking and sending it spinning so that the whole cosmos is distorted.

In the center, a specter-like, nightmarish body, with hands and mask rather than a face, is deformed by a cry that convulses through the picture, plunging it into a fabulous, unprecedented field of energy. And the landscape—a painter's gesture in colored paste—becomes a wave; fluxes, surges up, propagating and flowing into an apocalyptic, blood-streaked, fiery sky, infusing it and dragging it off on its madcap dance.

The Scream belongs to a series of pictures entitled "The Frieze of Life," including *The Voice*, *Ashes*, and *Anxiety*, which constitute a synthesis of complexes and obsessions in the form of a vast poem. As Edward Munch declared: "In the cycle of life, death, and rebirth, humanity and nature are inexorably interdependent."

Describing his inspiration for *The Scream*, the artist wrote in his journal: "One evening, I was walking along a path with two friends. On one side stood the city, and below me was the fjord. I was tired, unwell. I stopped, leaning against a fence, to gaze at the bluish-black fjord. The sun was setting and then, suddenly, the clouds turned to blood red, flooding the city and the fjord. I felt an infinite scream surge through nature; and it seemed to me that I could hear this scream. And I painted this picture, painting the clouds like real blood. The colors howled."

Edvard Munch, Loten 1863–1944 Ekely
The Scream, 1893. Oil, tempera, and pastel on paperboard, 35¾ x 29 in. (91 x 73.5 cm).
Nasjonalgaleriet, Oslo.

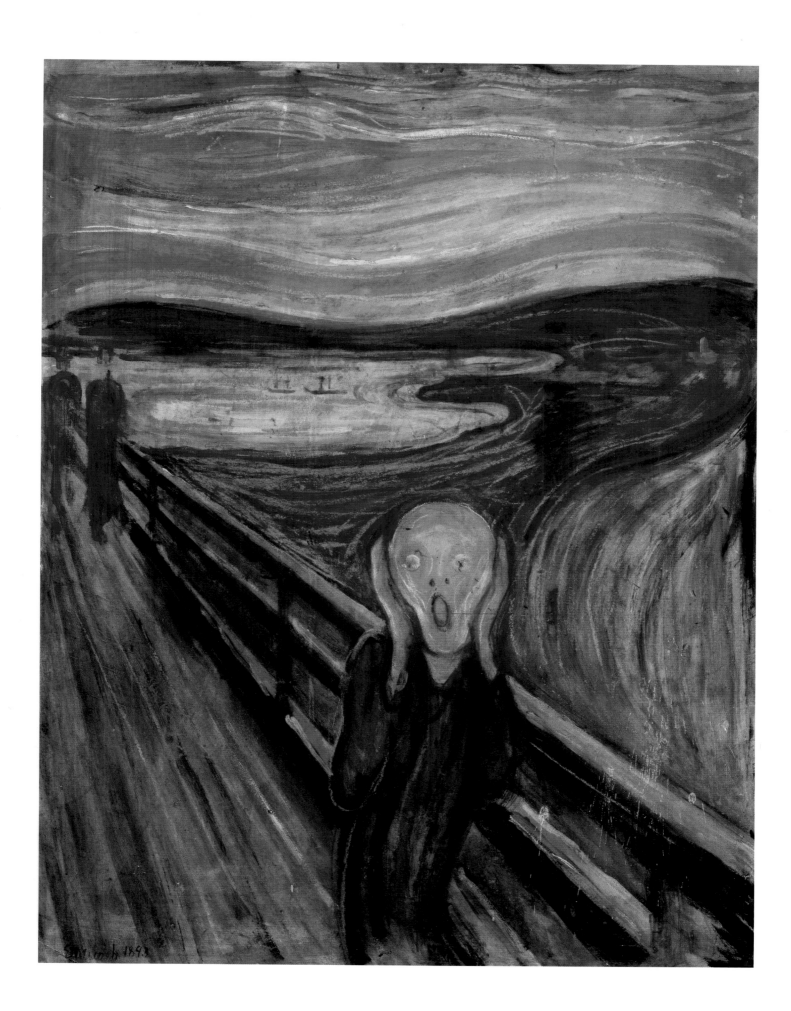

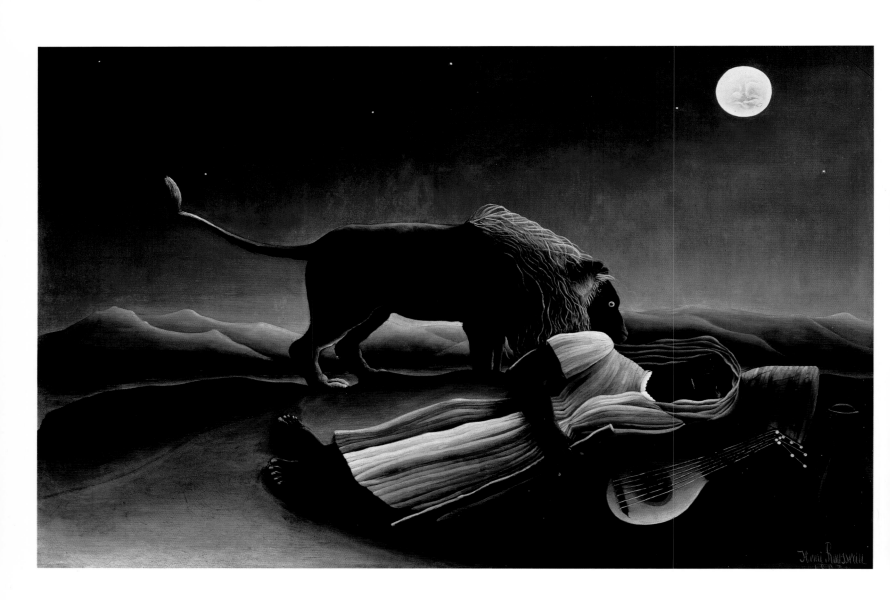

Henri Rousseau (also known as Le Douanier)
The Sleeping Gipsy, 1897

"That this picture emanates beauty is undeniable. Just ask a painter. They are unanimous: they all admire it," wrote Apollinaire, not particularly convincingly, in defense of a work signed by Henri Rousseau and entitled *The Dream*. It has to be admitted that this modest and improbably ingenuous artist, a customs and excise man at a Paris tollgate (hence his nickname, "Le Douanier," meaning customs officer), who had taken early retirement at the age of forty-nine, looked nothing like a revolutionary. He was a painstaking but awkward painter who, in the midst of neoimpressionism, admired academic artists; though he wielded a brush as best he could, he was unable to paint like his heroes. He was hardly a candidate for scandal or, contrariwise, for passionate defense. Faced with his art, people would be more likely to shrug their shoulders than riot.

But this agreeably dippy autodidact dared to be different. Operating outside all the schools, movements, and trends—and without, perhaps, being aware of exactly what he was doing—by simply being himself, as if playing a game, he staggered into uncharted territory. As Kandinsky, no less, declared in 1912: "Rousseau paved the way for the novel potential of simplicity."

In fact, Henri Rousseau was not a "naive" painter at all. He was an artist who squirreled away within him a part of his childhood that enabled him to produce unimaginably audacious works, an artist who entered the world of painting by stealth, who would methodically lay down colors one after the other: all the greens, then all the reds and so on.

Totally exempt from mannerism, he developed no procedures, no system, as was acknowledged by Apollinaire who, having been initially reticent, mentioned him hesitatingly in one of his chronicles before singing his praises in 1910. As always, artists were the first to pay attention to the newcomer, to become interested in his unconventional work, and propel it to the heart of the contemporary avant-garde. That said, even those who supported him were not averse to a hoax or two—as when Gauguin conned him into thinking he had won a State commission! But Signac, Pissarro, and Redon, were all sincere in their acclaim, Toulouse-Lautrec came to his assistance when he was threatened with exclusion from the Salon des Indépendants and, in 1908, Picasso organized a banquet in his honor.

Like the Musée d'Orsay's *War*, which was unearthed in a barn in 1944, *The Sleeping Gipsy*, today hanging in all its glory in New York's MoMA, was also rediscovered in 1923 in an unexpected hideaway: a plumber's shop. It is a painting close to those "idiotic" popular illustrations that Rimbaud talks of, and shows a dark-skinned girl lying in the desert with a mandolin and an earthenware jar (filled with water, Rousseau assures us) beside her. As in a fairy tale or a dream, and against a background of mountains beneath an idealized sky, a passing lion sniffs at her.

Clipped outlines, crystalline colors, freedom of style, and flattened perspective characterize this work, in which the artist who wanted to be—and indeed thought he was—a "realist" managed, quite simply, to paint magic.

Henri Rousseau (also known as Le Douanier), Laval 1844–1910 Paris
The Sleeping Gipsy, 1897. Oil on canvas, 51 x 79 in. (129.5 x 200.7 cm).
Museum of Modern Art, New York.

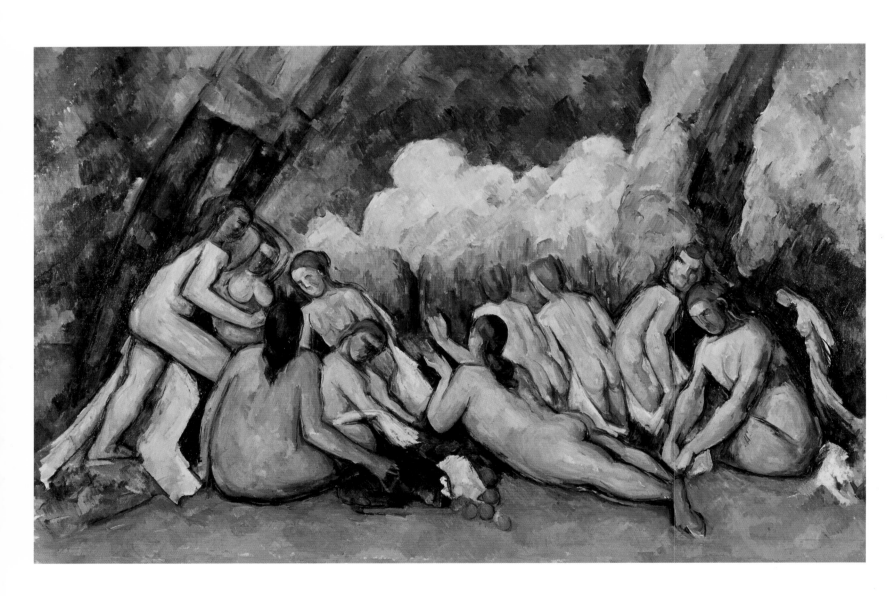

Paul Cézanne
The Large Bathers, 1895

Gauguin's exhibitionism riled Cézanne, who was by contrast the kind of artist who honed his craft at the easel. "Away I grind, on I trudge," he observed, and, "work must prove me right," and, "I work obstinately. I can glimpse the Promised Land." Cézanne was a persistent man.

His art, though far from being "thrown off," is not laborious or cerebral either. One has to be careful here: *sensation* is not the same as *impression*. There is, along the same lines, the *being-there* of the picture. D. H. Lawrence insisted on the intrinsic "apple" nature of an apple. That's it. Cézanne did not share the fondness for the instantaneous that characterized his contemporaries, the impressionists; it didn't interest him. And that is why, once he'd acknowledged his debt, the break was so spectacular.

"Monet is only an eye, but what an eye," he once remarked. Cézanne also had a fine eye, of course, but his standpoint was very different from those artists who admired his work: his was a search for harmony in painting through deconstruction.

Nowhere, perhaps, is this two-pronged quest more evident than in *The Large Bathers*, and, in particular, in the most powerful, roughest, most blatant, most concentrated of all, the one in London, with its faces without faces, bodies without waists, straight legs sawn down like logs. From this theme, normally voluptuous or titillating, Cézanne has removed all sexual character. These nudes are hardly women, but seem instead primitive or primary forms or masses, drenched in a lunar light in which ochers and blues meld almost seamlessly. Yet its homogeneity does not solidify into untold perfection, closed in on itself: such disassembly did not operate on the level of a sketch, as if awaiting future realization to attain ultimate form. There occurs a ceaseless to-ing and fro-ing, from deconstruction to construction and back again to deconstruction, and so on. This is where the modernity of Cézanne in general and of this painting in particular resides; in the new and uninhibited manner in which it exposes its working processes within the work, making this the true subject of the picture.

There are eleven women bathing (but where's the water?). One is coming up on the left. In the center, under the full moon, or the sun, a group chatters; they stroke a dog. Two redheads with the look of twins turn their backs and walk off. All appears located on the same plane, in a space without depth, except for one figure in profile on the right wandering about in the distance.

In a landscape reduced to its essence, these concentrates of nakedness mediate between the rupture that they consecrate and the classicism they hark back to. Poussin, perhaps, might come to mind. As Cézanne said, "I wanted, like Poussin, to place reason in the grass."

Cézanne toiled on his *Large Bathers*, the consummation of his art, for ten years. It might be said that here, as death approached, above and beyond all the asceticism and the harmony, the goal of his painting was innocence.

Paul Cézanne, Aix-en-Provence 1839–1906 Aix-en-Provence
The Large Bathers, 1895. Oil on canvas, 53½ x 75¼ in. (136 x 191 cm).
National Gallery, London.

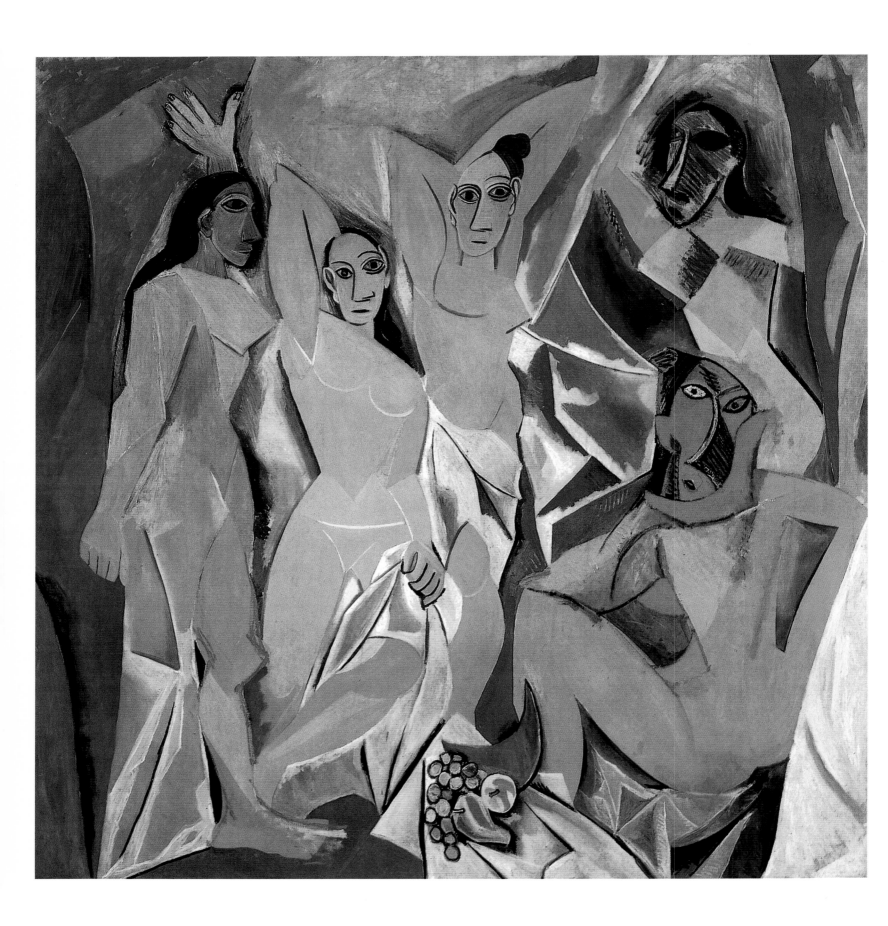

Pablo Picasso
Les Demoiselles d'Avignon, 1907

What was Picasso? A force on the move. An ogre. Artistic. Sexual. Media-friendly. And all the rest. A wizard. A phallus. A lunatic. A minotaur. "I do not seek, I find." Artistically speaking, the twentieth century opens in 1907 with him. Imagine it: he possessed the atomic bomb, otherwise known as *Les Demoiselles d'Avignon*.

It all sprung from Cézanne. Cézanne, whom he admired so much that one day when he was informed the painter had a grandson, Picasso cut the conversation short to exclaim: "But *I'm* Cézanne's grandson!"

In 1904, at the Salon d'Automne, Picasso visited the room devoted to Cézanne. The shock of seeing these ultimate compositions, and the conversations he had with his friends, led Picasso to ponder the processes of spatial deconstruction embarked upon by his predecessor. It was also in 1904 that, during a voyage to upper Catalonia in Spain, he discovered primitive art. He had then only to encounter the art of Black Africa and all the components of *Les Demoiselles d'Avignon* were in place.

Thus armed, Picasso entered the scene, breaking with everything and leaping into the unknown. He was no longer after "balance," even of a new kind, as Cézanne was. He pushed Cézanne's discoveries to their extreme, to their ultimate consequences. He tore and exploded form. And the chaos lives on.

I have already said that artists' interest is always aroused before others' in revolutionary works; they understand them better, defend them. But when it comes to *Les Demoiselles d'Avignon*, it would be an understatement to say that artists, including Braque and even Apollinaire, the future champion of cubism, were shocked to the core by it. In fact, they loathed *Les Demoiselles* and the "ignominious ugliness" of the faces.

We know that the "Avignon" of the title refers to a street of that name in Barcelona that had a famous brothel, and that the young ladies are therefore prostitutes. OK. But what knocks one sideways in this destructured vision is the violence, and the assertion of violence; the brutal exhibition of raw sexuality and the shattering of forms that goes with it.

The reference to *Las Meninas* is yet a further outrage. In Velázquez's picture, the figures look in our direction, where, as Michel Foucault reads it, we occupy the place of the king. But, here, as the prostitutes look at us, we surely take the place of the paying customer!

There was one final scandal. In 1924, the work, having long hung in Picasso's studio, was acquired by Jacques Doucet, the couturier-collector who had committed himself to bequeathing his collection to the Louvre. So, when he died, his widow wrote to the museum offering the picture, but they dragged their feet for so long that, at the end of her tether, she sold the canvas to an American gallery-owner. And so one of the great icons of modern art made its way to America. Two years later, MoMA acquired it. Alfred H. Barr justified his (costly) purchase with the observation that few modern works of art affirm "the arrogance of genius" so unashamedly.

Pablo Picasso, Malaga 1881–1973 Mougins
Les Demoiselles d'Avignon, 1907. Oil on canvas, 95½ x 92 in. (243 x 233.7 cm).
Museum of Modern Art, New York.

Vassily Kandinsky
Composition VII, 1913

The story goes that Kandinsky is supposed to have "invented" abstract art while contemplating a picture "of extraordinary beauty, ablaze with inner radiance," before realizing that it was in fact one of his own hung upside-down!

In reality, if the abstract painting of this Russian artist of Mongolian extraction derives from anything, it is primarily from music. He found in Goethe, whose theory of color was a source of endless fascination for him, the following astonishing sentence: "Painting must find its *basso continuo*"; and at the

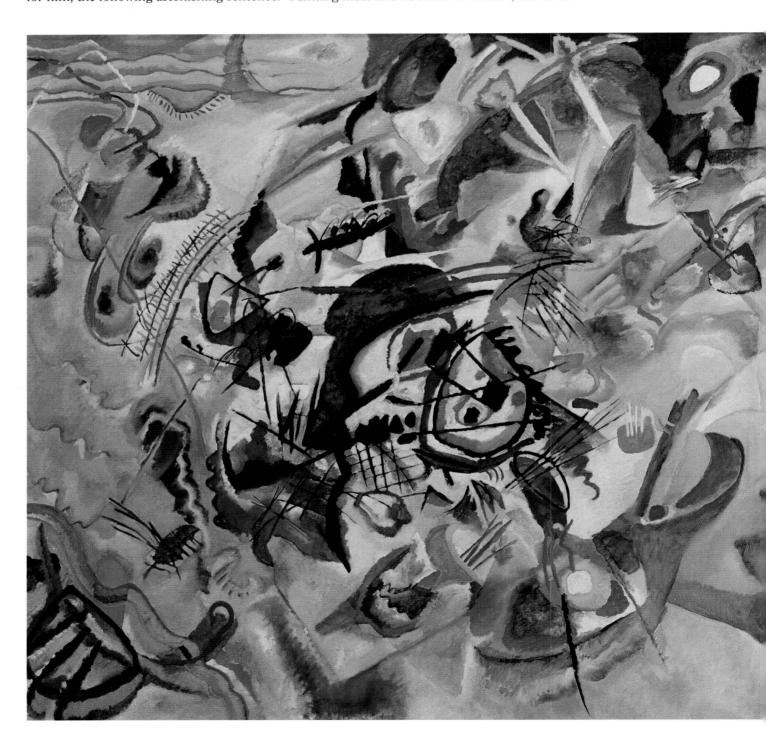

beginning of the 1910s, when he painted his first abstract work, he was also exchanging ideas and letters with Arnold Schoenberg, who was, like him, an adherent of the "spiritual in art."

In a letter to Kandinsky, the musician quotes Schopenhauer: "It is the composer who best uncovers the hidden essence of the world and delivers the message of deepest wisdom in a language reason cannot comprehend. Thus the sleepwalker reveals in his sleep things of which he is totally unaware when awake." Schoenberg went further: "Art belongs to the unconscious! One has to express the self!"

Kandinsky not only concurs, but actually outflanks Schoenberg, speaking of "inner resonance," of *another* order, seeing the essence of any art and the key to his own in the spiritual. At the same time, he directed his research towards rhythm, mathematics, and abstract compositions emerging from explosions of colors, which he explored with Franz Marc and Alexei Jawlensky at the time of the Blaue Reiter, passing from an idiom still rooted in the object to the high seas of abstractionism.

Like Rimbaud, who endowed the vowels with colors, Kandinsky affixes colors to sounds and sounds to colors, referring to "yellow sonorities," entitling the outpouring of canvases in the early 1910s *Improvisations* or *Compositions*. The most beautiful, the most violently colored, the brightest, the most unbridled and daring, the wildest, the absolute climax of these years is *Composition VII*, a splendid and barbaric work, eruptive, dizzying, and screamingly strident, which howls, gnarls, brays, rifling the air, searing the eardrums, unchecked, bursting: the *Rite of Spring* in painting.

These dislocations are not as impromptu as the titles of some works might imply: Kandinsky, before painting his monumental *Composition VII* between November 25 and November 29, 1913, undertook many studies, sketches, and designs in the form of detailed watercolors. Thus are masterpieces born; in addition to *Composition VII*, there were *Improvisation 30*, *Composition VI*, *Small Pleasures*, *Dream Improvisation*, *Black Lines*, *Painting with Red Spot*, all painted in 1913. If Kandinsky's art is, as Franz Marc stated, "as radiant as a comet," this year was truly the shining brightness of an ideal eternity.

Vassily Kandinsky, Moscow 1866–1944 Neuilly-sur-Seine
Composition VII, 1913. Oil on canvas, 78¾ x 118 in. (200 x 300 cm).
State Tretyakov Gallery, Moscow.

Kasimir Severinovich Malevich
The Black Square, 1915

A Ukrainian of Polish origin (but a subject of the tsar), a self-taught and combative theoretician, Malevich was the founder in the 1920s of the group devoted to modern art, UNOVIS (Advocates of the New Art) at the art school in Vitebsk. An outspoken polemist and champion of antedating, Malevich went through all the "-isms" of his time: realism, impressionism, symbolism, "Cézannism," fauvism, neoprimitivism, cubo-futurism, alogic cubism, culminating in suprematism, which he invented and embodied, before by 1930—following a three-month stretch in one of Stalin's jails—retreating into "tubist" neorealism.

"All past and current painting before suprematism," he wrote in his 1915 manifesto, *From Cubism to Suprematism*, "was enslaved by the form of nature, and awaits liberation so it can speak in its own language and not depend on reason, meaning, logic, philosophy, psychology, on the various laws of causality, or on technological developments in life."

At the beginning of 1915, Malevich executed several works presenting texts within a frame: *Brawl on the Boulevard*, for instance. For him, the word alone exerts an evocative power stronger than any image. Is he then a forerunner of conceptual art? No, for he himself stated repeatedly that "painters must reject both subject and object if they want to become pure painters." Forsaking the word, he went on to adopt the square, which he saw as the "face of the new art, the royal heir, full of life. The first step in pure creativity in art."

In December 1915, in Petrograd, the *0.10* exhibition was held. It was so named in reference to the mythical location of the world of Non-Objectivity in *Victory Over the Sun* (1913), a futurist opera for which Malevich had created "a stage curtain, with an evocation of initiatory rites by way of the purifying zero." He dared to deploy his *Black Square* on a white ground, a mind-blowing icon that marks the irruption of suprematism, parachuting into "alogism" and the "non-objective" (a term employed by Malevich to mean the elimination of all reference to objects).

The Black Square is in fact a quadrilateral, close to a square, none of whose angles exactly measures ninety degrees and whose right-hand corner points upwards slightly, endowing the piece with singular dynamism. As for the black, it is an amalgam of overlaid colors. *The Black Square* was hung in a corner of the showroom, right at the top, in the manner of an Orthodox icon. It is nothing short of a manifesto.

Is this square a subconscious form? Does it spring from intuitive reason? It is the "construction of a purely pictorial organism," refuting and subverting the very concept of colored composition. "A plane surface, and a living, genuine form." This was the long sought-after *essence*.

When he died in 1935, Malevich's coffin, painted in the suprematist style, was transported on a truck adorned with a black square—and followed by an immense crowd.

Kasimir Severinovich Malevich, Kiev 1878–1935 Leningrad
The Black Square, 1915. Oil on canvas, 19¾ x 19¾ in. (50 x 50 cm).
State Tretyakov Gallery, Moscow.

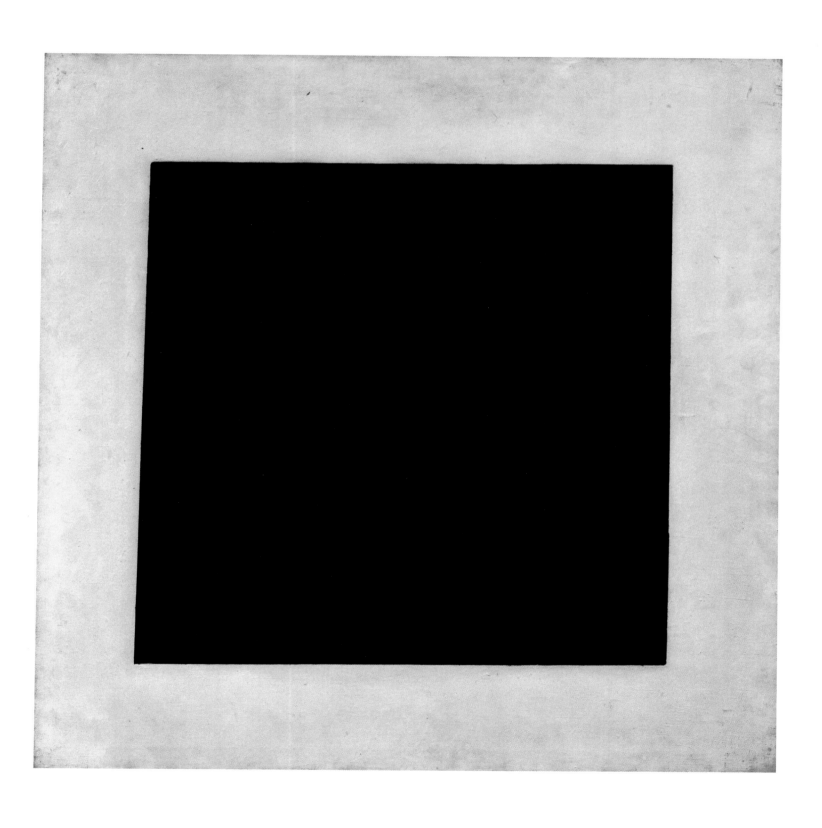

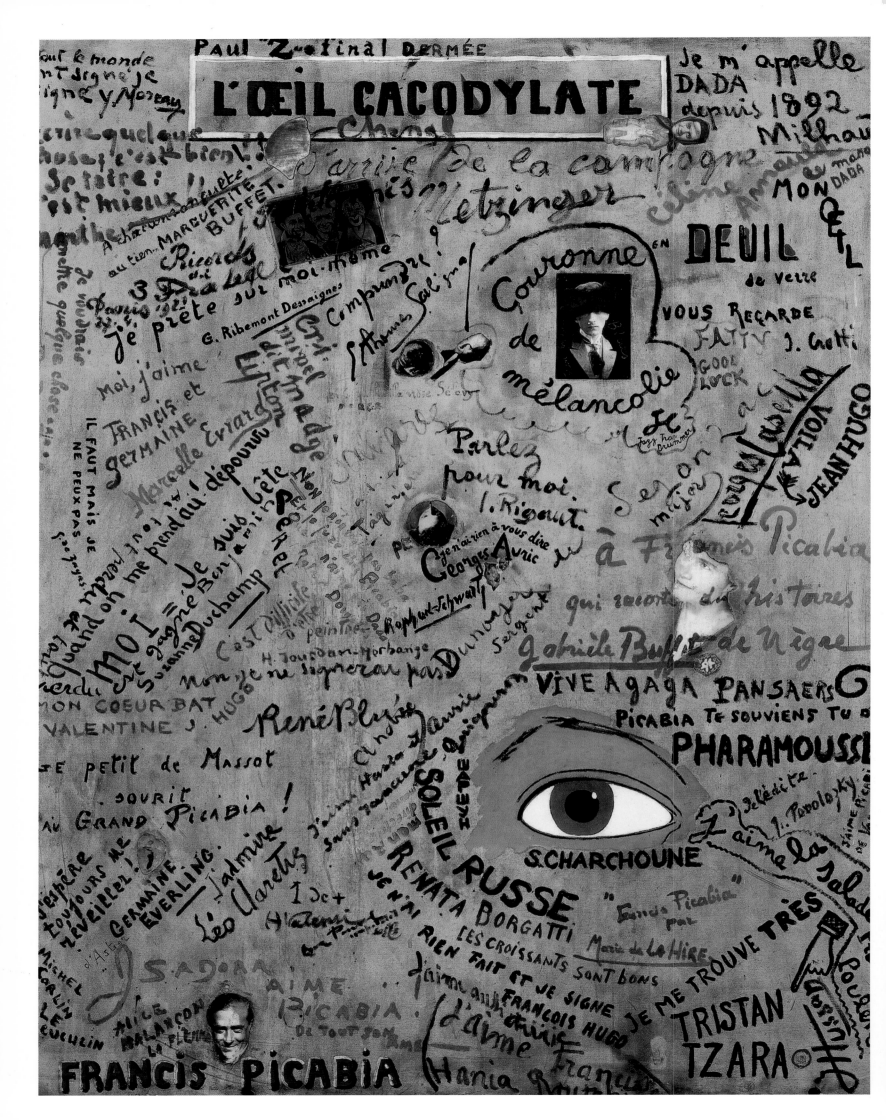

Francis Picabia
L'oeil cacodylate, 1921

Talented, debonair, bare-faced, provocative, amusing, charming, uncompromising; a party-goer and lover of classic cars, formidably inventive, as free as the wind, Picabia was dada to the tips of his fingers—even when he broke with dada. Or rather he was "himself" to the point of no return and this "self" happened to coincide with dada.

In Russia, during the first twenty years of the twentieth century, the burning question for artists was how to throw off their shackles, and for everyone else it was the Revolution; in western Europe, it was how to escape the absurd proliferation of "-isms" and leave behind the horrors of World War I.

From the slaughter arose dada: a breath of freedom and youth, unparalleled in its vitality, a peal of laughter that drowned out the untold violence, a laboratory where everything could be called into question, in which everything might start over. And a joy in creativity the like of which has never been seen again. Almost all modernity comes from dada—and I am tempted to remove the "almost."

Picabia embodied this, to the power of ten. He painted dada. He lived and breathed dada. He led dada. Before dada, after dada. He blazed trails in every direction: whether in wanting to sell his (artist's) shit at the Drouot auction house, or in trying to exhibit live mice and asking the warden to feed them.

Like his friend Duchamp, he started off in the ranks of impressionism. In spite of his success, he gave it up, as he always did whenever success threatened to halt his frenetic dynamism. He was also one of the pioneers of abstract art (*Udnie*, 1913). In New York, where he took refuge during World War I, he employed industrial design techniques to create the first machine pictures. He met Tzara in Zurich and was using enamel paint in the 1920s. Nothing could stop Picabia, who accepted no hierarchy of the genres: he painted "Spanish ladies," copied pornographic photographs, tried his hand at *transparencies*.

L'oeil cacodylate, a radical piece with more than a touch of humor, was refused at the 1921 Salon des Indépendants, but exhibited at the future *Bœuf sur le Toit*, where it stayed. The story of the painting starts with Picabia suffering a herpes attack in his eye, hence the organ's central position on the unprimed canvas. Around this there are signatures, glued photographs, "thoughts," notations, remarks—like the ones that friends write on a cast when someone has broken their leg; commonplace, spontaneous kinds of things. Life courses through a canvas in which the artist scarcely had a hand. Craftsmanship? Dumped. Taste? Dumped. That's dada. That's art, too. "This canvas was finished when there was no more space on top and I find the picture very beautiful, very pleasant to look at, and with a pretty harmony," Picabia wrote. But, for those with lingering doubts, he added: "I've been told it is not a picture ... I am of the opinion that a fan covered in signatures is no samovar! This is why my picture, which is framed, made to be affixed to the wall and looked at, can be only a picture."

It's as simple as that.

Francis Picabia (François-Marie Martinez de Picabia), Paris 1879–1953 Paris
L'oeil cacodylate, 1921. Oil on canvas and collage of photographs, postcards, and cut-out paper, 58½ x 46¼ in. (148.6 x 117.4 cm).
Musée National d'Art Moderne et Contemporain, Paris.

Marcel Duchamp
The Bride Stripped Bare by Her Bachelors, Even (The Large Glass), 1915–23

If Picabia created—indeed lived in—excess, then Duchamp made a show of reticence and silence. On the face of it, these two accomplices could hardly be less alike. But in fact, if one goes beyond the image and attitude, at heart they are closely related. Duchamp, the better strategist, naturalized American, became the undisputed figurehead of modernity; it was through him that everything on the other side of the Atlantic was channeled and transformed. Picabia, on the other hand, passes for something of a debonair ne'er-do-well, rather too amateur to be above board. The dry intellectualism of Duchamp, was acceptable; the jumpy vitality of Picabia was not.

It should not be forgotten, however, that before making his mark as the unaffiliated paragon of contemporary art, Duchamp had been not only an impressionist and member of the Section d'Or, like Picabia, but also an Orphist, and fascinated by the occult, by theosophy, by electromagnetism, and by anything and everything to do with the fourth dimension. I do not really know if—as is often alleged, and as the artist more or less said himself—before being turned into a "readymade" that emblem of indifferent beauty, the bicycle-wheel fixed to the stool, had been a "dreaming machine," a tool enabling Duchamp to observe "the principle of reduction by elemental parallelism." Whatever the truth, it is certain that, for him, the uprooting of perspective was related to a search for the fourth dimension that "is apprehended through diverse planar geometrical projections which are to be synthesized by the mind."

Duchamp is far more complex than international digests of contemporary art might allow us to suppose. So it is a good idea to deviate from the beaten path and read *The Large Glass* in the light of (amongst other things) writer Raymond Roussel's comments. Roussel buried the essence of what he had to say rather like a treasure beneath a forest of parentheses, of parentheses within parentheses (and so on), until it was so thoroughly hidden that he felt the need to write a book explaining his work: *Comment j'ai écrit certains de mes livres* ("How I wrote certain of my books"), though this hardly succeeds in making things any clearer. In the same way, it is interesting to note how the deluge of notes accompanying *The Large Glass* scarcely dispels the enigma. Duchamp delighted in muddying the waters, as one can see from this deadpan confession to Pierre Cabannes: "I made it without any ideas." Thus *The Large Glass*, comprising two superimposed glass plates, some oil paint, lead wire, and dust, operates like an intellectual speculation on the borders of alchemy.

Duchamp conceived and executed his work from 1911 to 1923, all the more slowly since he had agreed to hand it over to the Arensbergs when it was finished in return from them paying rent on his studio. By the time they sold the piece on to Katherine S. Dreier before they left for California, Duchamp had decided it would remain definitively in its incomplete state. It was seriously damaged during loan to an exhibition, but Duchamp found it just as beautiful on its return and refused to have it restored. So unfinished and cracked is how this masterpiece of modernity stands.

Marcel Duchamp, Blainville-Crevon 1887–1968 Paris
The Bride Stripped Bare by Her Bachelors, Even (The Large Glass), 1915–23. Glass plates, 107 x 69¼ in. (277.5 x 175.9 cm).
Philadelphia Museum of Art, Pennsylvania.

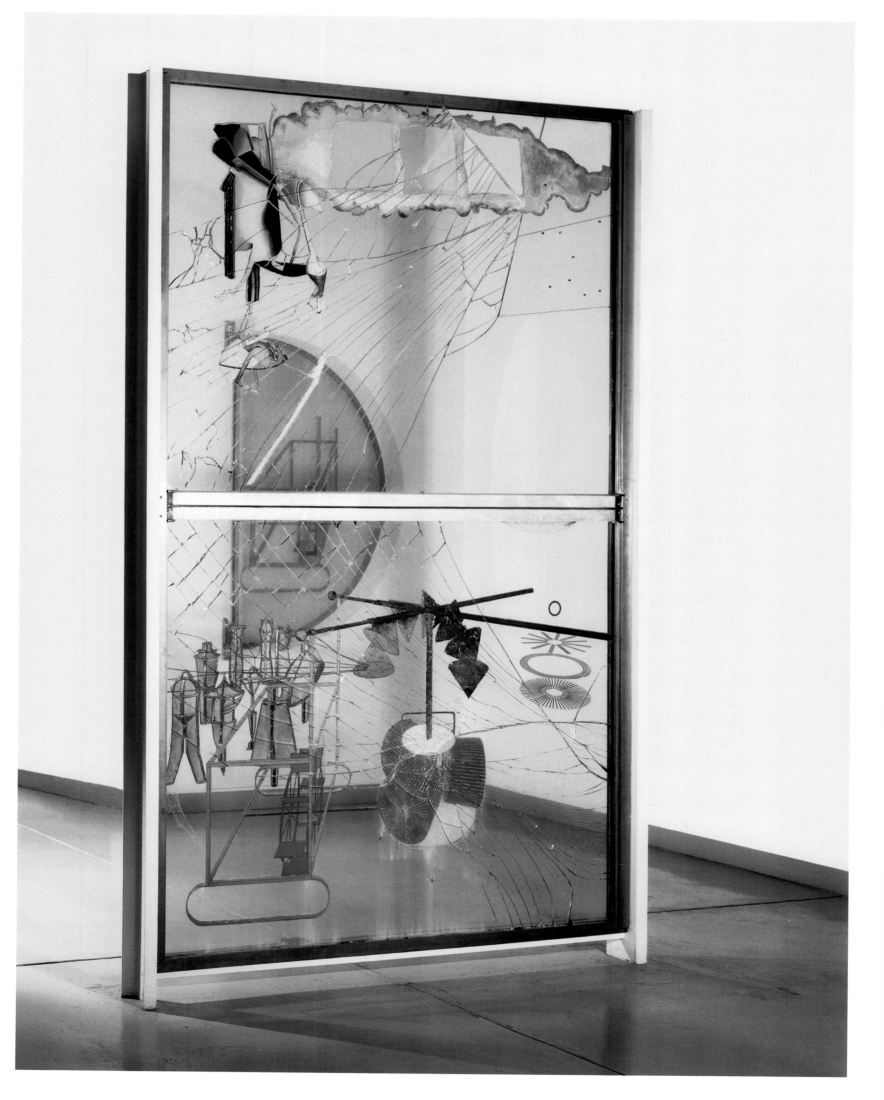

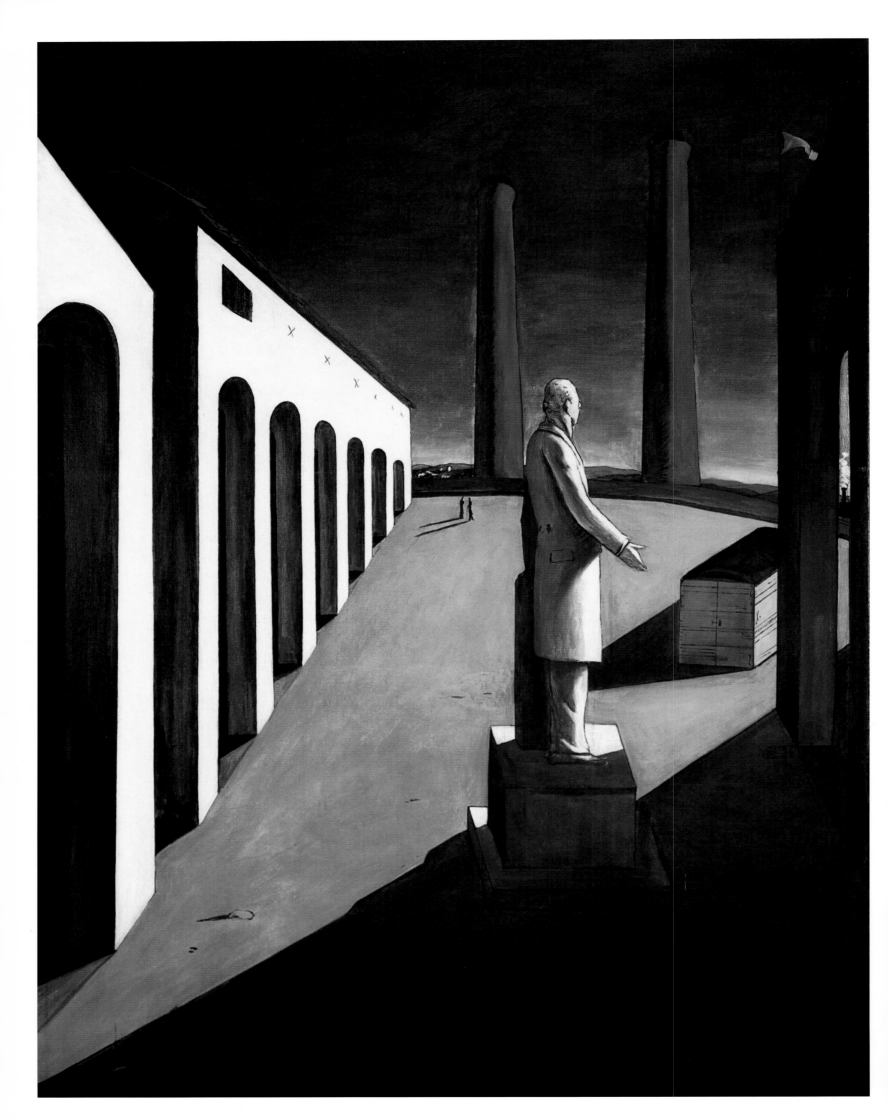

Giorgio De Chirico
The Enigma of a Day, 1914

Explaining one of his earliest metaphysical pictures (*The Enigma of an Autumn Afternoon*), Giorgio De Chirico recounts an experience as a "clairvoyant." "Then, I had the strange feeling of seeing these things for the first time, and the picture's composition appeared in my mind's eye. However, for me the instant remains an enigma in the sense that it is inexplicable. So I like to call the work derived from it 'enigma'."

That's the essence of his work: the impression of looking at things for the first time, of living through a revelation. All great De Chiricos present us with a feeling of surprise, but also with a secret logic confronted by an apparently unremarkable everyday experience, during which, all of a sudden, everything familiar and everything known is shot through with eeriness. It is this hypnotic, somnambulant type of painting that De Chirico dubbed *Pittura Metafisica*. Alain Jouffroy found a splendid formula to characterize their mysterious power: "The pictures of De Chirico make it go dark within us," he said.

From the outset, at the beginning of the 1910s, the painter declared himself in opposition to cubism, to abstraction, to pure painting, to futurism—that is, to the avant-garde en bloc—and claimed descent from the classical line, taking the cue for his meditative, haunted figuration from Böcklin, and creating paintings peopled by phantoms and charged with emotion. De Chirico's revolution was not in form, but in a way of seeing.

The Enigma of a Day shows a succession of blanched and shadow-draped arcades such as one finds in Turin, but seen in such an extreme perspective that it tips the picture over into the uncanny, an effect underscored by the pair of looming chimney stacks, the vastly deserted square, the trunk that has no place being where it is, the unconscionable white statue in the middle, the crisp, geometrical shadows, and the two silhouettes standing stock-still in the background, which make the space appear still more vast and empty.

In De Chirico's canvases, men are just shades, specters, or statues, locked in the heart of the dream that possesses them. There are no events here. Just an empty stage and a frozen set that arouse feelings of anguish and of uncertainty that do not necessarily herald some future catastrophe, but foster an intense, unsettling sense—hyper-lucidity—favorable to hallucination.

As always, external existence appears to De Chirico simply as a peculiar case of interior life, as in *The Child's Dream* and the *Portrait of Guillaume Apollinaire*: the faces portrayed look inside, interiorizing their vision and, in this manner, transforming all around them.

Apollinaire, that eagle-eyed, tireless, and generous observer, was (as so often) the first to perceive this. He brought De Chirico's oeuvre to the attention of Picasso and the rest, hailing him as "an unskilled and highly gifted painter." De Chirico never accepted anyone else's reasons for admiring his work, except for Apollinaire's.

Giorgio De Chirico, Volos, Greece 1888–1978 Rome
The Enigma of a Day, 1914. Oil on canvas, 72¾ x 54¾ in. (185.5 x 139.7 cm).
Museum of Modern Art, New York.

Fernand Léger
The Constructors, 1950

Pop artists freely acknowledged Léger as a precursor for the way he threw off the burden of culture, chose his subjects from everyday reality, and looked squarely at real life. "The pop artists did images that anybody walking down Broadway could recognize in a split second—comic strips, picnic tables, men's trousers, celebrities, shower curtains, refrigerators, coke bottles—all the great modern things that the abstract expressionists tried so hard not to notice at all," Warhol said.

"In painting, a nail must have as much interest as a face," Léger had written more than forty years previously in *Cahiers d'art*. "By going to the museum too much, we have been saddled with an olde-worlde attitude to beauty." It was in 1917; back from the Front, he proclaimed that the breech of a field-gun "gaping in the sunlight taught me more in terms of my development than all the museums in the world. Raw, searing reality. That's how I get a hold on things."

As World War II drew to a close, the French Communist Party had the wind in its sails. Membership swelled from three hundred and seventy thousand in 1944 to eight hundred thousand by 1946. The elections of that year saw it come second behind de Gaulle's party with 28.6 percent of the vote. When, in 1945, Léger returned from the United States, where he had sought refuge, he cherished the (naive, one might say) hope of constructing, out of the ruins of the war, a more just and "brotherly" society. Like Picasso, he joined the Communists.

What was the context? In the United States, McCarthy was whipping up "witch hunts," while in the USSR Zhdanov was repressing everything that failed to tally with the doctrine of socialist realism, promoted in France by Aragon who decreed: "The Party has but one aesthetic and this is called *realism*." Among artists, the word of command was followed in different ways. Matisse, Picasso, Herbin, and even Léger protested, and abstraction entered the breach.

The great composition of *The Constructors* should be seen against the backdrop of the *ouvriérisme* of the 1950s, a reaction, this time, against abstract art and the rather flaccid aftermath of surrealism. But Léger's "workerism" was a far cry from that of certain opportunists, since, as he recalled, he had been in the vanguard of those who denounced the demagogy with which it was associated and had been trumpeting fraternity and solidarity with the working man for many years.

The crux of *The Constructors* is to attain a compromise between abstraction—materialized by a system of metal frames squaring up the plain sky-blue ground, together with the handful of clouds to add life—and, above this, the powerfully modeled bodies, encircled in black and shown in dynamic, ascending movements.

It marks a return to simplicity, to a direct art, comprehensible to all—rigidly solid, monumentally potent, yet far from bereft of subtlety—and a grandiose example of Léger's incomparable gifts as a colorist.

"Turn your eyes away from the past," this tireless optimist would plead, "look how beautiful our world is. The new art brings peace and happiness."

Fernand Léger, Argentan 1881–1955 Gif-sur-Yvette
The Constructors, 1950. Oil on canvas, 118 x 78¾ in. (300 x 200 cm).
Musée National Fernand Léger, Biot.

Piet Mondrian
Broadway Boogie-Woogie, 1942–43

Mondrian was inordinately fond of the tango and the foxtrot. Is this hard to believe? Read the titles of his later pictures. They all have names of "in the swing" dances: *Foxtrot, Victory Boogie-Woogie, Broadway Boogie-Woogie.*... However, since Mondrian tirelessly endeavored to come over as a stiff-necked and distant Calvinist, complete with receding hairline, round, black-rimmed glasses, a courteous, unpretentious, but unsmiling manner, saying of himself, "I was born old," and living like a monk without a stick of furniture, adopting a self-controlled dandyism of austerity and concentration; and since commentators were prone to add further stiffening to this already starchy persona, the idea of Mondrian's *Boogie-Woogie* is hard to credit. The artist had his own explanation: "In modern dance (two-step, Boston, tango, etc.), the curves of the old dances (waltz, etc.) make way for straight lines, and each movement is immediately neutralized by a counter-movement that corresponds to a quest for balance."

It's time to look more closely at Mondrian's painting. In his search for the underlying structure of the world, rhythm is all pervasive—from the horizontal Dutch landscapes of his beginnings in about 1900, in which the artist rejected modulated color and depth and proceeded by simplified color masses in which detail is increasingly eliminated, to works carried out with adhesive tape, such as *Broadway Boogie-Woogie*, via the famous *Compositions* in primary colors—blue, yellow, red—which encroach on design, architecture, town planning.

Is *Broadway Boogie-Woogie* a pictorial version of the Andrew Sisters' *A-toot a-toot diddle-ee-ada-toot*, or the snappy tunes of Albert Ammons and Pete Johnson? It sparkles, flutters, in syncopated blocks of colored lines: a breath of lunacy and pleasure within the heart of the "system."

That said, much has been made of the relentless logic of Mondrian's approach, and that's not wrong either. His progress was systematic: from his early years of training and theosophy; to the cubism he discovered in 1911, which constituted for him "the great step towards abstraction," and which, according to Apollinaire, made the "cerebral" tangible; right up to his rejection of analytical cubism in favor of an art form that dispenses with all reference to the outside world, neoplasticism. The right-angle rules in this rational, balanced art, which refuses all effects of depth, and functions through blocks of pure color crisply delimited by black lines that abut at ninety degrees, forming the grid system that was to become his trademark.

Mondrian was at pains to eliminate anything that might convey a personal sensibility, seeking instead to attain the universal, thereby bringing about the end of humankind as individuality, as well as the end of easel-painting and its fusion in the great entirety of the social and urban fabric.

His art dreamed the new so as to start out on a new life.

Piet Mondrian (Pieter Cornelis Mondriaan), Amersfoort 1872–1944 New York
Broadway Boogie-Woogie, 1942–43. Oil on canvas, 50 x 50 in. (127 x 127 cm).
Museum of Modern Art, New York.

Henri Matisse
The Parakeet and the Siren, 1952

Here we see Matisse, the greatest colorist of the twentieth century, immersed in color. In his youth he had been the leading light of the fauves, who were notoriously accused of having thrown a pot of paint in the public's face; now, aged seventy-two, he staggers from an operation that almost cost him his life, ending up, a few years later, in a wheelchair. Flanked by assistants, scissors in hand, he cuts, slices into gouaches of pure color, and conjures up leaves, seaweed, nudes, and birds. His suffering body is as nothing to him. He is once again a man of the sun, yet devastating in his humility.

He had already tried his hand with flat tints of cut-out colored paper at the beginning of the 1930s, when working on *The Dance* for Dr. Barnes, passing from six to eight figures, constantly altering the fragments of arms, legs, hair, and their poses and relative positions. The paper was first cut out then pinned onto the canvas, a process he revisited in paintings such as the *Pink Nude* of 1935 and on covers for *Cahiers d'art* and Tériade's new review, *Verve*.

Then, in 1943, came *Jazz*, again with Tériade, which was unheard-of: a cymbal clash in art

publishing. Twenty prints based on Matisse's cut-outs, in sharp and violent hues, were accompanied by a text written by the artist himself. From there, Matisse's gouache cut-outs scurried over stained-glass windows, over walls like real frescoes, decorating his house. On occasion they were of vast proportions: one of his favorite compositions, the one he kept with him the longest, *The Parakeet and the Siren*, measured more than 25 feet (7.73 meters) wide. It is therefore hard to place much credence in the rumor that his use of gouache cut-outs was just a reaction to weakening physical ability.

In 1952, Matisse was eighty-two. It was a capital year, one of *bonheur de vivre* that brought forth vermilion and fuchsia, acid and apple greens, ultramarine and orange for the sea floor and the midsummer sun. And he had to invite the sea and the sky into the studio since he could no longer leave it. Unbridled freedom, both intense and serene: never had he worked on such sprightly compositions on so vast a scale. There are the grandiose, long-pondered blue nudes, *The Swimming Pool*, and the contemporary *Parakeet and the Siren*: heavenly, multicolored, all in artful waves.

But there's a proviso: Matisse did not make cut-outs from ready-made tinted paper. Instead he used sheets of rather heavy drawing stock (Vélin, Arches, Canson) that were painted in gouache by his assistants. The surface then is not plain, not neutral: traces of the brush can be seen here and there—it is a living surface, nothing like the cubists' "stuck papers" or early nineteenth-century silhouettes. Matisse remains wedded to painting. For him, as he wrote in *Jazz*, "cutting directly into color like this reminds me of the direct carving of sculptors."

Henri Matisse, Cateau-Cambrésis (now Le Cateau) 1869–1954 Nice
The Parakeet and the Siren, 1952. Cut-out gouache, 304 x 133 in. (773 x 337cm).
Stedelijk Museum, Amsterdam.

Raymond Hains & Jacques Villeglé
Ach Alma Manetro, 1949

In 1947, on the beach at Saint Malo, Jacques Villeglé was collecting twisted bits of scrap iron, seeing them as sculptures. He gathered them together and, later, exhibited them. About the same time, Raymond Hains was filming, with his Paillard Bolex camera, ads on billboards being torn up by passers-by. Both ended up making use of this filmed motif, marking the birth of a new aesthetics of the *objet trouvé*. Meeting and becoming friends in the art school at Rennes where they both studied, the ambition of these two artists was to put together a series of posters to turn it into a contemporary Bayeux Tapestry. This was *Ach Alma Manetro*, the title coming from a few of the words they could make out amid the torn patchwork.

The painter and poet Camille Bryen, who opposes the "harnessing" of reality, in the manner of Hains and Villeglé, to subjective "expression" (informal art was all the rage), spoke of the shift "from an art of creation to an art of predation." Hains was not displeased with this: "I am a photographer who instead of photographing the motif makes off with it." "I gave up 'doing' for 'purloining'," Villeglé concurred, employing the word *ravir*, a word that has connotations of theft as well as rapture. All nouveau réalisme is there, and well before Pierre Restany, who didn't in any case invent it, but rather unified the principal trends, linking it back to the "readymade"—a gross misinterpretation, one must say in passing; one that almost split the association apart after just a few months.

The two young artists enjoyed seizing posters, which were ripped by anonymous pedestrians or just peeled off, with holes, scraps of images, odd words. It proved a great joy to escape the studio, to run about the street hunting for artistic bolts from the blue. They could commit their larceny with impunity: "I put on a tie and acted as if it were perfectly natural," Villeglé once told me. "People stared, but didn't

dare say anything. The police just wandered off sniggering: 'Whatever will they think of next?' they'd say. And I'd reply: 'I'm not doing anything wrong, I'm taking down a poster that someone's ripped. On the contrary, I'm cleaning up.'"

Their action is not entirely without precedent. Some have referred to Léo Mallet's idea in the 1930s of tearing off bits of poster to reveal the layers beneath, to investigate the uncanny appearance of the "composition." But Mallet's plan went no further. As for Picasso and Braque's *papiers collés*, fragments of reality incorporated into the picture, those are entirely different. But such notions were evidently in the air.

Hains, more interested in shifts in linguistic meaning, and Villeglé, more concerned with composition and gesture, just present the results of their thievery. From representation, one passes to presentation.

There's more than one way of painting.

Raymond Hains and Jacques Villeglé
Raymond Hains, Saint Brieuc 1926–2005 Paris
Jacques Mahé de la Villeglé, Quimper 1926–
Ach Alma Manetro, 1949. Torn posters stuck on paper and glue-mounted on canvas, 22¾ x 100¾ in. (58 x 256 cm).
Musée National d'Art Moderne, Centre Pompidou, Paris.

Jackson Pollock
One: Number 31, 1950, 1950

With his inside-out jeans, skintight T-shirt, fine, tortured mouth, a car accident from which he escaped, but that cost the life of a female passenger, more than one stint in a psychiatric hospital, and binge drinking, Jackson Pollock is the perfect incarnation of the martyred, rebel-without-a-cause, all-American artist. His champion, Clement Greenberg, decided to make him into a hero, with unqualified success: the U.S. needed to affirm its position on the international art scene. The U.S. demanded legends. It got one.

Pollock employed "dripping," paint poured directly onto a canvas spread out on the floor: the image of Pollock leaping around and working on it from all angles (even on top of it), as recorded by Hans Namuth in his 1950 film, did more than practically anything else to establish his fame and legendary reputation. Pollock confessed: "On the floor I am more at ease. I feel nearer, more a part of the painting, since this way I can walk round it, work from the four sides and literally be *in* the painting." And all this while Europe and the United States were wrestling for artistic-commercial supremacy.

In the magazines of the time, Pollock was hailed as an apple-pie American painter who owed nothing to old Europe. This was a point of view singularly undermined by Pollock's unreciprocated admiration for Picasso, the patent influence of André Masson, whose work he knew well, and by dripping itself, easy to account for as a logical extension of surrealist automatism. Pollock himself actually seems more lucid and less hysterical than his zealots: "The idea of an isolated American painting, so popular in this country during the 1930s, seems absurd to me, just as the idea of creating a purely American mathematics or physics would seem absurd." In other words, for Pollock the problem did not exist, and—if it did—it would have solved itself: an American is an American and his painting is naturally partially predetermined by this fact, whether he wishes it or not. But the essential problems of contemporary painting are independent of nationhood.

Was Pollock's work then an act, above all, of "action painting," as Clement Rosenberg dubbed it, in which the canvas became an "arena," the theater of an "event"; or did his pictures, as the other Clement,

Clement Greenberg, proclaimed, circumscribe a specific space within the flatness of the support, an interlace generated by "dripping" that abolished the time-honored distinction between figure and ground?

The truth lies at the intersection of these two analyses. Pollock's work is subtle and strong, a painting-event, an action that expresses the artist's physical and psychic engagement. At the same time, the webs of paint act both to mask and to reveal, in particular in *One* of 1950, considered the masterpiece of the artist's triumphant period (1947–1950), where one's gaze, asked tirelessly to traverse various planes without ever fixing itself on one, weaves a "third dimension" that Greenberg promptly defined as "strictly pictorial," "strictly optical".

Pollock is the only artist, apart from Matisse, to have an entire room devoted to his works at the MoMA.

Jackson Pollock, Cody 1912–1956 The Springs, New York
One: Number 31, 1950, 1950. Oil and enamel on unprimed canvas, 106 x 209 in. (269.5 x 530.8 cm).
Museum of Modern Art, New York. Sydney and Harriet Janis Collection.

Robert Rauschenberg
Bed, 1955

Robert Rauschenberg first made a splash in 1953 when he painstakingly rubbed out a drawing he'd bought from de Kooning, one of the figureheads of abstract expressionism. Never had an upcoming generation so insolently told its predecessors to move out of the way, that they were outdated.

After serving in the U.S. Navy from 1942 to 1945, in 1948 Rauschenberg followed courses at the Académie Julian in Paris, and then at Black Mountain College in North Carolina, an experimental school and mythical talking-shop that gained an enviable reputation through the quality and innovative nature of the research it fostered. Professors included Josef Albers, who had taught at the Bauhaus, John Cage, and Merce Cunningham, who in 1952 staged the first "Happening" in an effort to break down the barriers between art and life.

For this *"enfant terrible* of American modernism," who designed stage sets with Cunningham, and showed monochromes—first white, then black, then red—well-nigh everywhere, traveled widely, and produced his first object assemblages in a dada "collage" vein, it was a time of pranks and effervescence. New York artists like him, who practiced this kind of activity, working "between art and life," were dubbed neodada. Rauschenberg also invented a term for his way of proceeding: "combine paintings." Forty years later he noted with a wry smile in an interview that he had invented the word "combine," and now it had gotten into the dictionary. There was a difference, though (one underscored by Rauschenberg himself), between "old" dada and American neodada: dada was intent on "excluding," the new variant on "including."

Bed, the masterpiece of these years, is a three-dimensional collage essentially made up of a bed placed vertically, whose sheets and coverlet act as a "canvas" on which Rauschenberg sprays and daubs on paint with great, dolloping brushstrokes. I am not sure whether this type of collage is novel, exactly, with respect to the earlier forays of Schwitters or Picabia; but the way it shatters the categories of painting and sculpture is new, as is the brutal power that such forthright statements express.

Scandalized critics saw it as an icon of gore and mayhem. This certainly recognized the violence of this uncompromising art, but it is a far cry from the artist's true intentions. Never had the energy of American art been so blatant as here, in the work of this exceptionally gifted, inventive artist of "junk art," who, like his friend Jasper Johns, prefigures many aspects of pop art, in particular the use of photography and silkscreen printing.

It should also be recalled that Rauschenberg was the first American artist to carry off a prize at the Venice Biennial, in 1964, to the intense fury of the Europeans and especially of the French who, up to that point, had enjoyed a near monopoly over such awards.

Robert Rauschenberg, Port Arthur 1925–
Bed, 1955. Oil and pencil on pillow, eiderdown, and sheet on wooden supports, 75¼ x 31½ x 8 in. (191.1 x 80 x 20.3 cm).
Museum of Modern Art, New York. Gift of Leo Castelli in honor of Alfred H. Barr.

Jasper Johns
Flag, 1954

In 1954, a radical deflagration caught the existential "angst" of abstract expressionism and its much-vaunted emotional subjectivity on the hop.

The fire-starter was a man called Jasper Johns. He painted the American flag—on an American flag.

Eisenhower was still in power. Kennedy would not become president for a further six years. Pop art was still to come, but it is already here, all its components, all its characteristics—together with its unflappable impersonality.

Did Warhol understand that, in 1954, Jasper Johns, with his *Flags* and *Targets*, was reconstructing in another manner what the readymade had demolished? Perhaps he was receptive to the fact that, whereas Duchamp would have chosen to show a flag just as it is, a readymade, Jasper Johns carefully, almost laboriously paints it—a fundamental displacement since the result is not an iconic painting, but a painting-object whose function is no longer representation but presentation. Surely Warhol must have realized this. In any case, the message, in one way or another, was passed on, and it is a crucial one: not to paint "against" Duchamp, but to follow his lead.

Jasper Johns's work then emerges from a breach. With him, it is the very surface of the picture that becomes the site of representation, not a hypothetical plane or space demarcated by the illusion of depth. The layer of encaustic, applied in neat little brushstrokes, doggedly following the design and colors of the flag or target, is, on closer inspection, the only clue that allows us to be sure that we are looking at a fictional flag or target. Whereas the cubists folded back the surfaces of the three-dimensional object onto the plane of the canvas, Jasper Johns keeps faith with two dimensions (flags, target, maps, numbers). Thus we are presented with, not the result of an alteration, or the flattening of volume to plane but, more simply, with a certified copy of a real object. The difference is not semantic.

In an interview on the BBC in 1965, David Sylvester asked Johns where he got the idea of starting with flags, targets, and numbers. Johns answered: "It was [that] in my eyes [they were] pre-formed, conventional, depersonalized, factual, exterior elements." Going further, in answer to another question, he said: "I am interested in things which suggest the world rather than suggest the personality. I'm interested in things which suggest things which are, rather than in judgments... the most ordinary thing... it seems to me to exist as clear facts, not involving aesthetic hierarchy."

The picture was received with enthusiasm by some and with dismay by others, primarily because of the subject matter. Nothing so boring, they sighed, had ever been painted before, nothing so banal. That is correct, but irrelevant: banality, in Jasper Johns's hands, is hugely enthralling.

Jasper Johns, Augusta 1930–
Flag, 1954. Encaustic, oil, and collage on fabric mounted on plywood, 42¼ x 60½ in. (107.3 x 153.8 cm).
Museum of Modern Art, New York. Gift of Philip Johnson in honor of Alfred H. Barr.

Andy Warhol
Campbell's Soup Cans, 1962

To be provocative, or give further credence to the image of himself and of his art that he liked to project, Warhol stated that the idea of painting Campbell's soup cans and dollars (his earliest pop works) was not his own: he had bought it. The very next day, he sent his mother down to the corner store to buy the whole range of the thirty-two tins and started to work on the idea, trying out various sizes and combinations.

Warhol's debut exhibition as a pop artist was at Irving Blum's in Los Angeles, on July 9, 1962. In a single row around the gallery, Blum set up the thirty-two cans of Campbell's soup, each priced at a hundred dollars. He sold six (one to actor Dennis Hopper), and bought the remainder himself. Then he got busy, spending months trying to buy back the six others so as to have the complete series, to the immense satisfaction of Warhol who confessed that he had always envisaged the thirty-two paintings as a sequence.

From where does the searing modernity of Campbell's come? Above all from the subject: not soup itself, which remains out of sight, but the can containing it. Surface is given preference to interiority, if I might put it like that—or at least to contents. Then it is the way that the theme is treated, from the total elimination of effect. The can is there, face on, drawn and painted in a trim, chilly, objectified way, without the least hint of emotion. Nothing else interferes. The series—unyielding, repetitive, boring even—prefigures the grid-based compositions, the serial repetition, and the erosion of meaning in mass production, exhibited so as to evoke an economy whose effects can be felt by each and every American in any supermarket in Los Angeles or New York.

Visitors scratched their heads. Los Angeles artists shrugged their shoulders. The Press went on the attack, violently. Critics wondered where the art was in reproducing a soup can so common that you could buy one for a nickel in any store. Where is the aesthetic transformation—the essence of art according to such criticism—in the perfectly impersonal, perfectly inexpressive depiction of images that the artist has not himself invented? People referred darkly to Warhol's past life as an advertising illustrator in an effort to undermine and deride the whole enterprise. Then there was the question of ethics: what lurks behind these "portraits of Campbell's soup"? Critique? Condemnation? An attack on capitalism and American culture?

Duchamp's point of view is this: "If you take a can of Campbell's soup and you repeat it fifty times, the retinal image clearly doesn't interest you. What interests you is the concept that induces you to put fifty cans of Campbell's soup on a canvas."

Understanding the Duchamp-Warhol relationship is the right approach to what's at stake here: "appropriation" and the virtue of indifference.

Andy Warhol, Pittsburgh 1928–1987 New York
Campbell's Soup Cans (series of 32 canvases), 1962.
Synthetic polymer paint on canvas, each 20 x 16 in. (50.8 x 40.6 cm).
Museum of Modern Art, New York. Gifts of Irving Blum; A. Rockefeller;
Mr. and Mrs. William A. M. Burden; the Abby Aldrich Rockefeller Foundation.

Barnett Newman
Vir Heroicus Sublimis, 1950–51

Newman's position was that the prime purpose of pictorial language is vision and "illumination." Nothing, it should be stated at the outset, is less formalist than this abstraction, which surges forth into a painting that "stands," that plunges us body and soul into pure color. Nothing is more formidably powerful than this art: an intense affirmation, vibrating and extending ad infinitum into the light.

Of course, some nod and murmur: "color-field." Color-field, we're told, is what describes him—as it does Rothko, Gottlieb, Still, and others, too, of course, but Newman first and foremost. The consensus is that color-field designates surface saturated with color (most often all over), without thickness or sign of brushstroke, and in which every zone enjoys the same value and emphasis, as if trimmed down from a larger surface. It will be said that in the 1950s Newman, like Rothko, Gottlieb, and Still, sought to exemplify the primarily visual, optical quality of paint as a colored surface. This he explained in theoretical texts: abstract form has the power to transmit thoughts and feelings directly, without reference to the visual world.

There is one essential rider, however: this abstraction is first and foremost designed to stimulate contemplation, reflection, and meditation. The studio is a "holy place," he says. Barnett Newman's

work, like that of so many abstract artists (Rothko, Nemours, Kandinsky) was underpinned by metaphysics. His own rubbed shoulders with that of Indian artists from the northwest coast of the United States, and with Jewish mysticism, the cabala in particular, and he found in the concept of *makom*—the dwelling place of Jehovah—an equivalent to what he was trying to create or record in his painting.

At the end of the 1940s, and more especially in the early 1950s, his color-fields, increasingly vast, were to be traversed by slender vertical stripes. These are the famous *zips*, like flashes over a cloudless sky in his own special tone of red, or the sumptuous black split by a clean blue line in *Midnight Blue*, or demarcating the eponymous hues in the celebrated *Who's Afraid of Red, Yellow, and Blue?*

For Newman, the point is nothing less than to unveil the origin of painting and of the cosmos, an equivalent perhaps of the divine act of breathing life into humankind. It can be no coincidence that his pictures have titles like *Adam*, *Eve*, and *Abraham*.

At the beginning of the 1950s, Newman's canvases increased in size and tended to the horizontal. The unquestioned masterpiece of this opulent period, *Vir Heroicus Sublimis*, affirms that the sublime is at once possible and necessary in our day. And he declares, proclaims, and chants this from within

an ideal balance between horizontal and vertical forces, between the erect bands and the expanses of red that they awaken, reveal, and set to resonate like a giddiness and an alleluia. His aim was "to change geometry into a language of passion," he once said.

Barnett Newman, New York 1905–1970 New York
Vir Heroicus Sublimis, 1950–51. Oil on canvas,
95¼ x 213¼ in. (242.2 x 541.7 cm).
Museum of Modern Art, New York.
Gift of Mr. and Mrs. Ben Heller.

Daniel Buren
Peinture-sculpture, 1971

Daniel Buren was the only French artist invited out of twenty-one participants in the Sixth Guggenheim International Exhibition in 1971. His work was based on an observation he describes as follows: "The spiral shape of the museum directs all the exhibits towards the outside, throwing them out to an extent onto the (oblique) walls over which they slide; it is a rejection all the more strongly felt as the 'spectacle' of the architecture itself attracts one irresistibly towards the interior of the spiral, that is, to the empty part of the museum, where there is nothing, a haunting nothing that accentuates the general inanity of the works struggling to brave it."

So Buren installed, in the center, high up in the well, a bolt of cotton cloth 10 meters broad by 20

meters long, suspended from a steel cable at the height of the glass roof. The fabric, comprising alternating white and blue stripes measuring 3½ inches (8.7 centimeters) across, the two bands at the edge being covered with white paint back and front (Buren's particular visual tool), is so engineered that "the gaze directly confronts not the void, but something that offers nothing save its own image, clearly raising the question of its own presence."

The question impinges on its inherent status, since, as one walks along the spiral, one rotates round the striped and painted cloth so that it appears from an infinite number of viewpoints. Whether put out or charmed, we see it both as painting and sculpture—or else as an interrogation.

One might expect this to be heralded as acuity of vision; a radical proposal; a masterly declaration of freedom. "Three cheers for the artist?" Wrong: in fact, Buren's name was mud. Three other participants, Flavin, Judd, and Heizer, regarded the cloth as "unacceptable," and, not satisfied with lodging a protest, demanded and indeed succeeded in having the piece withdrawn, alleging that the "banner" jeopardized the visibility of their work. They objected because of its size, they said, but we reckon that it was at least as much because of its power and relevance. Lawrence Weiner, Carl Andre, and others took up cudgels on Buren's behalf, and a spat broke out in the Press. Some saw the specter of censorship, wielded—what is more—by artists.

Buren barely had time to photograph his installation. "One curious effect of the piece's removal," he remarked with a smile, "was that the museum no longer looked like a gigantic sculpture unfolding in a triumphant spiral, but like a huge, dumb, and uninhabited black hole."

For the first time, and in a particularly resounding manner, Buren laid down the gauntlet to a hierarchical relationship and a frame of representation which, even if it is behind the scenes, rules over so many works of art: the museum. Operating a complete conceptual inversion, or reversal, the artist went beyond a mere "critique" of exhibition space, as Guy Lelong clearly saw. Buren "derived his work from the place it occupies in order to integrate the latter into the work."

Daniel Buren, Boulogne-Billancourt 1938–
Facing page: *Peinture-sculpture*, 1971. Cotton fabric with alternating stripes of white and blue, the two white bands at the edge being painted white front and back, 32¾ x 65½ ft. (10 x 20 m) suspended from a steel cable on a level with the canopy. Work completed *in situ* for the Sixth Guggenheim International Exhibition at the Guggenheim Museum, New York. Above: *Around the Corner* (detail), 2005. Photograph of a work completed *in situ* for the *In The Eye of the Storm* exhibition at the Guggenheim Museum, New York, March–June 2005.

Jean-Michel Basquiat
Pegasus, 1987

Can one imagine Jean-Michel Basquiat crashing onto the New York art scene without its having earlier been exposed to German "bad" painting, to Salome, Castelli, et al., a movement that erupted onto the American market in the late 1970s and strutted its stuff for a few years? Probably not. But to move from this to considering his art as shamelessly opportunistic—a weapon filling a niche, and "regressive" to boot (after the radical statements of Barnett Newman, Daniel Buren, and Jackson Pollock), as if it were a kind of return to cave art, a sort of art brut, bereft of interest because bereft of concepts—is patently unjust.

This is in essence underground art, but it is comprehensible, too, and harks back in fact to Warhol and Lichtenstein. It is assuredly more sophisticated and "arty," but equally fed by popular culture. In fact, Basquiat actually collaborated for a time with Warhol.

The first tag graffiti appeared in the New York subway in 1970. Puerto Ricans and black kids, barely out of their teens, with links to rap and break-dance soon followed suit, spraying gang names and hood insignia on subway trains and tunnels, before overflowing into the city. The authorities clamped down, but were powerless to stem the tide.

One of the earliest exponents, Jean-Michel Basquiat, of Puerto Rican descent on his mother's side and Haitian on his father's, christened himself *SAMO* (for "Same Old Shit"), initials he combined with a crown.

In 1980, he took part in an event at an alternative gallery in the South Bronx, *The Time Square Show*, which marked the end of graffiti's marginalization. Galleries embraced street artists with open arms, while the practitioners themselves adapted more or less diligently to the demands of canvas and the constraints of the exhibition space. Critics and the market breathed more easily. Make way for the formal imagination of New York! Except that with Basquiat, this was to miss the mark.

Like other graffitists, Basquiat emerges from a socioeconomic context and a necessity; but this is to pigeonhole him and—above and beyond the unpolished shell of his art—to turn a blind eye to the exceptional grace of his line and to the miracle that took place each time the artist applied canister, brush, or pencil to wall, wood, or canvas, and let them roam, free and untrammeled.

Untold elegance lurks beneath the brutality of his tags and gestures, an enigmatic innocence beyond the "in-yer-face" grandstanding. His idiom mixes traditional themes (sex, death) with allusions to drugs, but it also features numbers and letters. Perhaps it is the stricken accumulations he made a few months before his tragic death due to an overdose when he was only twenty-eight that best embody this unclassifiable artist.

But was he even an artist? At the beginning at least, weren't graffitists called "writers"?

Jean-Michel Basquiat, New York 1960–1988 New York
Pegasus, 1987. Acrylic resin, graphite, and colored pencil on mounted paper, 88 x 90 in. (223.5 x 228.5 cm).
John McEnroe Collection, New York.

Table of Contents

Editor's note
This book presents one hundred masterpieces of painting, chosen
and brought together by Michel Nuridsany, arranged primarily in chronological
order. However, in some instances the order has been slightly modified
to take into account thematic or aesthetic links.

Translated from the French by David Radzinowicz
Copyediting: Penelope Isaac
Design: Dune Lunel aka modzilla!
Typesetting: Anne-Lou Bissières
Proofreading: Emily Ligniti
Color Separation: Les Artisans du Regard, Paris

Distributed in North America by Rizzoli International Publications, Inc.

Simultaneously published in French as *100 chefs d'œuvres de la peinture*
© Flammarion, Paris, 2006

English-language edition
© Flammarion, Paris, 2006

www.editions.flammarion.com

06 07 08 4 3 2 1
FC0529-06-X
ISBN-10: 2-0803-0529-8
ISBN-13: 9782080305299
Dépôt légal: 10/2006

Printed in Spain by Egedsa

Photographic credits
akg-images, Paris: pages 6, 8–9, 12, 16, 20, 21, 27, 32, 46, 47, 59, 60, 65, 66, 67, 68, 69, 73, 74, 88, 90, 91, 92, 94,
95, 98, 99, 107, 127, 130, 140, 168, 174–175, 177, 187; Erich Lessing/akg-images: pages 11, 66, 67, 70–71, 77,
78–79, 86–87, 96, 100, 111, 114115, 119, 124, 128, 129, 133, 134, 142, 143, 144, 148, 162, 170, 172, 184; Tristan
Lafranchis/akg-images: page 15; Jean-Louis Nou/akg-images: page 19; Hervé Champollion/akg-images: page 33;
Cameraphoto/akg-images: pages 54, 55, 112; Rabatti-Domingie/akg-images: pages 62–63, 82, 83, 84–85, 123, 137;
Electa/akg-images: pages 81, 108.
BPK, Berlin (Dist. RMN): page 147, photo © Elke Walford.
CNAC/MNAM, Paris (Dist. RMN): pages 190–191, photo © Christian Bahier/Philippe Migeat.
Flammarion Archives, Paris: pages 7, 13, 22, 23, 24–25, 28, 30–31, 34, 36, 37, 38, 39, 40–41, 43, 44–45, 48, 51, 56,
103, 104, 116–117, 120, 150–151, 152, 153, 154, 156, 157, 158, 161, 164–165, 167, 178, 204.
RMN, Paris: page 139, photo © Hervé Lewandowski.
Scala, Florence: page 52, photo © 1990. Photo, Opera Metropolitana, Siena/Scala, Florence; page 181, photo ©
2004. Photo, Philadelphia Museum of Art/Art Resource/Scala, Florence; page 182, photo © 2005. Digital image,
Museum of Modern Art, New York/Scala, Florence; page 192–193, photo © 2005. Digital image, Museum
of Modern Art, New York/Scala, Florence; page 194, photo © 2005. Digital image, Museum of Modern Art,
New York/Scala, Florence; page 197, photo © 2005. Digital image, Museum of Modern Art, New York/Scala,
Florence; page 198–199, photo © 2005. Digital image, Museum of Modern Art, New York/Scala, Florence;
page 200, photo © 2005. Digital image, Museum of Modern Art, New York/Scala, Florence.
Studio Daniel Buren, France: pages 202–203.

© Succession Picasso 2006, Paris: page 172.
© Succession H. Matisse
© ADAGP, Paris, 2006 for the works of Daniel Buren, Raymond Hains, Vassily Kandisky, Fernand Léger,
Barnett Newman, Francis Picabia, Jackson Pollock, Jacques Villeglé, Andy Warhol.
© Succession Marcel Duchamp / Adagp, Paris 2006
© Munch Museet / Munch Elligsen Group / Adagp, Paris 2006
© Robert Rauschenberg / Adagp, Paris 2006
© Estate of Jean-Michel Basquiat / Adagp, Paris 2006